SECRET CITIES OF
EUROPE

SECRET CITIES OF
EUROPE

70 Charming Places Away from the Crowds

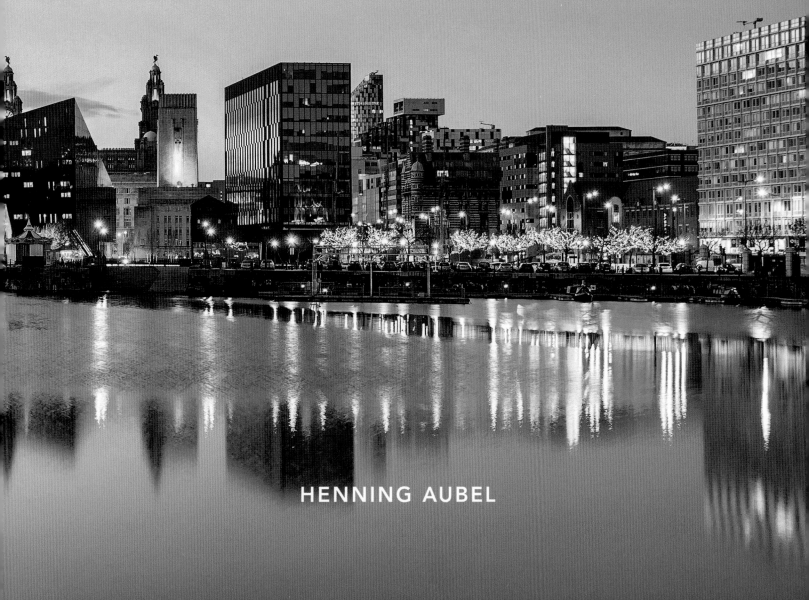

HENNING AUBEL

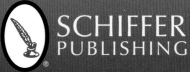

SCHIFFER
PUBLISHING

4880 Lower Valley Road • Atglen, PA 19310

TABLE OF CONTENTS

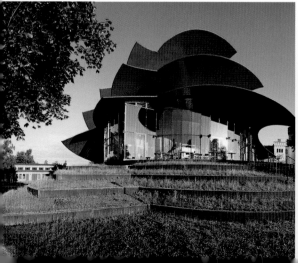
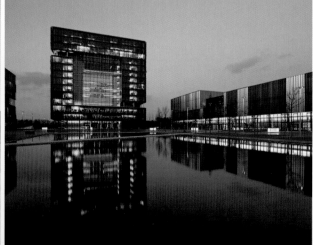

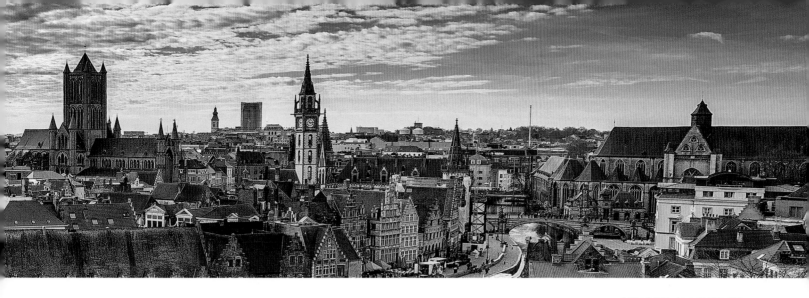

PANORAMA OF FLEMISH GHENT

POTSDAM'S CITY THEATER; THYSSENKRUPP
CORPORATE HEADQUARTERS IN ESSEN; FOOTBRIDGE
TO THE ISLAND IN THE MUR, GRAZ; ARCADE
PASSAGEWAY IN LIVORNO; TREATS FROM GHENT
(*FROM LEFT*)

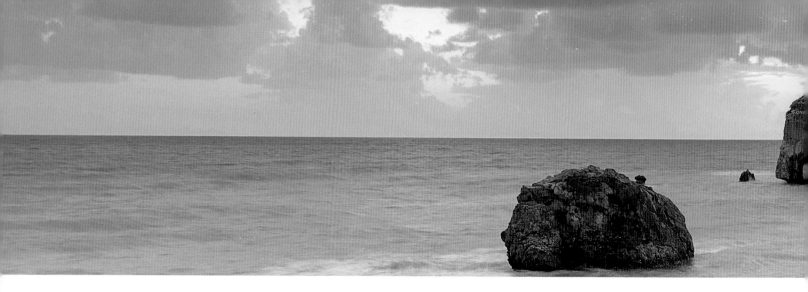

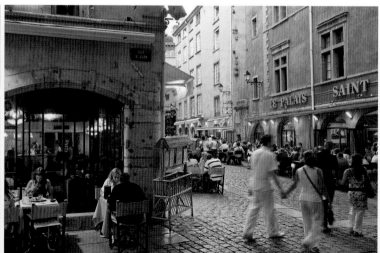

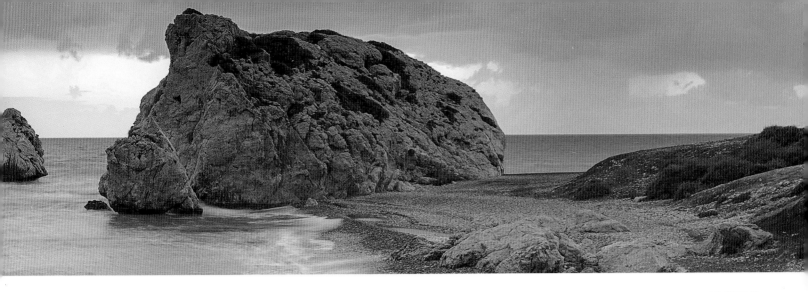

THE APHRODITE ROCK NEAR PAPHOS, CYPRUS

BRIDGE OVER THE MAYENNE RIVER IN ANGERS, RUE SAINT-JEAN IN
LYON, BAZAAR IN SARAJEVO, FESTIVAL OF SANT'EFISIO IN CAGLIARI,
ALEXANDER NEVSKY CATHEDRAL IN SOFIA (*FROM LEFT*)

0 300 km

N

Faroe Islands (DK)

[65] Ålesund Trondh
NORWAY
Bergen Osl

Shetland
Islands (GB)

Rockall (GB) Outer Hebrides

Orkney
Islands Skagerrak

Isle of Skye Gothenbu

DENMARK

ATLANTIC [27] Aberdeen Aarhus [63]

Glasgow Edinburgh Copenhage

GREAT North Sea [64] Odense

Belfast Newcastle-
IRELAND upon-Tyne Sylt Rostock

Dublin Leeds NETHER- Hamburg
Liverpool LANDS Groningen [31] Bremen
[26] Cork [28] Manchester Alkmaar [32] GERMANY
BRITAIN Amsterdam Hildesheim [5]
OCEAN Birmingham Antwerp [34] Rhine Essen Magdeburg Halber
[30] Bath Bruges Ghent [33] Düsseldorf Weser Kassel [4]
Winchester London Lille [35] Maastricht Weimar
[29] BELGIUM [36] Malmedy [6] Zwick

English Channel Brussels [8]
Channel Islands [37] LUXEM- Luxem- Frankfurt
Le Havre BOURG burg [10]
Brest Seine [38] Reims Metz [40] Speyer Main Nuremberg
Paris Straßbourg [11] Ludwigsburg
[39] Angers Orléans Stuttgart [12]
Nantes Augsburg Munich
Loire Dijon [13] Basel
FRANCE Beaune [41] Vaduz LIECHTEN- [16]
[14] Bern STEIN Kufst
La Coruña Geneva Gruyères [44] Brixen
Gijón Bay of Lyon [42] [15] Lugano Bolzano
Vigo Biscay Bordeaux Milan Lake Garda Veni
[50] Garonne Genoa Po
Porto Bilbao Arles [43] Pisa [47]
Valladolid Duero Toulouse Nizza Livorno [46] Ur
[55] Coimbra Ebro Marseille Monaco [45] Florence
PORTUGAL SPAIN Zaragoza ANDORRA Corsica Elba Grosseto ITAL
[52] Andorra la Vella
Lisbon Cáceres Tajo Madrid Figueres [51] Rome
Guadiana Barcelona
Valencia Mallorca
Córdoba Menorca Sardinia Ponza Na
[56] Tavira Ibiza Palma
Seville [54] de Mallorca Tyrrhenian
Cádiz Málaga Murcia Baleariac Islands [48] Sea
Gibraltar [53] Cartagena Cagliari
Tangiers Ceuta Palermo
Tetouan MEDITERRANEAN SEA
Rabat Kénitra Melilla Algiers Tunis
Oran
Casablanca Meknès Fez Oujda Constantine MAL
MOROCCO ALGERIA TUNISIA

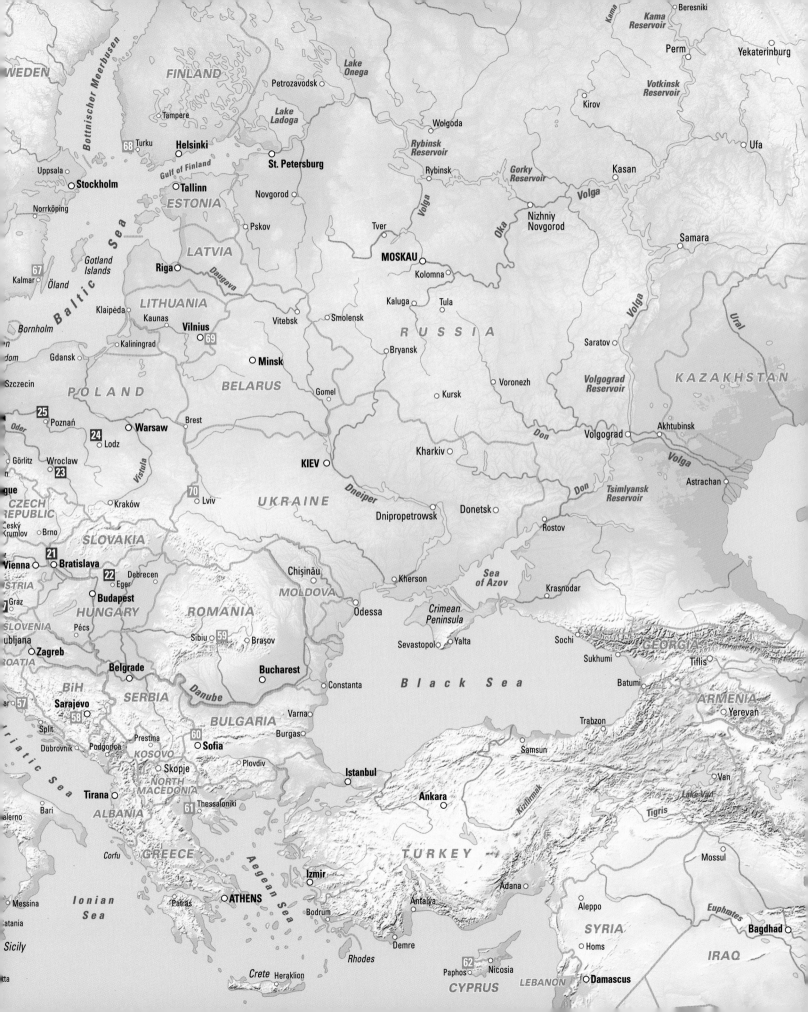

A SPECIAL PLACE

City air clears your mind. In the European Middle Ages, a city was a longed-for destination, because after a year and a day there, you were rid of all your unpleasant ties to your village and manorial lord. Life could start over again. The scents of the wide world—gathered together in markets, in cloth halls, in cathedrals, at the harbor, and in pubs—beckoned you to bargain, pray, and carouse.

Cities hold great promise. Today, old and young are still drawn to them. Suburbia was yesterday, and reurbanization is in. *Secret Cities of Europe* presents 70 special cities to you. They do not include either metropolises or picturesque towns that are constantly and regularly afflicted by tourists, but rather cities with an unmistakable character, some tranquil, many original, and all attractive. The 70 are well known, but a little off the beaten track, and people often drive right by them on their way along the highway to their vacation. Who has already made a stop in Kufstein, heard a Heldenorgel (hero's organ) concert, and taken the time to learn about a functional wineglass specific to each grape variety? Who has the Côte d'Azur in mind, has ventured into Lyon, the "belly of France"—and the third-largest city in France—and posed the really important questions of life at the Musée des Confluences science center? Who knows the palace of Israel Poznański in Łódź? Who knows that the "Silver City"

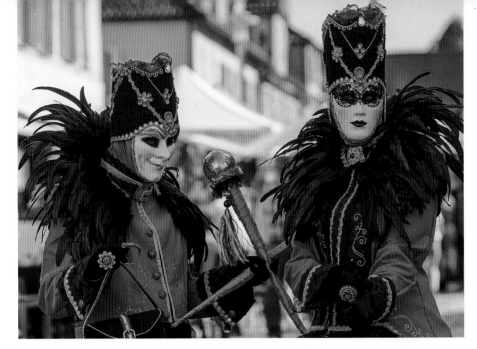

THE NEOBAROQUE OPERA HOUSE DATING FROM 1890 (TEATRO ARRIAGA) IN BILBAO (*OPPOSITE*). MASQUERADE FESTIVAL PARTICIPANTS DURING THE VENETIAN FAIR IN LUDWIGSBURG (*LEFT*). PINOT NOIR TASTES BEST IN BEAUNE, THE PLEASURE CENTER OF ITS HOME PROVINCE, BURGUNDY (*BELOW*).

isn't a ghost town in Kansas? Who has seen the baroque in Vilnius and art nouveau in Ålesund? Who finds peace in Sarajevo?

Europe has a distinctive urban culture that has its roots in antiquity. In the agora and the forum, citizens once came together to trade, exchange news, celebrate successful generals, or cheer on their political favorites. Rome, the first million-person metropolis on European soil, populated its empire with provincial towns, which were basically copies of the Eternal City on the Tiber. Many cities in Italy and France can look back on their ancient heritage, but cities in Spain, on the eastern side of the Adriatic, and on the Balkan Peninsula can also do the same. Northern and eastern Europe, as well as the once-Muslim-dominated Iberian Peninsula, have their own traditions that are no less proudly presented today. Some treasures from more than two millennia are only now being excavated (in Cartagena); others are presented confidently (in Halberstadt). Some city jewels are only just being dusted off (in Sibiu). Gray industrial cities are reinventing themselves and can now easily compete with the metropolises in terms of art and culture. Bilbao and Liverpool are particularly successful in this, and Linz and Essen are following suit. Much of what was once hailed as progress and gave people work, then turned to rust and was in danger of being forgotten, is being "repurposed" and given a new, chic guise. One city almost certainly would have disappeared had an Austrian grand duke not energetically lent it a hand. In a

very few places, everything has remained as it once was (found to be good): in Coimbra, the university continues to take pride of place; the baths continue in Bath; and cheese is still carried on sledges in Alkmaar. *Secret Cities* has looked around in Europe—from Sardinia to Norway, from Portugal to Lithuania, from England to Greece—and has struck it rich 70 times. Join us on a journey through 28 countries and find your pearl. By the way, one of them was worthy of six pages, because it really has many, many stories to tell. The name begins with "O" (Greek) or "S" (Latin), depending on which story you tell.

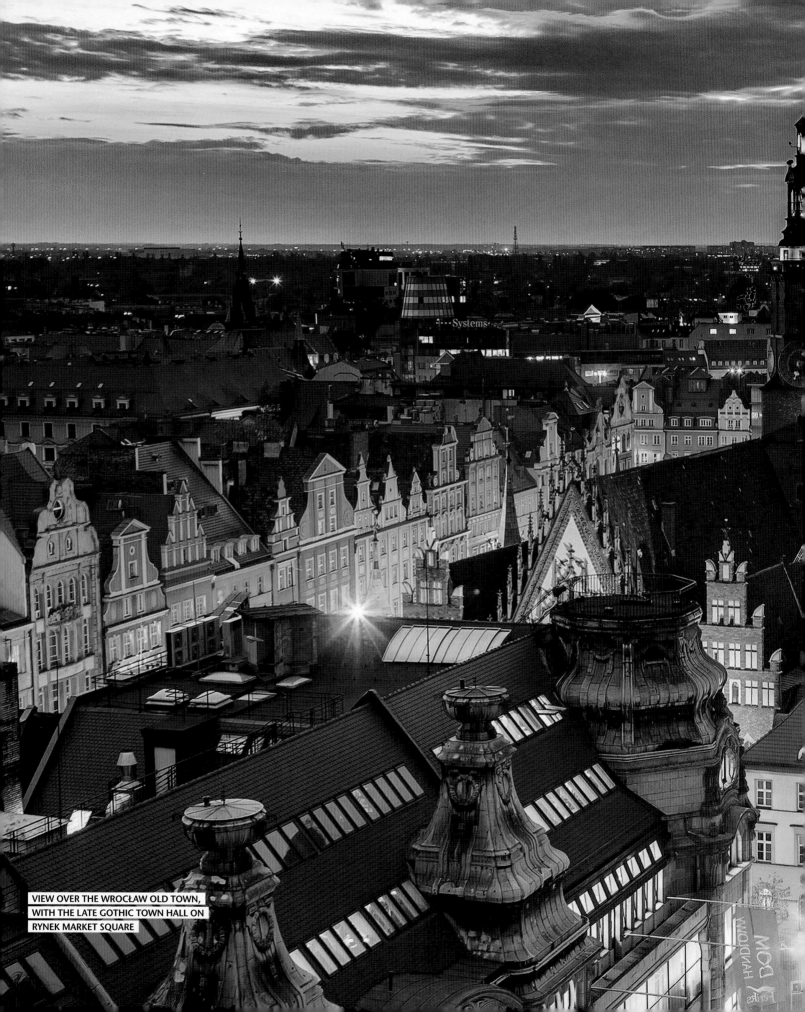

VIEW OVER THE WROCŁAW OLD TOWN,
WITH THE LATE GOTHIC TOWN HALL ON
RYNEK MARKET SQUARE

CENTRAL EUROPE

Emperors, Princes, Industrial Palaces

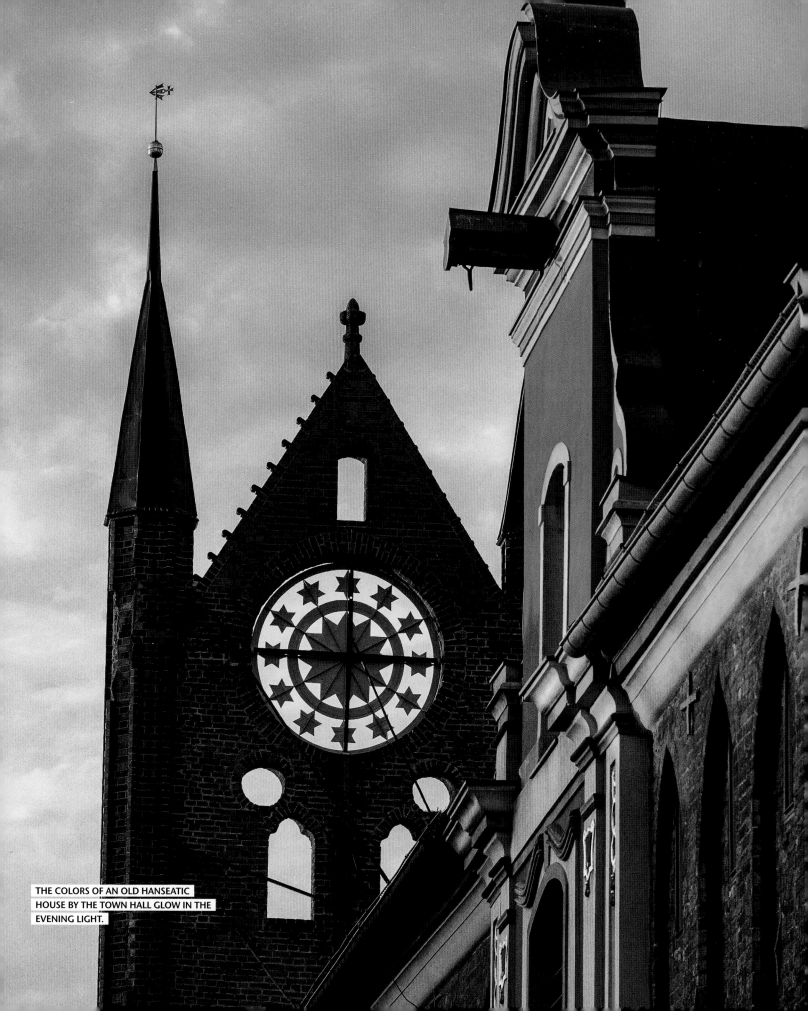

THE COLORS OF AN OLD HANSEATIC
HOUSE BY THE TOWN HALL GLOW IN THE
EVENING LIGHT.

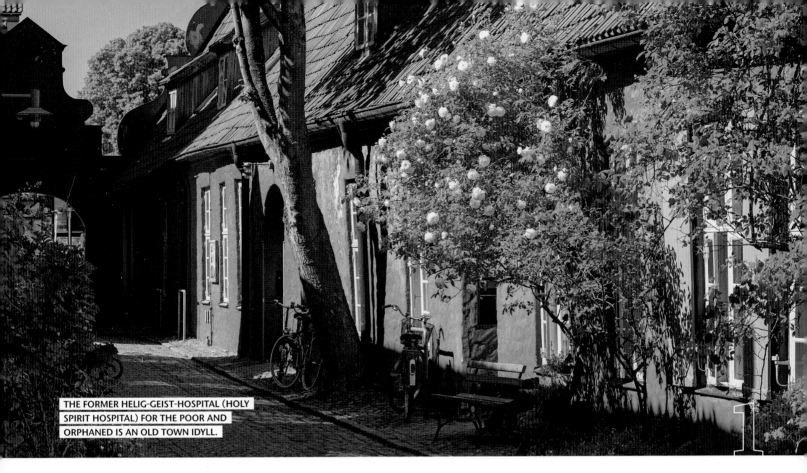

THE FORMER HELIG-GEIST-HOSPITAL (HOLY SPIRIT HOSPITAL) FOR THE POOR AND ORPHANED IS AN OLD TOWN IDYLL.

PROSPERITY BEHIND BRICKS

The mighty towers of the Gothic churches rise like lighthouses from the sea of houses in this Hanseatic city on the Baltic Sea. Cobblestone streets lead to the old and new markets. The town hall with its striking brick facade is a Stralsund landmark. The brick glows red, a contrast to the sky and the sea.

GERMANY

Like a natural weir, the Strelasund lagoon lies between the mainland and the island of Rügen. This Baltic Sea inlet gave Stralsund its name—and brought it wealth. As a natural "trap," it drives the fish toward the Stralsunders and offers space for a protected harbor. In the Middle Ages, the city achieved a prestigious rise as an important member of the Wendish Quartier of the Hanseatic League. The Old Town streets lead back to the past of the merchant and city associations. To the right and left stand gabled houses from different eras. The Wulfamhaus on the Old Market, with its imposing pillar gable, is one of the best-preserved buildings in the north German Gothic style.

A few streets away, the Dielenhaus (Hallway House) and the Museumshaus (Museum House) open the doors to their large foyers for visitors. They invite you into the Hanseatic era. Even the wooden hoist to the upper floors is still working.

STONY ISLAND

Stralsund is a fortified island, surrounded by the Strelasund lagoon, three large ponds, and a partly preserved, partly rebuilt city wall. The Knieperteich, Frankenteich, and Moorteich ponds form a natural barrier and were a strategic advantage for the impregnable fortress. The city wall, with its *Wiekhäuser* (guardhouses) filling the gaps, once had 11 city gates. Two of them, the landside Kniepertor and the Kütertor, still admit you to the city today.

PERFECT BRICK GOTHIC STYLE

In the Alter Markt (Old Market), your glance gazes upward and the sky shines through the openings of the display facade of the town hall. Together with the St.-Nikolai-Kirche (St. Nicholas Church), this is an impressive ensemble of north German Brick Gothic. In the 13th century, construction began on the town hall. From the very beginning, the four-wing multipurpose building was the economic and political center of the city. Citizens meet on the upper floor to this day. Downstairs, goods were traded in more than 40 stalls, and cloth and other valuable goods were stored in the largest medieval vaulted cellar in Europe. In the passage arcade of the town hall, the bust of Gustav II Adolf commemorates the Swedish king's stay in Stralsund and the beginning of the time when Stralsund belonged to Sweden: from the Thirty Years' War until 1815. The garrison commander resided diagonally opposite in the commandant's residence.

Right next to the town hall is the oldest of the three Gothic churches, the St.-Nikolai-Kirche, first mentioned in 1267. It is dedicated to the patron saint of seafarers and merchants, the most-important employers in the medieval city. The interior of the three-nave basilica with cross-ribbed vaulting gleams in restored color. Despite the loss of many furnishings during the Reformation iconoclasm of 1525, important sacred objects were preserved. One of the oldest is the approximately 6-foot-high figure group of the Virgin and Child with St. Anne, which was first mentioned in 1307. The triumphal cross, over 600 years old, has been given a new place in the southern choir; the high altar, which probably dates from the 15th century, has also been restored. The pews of the Riga merchants, the pews of the Russian merchants, and the altar of the Bergen merchants tell of the far-reaching connections of the Hanseatic people across the Baltic Sea. The exterior of St. Nikolai is dominated by two mighty towers. After a fire in 1662, the south tower was given a baroque dome, while the north tower made do with a simple tent roof.

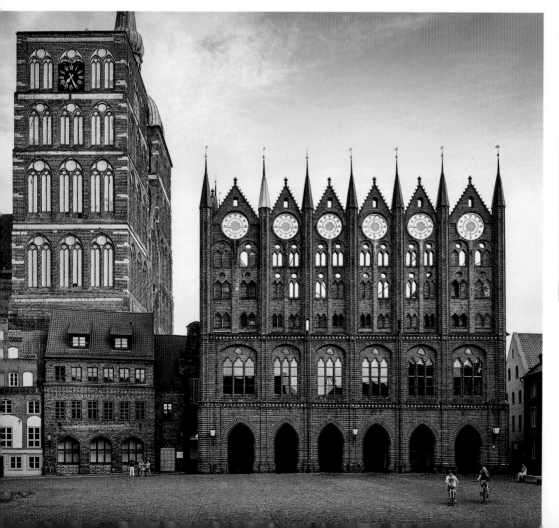

THE IMPOSING TOWN HALL STANDS NEXT TO THE ST. NICHOLAS CHURCH (*LEFT*).
"AHOY": STRALSUND IS A GOOD PORT FOR A SAILING TOUR (*ABOVE*).

SUPERLATIVE OF THE HANSEATIC PERIOD

The second large Brick Gothic basilica stands by the Neuer Markt (New Market): St. Marien, first mentioned in 1298, is a masterpiece of late Brick Gothic. Its tower (1549), also a navigation mark, was the tallest building in the world for 150 years: 495 feet high, until lightning struck it in 1647. From the remaining 340 feet there is now a broad view over the city and the sea. Only a few of its furnishings are preserved on the church premises. The world-famous organ by Friedrich Stellwagen (1659) stands behind an imposing early baroque organ facade. The Jakobikirche (St. James's Church), the ruins of the Johanniskloster (St. John's Cloister), and the Katharinenkloster (St. Catherine's Cloister), which has been converted into a maritime museum, complete the medieval impression but also show the wounds caused by the bombings of World War II.

THREE VIEWS OF THE SEA

For anyone who wants to know more about the sea, there are three places to go. The Maritime Museum, the former Katharinenkloster, focuses on the Mediterranean and tropical waters, including sharks and turtles. Information is also provided about the deep sea and how people use the seas. The Nautineum on the island of Dänholm, before the Old Town, features an exhibition about fishing and securing sea routes. However, the crowd-pleaser is the Ozeaneum by the harbor, with its curved metal facade. Special attractions in this futuristic building include the models of whales and the aquariums with flora and fauna from the North Sea and Baltic Sea and the North Atlantic. You can try out the fresh Baltic Sea itself at the Stralsund beach along the Sundpromenade.

BISMARCK HERRING AND MEGA-YACHTS

Do you prefer your fish on a roll? That is how Bismarck herring comes. This special way of preparation is said to have been named after Chancellor Otto von Bismarck in Stralsund in 1871. Would you like a beer? Since 1827, the Störtebecker brewery has been brewing several excellent beers, and there are daily tours through the brewery. Nearby are the buildings of the MV Shipyard, where 600 employees are once again working following the difficult years after the German reunification. They build "ice class" mega-yachts. The tradition of the proud Hanseatic city of Stralsund lives on.

HIDDENSEE

The actress Asta Nielsen described this island as an oasis by the Baltic Sea, and the playwright Gerhart Hauptmann called it a place of seclusion from the world. The trip across the Bodden takes 1.5–2 hours from the ferry dock in Stralsund. Hiddensee, a car-free part of the Vorpommersche Boddenlandschaft National Park, is a paradise for nature lovers. The beaches, reed beds, dune heath, and pioneer vegetation on the new land formations create refuges for plants and animals. In spring and autumn, the cranes offer a graceful and, at the same time, loud spectacle. The hook-shaped island is a place of well-being. Prominent persons, besides Hauptmann and Nielsen, such as Oskar Kruse and Albert Einstein, liked to visit the *söte Länneken* (sweet little land). The light from the Dornbusch beacon flashes over the dunes from almost 28 miles away across the open Baltic Sea.

MORE INFORMATION
Stralsund
www.hansestadt-stralsund.de
Maritime Museum
www.deutsches-meeresmuseum.de/en
Hiddensee
www.seebad-hiddensee.de

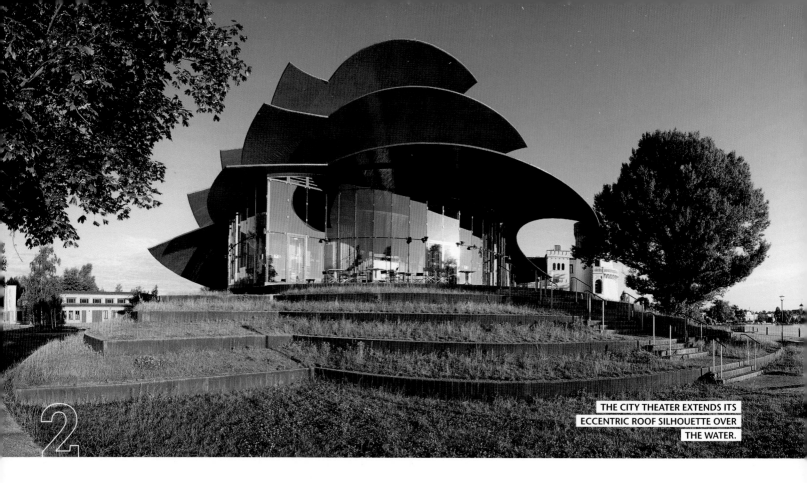

2

GERMANY

A PLEASANT TRIP THROUGH THE COUNTRYSIDE TO THE WATER

A visit to Potsdam in Brandenburg is like a trip through Europe: the world-famous Sanssouci Palace, a Dutch quarter, the Alexandrovka Russian colony, a waterworks in the style of a Turkish mosque, obelisks as if from Egypt, an Italian village, a French church, and Roman baths.

In addition to the castles and the historic city center, spacious landscaped gardens and the extensive Havelsee lakes shape the image of the city, which is a UNESCO World Heritage Site. In 1660, the Great Elector Friedrich Wilhelm declared the town of Havel, first mentioned in 993, to be his residence. He issued the Edict of Tolerance of Potsdam, inviting the Protestant Huguenots who were being persecuted in France. The 20,000 newcomers brought their experience in the agriculture and architecture of their homeland along with them. The golden age of this royal residence city had begun. Potsdam has been the state capital of Brandenburg since 1990 and, in comparison with its 15 sister German state capitals, offers the most hours of sunshine, the second-highest rate of academics, the fastest internet, and the highest values for nature and leisure.

SEVENTEEN CASTLES IN THE COUNTRYSIDE

The city on the Havel River nestles around the largest park and garden landscape in Germany. Scattered like pearls, its 17 castles, palaces, and stately buildings lie amid the greenery of the grounds. Their most famous garden architect was Joseph Peter Lenné. The world-famous Sanssouci Palace stands in a vineyard, the fountain bubbles in the valley, and, to the right and left, cherries are

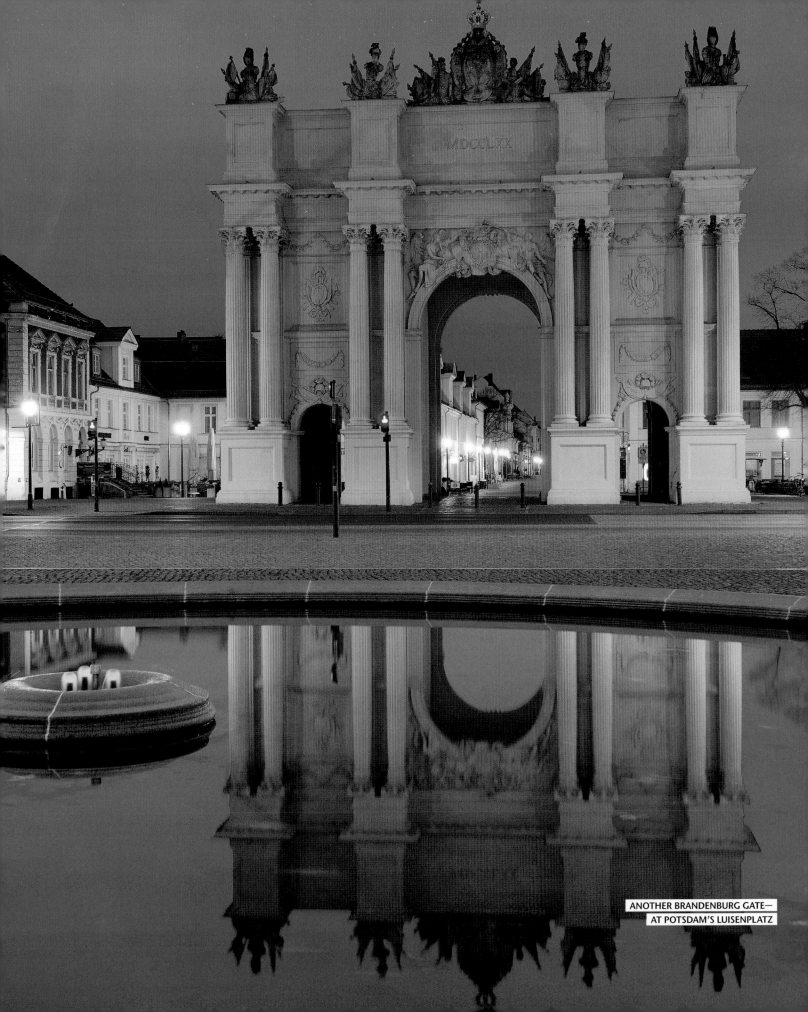

ANOTHER BRANDENBURG GATE—
AT POTSDAM'S LUISENPLATZ

growing. Friedrich II had his pleasure house built with the support of Georg Wenzeslaus von Knobelsdorff and called it Sanssouci—"carefree." While the rococo castle was still in the planning stage, the aged Fritz had already requested that the vault for his grave would be dug next door. Potsdam's castles are as diverse as the passage of time. The Prahlerei (bravado) stands in the Great Garden. This is what Friedrich II called the Neue Palais (New Palace), with its 970 rooms, which was built after the Seven Years' War. Later, it became the preferred residence of the last German emperor, with a tennis court and electric lighting, before he went into exile in Holland, taking 90 railroad cars fully packed with luggage along.

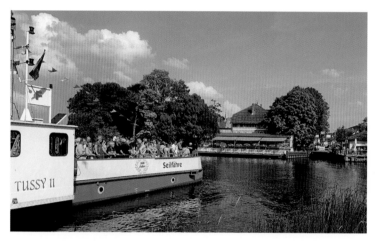

LAKE SCHWIELOWSEE

The Schwielowsee lake region combines the beauty of natural Brandenburg with many gems. In Ferch, a baptismal angel hangs from the cloud-painted ceiling of the Fischerkirche (Fisherman's Church); it might once have been the figurehead of a ship. Works from the painters' colony are exhibited in one of the oldest village houses, and since 1996 a bonsai garden has flourished on the edge of the village. A hunting lodge stands in Caputh; its state room was decorated with over 7,500 Dutch-style tiles. The ferry, *Tussy II* (Drama Queen II), departs from the lakeshore. Albert Einstein invited his son to his summer house: "Come to Caputh; let the world take care of itself." On the other shore in Petzow, there is a picturesque ensemble of church, castle, manor, and park designed by Karl Friedrich Schinkel in 1825. A bicycle path leads around the lake, past water sports facilities, rental houseboats, and idyllic places to visit.

MORE INFORMATION
Potsdam
https://en.potsdam.de
www.brandenburg-tourism.com/holiday-region/potsdam
Lake Schweilowsee
www.schwielowsee.de

A jewel of classicism is not far away, behind the premises of the Hippodrome. The Charlottenhof Palace was designed by Karl Friedrich Schinkel in delicate shades of white and blue for the Bavarian princess Elisabeth Ludovika. Above the Maulbeerallee (Mulberry Avenue), steep steps lead to the Dragon House, with its Chinese-style gargoyles, and the belvedere rises on the Klausberg hill, through the avenue of trees. Nearby is the orangery, which creates the effect of a stage backdrop in neo-Renaissance style. With its lavish design and presentation of citrus fruits, it brought an Italian flair to Prussia. Below lies the Bornstedt royal estate, designed as an "Italian village" and painted pale pink and light yellow. For centuries, Potsdam was the most important residential city for the German Hohenzollern dynasty. There is a second orangery in Park Sanssouci, a second, newly renovated belvedere on the Pfingstberg hill, and a second large garden, the New Garden by the Heiligen See (Holy Lake). The early classicist marble palace stands on a terrace directly at the shore. This gem by architect Carl von Gontard is clad in Silesian marble in various color shades and offers an idyllic view of the lines of sight in the design of the garden and over the lake. A footpath leads past the icehouse to the last castle of the Hohenzollerns. With a view of the Havel River, the Cecilienhof Palace was built in English country-house style during World War I. At the end of World War II, the Potsdam Allied Conference took place here. An exhibition in the historical castle rooms explains the events of that time.

FORBIDDEN CITY, LATE ROCOCO HOUSES— AND NOT A PALACE

The former "forbidden city" next to the New Garden shows the dark consequences of the division of Germany. The Soviet military confiscated the villa quarter to set up the KGB's German headquarters. This Soviet counterintelligence agency was the most important intelligence outpost at this interface with the West. The KGB prison from back then is now part of an exhibit, with a history trail leading to it.

The largest Dutch quarter outside the Netherlands is located in the city center. These 134 red-brick houses dating from the 18th century create the ambience for small shops and restaurants. Once a year, it is the setting for a big tulip festival. At the end the inner city's main street is the

Brandenburg Gate, full of pride that it is a few years older than its famous Berlin namesake. Soldiers' barracks were housed in the attics of the simple late rococo houses in the baroque city center—in this garrison town, which had been expanding since 1713, the Hohenzollerns thought in practical terms. The Alter Markt (Old Market) was the nucleus of the city. The old castle, converted into a city palace, collapsed along with the center city in the hail of bombs on April 14, 1945. The reconstruction, opened in 2014, houses the Brandenburg State Parliament behind historical fronts. *Ceci n'est pas un château* (This is not a palace) is written self-ironically in gold letters on the facade. The Nikolaikirche (St. Nicholas Church), with its classicist simplicity, offers a beautiful panoramic view of the city center when you ascend the tower. The latest crowd-pleaser is the Barberini Museum, located in the palace of the same name, which has also been reconstructed.

SCIENCE AND ILLUSIONS ON THE WATER

The highlights include the Telegrafenberg with the Albert Einstein Science Park, 308 feet above sea level. The first optical telegraph station, dating from 1832, recalls the beginnings of communication technology. The Great Refractor of 1899 was once the refracting telescope with the longest range in the world; it is in the observatory specially built for astrophysics. In 1920 Albert Einstein and Erich Mendelsohn planned a new observatory in the revolutionary Einstein Tower, with a tower telescope for observing the sun. This was intended to prove the theory of relativity. The neighboring Institute for Climate Impact Research displays highly topical works and exhibitions. In the Babelsberg film studios, nothing is about reality, but rather everything is about fiction. The first silent movie was shot there in 1912. Since then, the studios have developed into the largest film studio in Europe, with productions such as *Babylon Berlin*. Potsdam is a city on the water. The Havel River is divided into the Jungfernsee (Maiden Lake), the Tiefen See (Deep Lake), the Genthiner See, the Zernsee, and the Alte Fahrt and Neue Fahrt (Old and New Passages). There is always a body of water close by, and there are plenty of possibilities for water sports, boat trips, or swimming. A supermarket with its own boat-landing stage and restaurants along the waterfront paths invite you to enjoy the "Potsdamer," a beer with raspberry lemonade.

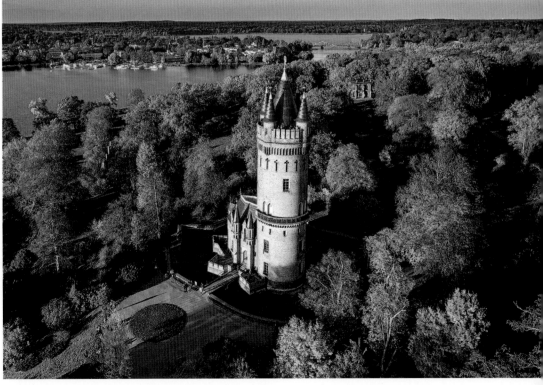

THE FIGURES IN THE CHINESE HOUSE IN THE SANSSOUCI PARK INVITE YOU TO ENJOY YOUR TEA (*ABOVE*). **VIEW OVER THE FLATOW TOWER, WITH THE HAVEL IN THE BACKGROUND** (*RIGHT*)

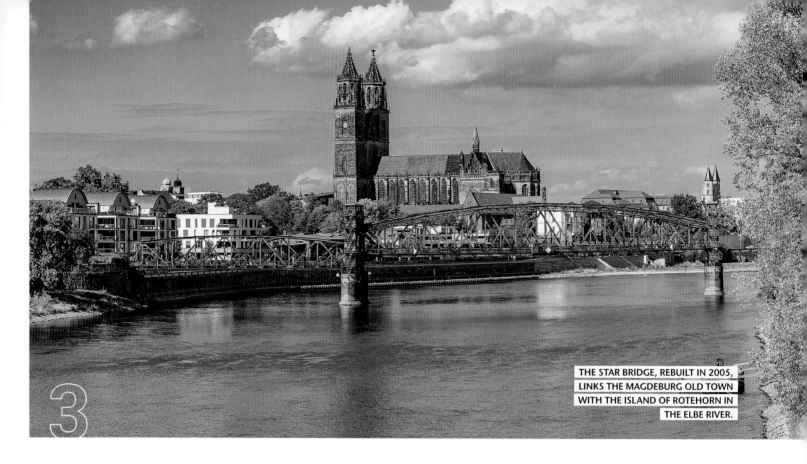

THE STAR BRIDGE, REBUILT IN 2005, LINKS THE MAGDEBURG OLD TOWN WITH THE ISLAND OF ROTEHORN IN THE ELBE RIVER.

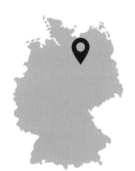

GERMANY

MODERN "OTTO CITY"

The state capital of Saxony-Anhalt has been nicknamed "Ottostadt" (Otto City) since 2010. This is because more than a thousand years ago, Emperor Otto the Great made Magdeburg a city with charisma as well as an important trading base. During the 17th century, the mayor and scientist Otto von Guericke was an inspiration for the city.

From its dominant position, the Dom St. Mauritius und Katharina (Saints Mauritius and Catherine Cathedral), built on Cathedral Rock, rises above the old town. The cathedral, built over its Otto-era predecessor, is the first Gothic church building in Germany. The rich interior decoration includes the 10 sculptures of the wise and foolish virgins, canon choir stalls, and an alabaster pulpit. The cathedral, some houses on the large Domplatz (Cathedral Square), and the Kloster Unserer Lieben Frauen (Convent of Our Lady) were the only buildings that were spared from the total destruction of the city by the Holy Roman Empire troops under Counts Tilly and Pappenheim during the Thirty Years' War. The subsequent gruesome massacre, which killed some 20,000 Magdeburg citizens, was recorded in history as the "Magdeburg Wedding." This once-rich Protestant stronghold at the edge of the fertile Magdeburg Börde region sank into insignificance for some time.

IN THE FORTRESS

The fortress walls, which had existed since the 13th century, were unable to protect the city from the devastation. Reconstruction started in 1702, and the city grew to become the strongest fortress of young Prussia. Many older remnants have been preserved and enrich the cityscape—the city wall tower Kiek in de Köken from the Middle Ages, the Bastion Cleve from Prussian times, and several "Rayon" Tudor-style houses from the 19th century. An approximately one-and-a-half-hour city tour takes you through the, at times, elaborately restored fortress buildings. The Grüne Zitadelle

IN 2000, THE COPY OF THE MAGDEBURG RIDER, CREATED IN 1966 IN THE ALTER MARKT, WAS GILDED. THE STATUE OF THE RIDER, FIRST FASHIONED AROUND 1240, MAY REPRESENT EMPEROR OTTO I.

(Green Citadel) is not among them—this bizarre, colorful building complex is the last object designed by artist Friedensreich Hundertwasser. There are important sights located within the Old Town fortress and in the old New Town. Around 1063, the Romanesque Kloster Unserer Lieben Frauen (Convent of Our Lady) was built in the immediate vicinity of the cathedral. Today the building complex is used as a museum and concert hall. After the destruction during the Thirty Years' War and World War II, little remained of the merchants' houses on the Alter Markt (Old Market). After 1950, the old town hall and new town hall were rebuilt. A copy of the Magdeburg Rider statue, dating from the 13th century, stands in the Marktplatz (Market Square) under a baroque canopy. On the occasion of the centenary of the Bauhaus style in 2019, the city paid tribute to its numerous buildings from that period under the motto "Magdeburg Modernism." They include the town hall from 1927 (designed in a cubic shape), the war memorial by Ernst Barlach in the cathedral, the Pferdetor (Horse Gate) in Rotehorn Park, and the colorful Otto Richter Straße, inspired by city councilor Bruno Taut.

CITY OF THE LEANING TOWERS

The outstanding Bauhaus buildings include the 195-foot-high Albinmüller Tower in Rotehorn Park, Magdeburg's green lung on an island in the Elbe. Albin Müller also created style-defining buildings in the Mathildenhöhe artists' colony in Darmstadt. The glass tower top is the eye-catcher of the lookout tower. The leaning tower in Hundertwasser's Grüne Zitadelle also attracts the eye, as does the Millennium Tower in the Elbauen Park, erected on the occasion of the Federal Garden Show in 1999. At 195 feet, it is one of the tallest wooden buildings in the world and shows the scientific achievements of mankind. The Otto von Guericke Museum is located in the Lukasklause, a late Gothic defense tower.

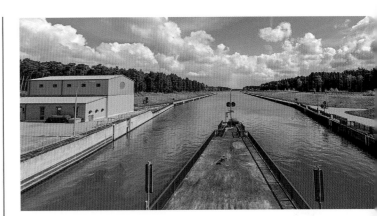

MAGDEBURG WATER BRIDGE

The Water Bridge near Hohenwarthe, north of Magdeburg, is considered a technical masterpiece. Here the Mittelland Canal crosses over the Elbe River. Its beginnings go back to the early 20th century. The Rothensee boat lift was built in 1938 to bridge over the 52-foot difference in level between the Mittelland Canal and the Rothenseer connecting canal. Since 2006, the Rothensee lock has replaced the ship's hoist, now a technical monument. The highlight is the canal bridge, constructed in the trough bridge design. Boat trips on the water bridge are very popular. The structure is part of the German Unity No. 17 transport project to create a waterway connection between the Dortmund-Ems Canal and Berlin.

MORE INFORMATION
Sights
www.magdeburgtourist.de
Water Bridge
www.wasserstrassenkreuz-magdeburg.info

The exhibit is dedicated to Guericke's life and work and shows functional replicas of his experimental equipment. A sculpture of the famous Magdeburg hemisphere experiment was inaugurated in 2005 at the Ratswaageplatz. Guericke proved the effect of air pressure in this experiment. Chocolates in the shape of hemispheres are a popular souvenir.

GERMANY

LASTING TONES, PRECIOUS PIECES, AND SAUSAGES IN GLASS

The church towers' silhouette makes an impression and tells of the 1,200-year history of the city. Halberstadt lies on the northern foothills of the Harz Mountains, at the edge of the Huy range. It developed into a rich city in the Middle Ages under the imperial Ottonian dynasty. The cathedral treasure is its greatest jewel.

Until April 8, 1945, Halberstadt was one of the most beautiful half-timbered cities in Germany. On that day, American bombs turned the center into a fiery hell. The target of the attack was the center of the old garrison town and the branch Junkers aircraft factory. On April 11, Americans occupied the city, on May 18 it was handed over to the British and, in late June 1945, to the Soviets. The city was 82 percent destroyed. In the postwar period, prefabricated buildings were erected due to the lack of housing, and wide trusses were forced through the rubble. Many of the old half-timbered houses that had survived the war fell into disrepair. Entire streets were cordoned off for safety, and the ramshackle houses were eventually torn down. Yet, the church towers of the cathedral always rose proudly out of the sea of houses and, opposite it, stood the Liebfrauenkirche (Church of Our Lady), the Romanesque basilica, is the only one in central and northern Germany with four towers.

LUSTER AND TONE: CHURCHES AND THEIR TREASURES

The cathedral, begun in 1236 and consecrated in 1491, is a consistent application of French Cathedral Gothic. The Halberstadt Cathedral master builders followed the great example in Reims, with an open buttress and side aisles as a way of dealing with the polygonal choir. One of the world's largest medieval collections of sacred art awaits visitors in the cathedral treasury.

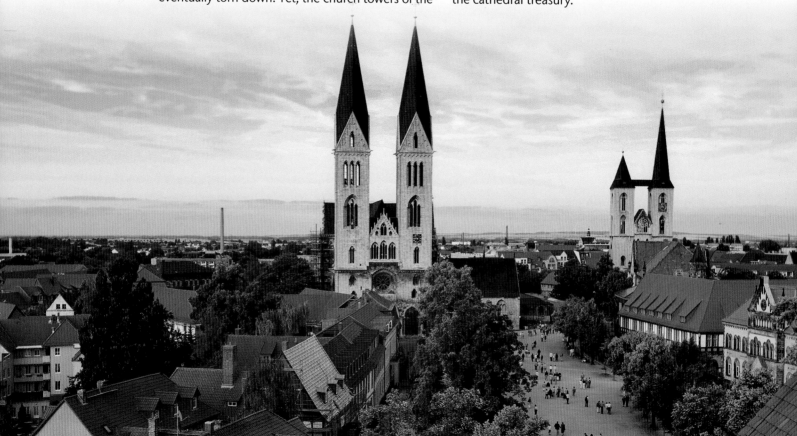

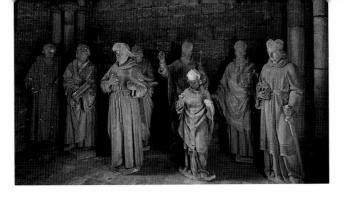

VIEW OVER ROOFS AND CHURCH TOWERS (*CENTER,* THE CATHEDRAL; *RIGHT,* ST. MARTINI), AS FAR AWAY AS THE EDGE OF THE HARZ MOUNTAINS (*OPPOSITE*) STONE LISTENERS IN THE CATHEDRAL TREASURY (*LEFT*) AN OLD TOWN IDYLL (*BELOW*)

Some 300 out of a total of 650 are there to be admired, and not just behind show cabinets. The Abraham Engel carpet from 1150 is one of the most famous. The oldest exhibit is a consular diptych in the form of a foldout writing tablet from Ravenna and dating from 416. Not only the churches on the Domplatz (Cathedral Square), but also their nine Romanesque and Gothic sisters, were rebuilt or restored: St. Martini, with its two towers of different heights, always belonged to the citizens, never to the clergy. St. Johannis Kirche (St. John's Church) is the largest half-timbered church in Germany. St. Burchardi is the destination for those seeking mindfulness: this is where John Cage's work for organ, "As Slow as Possible," can be heard. The last note of the composition will fade away in the year 2640.

CLARIFICATIONS AND OTHER INSIGHTS

On the north side of the Domplatz, the city museum in the former baroque residence of the Baron von Spiegel invites you to visit. Right nearby is the Gleim House, a "cultural memory site of special national significance." One of the oldest literary museums in Germany has been housed in the former home of the poet, collector, and gifted networker Johann Wilhelm Ludwig Gleim since 1862. Gleim's friend Johann Wolfgang von Goethe was already enthusiastic about the collection, now called the "Museum der deutschen Aufklärung" (Museum of the German Enlightenment).

In addition to a Plateosaurus and a Plesiosaurus, an outstanding ornithological collection awaits visitors in the Heineanum Museum. The Berend Lehmann Museum of the Moses Mendelssohn Academy is a testimonial to Jewish life in Halberstadt. The heart of the museum is the partially preserved mikveh and the Klaus Synagogue.

Biting into a crisp "Halberstädter" helps if you are a bit hungry between meals. In 1896, they first preserved these scalded sausages in glass jars in Halberstadt. Unfortunately, the giant wine barrel in the hunting lodge is empty.

ELBINGERODE DEACONESS MOTHER HOUSE

Undamaged, maintained at the highest level, still being used as originally intended, and little known, the Diakonissenmutterhaus (Deaconess Mother House) on the outskirts of Elbingerode is one of the outstanding examples of Bauhaus architecture. In 1932, it was built according to plans by the architect Godehard Schwethelm as an extension to an existing facility. Schwethelm was trained in contemporary modernism, and his ideas were also realized in many fittings and fixtures such as door handles and cooking stoves. The indoor pool, which is still in operation directly under the church nave, is spectacular. The separate entrance is decorated with fish. People pray above and swim below. Here "Bauhaus" is not a museum, but part of everyday life. An integrated thermal power station warms the tomato plants and the swimming pool. The latter is open to the public and provides a stylish experience.

MORE INFORMATION
The Cathedral treasure
www.dom-schatz-halberstadt.de/en
Gleimhaus, Museum der deutschen Aufklärung (Museum of the German Enlightenment)
www.gleimhaus.de
Elbingerode
www.mutterhaus-elbingerode.de

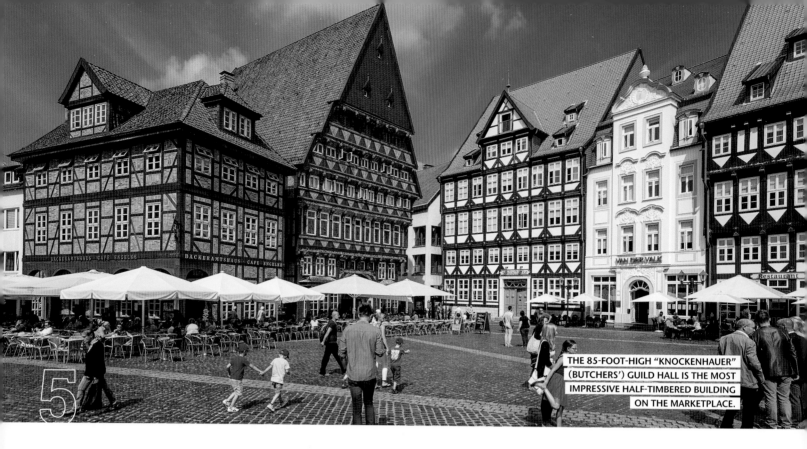

THE 85-FOOT-HIGH "KNOCKENHAUER" (BUTCHERS') GUILD HALL IS THE MOST IMPRESSIVE HALF-TIMBERED BUILDING ON THE MARKETPLACE.

GERMANY

ON THE ROSENWEG—ROSE ROUTE— TO ART

The cityscape of 1,200-year-old Hildesheim is close to miraculous because of its Romanesque houses of worship, the Mariendom (St. Mary's Cathedral) with its art treasures and the Michaeliskirche (St. Michael's Church), and, last but not least, because of the reconstruction of the Old Town, which was reduced to rubble and ashes by bombing raids in February and March 1945.

A miracle also inspired the building of the Mariendom (9th century, just freshly restored): according to a legend, Emperor Louis the Pious had a chapel built to the Virgin Mary out of gratitude for his deliverance after a failed hunting expedition and in 815 elevated the merchant settlement at the ford of Hellweg, an important east–west connection, to the status of an episcopal seat. It was there, where Ludwig received the help of the "Mother of God," that the now "thousand-year-old" wild rose bush grew. Hildesheim's emblem also survived the inferno of World War II and is still blooming today on the apse of the cathedral. Hildesheim flourished as a city under Bernward, bishop from 993 to 1022. He had the Michaeliskirche, a double-choir basilica with mighty crossing towers

and a painted wooden ceiling (13th century), constructed, and he created a unique work of art in a 15-foot-high bronze portal: the two wings of the Bernward door at the cathedral are decorated with 16 detailed reliefs, which bring scenes from the New Testament to life in an almost modern look.

SOLID OAK AND LIGHT, 1950S

Hildesheim is also famous for its five centuries of historical civic, patrician, guild, and craft houses. The Knochenhauer-Amtshaus (district building) is one of the most beautiful half-timbered buildings in Germany. It was formerly the butchers' guild hall on the Marktplatz (Market Square), featuring lavish carvings and decor; this 85-foot-high, half-timbered jewel overlooks the late Gothic town hall

HILDESHEIM'S OLDEST ORIGINAL BUILDINGS ARE STILL STANDING IN THE KEHRWIDERTURM (RECURRENCE TOWER) QUARTER.

(13th–15th centuries). In contrast to the neighboring houses, on this building not only the facade (except for on the Tempelherrenhaus [Knight's Templar House], 1457) but the entire building itself was reconstructed (continued until 1990). A film presented by the Stadtmuseum (City Museum) on the upper floors shows the impressive reconstruction. Original idea: taking a ride through Hildesheim on an old tram as a "road movie." The New Town in the quarter around Gelben Stern, Keßlerstrasse, and Goschenstrasse (streets) offers even more half-timbered houses—in original form. If you can't decide where to go first—the Rose Route leads to the most-important sights. What is attracting more and more attention, not only among monument conservationists, is the city's postwar development. Entire streets lined with two-story houses painted lime green and soft pink exude the charm of the 1950s. You can admire all the beauties from the Andreaskirche (St. Andrew's Church) tower—at 377 feet, the tallest in Lower Saxony.

YOUNG CITY, OLD WORLD

Under the umbrella of an awe-inspiring history, Hildesheim presents itself as a young city where the students of the growing university have left their mark. Quaint pubs, cozy cafés, lively restaurants, and snug bookstores bear witness to this. Every year in September, the streets and alleyways of the city center are transformed into a stage for street musicians and street artists in the *Pfasterzauber* (Magic on the Cobblestones) festival. The Roemer-Pelizaeus Museum, a cultural and historical collection of European-level rank, takes you to ancient Egypt, ancient Peru, and East Asia. Chinese dragons grin from fine porcelain, and a friendly terra-cotta warrior shows visitors the way.

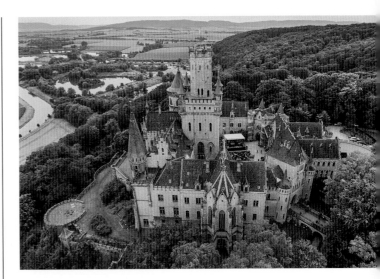

SCHLOSS MARIENBURG

Georg V, king of Hanover, had his own version of the Bavarian Neuschwanstein palace built within sight of the Hildesheim church towers, on the Schulenburger Berg above the Leine River. However, this was not for a retreat but an impressive gift for his wife, Marie, after his accession to the throne in 1857. She took over the design—her husband was blind—and built her summer residence, Marienburg Castle, as a Neo-Gothic dream with 144 rooms, a modern castle kitchen, and underfloor heating. The interior decor is almost completely preserved. Although the queen was hardly able to enjoy her gem, because she had to follow her husband into exile in 1867—after the German war of 1866, Hanover fell to Prussia—today the Guelphs open their doors to ordinary citizens in a romantic or festive mood.

MORE INFORMATION
World Heritage Visitor Center
www.hildesheim.de/tourismus
Roemer-Pelizaeus-Museum
www.rpmuseum.de
Marienburg Castle
www.schloss-marienburg.de

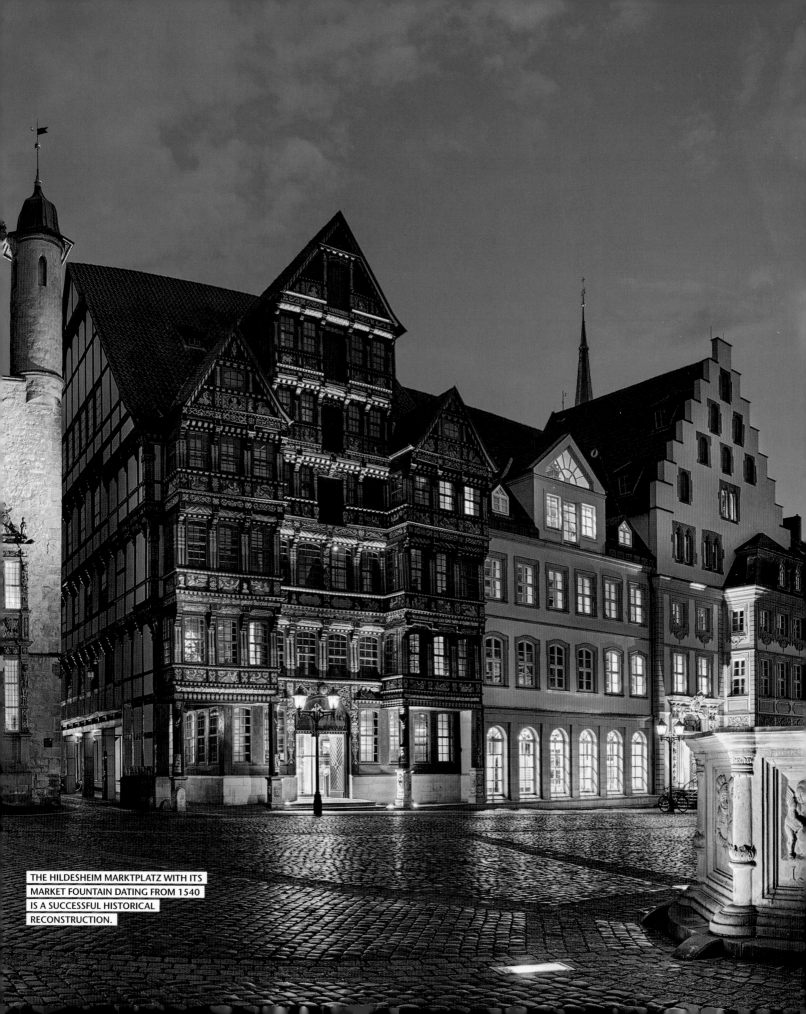

THE HILDESHEIM MARKTPLATZ WITH ITS
MARKET FOUNTAIN DATING FROM 1540
IS A SUCCESSFUL HISTORICAL
RECONSTRUCTION.

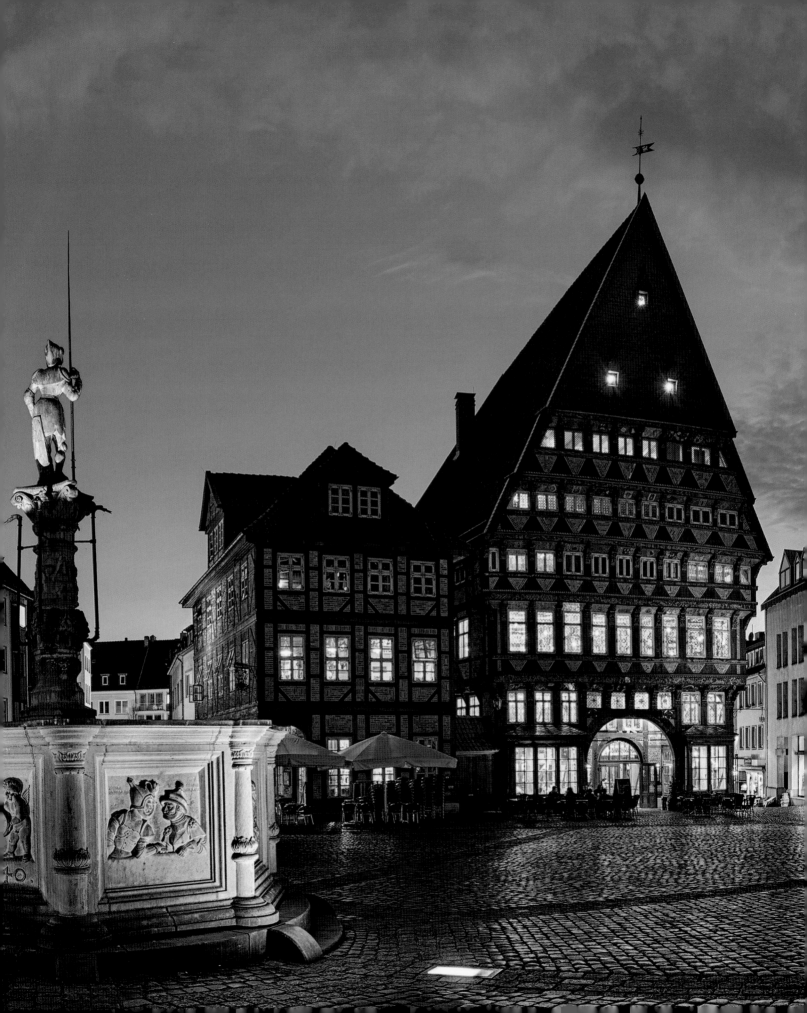

THE "PICKAX" ON THE BANK OF THE FULDA RIVER WAS CREATED BY CLAES OLDENBURG IN 1982 ON THE OCCASION OF THE *DOCUMENTA 7* ART EXHIBIT.

GERMANY

GARDENS, ART, AND POETRY

The Documenta art exhibition, the Wilhelmshöhe (Wilhelm's Heights), and, yes, a major highway interchange—that is what many people associate with Kassel. The first two mentioned could indeed make you curious about a city. But Kassel, blessed with princely architectural splendor and exquisite green spaces, also scores points with museums ranging from the bizarre to the spectacular.

Kassel sounds like a boring provincial town to many ears. The opposite is true. The city, mentioned as early as the first millennium and located at the crossroads of important trade routes, has always flourished. This residential city for a landgrave (a German count) dating from the 13th century, and its mighty castle, was expanded in the 16th century into a fortress. It was considered impregnable. Territorial German lords such as Karl I or Wilhelm I did not spare funds when promoting architecture, art, and garden design. No wonder that great intellectuals such as the Brothers Grimm were happy to settle here. Between 1800 and 1813, Kassel was at the height of its recognition as the capital of the Kingdom of Westphalia—even if it was only a Napoleonic satellite state.

Ornate buildings, also designed in the historicist and art nouveau styles, fell victim to World War II, and too many of the damaged buildings were demolished—which damaged the overall impression. But anyone who takes a well-informed trip will discover true pearls.

EXTENSIVE GREENERY, ALWAYS NEARBY

The first German national garden show caused furor in 1955—in Kassel. Yet, well-tended greenery has a long tradition here, and anyone who walks around the city will be happy to find it everywhere. The landmark of Kassel and a monumental eye-catcher is of course the Wilhelmshöhe Park. Even those who have been there several times will experience anew each time how uplifting it is to follow the long,

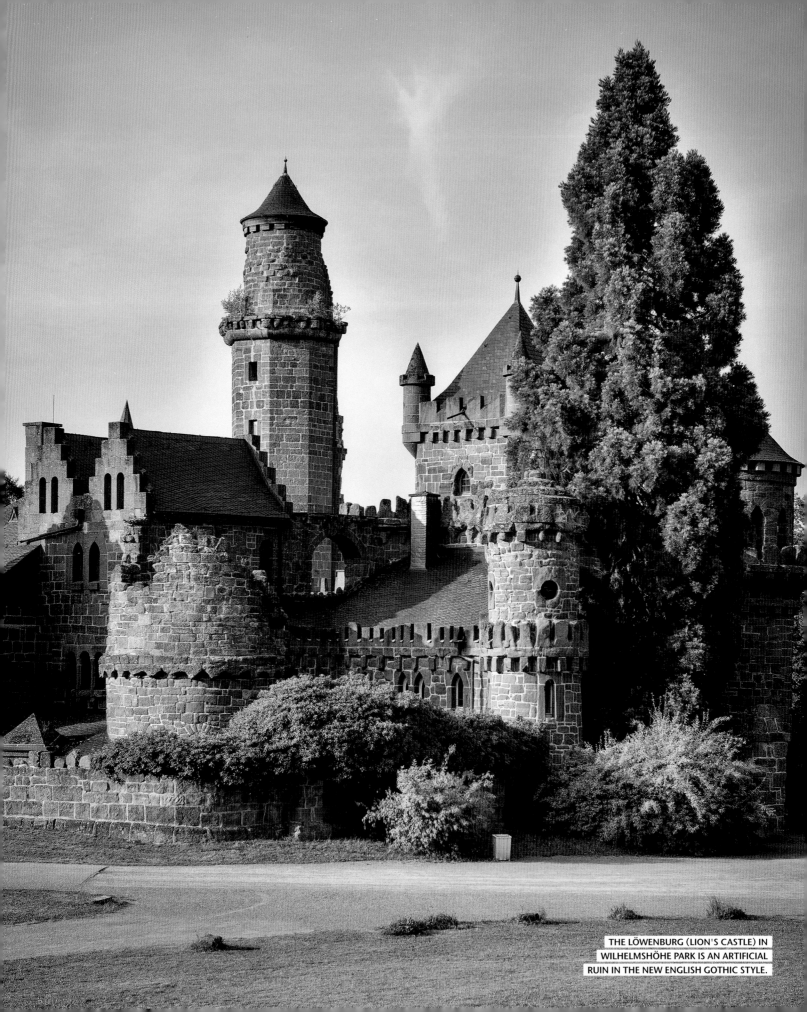

THE LÖWENBURG (LION'S CASTLE) IN WILHELMSHÖHE PARK IS AN ARTIFICIAL RUIN IN THE NEW ENGLISH GOTHIC STYLE.

gently curving paths through well-tended meadows and their clumps of trees to the heights, and at the end to be rewarded with a princely view of the city. The elegant iron construction of the greenhouse allows visitors to (almost) imagine themselves in England's Kew Gardens. In winter it becomes a protective home for magnificent exotic plants. The Steinhöfer waterfalls simulate nature in a deceptively real way; a white temple creates a bright accent. In front of the Scottish-style

MUSEUM FÜR SEPULKRALKULTUR (MUSEUM OF SEPUCHRAL CULTURE)

Among Kassel's museums, one stands out as quite bizarre: the Museum für Sepulkralkultur is dedicated to dying, being buried, and mourning. What sounds rather dark is still something present in everyday life and is viewed in all its manifestations and from many angles—sometimes even cheerfully. The museum, consisting of old and new buildings, is unique in the world. How is death represented artistically? How do other cultures bury and honor their dead? How have graves and coffins developed over time? This and much more about the subject of death can be experienced—presented in an up-to-date way and much less thought provoking than you might initially think—in the Museum für Sepulkralkultur, Weinbergstraße 25–27.

MORE INFORMATION
Center City Tourist Information Center
www.kassel.de/einrichtungen/gaeste/index.php
The Kassel Park Brochure guides you through green spaces.
Sepulkralmuseum
www.sepulkralmuseum.de/EN

Löwenburg, the visitor will feel chivalrous, with the Rose Island wrapping itself in beguiling scents during blossoming time. And above everything else, at the head of the water cascade, reigns the Riesenschloss (giant's castle), an octagon with a statue of Hercules. From the beginning of May to the beginning of October, water games are held on specific days—from June to September, at times illuminated in the evening. Then the water rushes over the cascade steps down into the castle pond with its 164-foot-high fountain. By the 16th century, a Renaissance garden had been created between two branches of the river. Not far from there, you can now enjoy gastronomic delights on the terrace of Germany's first orangery, a monumental 460-foot-long building. From here, you can take a stately stroll through the entire Karlsaue Park. Lots of space and water, such as the Hirschgraben (deer ditch) or Küchengraben (kitchen ditch), lead to the icing on the cake: the enchanting flower island of Siebenbergen (seven hills) with its garden house. A colorful round dance of flowers in artistically designed beds, surprising splashes of color in small meadows, and repeated views of the water make for a brief romantic break. Water lilies and orchids, wild plants, and perennials were composed on three levels to form a self-contained blooming and greening realm for garden lovers. Depending on the season, you can purchase plants and seeds at the garden house, which is often the subject of photographs.

THE ART IS COMING

In addition to an antique sculpture collection, the painting collection in Wilhelmshöhe Palace includes a significant collection of Old Masters, from Cranach to Dürer to Rembrandt and Titian. The Neue Galerie (New Gallery) has been presenting European painting and sculpture since the mid-19th century. There you will find works by the greats, such as Rodin, Kirchner, Nolde, Warhol, and Beuys.

The first documenta exhibition caused a wake-up call in art in 1955—since then, it has always been associated with Kassel. Every five years, the international art world meets there to discover new currents and new stars, and to discuss them in art theory. What started in the Museum Fridericianum as an overview of European art in the 20th century and then—a highlight—grappled with abstract art is today a platform for the artistic examination of political and social problems of the

time. Works by established artists and newcomers are present in the cityscape.

WALK-IN LITERATURE

The entire Kassel museum landscape is well worth seeing, including curiosities such as the Museum für Sepulkralkultur and the Astronomisch-Physikalische Kabinett (Astronomical-Physical Cabinet) in the orangery in the Karlsaue. The aesthetic measuring instruments and large experimental setups refuse to loosen their grasp on even the hard-boiled MINT-studies (mathematics, informatics, natural science, and technology) phobic, for whom scientific connections are now amazingly easy to grasp—and who will almost run out of time if they want to explore all the rooms.

However, one museum is really super. The Grimmwelt (Grimm's World; not to be confused with the Brothers Grimm Museum in the Palais Bellevue) not only is on the summit of the Kassel vineyard but has also been recognized as a World Heritage Site by UNESCO. In Kassel, the Grimms recorded the fairy tales and household tales for children that were otherwise in danger of being lost. They not only listened to their "guardian lady," Dorothea Viehmann, but roamed the surrounding countryside, collecting and writing down what had otherwise been passed on only orally. Once upon a time, there were Little Red Riding Hood, Rapunzel, Cinderella, or Hansel and Gretel. . . . Access to the fairy tales, as well as to the German dictionary and German grammar book written by the Brothers Grimm, can be experienced up close in an innovative and sophisticated way in a "walk-in" glossary through the letters of the alphabet, be it in installations such as a giant "horn" that responds in funny expletives, fairy-tale experience spaces, or the oversized inkwell containing the amount of ink (200 liters) that the Grimms are said to have used. High-level entertainment for young and old! And "ascending" the museum roof rewards you with a magnificent view over Kassel.

KASSEL'S GASTRONOMIC SCENE LEAVES LITTLE TO BE DESIRED (*ABOVE*). JONATHAN BOROFSKY'S 1992 WORK *MAN WALKING TO THE SKY* IS AFFECTIONATELY CALLED THE "HIMMELSTÜRMER" (HEAVENLY FOOTBALL STRIKER) (*RIGHT*).

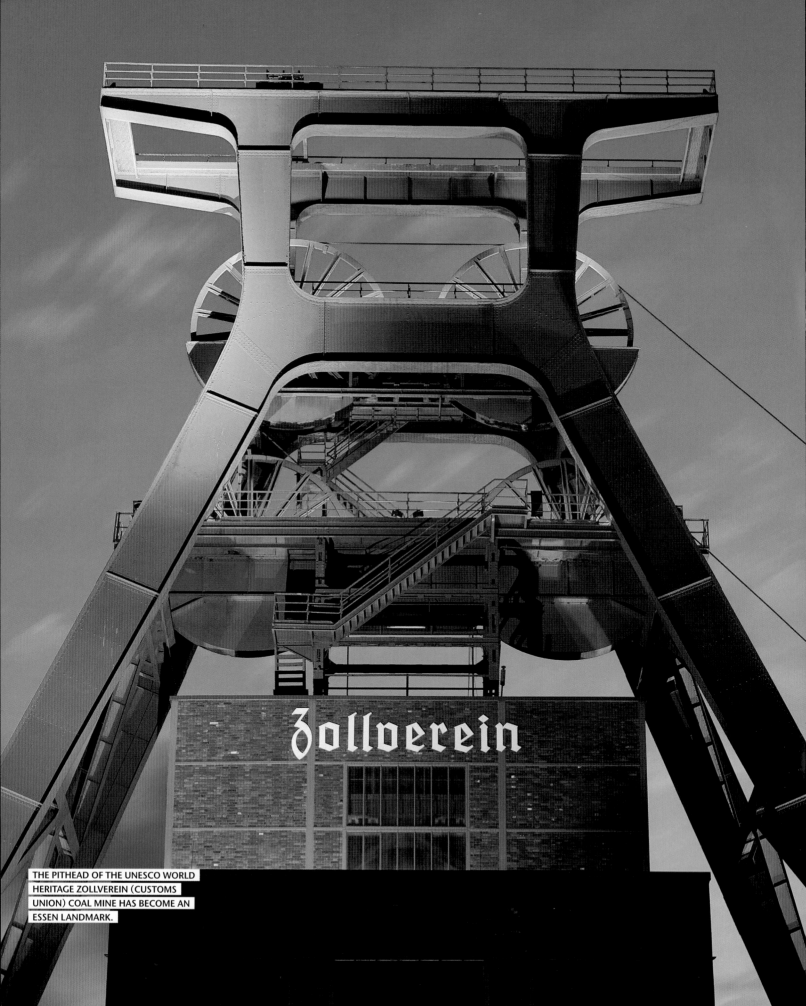

THE PITHEAD OF THE UNESCO WORLD HERITAGE ZOLLVEREIN (CUSTOMS UNION) COAL MINE HAS BECOME AN ESSEN LANDMARK.

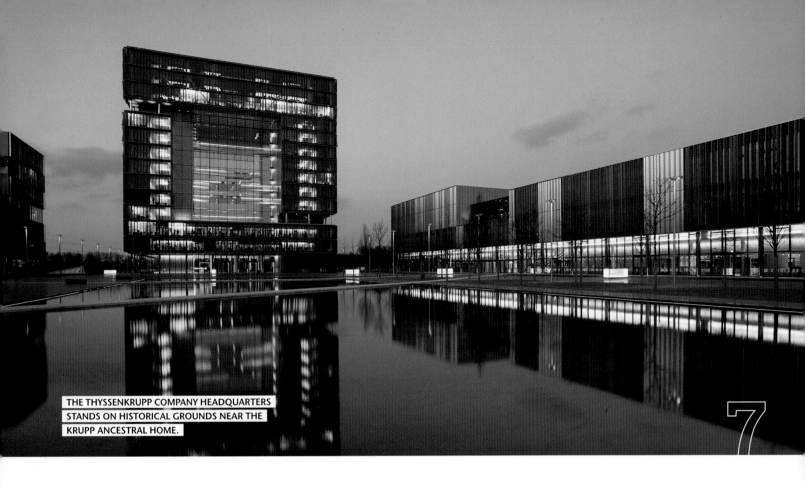

THE THYSSENKRUPP COMPANY HEADQUARTERS STANDS ON HISTORICAL GROUNDS NEAR THE KRUPP ANCESTRAL HOME.

COAL CULT AND PLENTY OF CULTURE

Essen owed its industrial upswing to hard coal and cast steel. Today, the Zollverein (customs union) coal mine and coking plant, once the most modern in the world, impresses visitors from all over the world as a UNESCO World Heritage Site. Since 2010, not only has the city lived up to the title of European Cultural Capital, but as the Green Capital of Europe in 2017.

GERMANY

Tourists in the Ruhrgebiet (Germany's Ruhr region) are always surprised that the region no longer corresponds to the cliché of being "*pottschwatt*" (sooty black): "It's so green here!" It was not just when the coal mining ended that recreational areas, such as region parks, were provided. Large forest areas such as the Schellenberger Wald and parks such as the Grugapark invite you to hike and stroll.

GREEN IS THE NEW BLACK
For most people, the name Krupp is associated with Essen. In the 28-hectare park surrounding the Villa Hügel (villa on the hill), the industrial baron has left a green jewel surrounded by dense forest, where you can take a lovely stroll. In 1961 the park was redesigned according to the layout of an English garden, and the greenhouses and showhouses disappeared. Uphill and downhill, there are easy paths today across meadows and through small groves. Alfred Krupp (1812–1887) built the white villa itself, with its almost 300 rooms and 87,000 square feet of living space, as a family home. Parts of it are open to visitors, and concerts and exhibitions are held in the magnificent rooms. Visitors should take the time to visit the exhibit about the company history, always closely interwoven with the Krupp family, in the smaller annex building. At the foot of Villa Hügel, Lake Baldeney spreads out as the largest of six Ruhr reservoirs. Walkers

appreciate the 8.5-mile circular route, and water sports enthusiasts like the lake's almost 5-mile length. Via a power station weir—a jewel of solid, historical technology—you enter the tranquil borough of Essen-Werden. In the Luciuskirche (St. Luke's Church), the oldest parish church north of the Alps, you can marvel at the remnants of figurative paintings from the 11th century. If things get too crowded by the lakes on the weekend for you, go upward: the Baldeney-Steig trail takes you in a circular route over 16 miles along the Ruhrhöhenweg (Ruhr high trail) around the lake. From the Korte cliff, you have a panoramic view of the waters, entirely embedded in green.

The Great Ruhrland Horticultural Exhibition in 1929 gave Essen the Grugapark, which was extended in 1965 for the federal horticultural show with bridges, miles of paths, a pavilion for music and readings, a stand for learning about bees, and Lake Margarethene. One of the largest parks in Europe continues to attract loyal fans and "rediscoverers." Spectacular dahlia and rose beds, the Mediterranean area with date palms and citrus

plants, the huge model gardens with theme gardens, and the colorful Friedensreich Hundertwasser house with its golden onion-dome tower will delight the hearts of all garden lovers.

THE COAL ROUTE MEETS DESIGN

The Zollverein colliery and coking plant, today a UNESCO World Heritage Site, is considered by many to be the most beautiful mining facility of all. It is certainly an architectural masterpiece of New Objectivity. Miners and cokers once toiled to extract hard coal and process it, especially for smelting steel. After the coal mine was closed in 1986 and the coking plant in 1993, some buildings were renovated as part of the Internationale Bauausstellung (IBA) Emscher Park—the Emscher Park International Architecture Exhibition (from 1990). Today, former miners are (also) knowledgeable guides through this unique landscape of industrial monuments, which allows visitors to intimately experience the work for processing hard coal. The Ruhr Museum at the Zollverein, in the former coal-washing facility, shaft XII, shows the

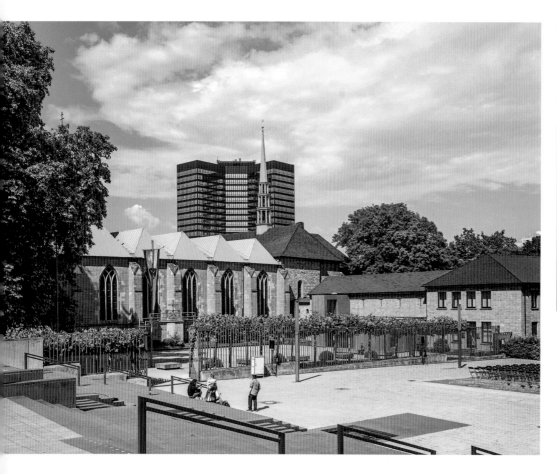

ESSEN CATHEDRAL LOOKS BACK OVER A 1,000-YEAR HISTORY; THE TOWN HALL BEHIND IT DATES FROM THE 1970S (*LEFT*). THE NIGHT WATCHMAN WATCHES OVER THE OLD TOWN OF KETTWIG (*ABOVE*).

history of the district from the development of coal to its "structural transition." A glowing orange escalator takes you up a steep ascent; inside, you walk, likewise guided by orange lighting, into the depths of the former "Coal Route." The premises are also a spectacular backdrop for special exhibitions.

The former boiler house of the Zollverein coal mine provides the right ambience for a display of current product designs. In the mid-1990s, the plans by British star architect Norman Foster merged a new glass-and-concrete interior design with the old building. The Red Dot Design Museum presents perfectly designed everyday objects from some 45 countries. A walk across the huge Zollverein site reveals how a "new nature" has reconquered industrial locations: bees swarm around the centaury, lilacs, and other blossoms—along the way everything is humming and buzzing (again).

GOLD TREASURES AND ART TREASURES

The works of art in the treasury of Essen Cathedral in the city center are dazzlingly beautiful. Essen owes its foundation to the establishment of a women's convent sometime around 850; later, women members of the Ottonian and Salian imperial families joined the convent. The collection of goldsmith work and sacral art from this period is second to none. The *Golden Madonna*, completely covered with fine gold leaf, is one of the oldest fully three-dimensional sculptures from the Middle Ages, and the most valuable work of art in the Ruhrgebiet. The Folkwang Museum was founded in 1902 by Karl Ernst Osthaus (1874–1921) in the Westphalian town of Hagen. Modern works, including pictures by Cézanne, Gauguin, Van Gogh, and Matisse, were acquired for the city of Essen and united with the Municipal Art Museum to form the Folkwang Museum. Today, together with collections of paintings and sculptures from the 19th century, post-1945 artworks and photographs as well as the poster museum have all found a brightly lit home in the new Museum Folkwang building, designed by architect David Chipperfeld.

CONSTRUCTION GUARANTEED

The Margarethenhöhe colony, named after its founder Margarethe Krupp, was built between 1906 and 1938 on the basis of a design by the architect Georg Metzendorf. Modernly furnished apartments with large gardens modeled on the Garden City movement were intended to make healthful living possible in Essen—and still do today. The Margarethenhöhe, with its lovingly cared-for houses, arcades, and green spaces, is considered one of the most beautiful housing developments in Germany. From here you can walk as far as the Grugapark. A guided tour provides an insight into civic and artist spaces and opens your eyes to the artistic details. The Rüttenscheid city neighborhood, not far from there, is Essen's shopping and nightlife district. When the 150 cherry trees on Rüttenscheider Straße start to bloom at the end of March, spring has arrived.

LIGHT MOMENTS

The Lichtburg (Light Castle) on Kettwiger Straße is Germany's largest and most beautiful movie palace, the location of glamorous premieres, and a meeting place for international film stars. Concerts and readings are likewise available for the public. The renovated Lichtburg has 1,250 seats and is thus the largest movie theater in Germany.

The Essen Light Festival in the city center heralds the Essen Light Weeks, which traditionally delight millions of visitors from home and abroad with artfully designed designs made from light elements. In association with the Essen International Christmas Market, they bring plenty of light into the dark time of the year. The magnificently illuminated Ferris wheel next to the cathedral is a landmark and one of the most popular photo motifs.

MORE INFORMATION
EMG—Essen Marketing GmbH, Essen Tourist Center
www.visitessen.de/startseite_14/Startseite.en.html

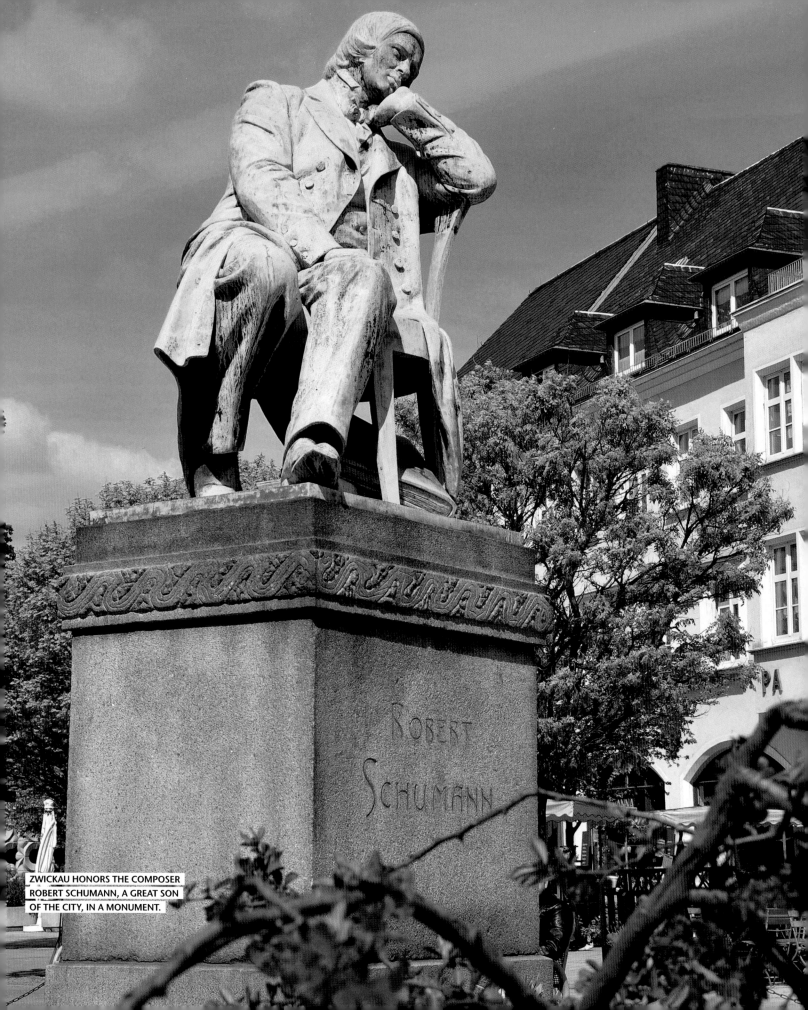

ZWICKAU HONORS THE COMPOSER ROBERT SCHUMANN, A GREAT SON OF THE CITY, IN A MONUMENT.

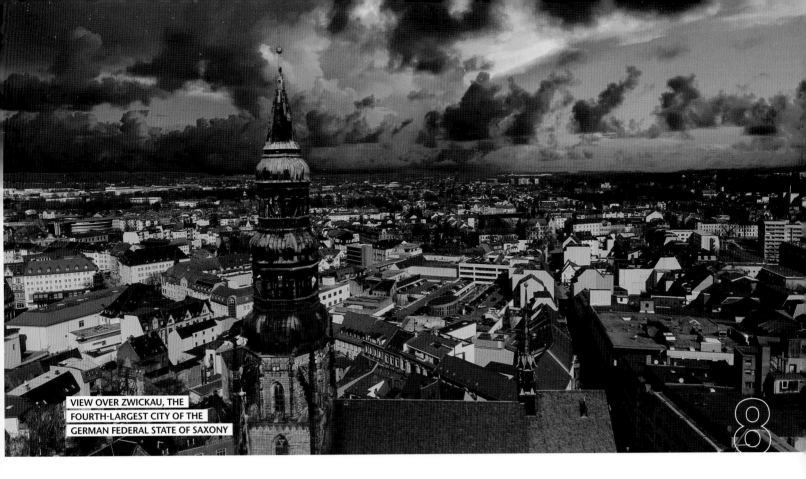

VIEW OVER ZWICKAU, THE
FOURTH-LARGEST CITY OF THE
GERMAN FEDERAL STATE OF SAXONY

8

ZWICKAU—JEWEL OF SAXONY

SMALL "BIG CITY" ON THE MOVE

Great names such as Thomas Müntzer, Robert Schumann, and August Horch shape the rich 900-year history of Zwickau, the fourth-largest city in Saxony. Mining and industry, but above all open-mindedness and inventiveness, have ensured prosperity and culture. More than just the well-tended architecture of the historic Old Town speaks to this.

GERMANY

By the 15th century, momentum came to this small town: silver had been found in the Schneeberg (snow mountain). Later, coal mining and cloth would propel Zwickau forward. Trade of all kinds was promoted by the convenient location—here, the Mulde River was easy for travelers to cross. In the 19th century, shaft mines were followed by factories. The city continued to grow and prosper. Over time, wars such as the Thirty Years' War or the Seven Years' War and World Wars I and II, epidemics, flood catastrophes and mine accidents, and the end of coal mining in 1978 have naturally also affected Zwickau. But the people here always knew how to handle their heritage with care and how to use it. Mining still moves them:

during the traditional mining parade through the city center, including a concert, which is held on the third Sunday of Advent, hundreds of participants in traditional uniforms and marching bands and singers revive the history of mining in the Erzgebirge (ore mountains).

DECORATIVE WITNESSES OF GOOD TIMES
The priest's houses by the cathedral are witnesses of former prosperity. This fully furnished and faithfully restored ensemble of medieval houses for priests, merchants, and councilors lets you understand how the upper classes must have lived from the 13th to the 15th centuries. In the Rußküche (sooty kitchens), a filling stew was prepared in huge pots over

an open fire—it is still made today for special events. Two churches in particular shape the cityscape: the Dom St. Marien (St. Mary's Cathedral), a Romanesque basilica (12th century), was made into a late Gothic hall church in the 15th and 16th centuries, a Protestant place of worship with the Reformation—and the mining industry caused it to subside considerably. The winged altar from the workshop of Michael Wolgemut (1434–1519)—painter, wood carver, and teacher of Albrecht Dürer—and the Vespers artwork by wood sculptor Peter Breuer (1472–1541) are still impressive today. A figure of Christ in the Katharinenkirche (St. Katherine's Church) (13th century) by von Breuer can also be admired. The splendid Gewandhaus (cloth hall) (16th century) on Hauptmarkt (main market), with its steep roof and window-rich gable facade, where cloth was once tested for quality and stored, has mutated into the site of a theater and is a popular photo subject. The old Kornhaus (granary) became the city library. Other photogenic buildings from the Wilhelminian and art nouveau styles, such as the "Neue Welt" (New World) and "Johannisbad" (John's Baths) buildings, are located in the northern Zwickau suburbs.

SPIRIT OF PROGRESS, LIGHT OF ART

Zwickau's openness to new things was already proven in 1525, when the Reformation took hold there, right after Luther's hometown of Wittenberg. The reformer himself had recommended Thomas Müntzer as a preacher here—which he later regretted, since Müntzer in the end turned out to be an enemy of the Wittenberg "Fürstenknecht" (princes' lackey). The music of Robert Schumann (1810–1856) moved not only his contemporaries; present-day music lovers make a pilgrimage to the corner house at Hauptmarkt 5, where the city's great son was born. There he learned to play the piano, wrote poetry, and composed—160 of his piano pieces, songs, choral, orchestral, and chamber music pieces have been preserved. The largest Schumann collection in the world, with over 4,000 manuscripts, impresses visitors to the Zwickau Schumann House. Eight rooms provide an insight into the everyday life of the artist and his wife, the no-less-famous pianist and composer Clara Wiek Schumann. The Schumann Festival in June and an international competition named after the musician promote young artists today. The expressionist Max Pechstein (1881–1955) brought color to life not only in Zwickau. After his training as a decorative painter and art studies in Dresden, he became a member of the Die Brücke (The Bridge) artists' collective. The travel-loving artist found themes for his colorful works in southern Europe and even in the South Seas. Some 50 portraits and still-lifes, glass pictures, and sculptures have found a home in Zwickau as a permanent exhibition: in the

PALACES AND CASTLES AROUND ZWICKAU

In Zwickau, along the Zwickau Mulde River and in the surrounding area, enthusiasts for old walls will get their money's worth. The landscape is rich in castles and palaces. A small selection: Zwickau's Osterstein Castle, dating from the 13th century, was converted into a Renaissance palace—and temporarily misused as a prison. August Bebel and Karl May were jailed there. Today the beautiful building is a well-kept residential complex for the elderly. In Glauchau there is an impressive double castle, and the playing-card museum is located in Altenburg Castle; after all, the city has been known for making playing cards since the mid-18th century and is the hometown of the game of skat. In Blankenheim Palace in Crimmitschau, you can explore 80 buildings in the agricultural open-air museum, as well as the manor and mansion.

MORE INFORMATION
Zwickau Tourist Information
www.zwickautourist.de/en
City tours are available on many themes, such as automotive history, art nouveau, and Wilhelminian style and more.

Max-Pechstein-Museum der Kunstsammlungen (art collections) of Zwickau, at Lessingstrasse 1.

AUTOMOBILES WITH PANACHE

Zwickau remains associated with Germany's best-beloved child, the automobile, for all time. The eyes of the fans glow in this El Dorado for those who drive themselves; after all, a great inventor and courageous entrepreneur has written automotive history here. The trained blacksmith and engineer August Horch from Winningen brought the mechanical-engineering knowledge of his time to Zwickau after working in numerous companies and running his own businesses in Cologne and Reichenbach: the right man in the right place! In 1904, Horch founded the Motorwagen-Werke (Motor Car Factory) in Zwickau; in 1910 he started again and founded a new company besides the old one; namely, Audi (Latin for "Horch!" [Listen!]). In 1932, the Audi, DKW, Horch, and Wanderer companies merged to form the Auto Union under the sign of four interlocked rings. Where August Horch wrote automobile history, visitors can relive it. A complete street, including shop, workshop, gas station, test bench, pit lane, and starting lineup for a race, was faithfully re-created at the old site where the car was originally built. The stars of the scene are of course the automobiles and everything associated with them—with the visitor right in the middle of the action. Don't forget: the East German P50, known as the "Trabant," was more loved than the legendary Auto-Union Silver Arrow (the Mercedes Grand Prix racing car was also called that). The first "racing cardboard" Trabant model rolled off the assembly line in Zwickau in 1958. The Trabi with its plastic body got the German Democratic Republic citizen moving; he would have been able to get hold of this good piece of work after long-term perseverance in the "socialist waiting community." In the Zwickau Museum, the pride of many families is appropriately honored with an entire thermoset production plant. Another large corporation now manufactures automobiles in the city—Zwickau continues to be mobile.

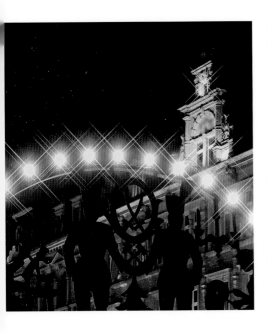

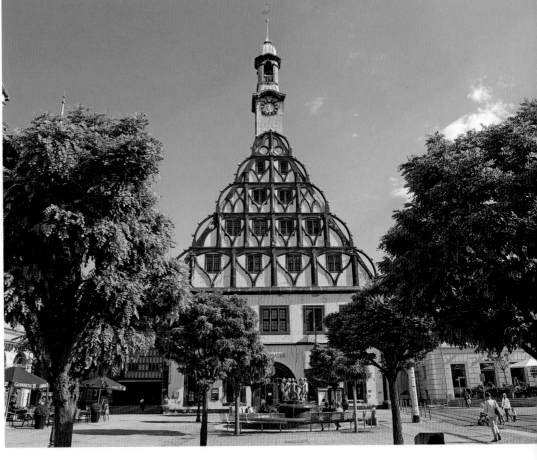

THE SCHWIBBOGEN (CANDLE ARCH) AT THE CHRISTMAS MARKET RECALLS THE REGION'S MINING TRADITION (*ABOVE*). THEATRICAL PERFORMANCES ARE HELD IN THE GEWANDHAUS (CLOTH HALL) TODAY (*RIGHT*).

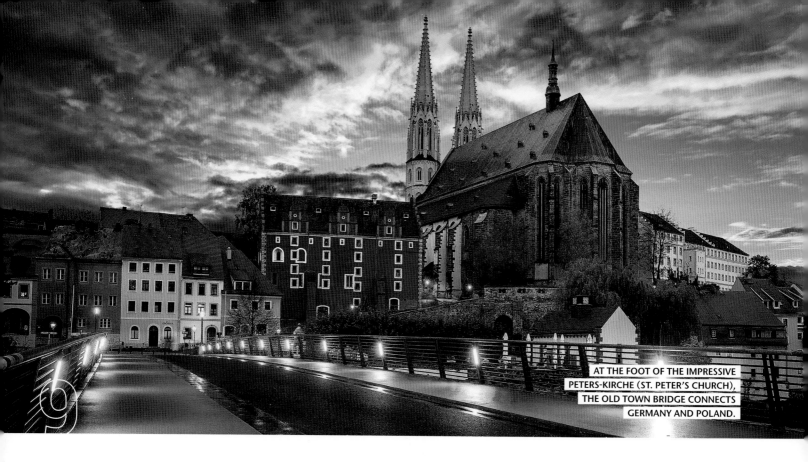

AT THE FOOT OF THE IMPRESSIVE PETERS-KIRCHE (ST. PETER'S CHURCH), THE OLD TOWN BRIDGE CONNECTS GERMANY AND POLAND.

GÖRLITZ—CITY OF FILM AND EUROPE

A VERY REAL FILM SET

"Thank you, Görlitz, for being the best location ever." No less than Hollywood actor Ralph Fiennes wrote these words of thanks in the city's Golden Book. And many of his famous colleagues have joined in the praise, including Jeff Goldblum, Willem Dafoe, Jackie Chan, and Quentin Tarantino.

GERMANY

The easternmost city in Germany has been a popular location for film productions since the 1950s, and over 100 films have been shot here. Hollywood discovered Görlitz in 2003 with the adventure movie *Around the World in Eighty Days*. Since then, the stars have been continually coming and going, and blockbusters such as *Inglourious Basterds*, *The Reader*, and *Grand Budapest Hotel*, as well as German films such as *Measuring the World* and *The Tower*, have been made here. The main reason is the beautiful Old Town, little of which was destroyed in World War II. It displays more than 500 years of building history from the Gothic, Renaissance, baroque, Wilhelminian, and art nouveau periods. Around 4,000 buildings are protected as historical sites. Still neglected during German Democratic Republic times, a thorough restoration was started after the fall of the Berlin

Wall. From 1995 to 2016, an anonymous donor gave one million German marks, or half a million euros, to the city for reconstruction each year. This godsend has paid off: today visitors can stroll through one of the best preserved Old Towns in central Europe.

BRIEF TOUR OF THE OLD TOWN

In the direction of Obermarkt (upper market) you will pass the Reichenbacher tower, part of the former fortified wall. Together with the Nikolaiturm (Nicholas tower) and the Frauenturm (Our Lady's tower)—also known as the Dicker (fat) Turm—it is one of the four large defensive towers that have been preserved. The Ochsen (ox) bastion, the Nikolaizwinger (Nicholas enclosure), and the Hother bastion still remain from the city's former ring wall.

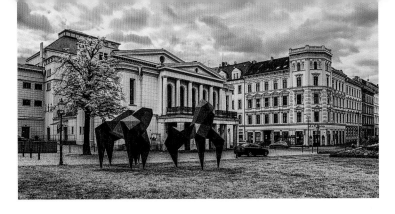

THE HERD **BY POLISH ARTIST PIOTR WESOLOWSKI HAS BEEN GRAZING ON THE THEATER MEADOW AT ELISABETHPLATZ SINCE 2016. IT SYMBOLIZES MOVEMENT, COMMUNITY, AND FAMILY.**

The Kulturhistorisches (History of Culture) Museum Görlitz is located in the Kaisertrutz (imperial defense) bastion on the Obermarkt (15th century). The square, with its Renaissance and baroque houses, once served the salt and spice trades. Napoleon Bonaparte stayed in the house at number 29 in 1813, and since then it has simply been called the Napoleon House. From the Obermarkt, you can reach the Untermarkt (lower market) via Brüderstraße (Brothers Street), with its splendid Renaissance houses such as the "Brauner Hirsch" (brown stag) and other typical Görlitz hall houses with closed arcades. The Schönhof (beautiful courtyard), from 1525, is considered the oldest middle-class Renaissance building in Germany. The eye-catcher is the town hall pharmacy with its two sundials. Their hands point to colored lines that symbolize different time scales. The town hall clock has two dials. Built in 1369, the town hall is still the seat of the city administration. The Untermarkt is a coveted film set, but also the setting for many events such as the Silesian Tippel Market. The Wilhelminian and art nouveau quarters stretch slightly south of the Old Town, and the train station and the Strasbourg Passage also date from this period. The Görlitz department store was built on Demianplatz in 1913, modeled on the Wertheim department store in Berlin. The Görlitzers rightly call the building the "most beautiful department store in Germany." Its impressive external facade and, above all, the breathtaking atrium inside also convinced Hollywood: The *Grand Budapest Hotel* was created there.

WHERE IT ALL BEGAN: NIKOLAIVORSTADT (THE NICHOLAS SUBURB)

Görlitz actually consists of two cities, the German section and the Polish Zgorzelec. Thus, this "European city" builds a bridge between west and east: the Old Town bridge, the Pope John Paul II Bridge, leads from one side to the other. The bridge over the Neisse River runs south of the Nikolaivorstadt. The is where the first settlers colonized the city in the Middle Ages. Today, the Finstertor (Sinister Gate) is the only fully preserved half-timbered structure in the city. The Nikolaikirche (St. Nicholas Church) can be dated to around 1100. The church, until the late Middle Ages the main church of the city and later for a long time the funeral church, impresses visitors with its expressionistic ceiling vault. More important—and because of its imposing towers, a landmark of Görlitz—is the Pfarrkirche (parish church) St. Peter and Paul (also the Peterskirche). The old synagogue near the city park was the only one in Saxony that survived the pogrom night of 1938 almost undamaged and is now a center for culture and engagement.

LANDESKRONE CROWNS THE LANDSCAPE

Another landmark of Görlitz stands outside the city: the Landeskrone, a 1,375-foot-high basalt cone, welcomes those arriving from afar. From here there is a magnificent view over the Lusatian Highlands, and if visibility is good, you can see as far as the Polish-Czech Giant Mountains, with the Schneekoppe (snow peak). The 42-foot-high Bismarck column rises on the southern summit of the Landeskrone, in memory of the former imperial chancellor, "Reich unifier," and honorary citizen of the city of Görlitz.

MORE INFORMATION
City of Görlitz
www.visit-goerlitz.com/Tourismus.html

GERMANY

BETWEEN CATHEDRAL AND SPACE SHUTTLE

Founded by the Romans and named Noviomagus or Nemetum for the Germanic tribe of Nemeter, who lived on the terraces on the left bank of the Rhine; seat of a bishopric since the fourth century; center of the Salian emperors from 1024 to 1125; free imperial city in the late Middle Ages: Speyer is among the oldest and historically most important cities in Germany.

Most of today's cityscape was created after the city fire of 1689, when Speyer was almost completely devastated in the Palatinate War of Succession. Even the Romanesque cathedral was impacted at the time. It was only in the 19th century when Max I, King of Bavaria—the Kurpfalz (Electoral Palatinate) was part of Bavaria at the time—initiated a comprehensive restoration. When it was consecrated in 1061, the mighty six-towered Dom St. Maria und St. Stephan Cathedral was the largest church in western Christianity. This UNESCO World Heritage Site is still the world's largest preserved Romanesque church. It was commissioned by the Salian emperor Konrad II around 1027. The crypt, the burial place of eight Salian, Hohenstaufen, and Habsburg emperors, kings, and queens, is even 20 years older. The newly created observation deck offers a magnificent panoramic view.

The main axis of the city is the wide Maximilianstrasse, Speyer's promenade and shopping mile with many cafés. It leads from the cathedral to the medieval Altpörtel (old portal), at 180 feet high one of the tallest German city gates that visitors can ascend. The historical baroque town hall and the Alte Münze, the former department store by the market, are also located in Maximilianstrasse. Between the shopping streets and the picturesque Old Town, the baroque Dreifaltigkeitskirche (Church of the Holy Trinity) rises in Korngasse, after its restoration a gem of Protestant sacred building.

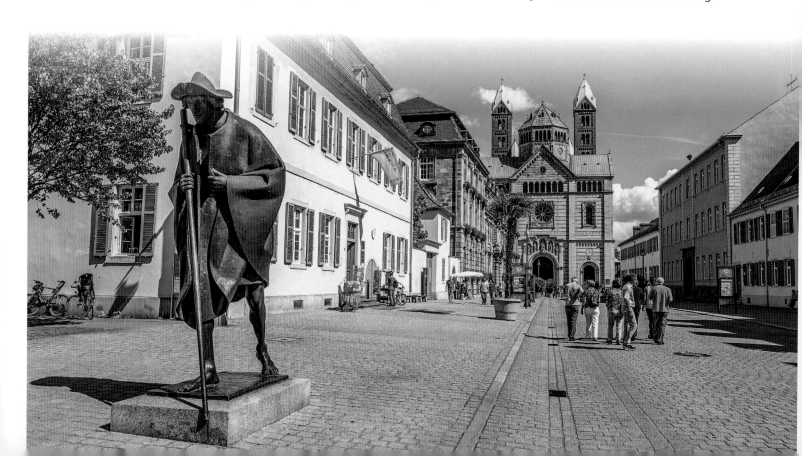

IN THE MIDDLE AGES, SPEYER WAS AN IMPORTANT WAY STATION FOR PILGRIMS ON THE WAY OF ST. JAMES AND TO ROME (*OPPOSITE*).
THE BREZELFST (PRETZEL FESTIVAL) IS DEDICATED TO SPEYER'S "NATIONAL PASTRY," THE PRETZEL (*BELOW*).
THE FRESCOES IN THE CATHEDRAL INTERIOR WERE CREATED IN THE MID-19TH CENTURY IN NAZARENE STYLE (*LEFT*).

SCHUM CITY

In addition to Worms and Mainz, Speyer is one of the three SchUM cities, a network of three Jewish communities on the upper Rhine, which have existed since the 10th and 11th centuries. "Sch" stands for the Hebrew letter SchPIRA (for Speyer), "U" for Warmasia (for Worms), and "M" for Magenza (for Mainz). This unique ensemble from the Jewish quarter of this period has been preserved, including a ritual bath, the mikveh, and the remains of the synagogue dating from the 11th century, and comprise, together with the cathedral, a World Heritage Site. The medieval buildings on Alte Judengasse (Old Jewish Alley), today Kleine Pfaffengasse, were destroyed in the great city fire in 1689. The SchPIRA Museum is dedicated to Jewish life in the Middle Ages. The new synagogue was built between 2008 and 2011 in the Bauhaus style, while partially preserving the former St. Guido Church. The previous synagogue building was burned down in 1938; there is a department store there today.

LARGE-SCALE TECHNOLOGY YOU CAN TOUCH

The Speyer Technology Museum is another crowd-pleaser. A Boeing 747, which is accessible to visitors (even including the cargo hold), is not the museum's only highlight, but a particularly striking one. More than 70 planes and helicopters, a submarine, and the Soviet space shuttle *Buran* can be viewed on the large, open-air grounds and in the exhibition halls. Liller Hall, a protected historical building, was dismantled in Lille during World War I and transported to Speyer, where it served as a production hall for the Pfalz-Flugwerke aircraft manufacturer. A visit to the museum is rounded off by a screening in the IMAX DOME movie theater, Germany's only IMAX cinema, in which the films are projected onto a huge dome.

The Historical Museum of the Palatinate attracts visitors to Speyer with spectacular exhibitions. The exhibits include the mysterious golden hat of Schifferstadt from the Bronze Age, the Speyer Cathedral treasure, and the oldest liquid wine preserved from the third century CE. The more intimate museums are the Feuerbachhaus, with a wine

RHINE PROMENADE AND OLD ARMS OF THE RHINE

In fine weather, locals and tourists alike are drawn to the Rhine Promenade with its popular beach bar by the *aalschocker* (eel-fishing vessel) *Paul* and two large beer gardens. The path to the Rhine leads through the cathedral garden with the Heidentürmchen (little pagan tower), a remnant of the medieval city fortifications, which originally had more than 70 towers. The "Sealife" by the marina focuses on the underwater world of the Rhine, from its sources to its mouth in the North Sea. Popular excursions take visitors to the Berghäuser and the Reffenthaler Altrhein sites on old Rhine water bodies. Not far away, the Binsfeld recreation area invites you to swim during the summer. The Kuhuntersee and Gänsedrecksee are two of the eight interconnected landscape lakes created by gravel mining.

MORE INFORMATION
Speyer
www.speyer.de/en/tourism

bar and pretty rose garden, and the tiny Elwedritsche Museum, which is dedicated to the scientific research of this mythical birdlike Palatinate creature.

ENJOY THE PALATINATE

The region has a record-breaking abundance of gastronomy establishments. The Kaisertafel (Kaiser's table) food festival attracts many visitors every year. Since 1990, Speyer's restaurateurs have been transforming Maximilianstrasse into a "pleasure mile" at the beginning of August.

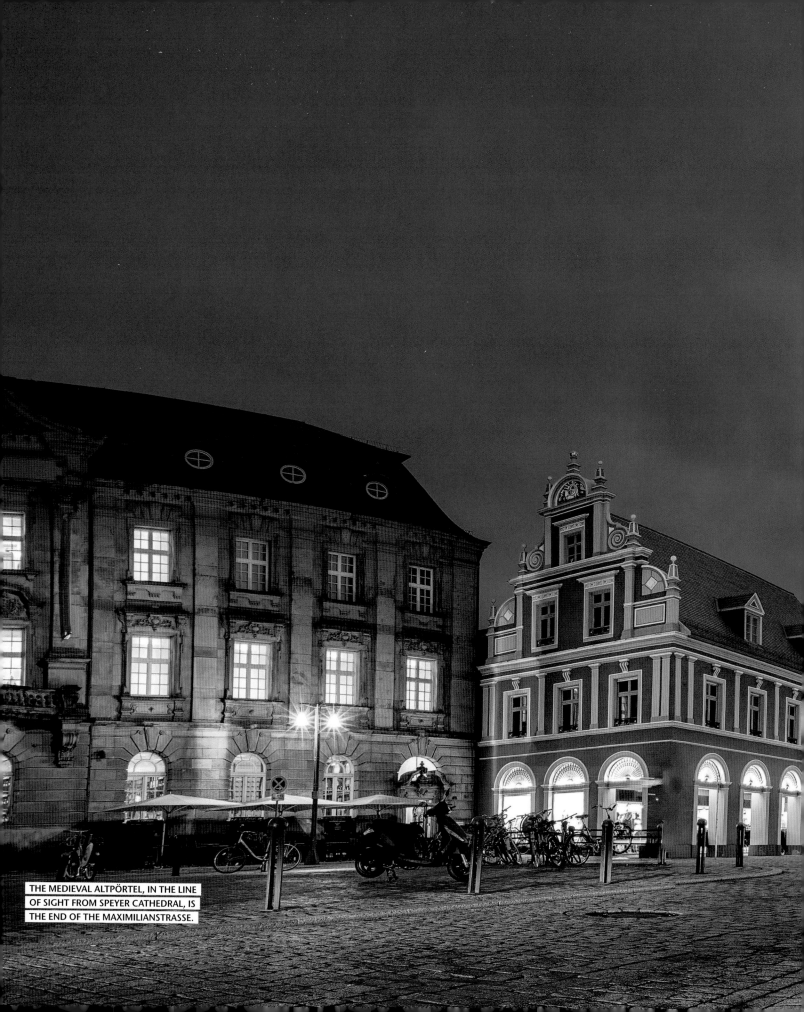

THE MEDIEVAL ALTPÖRTEL, IN THE LINE OF SIGHT FROM SPEYER CATHEDRAL, IS THE END OF THE MAXIMILIANSTRASSE.

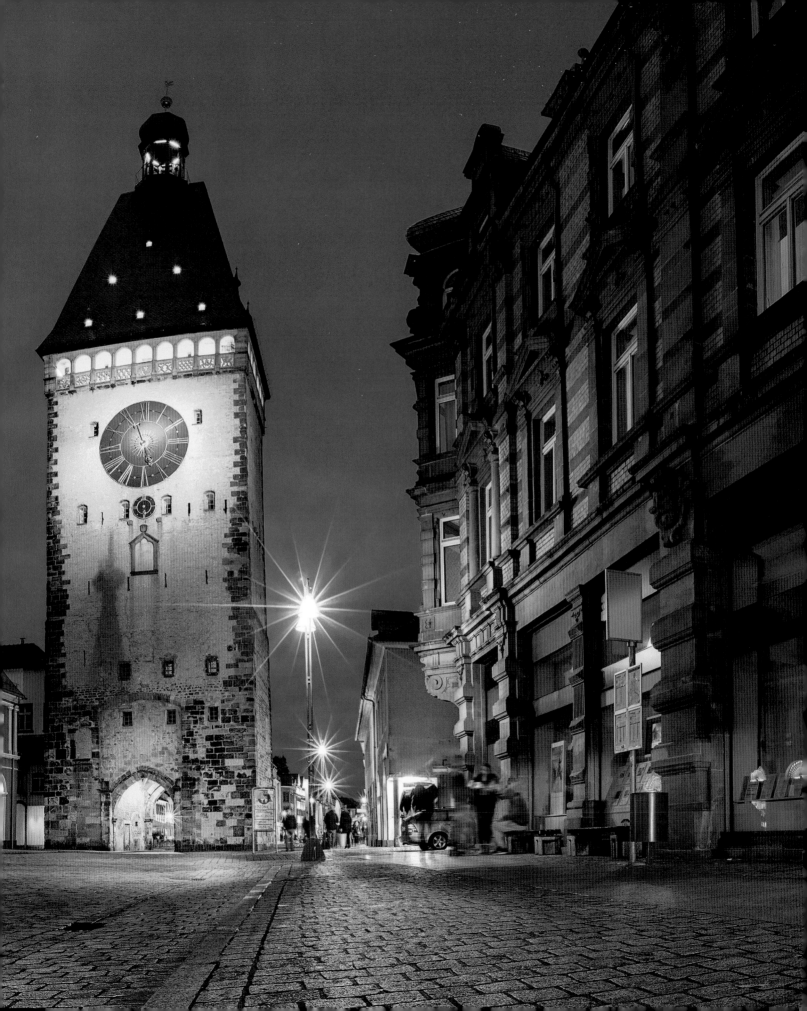

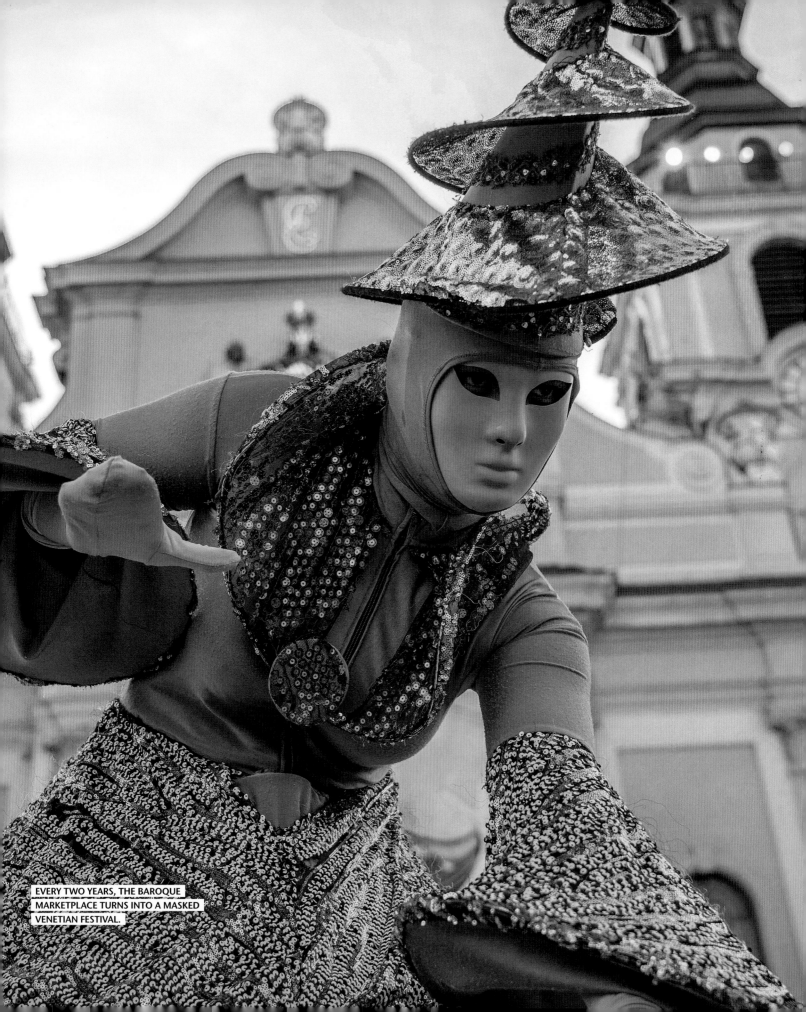

EVERY TWO YEARS, THE BAROQUE MARKETPLACE TURNS INTO A MASKED VENETIAN FESTIVAL.

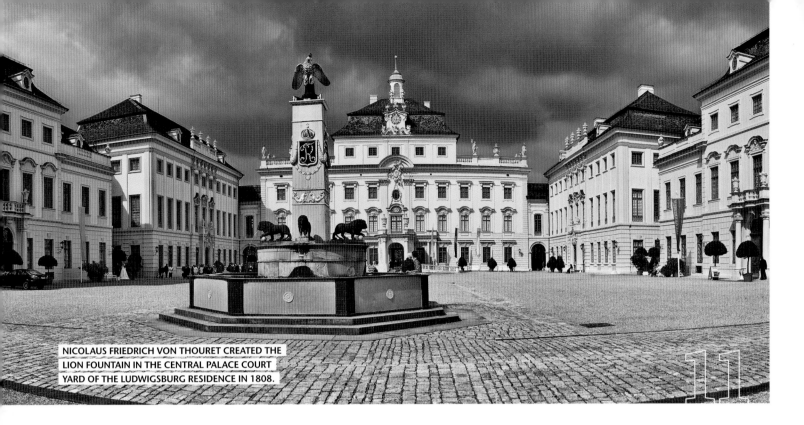

NICOLAUS FRIEDRICH VON THOURET CREATED THE LION FOUNTAIN IN THE CENTRAL PALACE COURT YARD OF THE LUDWIGSBURG RESIDENCE IN 1808.

LUDWIGSBURG—POTSDAM OF SWABIA

BAROQUE JEWEL

Who has the largest baroque palace in Germany? After Mannheim, Ludwigsburg is probably in second place. The Residenzgarten (residence garden), however, shows itself in all its glory. Its lavish displays of plants have earned it the name "blooming baroque." Because of its many soldiers' barracks, Ludwigsburg's popular name used to be the "Swabian Potsdam."

GERMANY

From a bird's-eye view, the Ludwigsburg city center looks as if it had been drawn with a ruler. At the beginning of the 18th century, Duke Eberhard Ludwig of Württemberg had planned to construct only a pleasure and hunting palace on the site of a farm near Stuttgart. The plans kept taking on ever-larger dimensions, and so Eberhard decided to add a city to the palace. Building plots and building materials were allocated free of charge—something hard to believe from today's perspective. A planned baroque city was created, with a flair that the Ludwigsburger Innenstadt-Verein (Center City Association) knows how to preserve with many activities.

IMPOSING PALACE

After the court moved in 1718, Ludwigsburg became a residence city. The magnificent palace, originally in a three-wing design, which the new main building converted into a four-wing design, has 452 rooms, a theater, and two churches. Three styles, from baroque to rococo to classicism, characterize the complex. The stage mechanics from 1758 still work in the palace theater. Hidden courtyards, an impressive roof landscape, and dark secret passages also await the visitor. The venues for the renowned Ludwigsburg Palace Festival are the Ordenssaal, the Forum am Schlosspark (palace park), and the Musikhalle (music hall), besides the Schlosstheater

(palace theater). Gardens surround the palace on three sides. The symmetrical south garden was created first, on the basis of the French model. Almost a hundred years later, the Friedrichsgarten and Mathildengarten were designed in the English style, and then a landscape garden with romantic elements. This includes a reconstructed historical children's playground with carousel and swings. When Ludwigsburg was no longer a residence city, the palace gardens turned into an orchard. The "blooming baroque" garden show brought them new life in 1954. The endearingly old-fashioned fairy-tale park, with its more than 40 scenes, also dates from this time. In autumn, the world's largest pumpkin exhibition attracts around 200,000 visitors.

ITALIAN IN A BAROQUE AMBIENCE

The 360-by-262-foot Marktplatz (Market Square), which is bordered by two opposite churches and arcaded houses, forms the counterpart to the stately palace. The baroque Christmas market is held in the space surrounding the market fountain. The number of Italian restaurants around the Marktplatz and in the rest of the city center is striking. Shortly after World War II, Francesco Moro, the "first Italian guest worker in the Federal Republic of Germany," came to Ludwigsburg. He imported Italian food and started a spaghetteria. The Signora Moro trattoria is now a Ludwigsburg institution. The Italian influence already goes back 300 years. This is because Italian architects were significantly involved in the construction of the palace and design of the Marktplatz.

CIVILIAN RECONSTRUCTION

Six of the originally eight gatehouses from the former 3.5-mile-long city fortifications have been preserved. The baroque guardhouses were primarily designed to prevent soldiers from deserting. Today they serve—each with their own motto—as a museum, exhibition space, or archive. The Garnisonsmuseum (Garrison Museum) is housed in the Asperger Torhaus. In addition to the palace complex and the Marktplatz, the many barracks shape the cityscape. From 1736 to 1994,

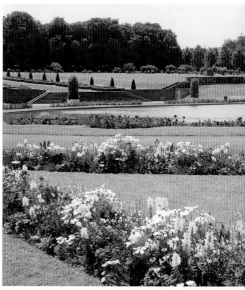

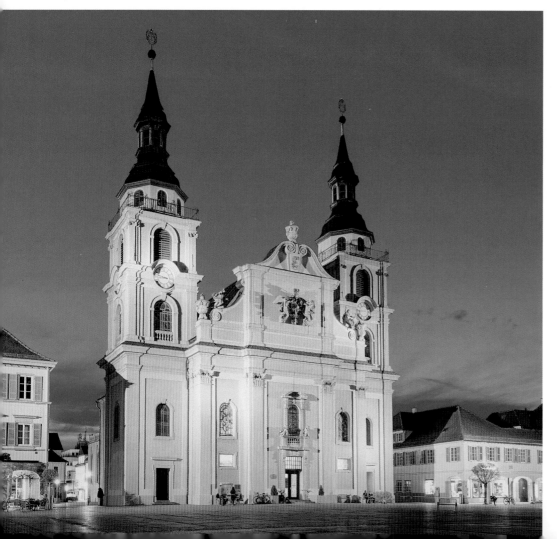

THE PROTESTANT CITY CHURCH ON THE MARKTPLATZ STANDS OPPOSITE THE LIKEWISE BAROQUE CATHOLIC CHURCH (*LEFT*).
AT THE END OF MARCH, THE GARDEN SEASON BEGINS: *BLOOMING BAROQUE* EXHIBITION (*ABOVE*).
THE NORTHERN GARDEN LIES IN FRONT OF THE OLD RESIDENCE PALACE CORPS DE LOGIS (*FAR RIGHT*).

Ludwigsburg was a large-scale garrison location. Today, the city is a prime example of successful conversion: The former Karlskaserne (Carl barracks) is an art and cultural center; the Reinhardtkaserne (Reinhardt barracks), a film and media stronghold.

MEDIA AND MASKS

The Baden-Württemberg Film Academy is located in the northern and southern stables, the carriage house, the team building, and the stately main building of the Reinhardtkaserne. The affiliated animation institute has been awarded many prizes. It isn't just children who would find the guided tours about animated and live-action films in the children's film house in the Aldinger Torhaus (gatehouse) interesting. As a film city, Ludwigsburg has also attracted many media agencies, IT companies, and designers. Talent for self-expression is required every two years at the Venetian fair. In September, the Marktplatz becomes a playground for unusual masks and costumes. Musicians, jugglers, artists, actors, and other performers stage a glittering party. Duke Carl Eugen introduced the masked festival to the residential city 250 years ago. In 1993, the event was revived.

JUST A STONE'S THROW FROM STUTTGART

On the way to Stuttgart, the state capital of Baden-Württemberg, a detour to the Hohenasperg fortress is a good idea. This isolated butte offers a wonderful view of the surrounding area. For centuries, the fortress on the "Tränenberg" (mountain of tears) was considered a political prison. One wing of the building today houses the prison hospital. The Baden-Württemberg Haus der Geschichte (House of History) in the arsenal building (Museum Hohenasperg) provides information about the eventful history of the prison and portrays its prominent prisoners.

Eduard Mörike, a poet born in Ludwigsburg, admired the beauty of Stuttgart in his tale *Das Stuttgarter Hutzelmännlein* (The goblin of Stuttgart) in 1853. In 1229, the original settlement, which was located near a stud farm (Gestüt or Stutengarten), was raised to the status of a ducal and royal residence. Witnesses of this period are the old palace in the Renaissance style and the baroque new castle. You can get the best overview from the Stuttgart TV tower (1956), the world's first of its kind. The city center is wedged into the Stuttgart valley basin, among vineyards and forests. Anyone who wants to reach the top by foot should be in good physical condition. More than 400 picturesque "Stäffele," which are often steep flights of steps, connect the center with the higher parts of the city. The many mineral springs in the Bad Cannstatt district offer a way to relax after all the exertion. The Romans also appreciated them. The Cannstatter Volksfest (folk festival), held at the Cannstatter Wasen fairgrounds, which starts at the end of September, is the largest festival in Germany after the Oktoberfest.

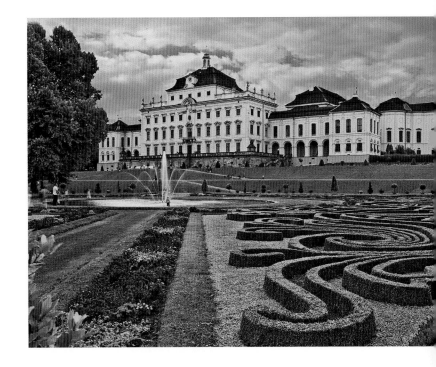

FAVORITE, MONREPOS, SOLITUDE

The Favorite pleasure palace was built on a hill in Favoritepark, north of Ludwigsburg Palace, between 1717 and 1723. The chateau, which was redesigned in the classicist style in 1807, offers a beautiful view of its big sister. Avenues of trees link Favorite and the residence with the Monrepos lake palace, a playful rococo-style chateau and hunting lodge with a "garden of paradise." The 8-mile Solitude Allee leads straight from the palace garden to the Solitude hunting lodge. Starting in 1820, the avenue was used as a trigonometric basis for the Württembergische Landesvermessung (state survey). Solitude is an imposing rococo-style building with classicist elements.

MORE INFORMATION
City portrait
www.ludwigsburg.de
Film Academy Baden-Württemberg
www.filmakademie.de/en

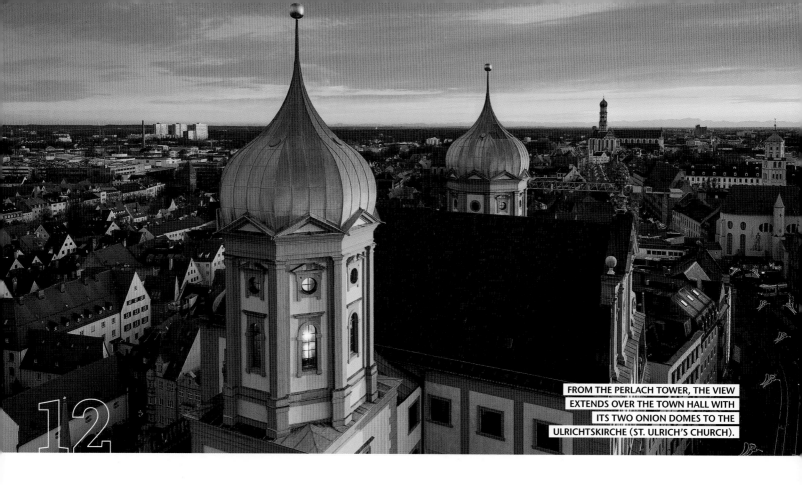

FROM THE PERLACH TOWER, THE VIEW EXTENDS OVER THE TOWN HALL WITH ITS TWO ONION DOMES TO THE ULRICHTSKIRCHE (ST. ULRICH'S CHURCH).

12

THE FUGGEREI AND PUPPET SHOWS

The best view of the Swabian metropolis is not offered by the Perlach Tower on the town hall, or the controversial hotel tower, but by a mountain of rubbish. Since December 2016, curious visitors have been able to climb up three routes on the 180-foot-high mountain of trash at the Augsburg-Nord (north) landfill site, after it was partially sanitized. Sometimes you can even see the Alps from atop over 7.5 million tons of trash.

GERMANY

Augsburg, located where the Wertach River flows into the Lech, is one of the oldest cities in Germany. As far back as the Romans, its strategically favorable location was recognized. Today, residents appreciate the high quality of life—and visitors appreciate sights from more than 2,000 years of history.

ROMAN IN CRATES, DEVIL ON A SPIT

In 15 BCE, the Romans established the Augusta Vindelicorum military camp. Due to building over it and demolition, only a few remnants from this time have been preserved. Exhibits can be seen today in the Tuscan-columned hall in the armory, after their former domicile, the Dominikanerkirche (Dominican

Church), had to be closed for structural reasons. To emphasize the interim character of the exhibit called *Römerlager* [Roman Camp]*: Roman Augsburg in Crates*, the exhibits are displayed in storage crates.

The cathedral, built around the year 1000 with its magnificent bronze portal, is the cathedral of the diocese of Augsburg. The Mozart house, where Leopold Mozart, the father of Wolfgang Amadeus, was born, is also found in the Augsburg Cathedral district. The attractive courtyard garden is part of the baroque former residence of the prince-bishop. The second important religious building, the Basilica of Sts. Ulrich and Afra, towers over the southern Old Town. Its 305-foot-high tower, probably the oldest onion-dome tower in Bavaria, is

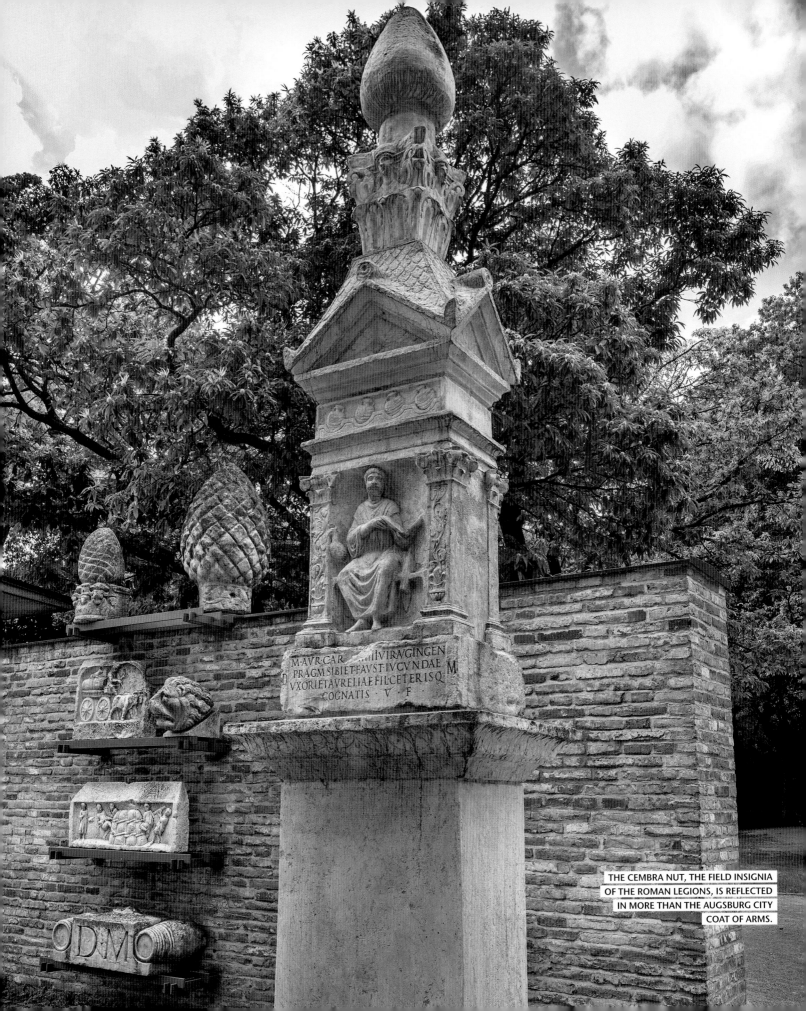

M·AVR·CARIIIIVIRAVGINGEN
D PRAGM SIBI ET FAVSTIVCVNDAE M
VXORI ET AVRELIAE FIL CETERISQ
COGNATIS · V · F

THE CEMBRA NUT, THE FIELD INSIGNIA OF THE ROMAN LEGIONS, IS REFLECTED IN MORE THAN THE AUGSBURG CITY COAT OF ARMS.

one of the landmarks of Augsburg. The St.-Anna-Kirche (St. Anne's Church), founded in 1321 by Carmelite monks, with its magnificent side chapels and paintings by Lucas Cranach, among others, became the city's first Protestant church. On August 8 of every year, the Augsburg High Peace festival commemorates the Peace of Westphalia of 1648, the only public holiday in Germany that is limited to one city. Since the 13th century, Augsburg has been a free imperial city. Its Renaissance buildings are an expression of civic pride, above all the town hall, with its Golden Hall, named after the gilded coffered ceiling. City architect Elias Holl created the most important secular Renaissance building north of the Alps from 1615 to 1620. He is also responsible for the modern appearance of the 230-foot-high Perlach Tower, which was built in the 10th century in the immediate vicinity of the town hall. It is possible to admire the "Turamichele" (tower Michael) display only on September 29, every hour on the hour between 10 a.m. and 6 p.m. With every stroke of the hour, the Archangel Michael stabs the devil lying at his feet. On St. Michael's day, there will also be a big children's festival on Rathausplatz (Town Hall Square). The Schaezlerpalais in Maximilianstraße is a magnificent rococo building, built around 1770 by a wealthy silver merchant. It houses collections of paintings. From there you can also go to the Staatsgalerie Katharinenkirche (Church of St. Katherine State Gallery), which has the Albrecht Dürer portrait of Jakob Fugger.

RICH MERCHANT PRINCES: FUGGER AND WELSER

In the Maximilianstrasse, or Maxstrasse for short, stand the houses of the Augsburger Fuggers, who are probably the most famous Augsburg citizens besides Bertold Brecht and the Holbeins. Jakob Fugger the Rich had the city palace built with its four Tuscan-style courtyards and a warehouse, starting in 1515. The Fugger houses remain in private ownership to this day. The Fuggers, who were based in Augsburg from the 14th century onward, acquired the start-up capital for their global company from cloth making. In the late Middle Ages, Augsburg was an important textile city, especially after the invention of fustian, a blend of cotton and flax. The Fuggers increased their wealth through the art of goldsmithing, and with their entry into the merchant guild they built up their trading empire. The Welser family was likewise an important trading house. A branch in Seville opened the gateway to the transatlantic trade for them. Emperor Charles V mortgaged the South American province of Venezuela to them in 1528. Compared to the Fuggers, the Welsers have left only a few traces behind them in Augsburg. The Welser house, built in the 15th century, stands in the former hay market; it was merged with a neighboring city palace to form the Maximilian Museum. As with the Fuggers, the women members played an important role in this patrician family. Philippine Welser (1527–1580), wife of Archduke Ferdinand II of Habsburg, kept a precise record of everyday life. In the Welser Kuche inn, you can try her recipes. Their

PUPPET SHOWS WITHIN HOLY WALLS

Who doesn't know them, the characters Jim Knopf and Lukas the engine driver from Lummerland, or the Urmele and Mama Wutz from the island of Titiwu. The Augsburg Puppenkiste (marionette theater) has written puppet theater history. Founded by Walter Oehmichen, the theater has been residing in the Heilig-Geist-Spital (Holy Spirit Hospital) since 1948. The four-wing Renaissance building was designed by the city architect Elias Holl from 1623 to 1631 and provided care for the sick and elderly. In 2001, the "die Kiste" (the box) museum moved into the premises, along with the marionette theater and workshops. Children and the young at heart can admire the puppets they know from television and stage sets at close range. The Puppenkiste also offers workshops.

MORE INFORMATION
Sights and activities
www.augsburg-tourismus.de/en/welcome
Augsburger Puppenkiste
www.augsburger-puppenkiste.de

immense wealth allowed the Fugger family to build an entire housing estate for needy Augsburg citizens in the Jakobervorstadt (Jacob's suburb) starting in 1516. The over 160,000-square foot Fuggerei, the oldest social settlement in the world, consists of 67 row houses, each with two apartments. Even today, 150 low-income residents enjoy the privilege of residing there for three prayers a day and an annual net rent of 88 cents. The Fuggerei, which is surrounded by a wall, closes its doors at 10 p.m. A model house at Ochsengasse 51 informs visitors about life there today. Roll-in showers are now standard. The interactive Fugger- und Welser-Erlebnismuseum (Experience Museum) in the historical landmark Wieselhaus has been introducing visitors to the world of old trading families since 2014.

HISTORICAL WATER MANAGEMENT

In 1419, Augsburg was given the right to make use of the waters of the Lech and Wertach Rivers. Canals were an important prerequisite for the development of handicrafts and industry. Some 100 miles of canals flow through the urban area and are particularly picturesque in the old Lech quarter. Numerous weirs regulated the network of waterways. The water towers date back to the 15th century, and the waterworks from the 19th century are still in operation today. The hydropower plants on the Wolfzahnau, the Hochablass, and the Rote Tor are protected historical landmark buildings. The city's more than a hundred fountains include several magnificent fountains, such as the Hercules Fountain or the Augustus Fountain. Hydroelectric power made Augsburg "Germany's Manchester." Little remains of the once-important textile industry. In 2004, the well-known Augsburg worsted spinning mill closed. The long-neglected textile district in the east of the city center is a reminder of pioneering industrialization. In 2010, the Staatliche Textil- und Industriemuseums (State Textile and Industrial Museum) was set up in the old worsted spinning mill; in the Glass Palace, Augsburg's former spinning and weaving mill, are the Zentrum für Gegenwartskunst (Center for Contemporary Art), the Kunstmuseum Walter (Walter Art Museum), and the Noah Gallery. Since then, many creative people have moved into the quarter.

EIGHT ALLEYWAYS RUN THROUGH THE FUGGEREI IN THE AUGSBURG OLD TOWN, SURROUNDED BY A HIGH WALL WITH THREE GATES.

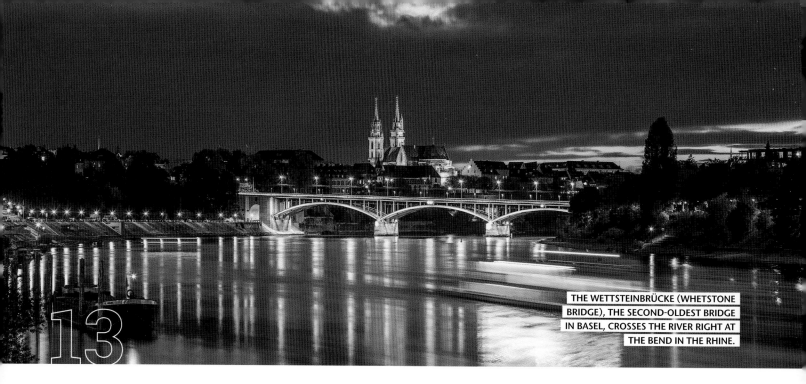

THE WETTSTEINBRÜCKE (WHETSTONE BRIDGE), THE SECOND-OLDEST BRIDGE IN BASEL, CROSSES THE RIVER RIGHT AT THE BEND IN THE RHINE.

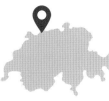

SWITZERLAND

COSMOPOLITAN CITY AT THE THREE COUNTRIES' CORNER

For many, Basel is the secret capital of Switzerland, more than the actual capital of Bern, more than Zurich, and more than Geneva. It has world-class museums, architectural highlights, an intact Old Town, and a charming hinterland. It also sits on the Rhine and close to France and Germany.

The third-largest city in Switzerland stretches along both sides of the Rhine, where the river changes direction from east–west to south–north. The High Rhine ends at the "Rhine's knee" and the upper Rhine begins. Kleinbasel (Little Basel) is on the right, and Großbasel (Great Basel) on the left. The two sides have always hated each other's guts. Kleinbasel, founded in the 13th century, is considered the Basel of ordinary people, formerly also called "lesser" Basel. The more distinguished citizens have always lived in Großbasel. Here you will find the big museums, the elegant shops, and the finest restaurants. In recent years, however, multicultural Kleinbasel has caught up considerably and developed into a trendy district; young families also benefit from the low rents. The most important holiday in Kleinbasel is the Vogel Gryff in January. Then the Wild Maa (wild man), the Vogel Gryff (Gryff bird),

and the Leu (lion), the three heraldic figures of the three Kleinbasel honorary societies (3 E or Ehrengesellschaften) of the Rebhaus, the Hären, and the Greifen, show the fine people of Großbasel their behinds. The 3 E guarded the Kleinbasel section of the city wall during the Middle Ages.

REACTION FERRIES AND BUVETTES

Not only in summer do the people of Basel spend their lives on and along the Rhine River. Several bridges cross the river. The oldest is the middle bridge, built in the 13th century. The original wooden bridge was replaced by a stone bridge between 1903 and 1905. Not only the bridges but also four pedestrian ferries connect Großbasel and Kleinbasel. These reaction ferries—rustic, flat, wooden boats—are an integral part of the Basel cityscape. Those in a real hurry take the Rhytaxi.

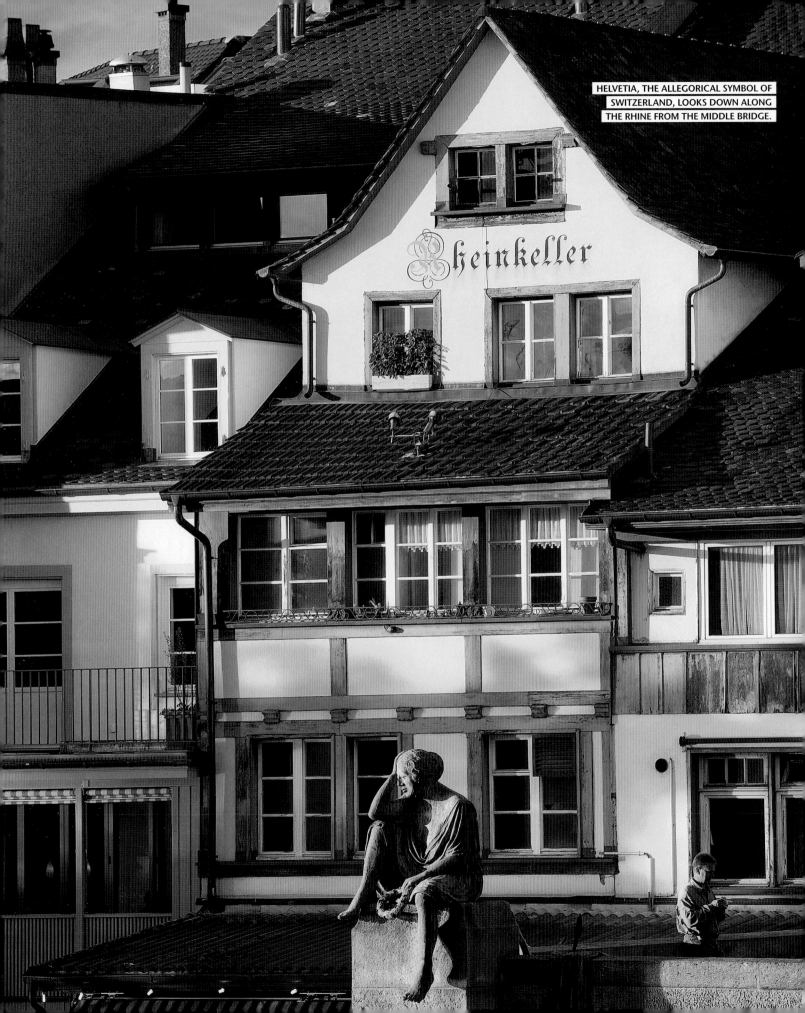

HELVETIA, THE ALLEGORICAL SYMBOL OF SWITZERLAND, LOOKS DOWN ALONG THE RHINE FROM THE MIDDLE BRIDGE.

The water taxis are also very popular with tourists for city tours.

In summer, the Rhine banks, whether the sunbathing lawn, the sandy beach, or just the steps, are transformed into an El Dorado for swimmers. You can change in one of the art nouveau bathhouses. Or you can stow your clothes in the waterproof Basel Wickelfisch, a waterproof swim bag invented by the 19th century. The buvettes on the shore, mobile open-air refreshment stands offering drinks and small meals, take care of your physical well-being. "Rhine swimming" is particularly popular. From the Tinguely Museum you can drift down the Rhine to the Wettstein Bridge, or to above or below the middle bridge. However, only good swimmers should try that.

AROUND THE MINSTER

The Romanesque-Gothic Minster, built on the rocky Münsterhügel (Minster Hill) between 1019 and 1500, is a Basel landmark. Münsterhügel is the historical nucleus of the city and an archeological hotspot. The Minster's predecessors include a Celtic rampart, a Roman fort, and the Haito Minster, a Carolingian church. In 1356 the Basel earthquake destroyed the five church towers. Today there are only two: the Martinsturm (213 feet) and the Georgsturm (219 feet). Both can be climbed by ascending more than 250 steps, and they reward you with a fantastic view. The quake was the strongest in central Europe in historical times. It is said to have left 300–1,000 dead. Many residents had fled the city after several foreshocks. In front of the Minster, built of red sandstone, lies Münsterplatz, a large square surrounded by imposing cathedral canons' houses. Behind the Minster, the Palatinate viewing terrace offers a wonderful view of the Old Town and the Rhine. From there you can reach the Gothic cloister of the Minster. A walk on your own or on the "Basel Old Town Histories" guided tour leads to other gems in the Old Town. Romantic alleys lead from the Münsterhügel to the Marktplatz, which is dominated by the town hall (16th century), with its magnificent wall paintings. The route leads via Hutgasse to Spalenberg, Basel's shopping mile. The Spalentor, one of the three surviving city gates and also the most beautiful, was part of the Basel city wall. Barfüsserplatz (Barefoot Square) is the city center tram junction. The modest late Gothic

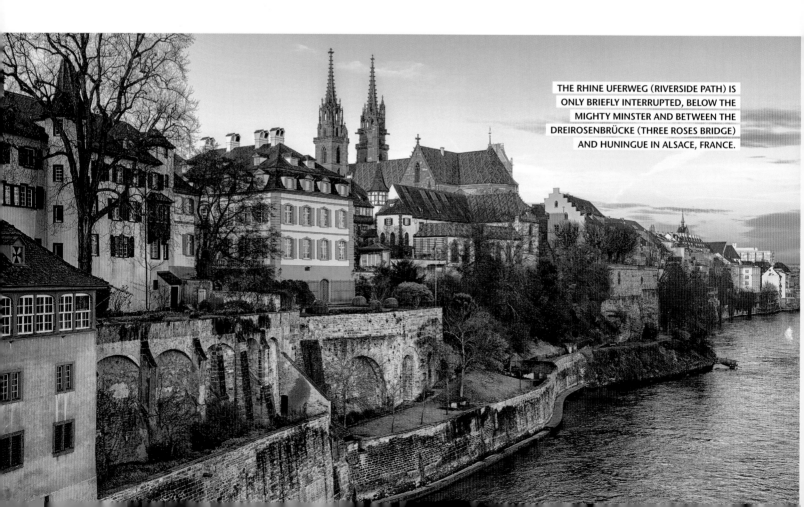

THE RHINE UFERWEG (RIVERSIDE PATH) IS ONLY BRIEFLY INTERRUPTED, BELOW THE MIGHTY MINSTER AND BETWEEN THE DREIROSENBRÜCKE (THREE ROSES BRIDGE) AND HUNINGUE IN ALSACE, FRANCE.

Barfüsserkirche now houses part of the Historical Museum; the Haus zum Kirschgarten (cherry garden house) and the Lohnhof are other exhibition houses. The Fasnacht (Carnival) fountain, with its 10 water-spouting machine sculptures, built in 1977 by Jean Tinguely (1925–1991), awaits you on the Theaterplatz. On the Kleinbasel side, the Tinguely Museum is home to other whimsical objects by the painter and sculptor.

HIGH ABOVE

Right next door is Basel's second landmark, the Roche Tower, at 584 feet the tallest building in Switzerland and the headquarters of the pharmaceutical company Hoffmann–La Roche. The Roche Tower was to be even taller, at 672 feet. Competitor company Novartis can score points on the Novartis campus in northern Basel, with spectacular architecture by Frank O. Gehry, among others. Mario Botta designed the second building of the Bank for International Settlements on Aeschenplatz. The Messeturm (trade fair tower) is another eye-catcher. The Bar Rouge offers a spectacular view from 345 feet in the air.

KUNSTMUSEUM BASEL AND FONDATION BEYELER

There are two world-class museums among the almost 40 in Basel. The main building of the Kunstmuseum Basel (Basel Art Museum), designed in 1936, stands on St. Alban-Graben; it has collections from the Middle Ages to the 19th century as well as works of classical modernism and European postwar modernism. Large special exhibitions are held in the new building opened opposite in 2016. The collection of the gallery owners Hildy and Ernst Beyeler, with a focus on classic modern and contemporary art, formed the foundation of the Fondation Beyeler in Riehen, one of the three municipalities in the Basel Stadt (Basel City) canton. The foundation was established in 1982, and the museum building, designed by Renzo Piano, opened in 1997. It is surrounded by a sculpture park. An expansion by Peter Zumthor is planned, which should fit into the village character of Riehen.

VITRA DESIGN AND AUGUSTA RAURICA

The 5-kilometer Rehberger Weg runs along 24 milestones, from the Beyeler Foundation to the Vitra Campus, a world-class architectural ensemble on the premises of the furniture manufacturer Vitra in Weil am Rhein (in Germany). The Vitra Design Museum is one of the leading design museums. A tour of the largest archeological park in Switzerland, at Augst in the canton of Basel-Land (Basel Country), takes you to Basel's Roman roots. A large Roman festival is always held at the end of August in Augusta Raurica, with its well-preserved Roman theater.

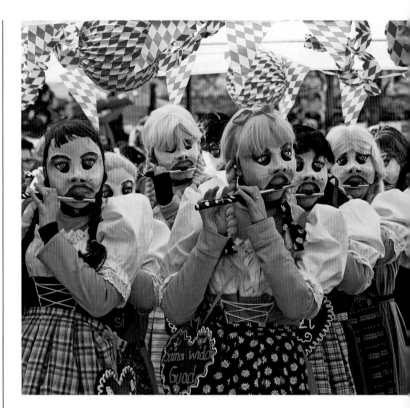

BASEL IN A "STATE OF EMERGENCY"

On the Monday after Ash Wednesday at 4.00 a.m., begin the *drey scheenschte Dääg* (three most beautiful days) in the life of the people of Basel. The Basel Carnival has been part of the Intangible Cultural Heritage (a UNESCO term) of mankind since 2017. At "Morgestraich," the entire city center is still in darkness. Only the elaborately designed high procession lanterns of the individual cliques, the carnival societies, bring light into the darkness—and there is a hell of a lot of noise besides, because the active members drum and whistle around their competitors. The traditional flour soup with onion or cheese quiche is served in pubs at this early hour. The lanterns are on display in Münsterplatz from Monday to Wednesday morning. During this time, parades are held, "Guggemusiker" provide weird music entertainment, and whistlers and drummers roam the streets at night. Confetti and pieces of paper with sassy satirical verses cover the streets.

MORE INFORMATION
Basel tourism
www.basel.com/en
Basel Carnival
www.baslerfasnacht.info

14

SWITZERLAND

POCKET-SIZED SWITZERLAND

A rock plateau rises in the Swiss canton of Friborg at the foot of picturesque Mount Moléson. Thick walls hide the rustic medieval village of Gruyères from the eyes of the world. Archaic architecture merges with treasures from East Asia and futuristic Hollywood to form a harmonious whole.

Anyone who climbs the plateau in the midst of a lovely picture-book landscape of the Swiss Prealps and enters through the medieval fortified wall will unexpectedly seem to find themselves on the set for a "Heimat" movie—German-language movies about home moors and mountains. Medieval houses, leaning and crooked, but dressed up, colorful, and decorated with flowers, line the bumpy cobblestones of Marktgasse (Market Alley) as it rises slightly. Low doors, curved window arches, balconies with exuberant floral decorations, golden symbols of guilds, plenty of lovingly carved wood, rustic ancient pubs, cute

terraces with red checkered tablecloths from the 1950s, and the splashing fountain in the midst of it all let you escape reality. A white chapel presides at the end of Gruyères' only street, and everything is set against the backdrop of pretty alpine pastures and rugged rock faces. This place invites you to take a relaxed stroll—and immediately gives the visitor a feeling of security.

BODHISATTVAS AND BAROQUE

The Tibet Museum in the rooms of the renovated St.-Josephs-Kapelle (chapel) transports its visitors to the high country of central Asia. Inside, Alain

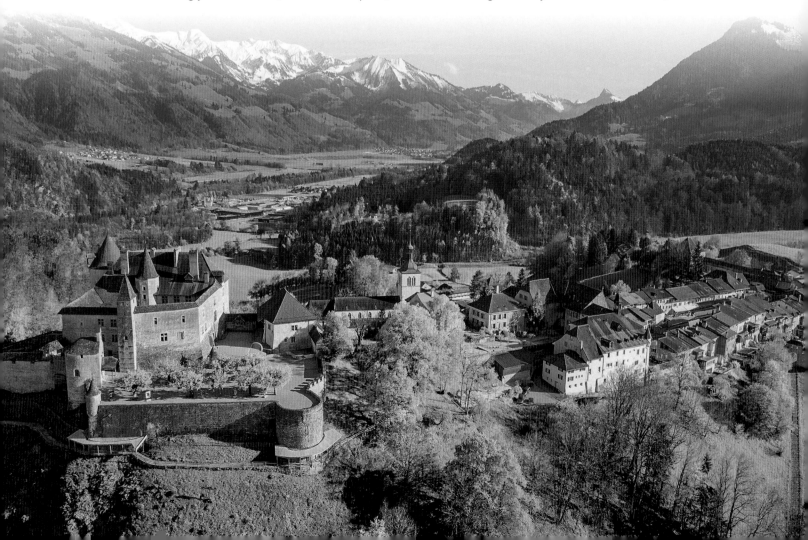

Bordier presents a knowledgeably assembled collection of Buddhist sculptures, paintings, and ritual objects from Nepal, Kashmir, Swat, northern India, and Myanmar (Burma), acquired on many trips over three decades, all in a spectacular atmosphere. Some of the treasures were hidden from the public for centuries, and today they attract guests from all over the world. The magically beautiful castle of the counts of Gruyères is located on the highest point of the plateau. In addition to a magnificent view, it provides an overview of eight centuries of architecture. The counts were once one of the most important princely families in western Switzerland, but in the middle of the 16th century, the last heir, Michael von Greyerz, went bankrupt. After an eventful history, today you can admire wall paintings by Camille Corot, the tasteful French baroque garden, the octagonal stair tower, and the courtyard with chapel and restrained decoration by contemporary artists.

A SLICE OF HOLLYWOOD

A completely different mysterious world is hidden in the HR Giger Museum, in the private collection of fantastic art by interior designer, designer, painter, and sculptor Hansruedi Giger. In the museum bar, you sit comfortably, under the vault of vertebrae, in the presence of aliens grimacing in huge bone chairs of a distant future on another planet. The "grand master of screen horror" became famous above all for his airbrush "bio-mechanical style." Hollywood won over Giger to stage many science fiction films. In 1978 Giger received an Oscar for the design of Ridley Scott's film *Alien*. A wonderful contrast to the picturesque village!

GRUYÈRES AND ITS PALACE LIE AT THE FOOT OF MOUNT MOLÉSON (*OPPOSITE*).
SWISS ALPHORN PLAYERS WELCOME TRAVELERS ON MARKTGASSE, THE ONLY STREET IN THE VILLAGE (*BELOW*).

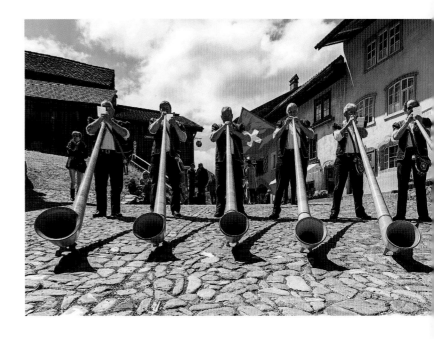

The architectural gem of Gruyères in the Swiss Prealps has many surprises in store and manages to combine alpine pastures, medieval architecture, and aliens to create a true place of well-being. Otherwise, hikers and cyclists value the paths around Gruyères, which lead to lakes, neighboring towns such as Bulle, totally different but also worth seeing, or to the world of the mountains.

GRUYÈRE CHEESE

In Gruyères, guests scent heavy, spicy fragrances everywhere: no wonder, because here is the home of the original fondue and raclette, prepared with Gruyère, also called Gruyère cheese. A fondue is served in all its simplicity. Boiled potatoes, white bread, gherkins, and at least one glass of cool fondant are served along with a pot of bubbling cheese. The price contrasts with the simplicity of the dish, but the aroma and creaminess of the cheese make it easy to forget how much it costs. If you want to experience how the creaminess is created, visit the "Maison du Gruyère" at the foot of the hill in the village of Pringy (www.lamaisondugruyere.ch).

After visiting the sometimes interactive exhibit, you can taste cheese delicacies in the restaurant and take your favorites along with you from the shop.

MORE INFORMATION
La Gruyère Tourism
www.gruyeres.ch
When visiting or going to restaurants in Gruyères, please take note that in the evening the village is closed to traffic at around 7:00 p.m.

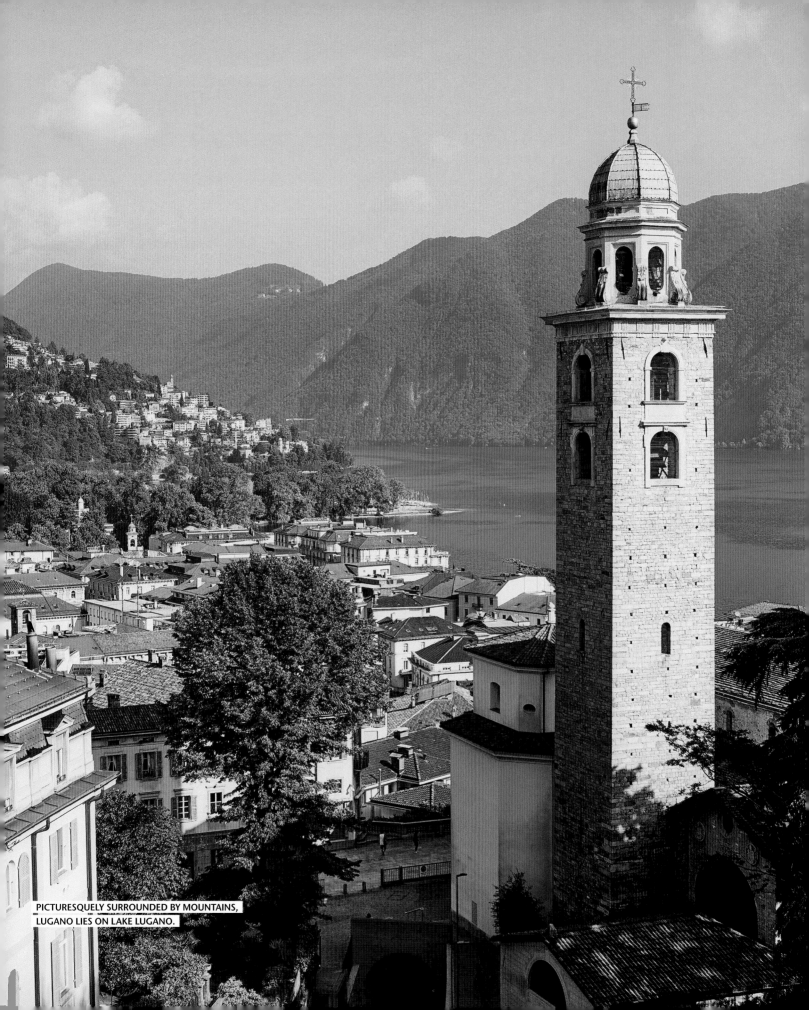

PICTURESQUELY SURROUNDED BY MOUNTAINS, LUGANO LIES ON LAKE LUGANO.

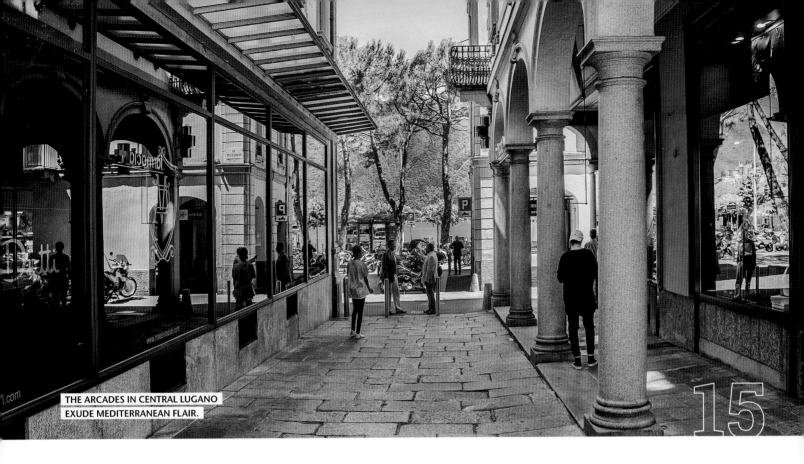

THE ARCADES IN CENTRAL LUGANO
EXUDE MEDITERRANEAN FLAIR.

15

MEDITERRANEAN GRANDESSA AT THE FOOT OF THE ALPS

SWITZERLAND

Nowhere is Switzerland more Italian than in Lugano: a mild climate, a historical Old Town with lively squares lined with sacred buildings and palazzi, a sophisticated promenade, street cafés of all kinds—and above all, an atmosphere of casual elegance. Its location on Lake Lugano at the foot of two local mountains also creates magical panoramas.

Lugano, in the south of the Swiss canton of Ticino, stretches along a picturesque bay in northern Lake Lugano. The city owes its mild climate to its location on the southern side of the Alps, and its Mediterranean flair not least due to the historical Old Town.

SOPHISTICATED ELEGANCE AND FINE ARCHITECTURE

The broad Piazza della Riforma in the Old Town is surrounded by impressive buildings from the Middle Ages and early modern times. The street cafés and bars are popular meeting places for locals and tourists alike. With an espresso or aperitivo, you can view the hustle and bustle in the piazza with relish. If you let your gaze wander over people and houses, at some point you get stuck at the town hall right next door. The monumental classicist building (1844) was first erected as a government building.

Behind the piazza is the Via Nassa, the most elegant shopping street in the city, with its arcades and sophisticated shops and boutiques. From Armani to Versace, this city in Canton Ticino (with 68,000 inhabitants) is home to all the big names in the world of fashion and design and can certainly

compete with its big sisters in northern Italy. Likely far more extensively available in Lugano than in Italy are Swiss precision timepieces, primarily in the upper price range. Lugano is Switzerland's third-largest financial center and has long attracted an affluent public—luxury labels must be at hand. But you can also find alternative offerings in small shops in the narrow and sometimes steep Old Town streets. There you can stroll and browse to your heart's content.

Palazzi such as La Picconaia on Corso Pestalozzi, a Renaissance building (15th century), or the three Palazzi Riva, important examples of late baroque architecture, contribute to the spacious flair of the Old Town. However, some of the historical-looking buildings were built only in the 20th century, in the course of renovation of the city. However, this was done in the old style, such as the Palazzi Gargantini with elements of neobaroque and art deco, the Palazzina Alhambra in the style of the neo-Renaissance, or the historical Palazzo degli Studi.

CHURCHES AND ART

Of course, Lugano is also rich in imposing churches. The Cathedral of San Lorenzo dates back to the 13th century and even integrated Roman walls. The current building is predominantly Gothic but has been rebuilt several times. The church got its magnificent display facade in Lombard Renaissance style only in the 16th century.

The parish church of Santa Maria Degli Angioli dates from the same century and is best known for its fresco cycle: Bernardo Luini (1482–1532), a student of Leonardo da Vinci, was responsible for the *Crucifixion of Christ*, the *Last Supper*, and *Madonna with Child*. The church of San Rocco (1528–1723) makes an impression with its trompe l'oeil architecture and baroque frescoes. The lavish interior of the church of Sant'Antonio Abate (17th and 20th centuries) is also baroque.

The MASI in LAC—the Museo d'Arte della Svizzeria Italiana in Lugano Arte e Cultura—is the figurehead of the rich cultural scene in Lugano. In the cultural center, which was completed in 2015, the

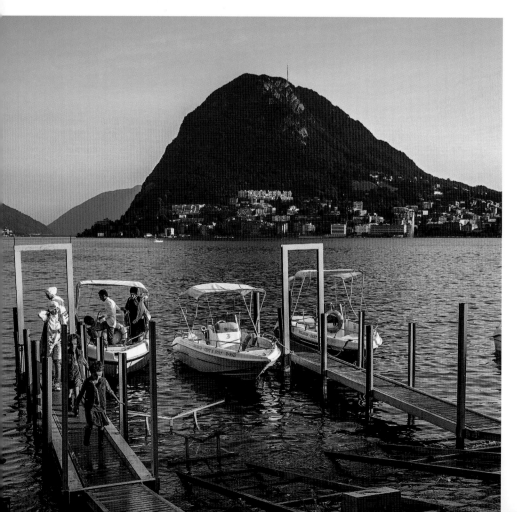

A BOAT TOUR AROUND THE LAKE OPENS UP TOTALLY NEW PERSPECTIVES (*LEFT*).
A SWISS COW WITH THE COAT OF ARMS OF THE CANTON OF TICINO AND THE CITY OF LUGANO (*ABOVE*).

MASI occupies three floors. The exhibits range from the 15th century up to the present. The LAC also stages concerts, theater, and dance performances as well as cultural events for children, teenagers, and families as part of its extensive offerings.

An important part of the cultural life in Lugano is the festivals, such as the Lugano Jazz Festival, held every year in June–July. Internationally known, in addition to jazz greats, it also attracts musicians from other genres from all over the world. The city also offers the perfect stage for rousing open-air concerts.

PROMENADE TO PARADISE

After strolling through the city and visiting a museum, a walk along the lakeside promenade in Lugano completes the day. The promenade was built in stages between 1864 and 1920 and leads to the Paradiso district, with its modern hotels. There are always delightful views of the lake, the city, and the surrounding mountains. At the other end of the lakeside promenade, the path leads directly into the Parco Civico. The well-tended walking paths in this 678,000-square-foot area are lined with centuries-old trees and exotic flowers and decorated with statues and fountains. Palm trees and other exotic trees sway in the wind. Roses, azaleas, magnolias, and camellias exude an intense fragrance. The Villa Ciani emerges in the middle of the park. With its classicist designs, it is one of the most beautiful buildings of the 19th century in Ticino. Today the Museum of the Arts is housed there.

LAKE MEETS BADI

If the very mild weather and the view of the blue-green lake encourages you to go swimming starting from April onward, you will be spoiled for choice among the many beach resorts, the Swiss "badi." Most of them have a separate area by the lake for swimming, and a small *ristorante* that serves its guests with Ticino cuisine. At the same time, several pools, including an Olympic pool, can be found at the Lido Lugano, the official city beach. Not far from the city center are, for example, the Lido San Domenico or the Lido Riva Caccia. At the latter, a large floating wooden platform serves for sunbathing. Lake and swimming pool meet at the Lidino Piscina Comunale Conca d'Oro: on one side you dive into the lake water; on the other there is a swimming pool. Speaking of the lake: Of course, you can also do like what George Clooney does on

Lake Como and flee across the water by boat. But with the view of the lakeside promenade with its villas and palazzi, of the church towers towering out of the lush greenery, and of the mountains framing Lugano, you know that even Clooney couldn't have it more beautiful!

UP SWITZERLAND'S SUGARLOAF MOUNTAIN

The two local mountains Monte Brè (3035 feet) and Monte San Salvatore (2992 feet) form an extremely attractive part of the Lugano panorama. Not only are they beautiful to look at from below, but you can also ascend them. Both peaks can be easily reached by funicular railway, either from the city center or from Paradiso. The ascent itself is already a feast for the eyes. Once at the top, there is a magnificent all-around view of the city, the lake, and the Alps—*grande emozione*. A hiking trail leads from Monte Brè down to the typical Ticino village of Brè. From San Salvatore, the "Sugarloaf Mountain," you hike along the panoramic path to Carona and then down to Morcote am See. From there, the boat takes you back to Lugano.

MORE INFORMATION
Lugano Tourist Information
www.luganoregion.com/en
Monte Brè
www.montebre.ch/en
Monte San Salvatore
www.montesansalvatore.ch/en

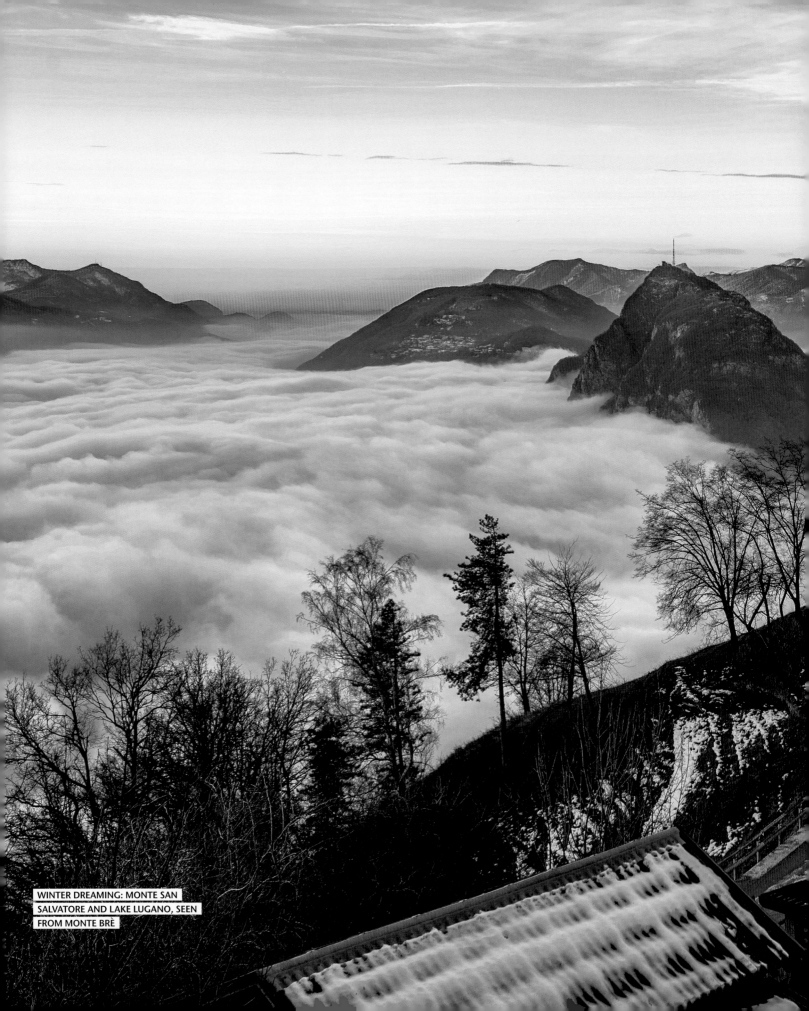

WINTER DREAMING: MONTE SAN
SALVATORE AND LAKE LUGANO, SEEN
FROM MONTE BRÈ

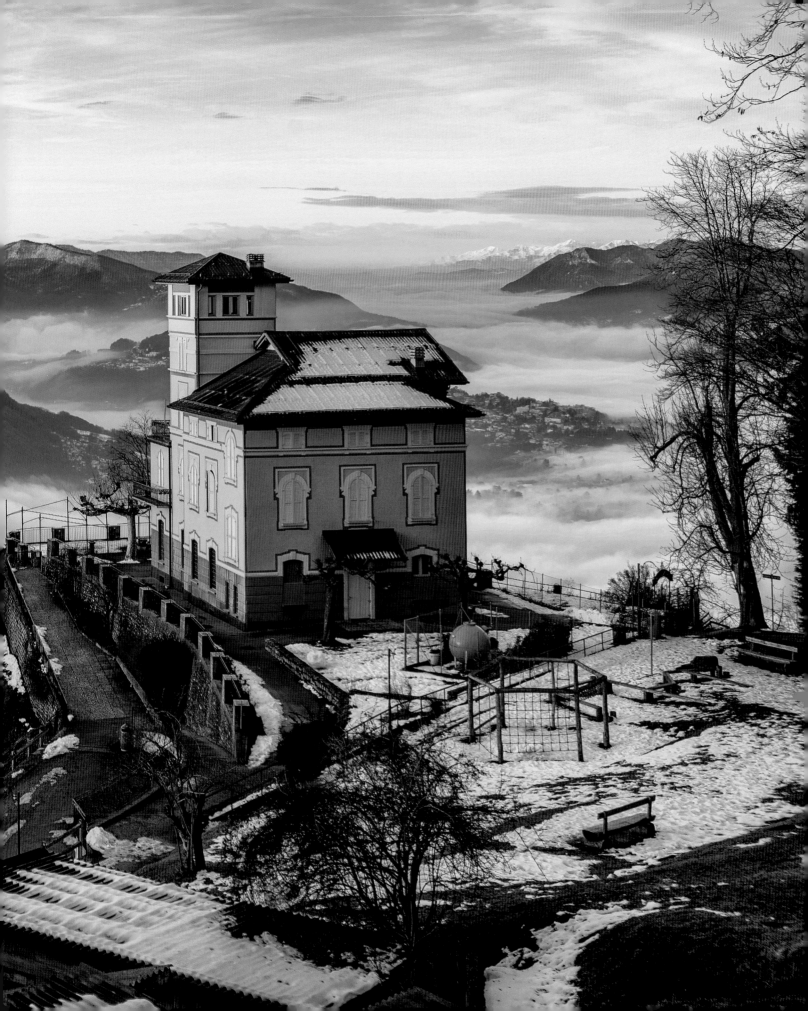

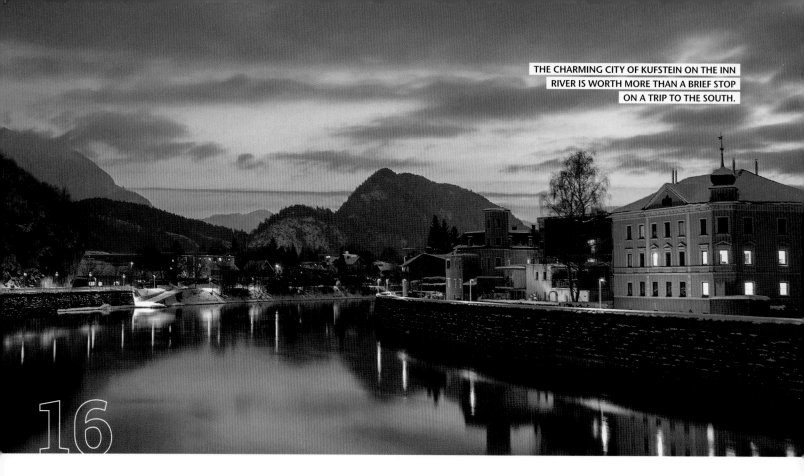

16

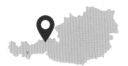

AUSTRIA

KUFSTEIN—PEARL OF TYROL

CITADEL OF GOOD TASTE

The famous "Kufstein song" by Karl Ganzer, written in 1947, already reveals a great deal about the town: it lies on the green Inn River, is framed by peaceful mountains, and has a good glass of wine ready for everyone. This in fact is how things actually are in Kufstein. But there is much more beyond this to discover about Tyrolean history and its way of life.

The citadel of Kufstein, with its brilliant white walls, has been presiding over a rocky plateau high above the Inn, against a picturesque mountain backdrop, since the early 13th century. Initially in the possession of Duke Ludwig of Bavaria and the Bishop of Regensburg in Bavaria, Bavarians and Tyroleans were soon fighting over the town. As bridal dowry of Duchess Margarethe "Maultasch" ("mouth pocket," a German ravioli dish; may refer to a deformed jaw), Kufstein fell to Tyrol. The duchess gave it as a gift to the Habsburgs, then the Bavarians invaded . . . It would be pointless to go through all the wrangling over Kufstein among the Bavarians, Austrians, and others over the centuries.

The city on the Inn River was obviously always in demand—since 1814, Tyrol and Kufstein have been part of Austria again. Tyrol has been a well-loved vacation destination for generations, but pretty Kufstein may still surprise some visitors.

DEFIANT LANDMARK WITH A CONCERT

If the fortress seems almost impregnable from below, it can still be conquered on foot. It is more comfortable and maybe even more impressive to take the Kaiser-Maximilian funicular railway from the visitor center and enjoy the panoramic view. In the fortress itself, with its huge area—almost a town in itself—children can now explore the cannons in the

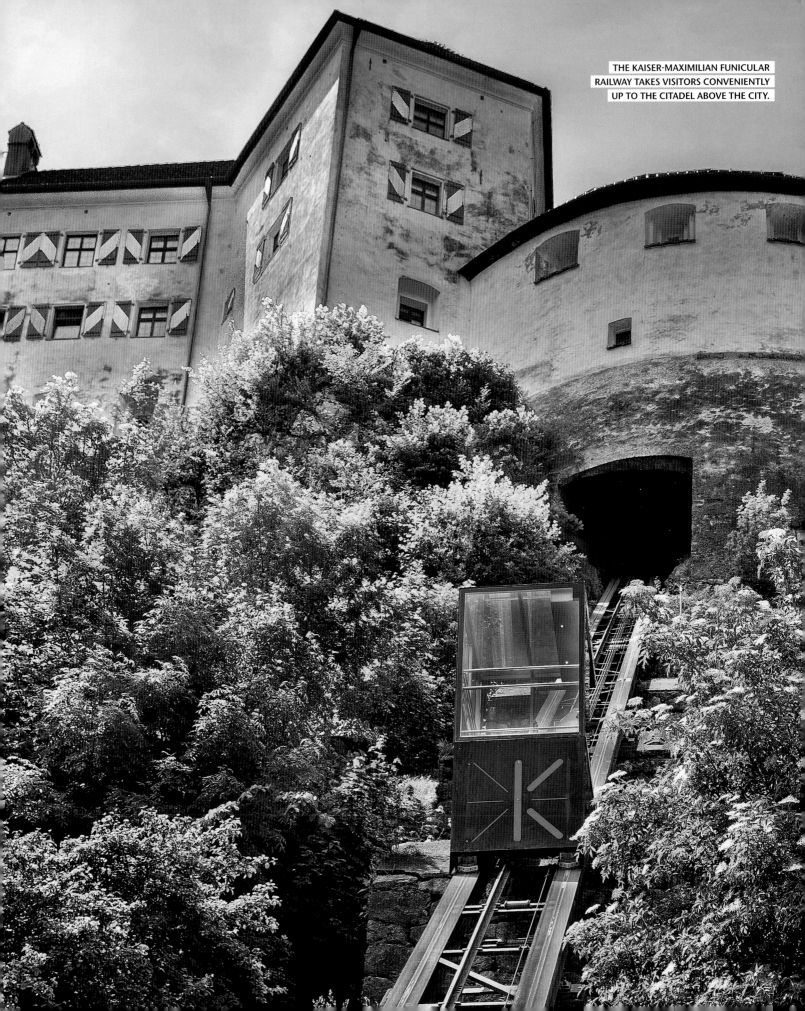

Elisabeth battery or discover the secrets of the 197-foot-deep "fountain." Numerous museum stations, modern and effectively designed, ensure visitors a very entertaining journey into the region's past. The small, steep, cobblestone-paved streets of the fortress complex are picturesque, and the panoramic view of the river and valley into the mountains is magnificent. After strolling, clambering, and climbing around on hot summer days, the beer garden, with its old trees within the old walls, lets you relax and cool down. The nearly 5,000 pipes of the world's first freestanding organ play a song of praise for this travel destination at the foot of the fortress every day at noon.

CHIC SNACKS

Connoisseurs have a single goal in Kufstein: The "cupa wein- und genussbar" (wine cup and enjoyable) at Unteren Stadtplatz 12. In this small, fine, vaulted eatery with its barrique, steel, and shell limestone ambience, snacks made of the world's best kinds of ham and cheese, caviar from the Alpine region, and products from fisheries on the Atlantic are featured for the spoiled gourmet palate. You can taste local wines or a fine international selection along with them. You can take out delicacies such as prepared fish in decorative containers.

Not far from here, at Unteren Stadtplatz (Lower City Square) 19, the "Café Liebelei" spoils its guests indoors—or outside in good weather—with an ever-changing range of small meals, homemade cakes, good coffee, and selected wines, which you can also buy here.

MORE INFORMATION
Tourist Association Kufsteinerland

www.kufstein.com/en
Everything is within walking distance within the very manageable city center.

THE OLD TOWN CELEBRATES THE GOOD LIFE

There are many more reasons not to just take a quick look at the fortress on the way to South Tyrol, but to stop and explore Kufstein yourself. Of course, the Kaiser Lift from Kufstein will also take any guest so inclined to the Kaiser Mountains for enjoyable hiking, but then he would miss surprising impressions of Tyrol. If you walk under the bridge passageway in the traditional, hundreds-of-years-old "Auracher Löchl" restaurant, you feel like you are in a different time. Here, quaint pubs with decorative guild signs and paintings are lined up in a row; from the narrow, short alley, you can look into the cozy pubs and vaulted cellars. The menus not only include substantial and tasty Tyrolean specialties such as hearty snacks including Tyrolean ham, Schlutzkrapfen (ravioli), bacon dumplings, or Kaiserschmarrn (desert pancakes), but also Tyrolean tapas or juicy Argentinian steaks. The buildings, for their part, also house surprising items such as a chic bar and the largest gin collection in the world.

HIGH PROOF AND FRUITY

Kufstein turns out to be a small, tranquil shopping paradise, and not just for typical regional items. Tyrol, like South Tyrol, is known for fine brandies, which you can get at the Kronthaler distillery. Tyrolean and other spirits, including local and Mediterranean delicacies, can be found in small, owner-run shops. Traditional "Tracht" costume fashions are also available. Anyone who takes the time and strolls down the street of Unterer Stadtplatz will discover a well-stocked bookshop, pretty cafés, and tasteful home accessories in light, vaulted cellars, and many a pub that invites you to relax and enjoy yourself.

WINE BY THE GLASS—FINE AND FUNCTIONAL

Wherever you are in Tyrol, wine is not far away. Whether red or white, in Kufstein they ensure that it is served in style and that its bouquet can open up. There is hissing and steaming in the Weissachstrasse—a hellish 1,000°C unfold at your feet—and it is masterfully controlled by strong men using strange-looking equipment. This is the way it has to be; otherwise, their efforts would not result in the immaculately beautiful and well-proportioned fragile objects that delight every aesthete, but above all, restaurateurs and sommeliers. From

the circular platform above the heads of the masters, you will never tire of watching all the production steps in the glassblowing workshop.

In the Riedel exhibition glassworks you can learn everything about glassmaking, the correct way to serve wine, and enjoying things with all your senses in an authentic and entertaining way. After all, the owner family, now in its 12th generation, produces mouth-blown vessels from quartz, lime, and alkalis, primarily for the juice of the vine. After World War II, Claus Riedel and his father, Walter, reopened the former Bohemian company in Kufstein with the help of the Swarovski family. Soon the brands Nachtmann and Spiegelau would also belong to them. The then company boss not only developed various series of glasses, he was also the first to recognize the effect of the shape of the glass on the wine aroma and went a step further: "glass professor" Claus Riedel developed the grape-specific, functional wineglass—no longer designed on a purely decorative basis, but puristic and subordinate to the character of the wine. The shape, size, and diameter of such a wineglass brings out the aroma, texture, taste, and reverberation of a wine in the best possible way.

Also worth seeing at the large campus with outdoor seating are the well-stocked and highly informative small museum on the history of glass in general and that of the family company in particular, as well as—not to be overlooked in Kufstein— the large shop, which sells more than just glasses and decanters.

THE GERMAN NATIONAL ECONOMIST FRIEDRICH LIST, A 19TH-CENTURY ADVOCATE OF DOMESTIC FREE TRADE, SETTLED IN KUFSTEIN (*ABOVE*). QUAINT PUBS ARE FOUND NEAR THE AURACHER LÖCHL (*RIGHT*).

17

AUSTRIA

BENEATH THE CLOCK TOWER

Graz adorns itself with many nicknames, and rightly so. The enclosed historical city center, which is a UNESCO World Heritage Site, and its immediate surroundings reflect the development of architecture and town planning from the Gothic period to the present. Graz has also called itself Austria's Capital of Delights since 2008—its 17 award-winning restaurants back this up.

The 1434-foot-high Schlossberg hill, together with its striking clock tower, the symbol of Graz, offers the best way to see the homogeneous cityscape. The city on the Mur River also owes this homogeneity to its red-tile roof landscape. The artificial Island in the Mur and the futuristic art house create modern accents. The 92-foot-high, square clock tower dates from the 13th century, and the striking dials on each side were painted as a fresco in 1712. A wooden rampart above them leads around the tower. The hour bell rings for every hour; the fire bell used to warn of fire, and the executioner's bell rang for executions. The tower and clockwork can be visited, as can the massive bell tower with its "Liesl" bell. The Schlossberg can be reached via the Schlossberg cable car, the glass Schlossberg lift, or on foot via the Kriegssteig (war ascent) with its 260 steps.

HAUPTPLATZ AND THE GRAZ STADTKRONE

In the heart of the Old Town lies Hauptplatz (Main Square), surrounded by magnificent town houses and city palaces. A particularly beautiful example is the Luegg House, on the corner of Sporgasse, richly decorated with baroque stucco. The seat of the Graz city government is the imposing 19th-century town hall, with its large dome and corner turrets, located on the south side of the square. The Landtag (State Parliament) of the Austrian state of Styria meets in the State Parliament building in Herrengasse. The Renaissance building is fascinating with its airy arcades, which surround all three floors of the arcade courtyard and the State Parliament building courtyard. The State Parliament building also houses the state armory, with the largest arsenal in the world. Stretching between the

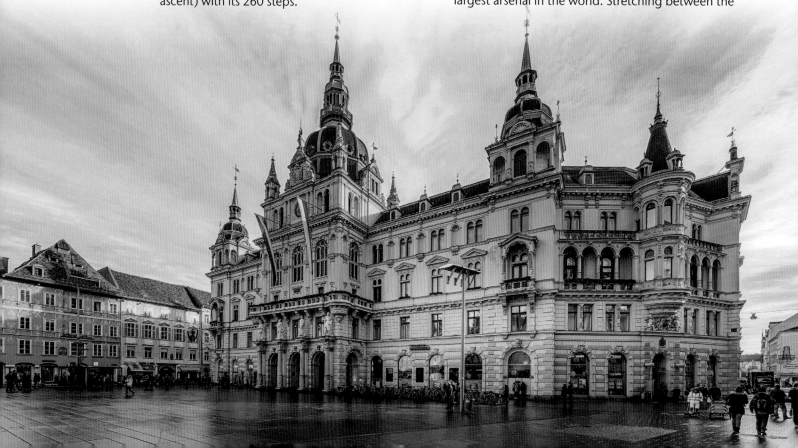

Schlossberg and the extensive city park, the "Grazer Stadtkrone" (city crown) is a unique urban ensemble. The focus is on the late Gothic-style Graz Cathedral and the mannerist mausoleum of Emperor Ferdinand II, dating from the 17th century, along with the Katharinenkirche (St. Katherine's Church). Other Stadtkrone gems include the old Jesuit University and Graz Castle.

TWELVE TIMES JOANNEUM

Graz also has an abundance of important museums. The Universal Museum Joanneum, the oldest and second-largest museum in Austria, is spread over 12 locations. In addition to the Landeszeughaus (state armory) in the Joanneum quarter—also connected together underground—they include the Neue Galerie Graz and the Naturkunde (Natural History) Museum, the Museum für Geschichte (History Museum), the futuristic Kunsthaus (Art House) Graz, the Volkskunde (Ethnological) Museum, the collections in Eggenberg palace, and other museums in the Austrian state of Styria. The open-air Kunstgarten Museum presents garden spaces as art.

WITH A FINGER ON THE PULSE OF THE TIMES

With its remarkable modern and contemporary architecture, Graz eclipses many a world metropolis. When taking a walk through the city of design, the successful combination of old and new immediately catches the eye. Contemporary elements were sometimes boldly incorporated into the cityscape, above all the Kunsthaus (Art House) am Lendkai, which has been given many names, such as the "friendly alien." Not far away, the artificial Island in the Mur, shaped like a shell, draws your attention.

THE TOWN HALL, BUILT IN THE LATE HISTORICIST OLD-GERMAN STYLE, PRESIDES OVER THE BROAD HAUPTPLATZ WITH ITS RENAISSANCE HOUSES (*BELOW LEFT*).
THE GRACEFUL FOOTBRIDGES TO THE ISLAND IN THE MUR GLEAM A LUMINOUS BLUE AFTER DARK (*BELOW*).

Near the converted main train station, with its colorful main hall, stands the Rondo, which houses living and business premises as well as studios. An early work of the Graz school, dating from 1977, is the bizarre multipurpose hall of the Franciscan Schulschwestern (teaching or school sisters) in its biomorphic forms. A wide variety of styles are represented in the university quarter, such as the fragile greenhouses in the botanical garden. The Styrian Autumn, a festival for contemporary art, enjoys a worldwide reputation.

EGGENBERG PALACE

Since 2010, the most important baroque palace complex in Styria and its extensive parks have been a UNESCO World Heritage Site. The former residence of the princes von Eggenberg, to the west of Graz, was intended to symbolize the universe in its architecture and interior design. The palace church stands at the center of the three-story rectangular complex. Among the 24 state rooms, the Planetensaal (planet hall) stands out. The highlight tours by candlelight are particularly atmospheric. For conservation reasons—heating and artificial light could damage the interior—the state rooms are closed in winter. Open all year-round, the gardens, which are combined to form a landscape

park, are a total work of art, as is the palace. The Planetengarten (planet garden) has been a pendant to the Planetensaal since 1999.

MORE INFORMATION
City of Graz
www.graztourismus.at/en
Award-winning restaurants
www.graztourismus.at/en/eat-and-drink/restaurant-guide (Gastroguide)
Eggenberg Palace
https://www.museum-joanneum.at/en

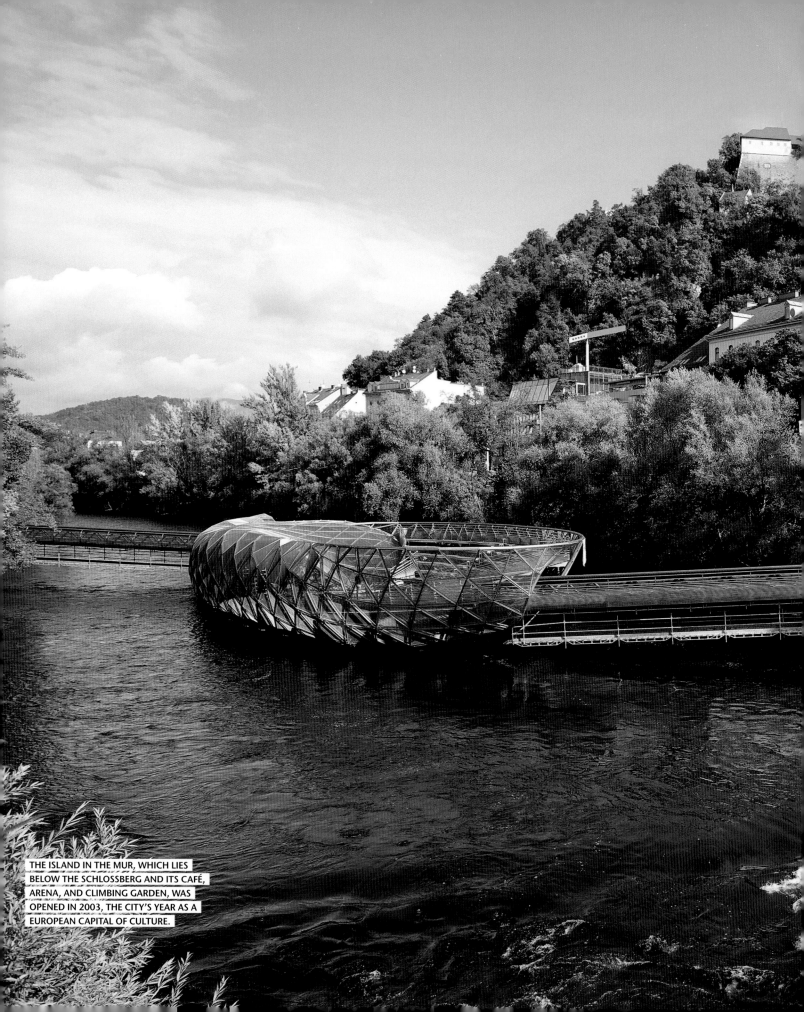

THE ISLAND IN THE MUR, WHICH LIES BELOW THE SCHLOSSBERG AND ITS CAFÉ, ARENA, AND CLIMBING GARDEN, WAS OPENED IN 2003, THE CITY'S YEAR AS A EUROPEAN CAPITAL OF CULTURE.

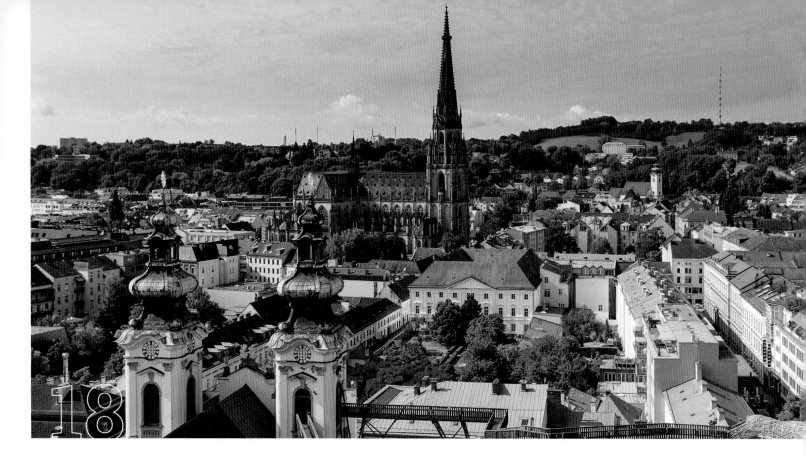

AUSTRIA

CULTURAL METROPOLIS ON THE DANUBE

Linz is something else! The lovely beauty of its architecture, as you know it from Vienna or Salzburg, does not dominate here. Among the magnificent historical facades there is plenty of space for modern life and contemporary art. The people of Linz enjoy both in a very relaxed way—and of course recommend Linzer torte to visitors.

The third-largest city in Austria is located right on the Danube River. The image of the former steel city has changed significantly. Greater environmental protection and intensive cultural support have made Linz a livable metropolis.

GREAT, SUBTLE, TASTY

The heart of the city beats on Hauptplatz (Main Square) and in the Old Town. Laid out in the 13th century, it is one of the largest rebuilt spaces in Europe with its 142,000 square feet. The center is adorned by the 65-foot-high Dreifaltigkeitssäule (Holy Trinity column), built of white Salzburg marble (in 1723), which was constructed in gratitude for rescue from war, fire, and plague. The square, which as a marketplace brought prosperity to Linz as early as the Middle Ages, is surrounded by imposing historical buildings. On the east side is the old town hall, which was given its current facade and the arcade courtyard inside in 1659. An aerial view of the city, mounted as an accessible city map, can be seen in its foyer. Not far away are the impressive late historical Kirchmayr House, the late Gothic Schmidtberger House, and the early baroque Feichtinger House palace, with the Linz glockenspiel chimes. The changing melody—sometimes Mozart, sometimes Bruckner, sometimes Christmas carols—can be heard for four minutes three times a day and is as much a part of Linz as Linzer torte (nut and black currant jam tart), which can be enjoyed in style at the Jindrak Konditorei (pâtisserie). But it also tastes just as good in the hip ambience of a modern café. By the way: it must be *real* Linzer torte, because there are different recipes.

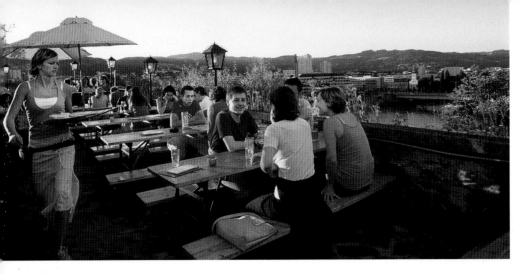

VIEW OF LINZ WITH THE NEW CATHEDRAL (*BACKGROUND*) AND THE URSULINE CHURCH IN THE FOREGROUND (*OPPOSITE*).
DAY'S END AT THE PALACE BEER GARDEN ABOVE THE DANUBE (*LEFT*)

The Linzer Landstraße, the main shopping mile, adjoins Hauptplatz (Main Square); from there, you should definitely also turn into the side streets. That is where you will find a lot of newer, alternative shops and labels that abide by ecological and sustainable production methods, and many cozy cafés and restaurants where you can take a break in between. At the southern end of Hauptplatz stand the Alte Dom (Old Cathedral) and the baroque Ignatiuskirche (St. Ignatius Church) (1669–1683) with the Bruckner. This organ is so named because the composer Anton Bruckner (1824–1896) played it as the Linz cathedral organist for 13 years. The Mariendom (St. Mary's Cathedral) is the new cathedral; it was finished in 1924 and is the largest church in Austria, with space for 20,000 people. If you are not afraid of climbing the 395 steps to the tower, you will be able to enjoy a fantastic panoramic view of Linz.

There is also a beautiful view on the local mountain, the Pöstlingberg; the Pöstlingberg mountain tramway takes you up comfortably. The Sieben Schmerzen Mariä (Mary's Seven Sorrows) pilgrimage basilica on the summit can be seen from almost every point in the Old Town.

GRAFFITI AND HIGH TECH

The river port is all about contemporary art. Old industrial buildings and house facades in the "Mural Harbor" are decorated with 200 graffiti, some of which are several hundred square meters in size. International artists created this impressive open-air gallery. A visitor is also allowed to spray-paint if he feels compelled to do so. The Lentos Kunstmuseum (Art Museum) (2003) on the Danube also features modern and contemporary art. Its 425-foot-long glass facade is brightly lit at night and is reflected in the Danube. Creating and exhibiting art merge together in the Offenes Kulturhaus (OK) (Open Cultural House).

THE FUTURE LIES ON THE DANUBE

The futuristic Ars Electronica Center (1996, renovated in 2009) on the Danube is also concerned with the future. It makes future technologies tangible today. In the four laboratories (BrainLab, BioLab, RoboLab, and FabLab), visitors can program, experiment, control robots, clone plants, or take pictures of their own retinas. Thinking for yourself and trying things out are welcome! The highlight is Deep Space, a 3-D projection room in which gigantic, high-resolution images and videos make it possible to take trips through space and time. A delightful gimmick: any visitor can illuminate the 38,500 four-color LEDs on the Ars Electronica Center's facade by using the facade terminal via a smartphone or laptop.

MORE INFORMATION
Linz Tourist Information
www.linztourismus.at/en/leisure
Ars Electronica Center
ars.electronica.art/news/en/
Harbor graffiti
www.muralharbor.at

LJUBLJANA—THE FRIENDLY DRAGON CITY

ITALIAN ELEGANCE AND HABSBURG SPLENDOR

Slovenia's capital city on the Ljubljanica River is quite manageable, with just under 300,000 inhabitants. But the many students there ensure a rich culture and nightlife. Ljubljana offers its visitors great architectural diversity. It's hard to imagine that the city has been completely destroyed by earthquakes twice.

The first earthquake, in 1511, hit the medieval building structures; the second, in 1895, buried many of the magnificent Renaissance buildings. Viennese builders and Italian artists shaped Ljubljana's style when it was rebuilt—here, Austrian Habsburg meets the Mediterranean South. The many buildings by the important Slovenian architect Jože Plečnik, a son of the city, are typical of the cityscape.

DRAGONS ON GUARD

The castle (Ljubljanski grad) proudly towers over the roofs: from its observation tower you have the most beautiful view of the Old Town and the surrounding city quarters. Settled since early times,

a fortress was built on the hill in the Middle Ages. Today's castle was built in the 15th century and continually enlarged over the next 300 years. A small cable car carries the footsore to the top. The Marionette Theater Museum and the *Slovenian History* exhibit, as well as the "virtual castle," are located in the castle rooms.

At the foot of the complex, on the banks of the river, lies the baroque-style religious power center: the Stolnica svetega Nikolaja (St. Nicholas Cathedral) and the Škofiski dvorec (bishop's palace). Two massive bronze gates from the 20th century were personally blessed by Pope John Paul II in 1996. The elegant houses and palaces in the pedestrian zone are also baroque—the Palais

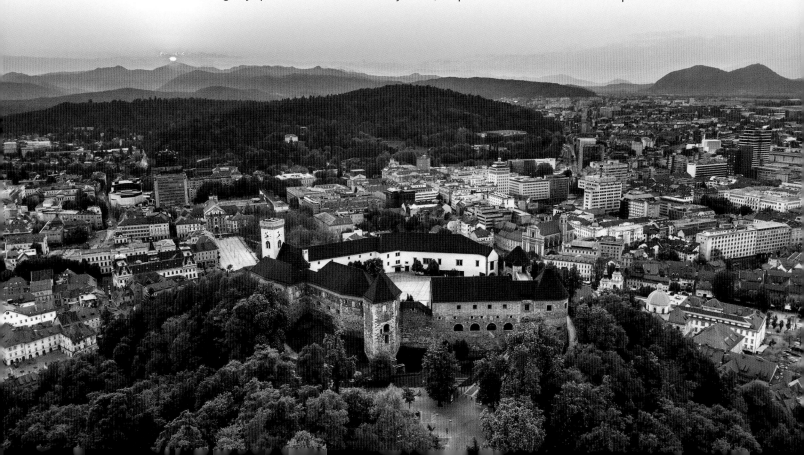

Gruber, the St. James Church, and the Rotovž (town hall) date from the same period. The Schweigerjeva house, with its detailed rococo facade, is considered one of the most beautiful baroque houses in Ljubljana.

Many bridges cross the Ljubljanica. The Zmajski most (Dragon Bridge) dates from 1901 and was one of the first reinforced concrete bridges in Europe. The four copper, art nouveau dragons guard not only the bridge, but also the entire city: they are a Ljubljana landmark. However, the Tromostovje is even more famous. Jože Plečnik's masterpiece is made up of three separate bridges. On the bridge sides are classicist columns and elegant lamps, which are reminiscence of the city's former Venetian style. From the cathedral, you can cross the three bridges to central Prešeren Square, where you can admire the Slovenian national poet France Prešeren on his monument next to the art nouveau department store Urbančeva hiša. When the weather is nice, tourists and students relax there and enjoy the Mediterranean atmosphere.

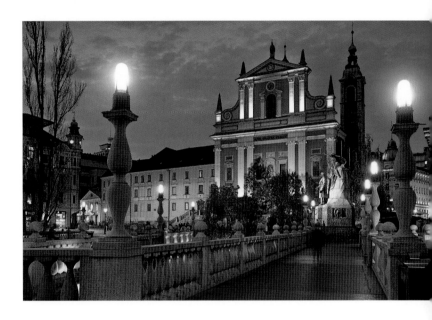

PANORAMA WITH CASTLE (*OPPOSITE*). LJUBLJANA'S BEST-KNOWN BRIDGE, THE TROMOSTOVJE, LEADS DIRECTLY TO THE 17TH-CENTURY FRANCISCAN CHURCH WITH ITS STRIKING ROSE-COLORED FACADE.

TRACES OF PLEČNIK AND THE NEBOTIČNIK

West of the Old Town, you encounter the master at every turn: Jože Plečnik left his mark everywhere, most impressively in the Slovenian National and University Library, from the 1930s, which combines Renaissance elements with ancient architecture. The magnificent market halls at the cathedral, with their stone market stalls and colonnades, also reflect these two epochs. Farther away, you can find more examples of his unique architectural style in the Žale cemetery and the St. Michael's Church in Črna vas. He also designed an avenue leading to the popular Tivoli Park, the largest park in the capital. The International Biennale for Graphic Art is held in the Museum of Modern Art right next door. Together with the Museum of Contemporary Art and the National Gallery, it forms the country's artistic center. Works from the Middle Ages to the present day convey the diversity of Slovenian culture. Ljubljana even has a real skyscraper: the Nebotičnik, built in 1933, is more than 230 feet high. The café terrace offers a wonderful view of the city and the castle hill.

ALTERNATIVE CULTURE IN METELKOVA

An empty barracks north of the city—there is where it all started in 1993. Artists and activists occupied the former military site of the Yugoslav People's Army near the train station to prevent it from being demolished. In recent decades, the Avtonomni kulturni center Metelkova mesto (Metelkova Center for Alternative Culture) in the Slovenian capital has developed. Music clubs and bars emerged. Concerts, exhibitions, theater performances, and festivals take place there regularly. Night owls meet students, alternative intellectuals, tourists, and ordinary residents from the neighborhood. The Metelkova sees itself as a center of creative freedom and is therefore constantly changing. Anyone looking for innovative impulses is right at home here.

MORE INFORMATION
City of Ljubljana
www.visitljubljana.com
Metelkova Cultural Center
www.metelkovamesto.org

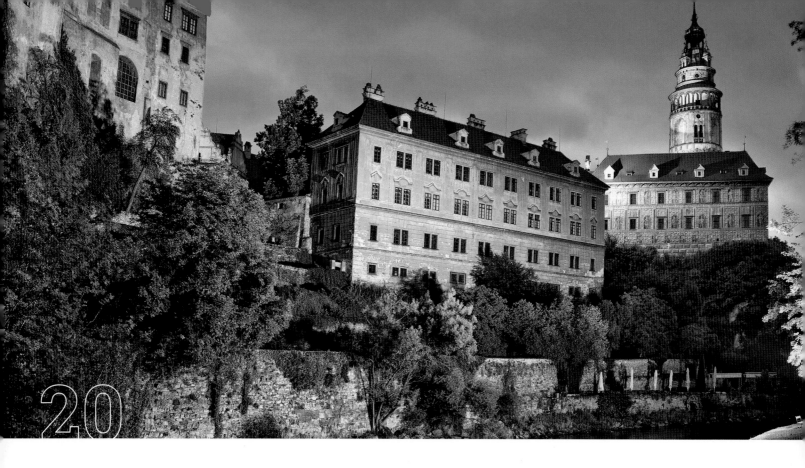

CZECH REPUBLIC

RESIDENCE CITY AT THE VLTAVA RIVER BEND

Český Krumlov rightly bears the nickname "Pearl of the Bohemian Forest," because the entire Old Town is a UNESCO World Heritage Site. Quaint houses and splendid churches stand on cobblestone streets and surround cozy squares. The second-largest castle complex in the Czech Republic towers above it all.

The name says it all. Under a castle on a long rock spur, two settlements developed in the meadows along banks of the Vltava River, which forms a large S bend here. Later, the two settlements grew together to form "Krumme Aue" (crooked meadow), the source of the name Krumlov (Krumau in German). The city was founded in the middle of the 13th century. This was followed by periods of prosperity under three families of the Czech and Austrian high nobility: the Rosenbergs, Eggebergs, and Schwarzenbergs. Prosperity was promoted by the yields from silver and gold mining, which reached its peak in the 16th century but then rapidly declined. Money, business, and art sense brought Italian Renaissance and Viennese baroque to

this three-country corner of Bohemia, Bavaria, and Austria, around 38 miles from Linz. From the end of the 18th century, this residence city fell into a deep sleep, from which it slowly awakened by the end of the 20th century. The elevation of the Old Town and castle to World Heritage status in 1992 spurred a comprehensive restoration, but with the secondary consequence that hardly any locals now live in the Old Town any more.

OLD TOWN WANDERING

The two quarters in the Old Town feature more than 300 protected historical landmark buildings. Around every corner—not just around the Town Square with its column fountain—and in narrow alleys, the fresh

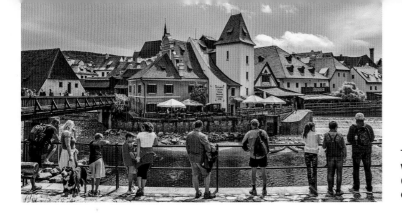

THE VLTAVA RIVER DIVIDES ČESKÝ KRUMLOV WITH ITS EXTENSIVE CASTLE COMPLEX (*OPPOSITE*); A BRIDGE CONNECTS BOTH PARTS OF THE OLD TOWN (*LEFT*).

facades of handsome town houses are a delight. Homey locations with places to sit down invite you to take a break to eat sweet pastries and drink a mug of Krumlov beer. Hidden paths open up to gardens and parks. In some places, water gurgles from small fountains. Anyone who will let themselves be adrift a little will have leisure for the delightful displays behind the arcades. Strong architectural accents are set by the former Clarissen and Minorite monasteries (1350), with their common church (exhibitions and other events in the late Gothic cloister), and the three-nave Gothic church of St. Vitus (1407–1439) on a knoll above the Vltava River. The Egon Schiele Art Centrum presents a certain degree of contrast. Located in a former home brewery, it features works by the Viennese painter Egon Schiele (1890–1918), who caused a sensation far beyond the province of South Bohemia with his lascivious nudes and unconventional lifestyle. The ESAC is a nationally recognized institution with temporary exhibits of contemporary Czech artists. In the former St. Jošt Church, marionettes bring historical puppet theater performances back to life.

CASTLE WITH A THEATER

The castle, located between the bend of the Vltava River and the Polečnice stream, comprises 40 buildings and five courtyards. In a national comparison, only the Prague castle is larger. The entire complex is accessible, and from the castle tower you have a wonderful view of the city. The multistory, one-level-atop-the-other Na Plášti (cloak bridge) (1777), over a deep gorge, is spectacular. Rooms with stately furnishings and imposing halls with elaborate frescoes, including the Eggenberger Hall with its golden carriage and the Masked Hall, take you back to the Renaissance, baroque, and 19th century.

There are only two surviving baroque theaters (from 1682) with functioning stage machinery that remain in the world. Český Krumlov castle has one of them. At times it takes three dozen people to get the wooden mechanisms in motion and to move the original sets from offstage to the middle of the drama. This gem in the castle's fifth courtyard always

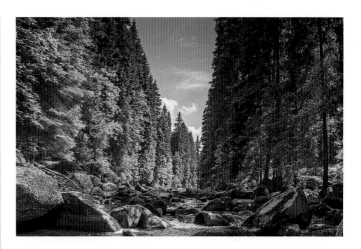

ON THE WATER, IN THE FOREST

After extensive sightseeing on foot, you need something to offset it. While a rafting trip on the Vltava River—only in good weather—is still comparatively leisurely, more skill and strength are needed for a canoe trip. Boats can be rented out at several locations. Český Krumlov is also a good starting point for bicycle tours through the hilly landscape; for example, to the demonstration graphite mine. The Blansky les (Blansky Forest), with its lookout tower on Kleť Mountain (3550 feet) and the Šumava biosphere reserve in the Bohemian Forest, invite you to hike. Enchanted castle ruins, such as Dívčí Kámen (maiden's stone), or the Lipno reservoir are located along the way.

MORE INFORMATION
Český Krumlov
www.ckrumlov.info/en/cesky-krumlov
Castle
www.zamek-ceskykrumlov.cz/en

stages performances during the summer baroque festival. The castle, with its historical ambience, is used regularly for holding music and theater festivals, including in the Masked Hall, in the Riding Hall, and on an open-air stage with a revolving grandstand in the middle of the 7-hectare baroque castle garden. You can take a breather at the cascade fountain in the park or at a restaurant and café terrace down on the riverbank.

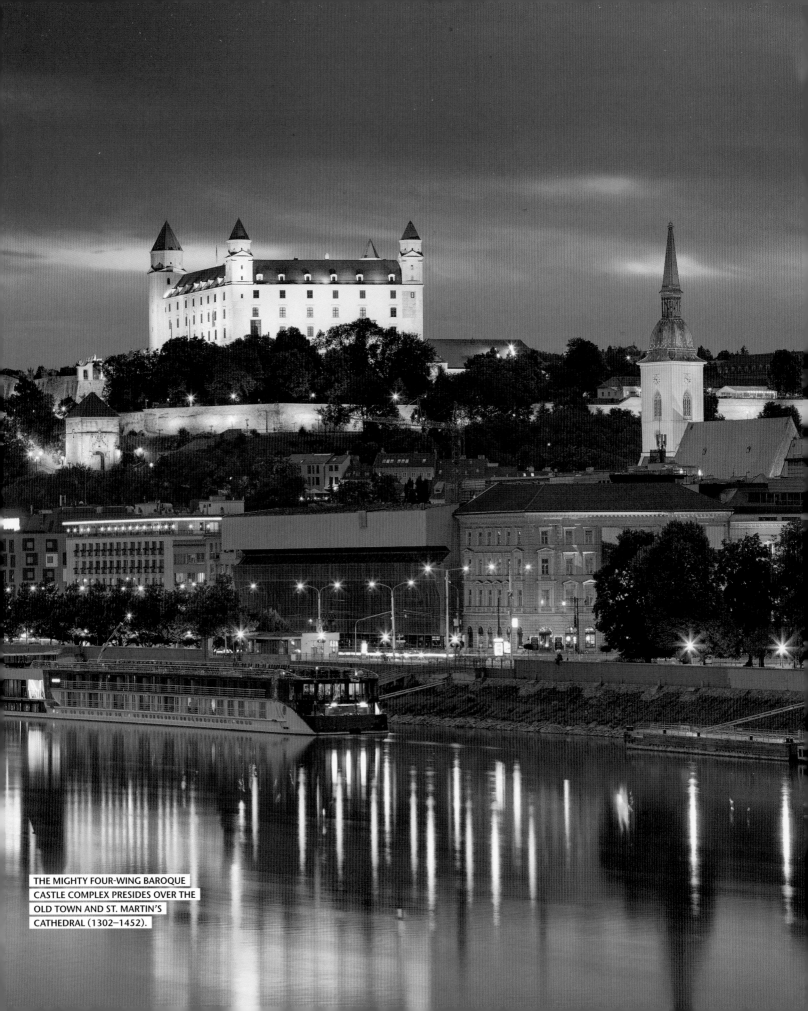

THE MIGHTY FOUR-WING BAROQUE CASTLE COMPLEX PRESIDES OVER THE OLD TOWN AND ST. MARTIN'S CATHEDRAL (1302–1452).

SHOPPING IN THE PRESENCE OF RESTORED TOWN-HOUSE FACADES, WHICH OFTEN DATE BACK TO THE 18TH CENTURY, IS ESPECIALLY PLEASANT.

21

BETWEEN THE DANUBE, CASTLE HILL, AND THE HLAVNÉ NÁMESTIE MAIN SQUARE

SLOVAKIA

It is still possible to see the old Europe in this 1,100-year-old city on the Danube River, where many nationalities lived together or side by side in a small area, but this perished after the world wars. Today, Bratislava—called Preßburg when it was part of the Austro-Hungarian Empire—is the lively young metropolis of the Slovakian nation-state.

All of its names are/were "official": Pozsony (Hungarian), Preßburg (German), and Prešporok and Bratislava (Slovakian). They identify the respective predominant linguistic, cultural, or even political element. Under Hungarian rule for 1,000 years, from the mid-19th century onward the city became ever more and more "Slovak," although shortly before World War II about half of the population still spoke German as their mother tongue. Nevertheless, Bratislava could never be reduced to a uniform "national" denominator until the expulsion of the Germans after 1945. Today the city is back in the center of Europe. The Old Town has been restored and has regained its cohesive beauty. The opera in the Slovak National Theater and the Cultural Summer even attract the nearby Viennese, as they did before, while the young scene happily indulges in rock music and jazz, without the burden of any historical baggage. The Jewish Community Museum in the synagogue (1926), a Holocaust memorial, and the mausoleum for the great scholar Chatam Sofer (1762–1832), with remnants of the Jewish cemetery restored in 2002, all commemorate Bratislava as a pearl of the Jewish culture that was almost wiped out after 1939.

QUEEN AND PRESIDENT

Bratislava's landmark, which rises around 278 feet above the Danube, is the Bratislavský hrad castle, a mighty four-wing complex (15th–18th centuries),

THE LITTLE CARPATHIAN WINE ROUTE

In the Old Town you can get in the right mood in the Appónyi palace: with a wine tasting in the courtyard and an exhibit on traditional wine growing (Múzeum vinárstva) on the southern slopes of the Little Carpathians, the beginnings of which go far back into pre-Roman times. The Wine Route starts in the northern outskirts of Bratislava (at Rača) and leads to Smolenice. The town of Pezinok is the center for regional grape growing and is a particularly picturesque place. In the "Národný salón vín" castle wine cellars, you can deepen your wine-tasting knowledge with the help of the top 100 wines of Slovakia. You can get to know regional wines personally during "Open Wine Cellar Day" in November. And beyond this, there is one wine festival after another during September. On this occasion you can also taste burčiak, the first drops of the season (federweisser—very young wine).

MORE INFORMATION
Bratislava
www.visitbratislava.com/de/
City museums with Devín castle
www.muzeum.bratislava.sk/en/
Little Carpathian Wine Route
www.mvc.sk

in which the Hungarian coronation insignia were temporarily kept. As queen of Hungary, Maria Theresa liked to stay in Bratislava and had the castle redesigned as a baroque residence. Burned down in the Napoleonic Wars, the ruin was rebuilt in the 1950s and 1960s. The historical coronation ceremony is reenacted during the Cultural Summer (with the Castle Festival). The Slovak Republic Parliament, which is in a new building next door, and the president, who has his or her official residence farther north in the fine Grasalkovič palace (1760; garden open to the public), use some of the castle's rooms for receptions.

CHURCH TOWER WITH GOLDEN CUSHION

People have been settled on the castle hill for 4,500 years. Emperor Frederick Barbarossa stopped off here on his way to the Holy Land, and his army of crusaders camped on the Danube riverside meadows. From the castle terrace (with a café) today, you can look out over the right bank of the Danube behind the Sad Janka Kráľa town park—one of the first public parks in Europe—to the skyscrapers of the satellite town of Petržalka, which was built in Socialist times to house 150,000 people. The new bridge (1972), with a "UFO" on its pillar, takes you there. You walk down into the Old Town through the Gothic Sigismund Gate.

St. Martin's Cathedral, which was rebuilt several times and is the largest of some dozen churches in the city center, was the coronation church for the Hungarian monarchs from 1563 to 1830—this is demonstrated by the tower spire with the gilded St. Stephen's crown resting on a golden cushion, instead of a weathercock or cross. Highlights from the baroque period include the very lively equestrian statue of St. Martin (1735) and the Elomosynarius chapel (1732), with the archbishop's grave, both works by the Austrian sculptor Georg Raphael Donner.

OLD TOWN: MAGNIFICENT AND CHEEKY

To take a tour through the Old Town, such as along the former coronation route (with markers), the visitor must bring one thing in particular along: time—to be able to adequately appreciate the magnificent town houses and palaces, above all those from the 18th century. If you pay attention, you will also discover some cheeky sculptures such as the Čumil, a curious city "sewer worker." Things are particularly lively in Michalská ulica, which runs

toward the only surviving one of the four town gates, Michael's Gate; in Rybárska Gate (Fisherman's Gate) and in the Main Square, with the stone statue of Roland; the Maximilian Fountain (1572); and, above all, the Stará radnica (the old town hall), with the Town Museum, a complex of several houses (15th–19th centuries) and the 147-foot-high baroque tower. Today the city mayor resides not far away, in the classicist Primate's Palace (18th century).

CULTURAL BREAKS

The Old Town cafés are ideal for taking a break, and do not limit yourself just in those on the Main Square, as are the bistros and wine bars. In Hviezdoslav Square, you can put together your evening program while sitting under shady trees and by the Ganymede Fountain. An Italian opera at the National Theater just opposite? Listening to live music in a club or played by street musicians? Or rather take in the full program at the autumn classical music festival?

DEVÍN CASTLE RUINS

Only a couple of miles up the Danube, above its confluence with the Morava River, lies Devín castle, a national monument that was destroyed and partially rebuilt in 1809. The Romans are said to have stood guard on the prominent rock, and archeologists have also made finds from the time of the Great Moravian Empire (9th century). The ruins inspired the Slovak national movement around the Romanticist and Slovak national revival leader Ľudovít Štúr. The founder of the Slovakian literary language made an excursion there on April 24, 1836, with his followers. The lonely Virgin's Tower on the steep escarpment is particularly romantic. The area was closely guarded during the Cold War, but some people tried to break through the Iron Curtain here. Most failed to do so—a memorial on the Morava commemorates the refugees. You can get to the Devín castle ruins by city bus, but there is also a hiking trail.

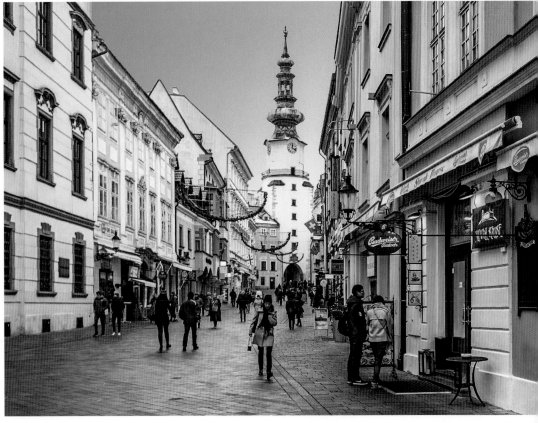

A POTTER DEMONSTRATES HIS SKILLS AT A CRAFTS FAIR (*ABOVE*). **THE MICHAEL'S GATE, WITH ITS 167-FOOT-HIGH TOWER, ONCE MARKED THE MAIN ENTRANCE TO THE OLD TOWN** (*RIGHT*).

22

HUNGARY

SPLENDOR AND FINE WINES

You simply have to enjoy Eger: in the streets and squares, you can indulge yourself in baroque architecture; the finest Hungarian wines—with a tradition going back to the Middle Ages—flow in the wine bars and restaurants; it is wonderful to relax or take a cure in the city's exquisite old and new worlds of spa baths.

Set scenically in the foothills of the Mátra and Bükk Mountains, Eger (German: Erlau) is framed by forests and gently undulating vineyards. The city, with its turbulent 1,000-year history, flourished in the 18th century. At that time, the city center was both newly designed and redesigned according to the ideas of the bishops and the plans of master builders from Germany, Italy, Austria, and Hungary. A countenance emerged that earned Eger the nickname "Baroque Pearl." During that same century, vintners started to store wine in a professional way in the Valley of the Beautiful Women. Eger gained a high reputation as a grape-growing and wine cellar region.

OPULENT OPEN-AIR MUSEUM

Eger Castle forms the town center. From the castle, the population was initially able to gloriously defy the Turks in 1552, but then the city was overwhelmed and came under Ottoman rule. The polygonal fortress has been restored since the 1990s and gives an exciting insight into 16th-century defenses. The Old Town spreads out at the foot of the castle, with squares and alleys lined with historical buildings, mainly in baroque style. The two-tower Minorite Church (1758–1773), one of the most beautiful baroque complexes in Hungary, rises on the Dobó ter, Eger's central square. The church vaults are painted with scenes from the life of St. Anthony. To the right of the church is the eclectic town hall (19th century). The monument to the former captain of the castle, István Dobó (1502–1572), after whom the square is named, presides over the northern part of the square. The smaller Eszterházy ter square lies west of this busy heart of Eger. This is the site of the classicist

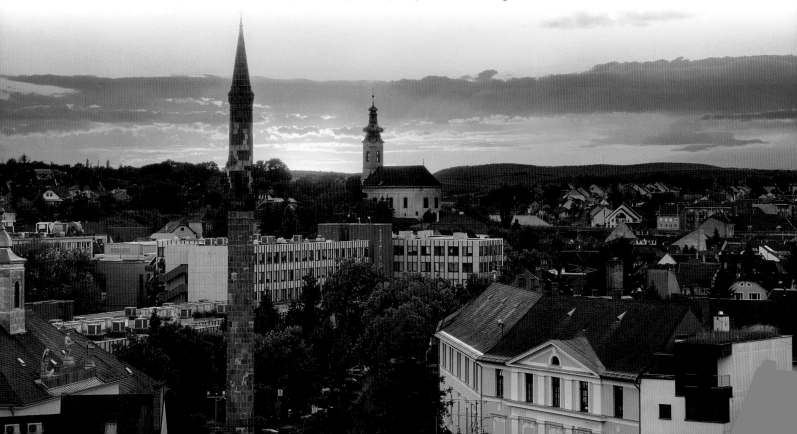

cathedral, a three-nave domed basilica (1831–1837). The interior is decorated with rows of marble columns and numerous frescoes. The archbishop's lyceum opposite is one of the largest rococo classicist buildings in Hungary. The ceiling of the library on the first floor is lavishly decorated with carvings and frescoes. The library contains some 130,000 volumes, including the first book ever printed in Hungary in 1473. The late baroque archbishop's palace adjoins the cathedral to the north. Eger's Old Town is like an atmospheric open-air museum.

OTTOMAN SOUVENIRS

When the Habsburg armies drove the Turks out of Eger in 1687, the Kethuda Mosque, built in 1624, was initially used as a church but then torn down in the 19th century. However, a minaret was preserved. The 130-foot-high building is the northernmost Ottoman structure in Europe and has meanwhile become the symbol of Eger. Some 93 steps lead upward; the view from on high is worth the effort! In the faithfully restored Turkish bath, a pool that is more than 400 years old invites you to relax. You can enjoy the warm, radon-containing healing waters in a relaxing atmosphere. The world of modern thermal baths starts right next door.

BULL'S BLOOD AND MAIDEN'S GRAPES

Since 1774, the Valley of the Beautiful Women in the wine country has been storing not only its own products, but also fine wines from other Hungarian winegrowers. The wine finds ideal conditions in more than 200 wine cellars, some of which are interconnected. Eger's Egri Bikavérer (bull's blood) and Leanyka (maiden) grape varieties are internationally known and

THE NORTHERNMOST "SOUVENIR" OF THE OTTOMANS IN EUROPE: THE EGER MINARET (*LEFT*)
THE BEST CONDITIONS FOR FINE WINES: A WINE CELLAR IN THE VALLEY OF THE BEAUTIFUL WOMEN (*BELOW*)

appreciated, and of course they are also served in the many wine bars and restaurants in the city. As dusk falls, people are drawn into the streets and squares to experience the joys of Hungarian wine in an atmosphere that is almost Mediterranean.

HUNGARY'S OWN PAMUKKALE
THERMAL SPRINGS

Just 3.5 miles from Eger is the small town of Egerszalók, which has a natural wonder that is unique in Europe but is somewhat better known in Turkey: an underground spring, like the one in the Turkish town of Pamukkale, is the source of this natural spectacle. The water, hot at 68°C, shoots like a geyser from a depth of 1,345 feet and then pours down the slope. Over the course of time, the calcareous water has formed brilliant white terraced deposits, which now cover a considerable area and continue to grow farther into the slope. In the Egerszalók thermal baths, you sit in the warm water and look out at this natural work of art—a very special experience. The locals call the structure the "salt hills," a real understatement for the spectacular formations.

MORE INFORMATION
Eger Tourist Information
https://eger.hu/en/
Information about Hungary, Eger, and Egerszalók
www.ungarn-tourist.de

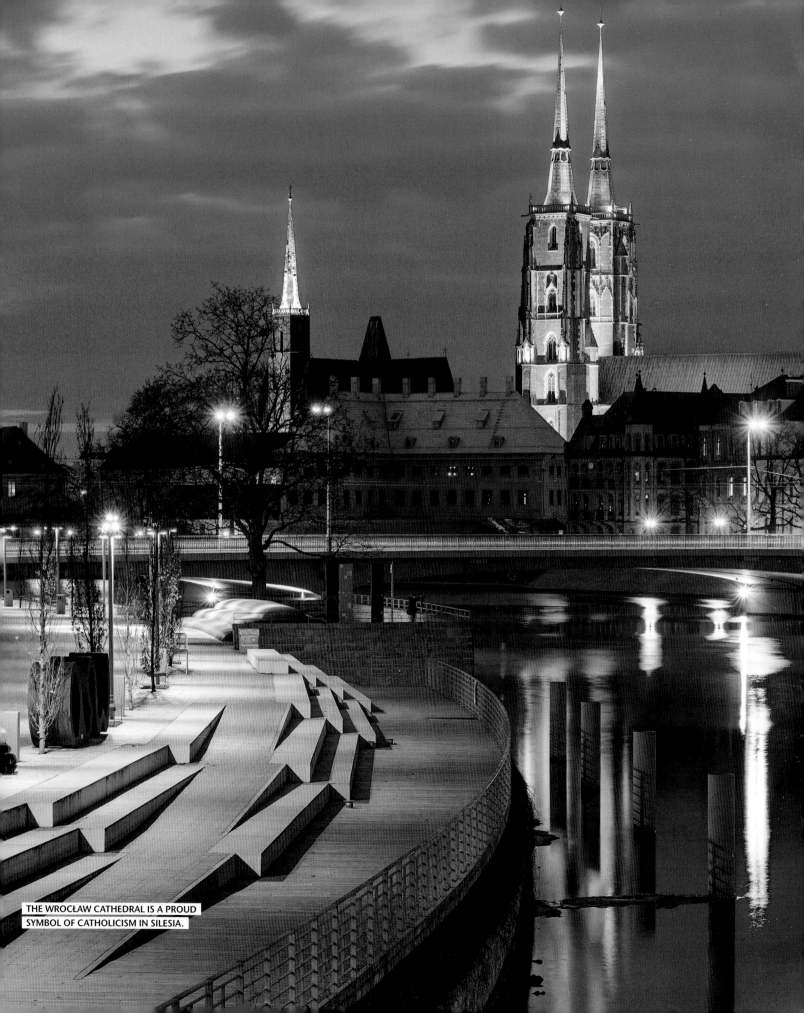

THE WROCŁAW CATHEDRAL IS A PROUD
SYMBOL OF CATHOLICISM IN SILESIA.

THE CENTENNIAL HALL WAS BUILT IN RECORD TIME AND HAD THE WORLD'S BIGGEST FREESTANDING DOME IN THE WORLD AT THE TIME. IT CAN ACCOMMODATE 10,000 PEOPLE.

WROCŁAW—BRIDGE BETWEEN EAST AND WEST

POLAND'S VENICE

Wrocław (for centuries, the majority-German city was named Breslau until it finally became part of Poland in 1945) is old and young at the same time. The capital city of the historical region of Silesia has been shaped by people of different origins for 1,000 years, and its ancient trade routes have always connected the East and West. The European Capital of Culture of 2016 presents itself as a young, cosmopolitan university metropolis with an exceptionally rich range of cultural offerings.

POLAND

The Rynek (Market Square) in the Stare Miasto (Old Town) is one of the largest of its kind in Europe. It is surrounded by stately houses from many artistic epochs: commercial offices dating from the Middle Ages, imposing patrician houses, and the Gothic Stary Ratusz (town hall). These gems are lined up along the sides of the Market Square: the Sieben-Kurfürsten (seven electors) house, the Naschmarkt ("nosch market") side, the Grüne-Röhr (green pipe) side, and the Goldene-Becher (golden cup) side. Countless cafés, restaurants, and beer gardens make their homes there; the most famous and oldest eatery is the Piwnica Świdnicka (the Świdnica cellar), dating from the 15th century. Both Goethe and Chopin enjoyed drinking there. The flower market is held today at the Plac Solny (Salt Market), with its colorful, elegant city villas. In view of this magnificence, it is easy to forget that its presence is not self-evident: Wrocław, called Breslau at the time, was bombed to rubble by the end of World War II and then rebuilt and restored in the decades following the displacement of the German population, especially by new settlers from Lviv, Ukraine.

READY FOR THE ISLAND

For over 1,000 years, the Ostrów Tumski (cathedral island) has provided a home for Catholic Christians with its churches and monasteries. The mighty Katedra św. Jana (St. John the Baptist Cathedral) was built over the course of 500 years. It also suffered severe damage during World War II. Considering the large number of faithful, it became clear that even socialism was hardly able to harm

their deeply rooted faith. From the cathedral tower you have a fantastic view over the Old Town and the island, although it has not been an island since the early 19th century because the branch of the Odra River has silted up. The Church of the Holy Cross and the Church of St. Giles can be seen from there, as well as the archbishop's seat and the botanical garden. The cathedral island can be reached via the much-smaller Wyspa Piaskowa (sand island), which is connected to the Old Town via the sand bridge—the Church of Mary on the Sand gave it its name. Another famous church, the Elisabethkirche (St. Elisabeth's Church) in the Old Town, is closely linked to the city's Protestant history: for over 400 years it was the primary Protestant church in Silesia. It also has a lookout tower, and access to the churchyard is through an archway between two houses called Hansel and Gretel (Jaś i Małgiosa).

LOVE THY NEIGHBOR

Tolerance toward others is called for in many cities; in Wrocław it is also put into practice: In the Dzielnica Wzajemnego Szacunku Czterech Wyznań (quarter of mutual respect), the former Jewish quarter, four religious communities joined together in the early 1990s to create a common basis. Catholic, Protestant, Orthodox Christian, and Jewish faithful created a lively cultural center and have been celebrating their festivals together since then. In addition to the four houses of worship, there are many restaurants, cafés, cinemas, bookstores, and artist workshops. The long-legged and delicate *Planeta*, a sculpture by Ewa Rossano, watches over everything at the intersection of the streets św. Antoniego and Kazimierza Wielkiego. Her dress is shaped like the globe and is intended to symbolize the unity of the world. At night, visitors and students flock to the district on the southwestern edge of the Old Town and turn it into a party area: people celebrate in the pubs, music clubs, and discotheques in the restored courtyards of Niepolda Passage and Pokoyhof until early morning. Jazz in particular is a permanent fixture in Wrocław.

1,000 YEARS OF ART HISTORY

Wrocław is a treasure trove for visitors interested in architecture. Medieval and Renaissance buildings

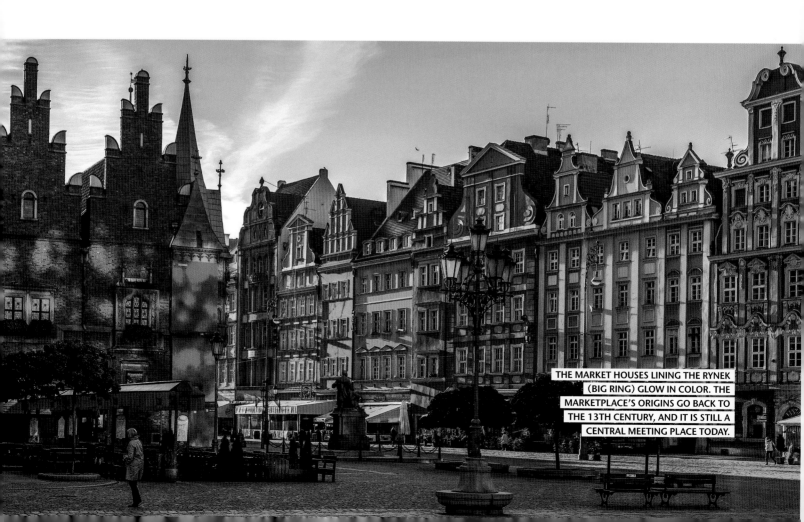

THE MARKET HOUSES LINING THE RYNEK (BIG RING) GLOW IN COLOR. THE MARKETPLACE'S ORIGINS GO BACK TO THE 13TH CENTURY, AND IT IS STILL A CENTRAL MEETING PLACE TODAY.

can be found in the Old Town; the main university (Collegium Maximum) buildings are baroque, as is the Prussian royal palace, which now houses the Historical Museum. The Wrocław Główny (main train station) gleams like a fairy tale and is almost kitschy in its 19th-century English Tudor style. Art nouveau houses are distributed all over the city. Near the Zoological Garden stands an exceptional building, the Centennial Hall at the Wrocław Exhibition Center. This monumental building, constructed of reinforced concrete by Max Berg, was erected in record time in 1913 and, with its span of 213 feet, had what was then the world's largest freestanding dome. There is space for over 10,000 people inside, which makes the hall attractive for holding trade fairs, sporting events, balls, festivals, and concerts. In the interactive Discovery Center, you can learn all there is to know about the building's history. The four-dome pavilion and the pergola designed by Hans Poelzig, to which the Japanese garden adjoins from behind, are also located on the grounds.

BAD WEATHER? NO PROBLEM!

Wrocław has a whole range of museums where you can pass the time wonderfully; for example, in the Architecture Museum at uliusz-Słowacki park on the Odra River. The National Museum and the Racławice panorama are both located there: inside the rotunda you find yourself in the middle of the historic battle between Polish and Russian troops on April 4, 1794. In the Hydropolis, an interactive center for ecological education that deals with issues related to water has been created in an old reservoir.

If that's too much culture for you, you can pass the time shopping in the elegant Świdnicka Street in the Old Town: the Renoma department store, formerly called Wertheim, gleams in its magnificent facade made of glazed bricks and bands of golden mosaics. Finally, drinking a good Polish beer in one of the breweries will taste good. The Spiż craft brewery offers their beer in their own steins. Pair with pierogi, dumplings, or bigos, an herb stew.

BY THE GREAT RIVER

More than 100 bridges and 12 islands impressively illustrate Wrocław's location on the Odra. This big central European stream, with its canals and branches, is Poland's largest water hub and a popular area for water sports enthusiasts. People are building homes along its banks, and hotels, restaurants, and

beer gardens attract guests in summer. The city can be explored in a different, relaxed way by boat or bike. The Old Town promenade (Promenada Staromiejeska) on the left bank of the Odra, which runs around the historical center, can be easily managed on foot or by bike. The Wrocław marionette theater, the Wrocław opera, and the National Music Forum, which was built in 2015 and is famous for its excellent acoustics, await visitors there.

THE LITTLE HEROES

You will notice them when rambling through the old alleyways: dwarfs on almost every street corner. Sometimes the small bronze figures sit comfortably while drinking beer; sometimes they are scrambling up lanterns or even withdrawing money at the bank. The "dwarf movement" started at the beginning of the 1980s as part of the Solidarność movement: under the motto "Dwarfs of all countries unite!," the "Orange Alternative" exposed the Socialist rulers to ridicule—and thus contributed to the political upheaval. Since then, the dwarfs have multiplied greatly. The original idea by "happenings" artist Waldemar Frydrych Major has grown into a large family. Its "progenitor," Papa Krasnal, lives on Świdnicka Street.

MORE INFORMATION
City of Wroclaw website
www.wroclaw.pl/en
Anyone interested can go to the krasnale.pl website to look for dwarfs.

ŁÓDŹ—FROM TEXTILE METROPOLIS TO CITY OF CULTURE

INDUSTRIAL ARCHITECTURE AND ELEGANT INDUSTRIALIST'S VILLAS

Its rise came rapidly. Around 1800, Łódź was a provincial backwater; by the late 19th century, there were over 300,000 people living in this textile metropolis. Today, the "Manchester of Poland," with its former factories and entrepreneur's palaces, is a testament to the Industrial Revolution and an example of reinventing itself as a city of art and culture.

Theo the marmot made a mistake: the lazy marmot celebrated in Greek German singer Vicki Leandros's hit 1974 song has not made its way to Łódź. Otherwise, he would have heard that Łódź sounds like "whoosh" in Polish, with a soft "w" at the beginning and a long "oo" in the middle. In 1820, the controlling Russian government declared the 200-person village to be an industrial location—Poland did not exist as a state at the time. German and Bohemian weavers, dyers, and spinners were recruited to process cotton. The big boom came when the first mill with mechanical looms was built in 1826. The lowest point in the city's history was the German terror regime during World War II. The Jewish population was forced to relocate to the Old Town, part of which was declared a ghetto and renamed Litzmannstadt. The Radogoszcz train station memorial commemorates the Holocaust.

LONGEST BOULEVARD IN EUROPE

The dead-straight, almost 5-kilometer-long Ulica Piotrkowska is not only the longest boulevard in Europe, but also the main street of cafés, restaurants, and bars. It is lined with magnificent buildings with facades in art nouveau and Wilhelminian style. In the back courtyard buildings, which have not yet been completely renovated, you can sense an innovative atmosphere. The Piotrkowska is also the Walk of Fame. Stars recall Polish directors, actors, and graduates of the "Hollylodz" film school founded in 1948; they include Roman Polanski and Andrzej Wajda.

At the end of the Piotrkowska stands the white-exterior factory of Louis Geyer, who began his rise with 12 hundredweight of cotton yarn. Today the Central Textile Museum is located in the former manufacturing facility. Old looms, fabric samples, and ready-made goods make it one of the most beautiful exhibitions.

COTTON BARONS IN THE MANCHESTER OF POLAND

Industrialists built 160 imposing buildings in Łódź. In the competition of the textile barons, Izrael Poznański built the biggest palace. In the meantime, the Museum of City History has moved into this play among neo-Renaissance, neobaroque, and art nouveau styles. The Manufaktura is located just around the corner, in the old factory empire. After almost 10 years of construction, the sandblasted factory complex was reopened in 2006 and is now used to house a mixture of art and commerce. In the former textile mill, the Muzeum Sztuki for Modern Art ms2 presents its collection of classic modern and Polish avant-garde art. Where the cotton fabrics were once finished, the Muzeum Fabryki tells the story of the Poznański empire and also describes the textile workers' working conditions. Karl Scheibler was another superrich cotton baron. After great economic success, his social conscience struck him. In addition to the factory building, he founded schools, provided free medications, and had 200 workers' apartments built. Paved paths lead through this "Księży Młyn" (priest's mill) complex. The Scheibler villa in the nearby park grounds houses parts of the film academy as well as the film museum. Perhaps the

PLAC WOLNOŚCI (FREEDOM SQUARE), WITH THE CATHOLIC CHURCH OF THE HOLY SPIRIT (*BELOW LEFT*)
INSTALLATION FOR THE ANNUAL "FESTIVAL OF LIGHTS" (*LEFT*)

most beautiful palace is the Herbst Palace, which Karl gave to his daughter for her wedding to Mr. Herbst. The building conversion boom continues, and the latest project is the conversion of the old power plant. The art nouveau–style machinery hall is used for events, while the adjoining buildings house the Science and Technology Center and the Center for Film Culture. Three former industrialists can meanwhile be found in the city. Cast in bronze, they sit together around a table.

THE CEMETERIES

In the Łódź cemeteries, the industrialists are lying in magnificent mausoleums next to their nameless, long-forgotten workers. The Scheibler family rests in the Protestant cemetery in a tomb that resembles a church. The Poznański family was buried in the New Jewish Cemetery in a grave decorated with two million mosaic stones. The parents of pianist Arthur Rubinstein are also resting here. This enchanting and overgrown burial ground was in use between 1893 and 1939. With about 180,000 graves and 65,000 tombs on 40 hectares, it is the largest Jewish cemetery in Europe. About 43,000 victims of the Litzmannstadt ghetto are also buried there. A memorial commemorates the victims of the ghetto and the extermination camps.

MORE INFORMATION
Łódź
www.poland.travel/en/cities/lodz-2
Central Museum of Textiles
https://cmwl.pl/public
Electric Power Plant EC1
www.ec1lodz.pl/?language=en

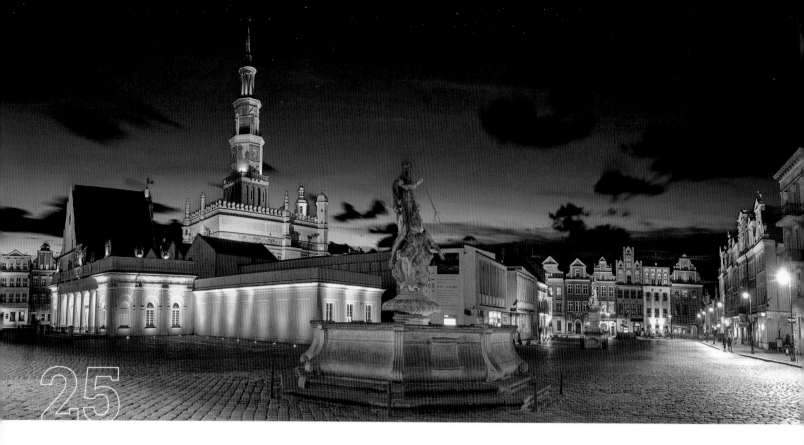

25

GLEAMING MARKETPLACE, GOTHIC CATHEDRAL

POLAND

Poznań is a lively trade fair and university city with a complex past and is the nucleus of old Poland. But the Prussian period has also left its mark there. The centerpiece of the city in Greater Poland is the town hall on the old Market Square, a pearl of the Renaissance.

The turning point was the 10th century. Poznań was first mentioned in 968, not long before the founding of the first Roman Catholic diocese in Poland. As an important trade route, the region at the crossroads of the Warta River has been settled for over 12,000 years. During the European Migration Period, Slavic tribes came to the area, which had been abandoned by the Burgundians. Duke Mieszko I of the Piast family saw his chance: in 966 he was baptized on the island between the Warta and Cybina Rivers and became the first Slavic prince to become the "Duke of the Poles."

BILLY GOATS AT THE TOWN HALL

The Stare Rynek (old Market Square) is surrounded by colorful houses of styles from various epochs.

They create the framework for the striking town hall. Between 1550 and 1560, in the heyday of the trading city, the Ticino master builder Giovanni Battista di Quadro directed its renovation and created one of the most beautiful secular Renaissance buildings north of the Alps. At noon, the tower bugler sounds his bugle and a small wooden door opens in the town hall's clock tower. Two metal goats emerge and butt their horns together, recalling a legend that tells of how the venison a cook was roasting was burned up, and the goats that he planned to cook to replace it escaped—unroasted. Souvenirs are sold in the arcades of the neighboring grocery stores. Today's town hall is housed in the former Jesuit college, dating from the first half of the 18th century. Besides this, a team of Italian and Polish master

THE MARKETPLACE WITH THE TALL TOWN HALL TOWER (*OPPOSITE*) AND STATUES OF SAINTS (*DETAIL BELOW*) MODERN ART IN FREEDOM SQUARE (*LEFT*)

builders worked to create one of the most outstanding baroque churches in Poland, the Church of St. Stanislaus. The oldest cathedral in Poland stands on Ostrów Tumski (Cathedral Island) by the bend in the Warta River. The cathedral and its Brick Gothic core was renovated after World War II. The first Polish dukes and bishops are buried in the crypt. The Porta Posnania and Genius Loci, two didactically modern and interactive museums, tell the history of the city. Cathedral Island, which was also used militarily in the past, is a true idyll with its late Gothic Chapel of St. Mary, extensive gardens, and paths along the rivers. A beautiful view of the cathedral opens up over the red arches of the Jordan Bridge over the Cybina River.

EMPERORS AND CRYPTOLOGISTS

The Imperial Palace stands on the edge of the Old Town, near the modern main train station and exhibition center. The mighty neo-Romanesque building was being built for German emperor Wilhelm II up to 1913 and was converted into a "führer residence" for Adolf Hitler during World War II. In front of the west wing, a monument and a museum box commemorate the Polish cryptologists who made a major contribution to deciphering the "Enigma" cipher machine during World War II. An exhibit inside the palace honors the participants in the 1956 workers' uprising.

You can also "do" Poznań without traditional sightseeing. The former Stary Browar brewery has been converted to create a mixture of culture and shopping. A street-art walk leads to the largest and most-exciting images. And if you get hungry between meals, there are plenty of bakeries offering *rogal świętomarciński* (St. Martin's croissants) filled with white poppy seeds.

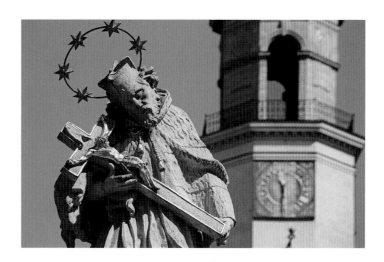

KÓRNIK CASTLE AND ROGALIN PALACE

Kórnik Castle is a moated castle; its first moat was built in the Middle Ages. It was rebuilt several times and redesigned by Karl Friedrich Schinkel during the 19th century for Count Tytus Działyński in neo-Gothic style. The collection of paintings in the castle includes the "White Lady" Teofila, who steps out of the picture at night and walks through the landscaped English garden, which includes the largest arboretum in Poland. The Rogalin baroque palace is one of the most beautiful residential complexes in Poland. The Raczyński family acquired the old castle in 1768 and began building a monumental late baroque family manor. The last private owner, Edward Raczyński, was the president of the Republic of Poland in exile until 1986. There is also the famous French park, which merges into the riparian landscape along the Warta. The Rogalin English oaks, more than 600 years old, stand there.

MORE INFORMATION
Poznań
www.poznan.travel/en
Porta Posnania
https://bramapoznania.pl/en
Imperial Palace
https://ckzamek.pl

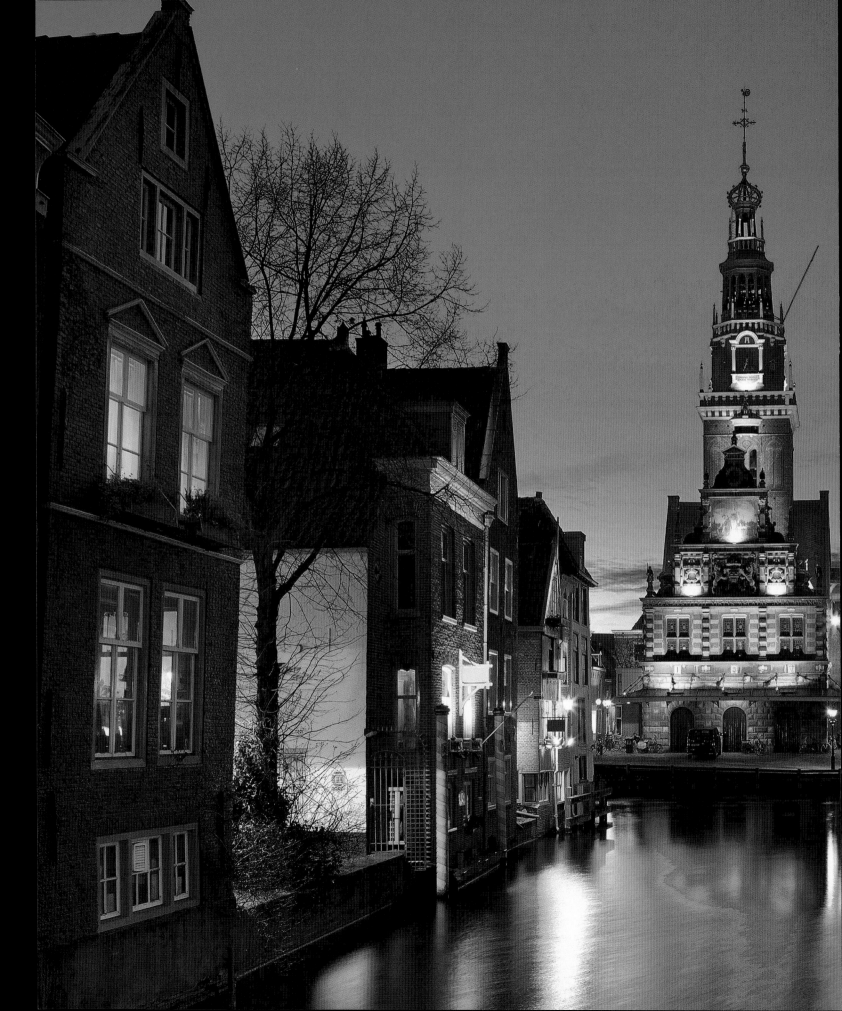

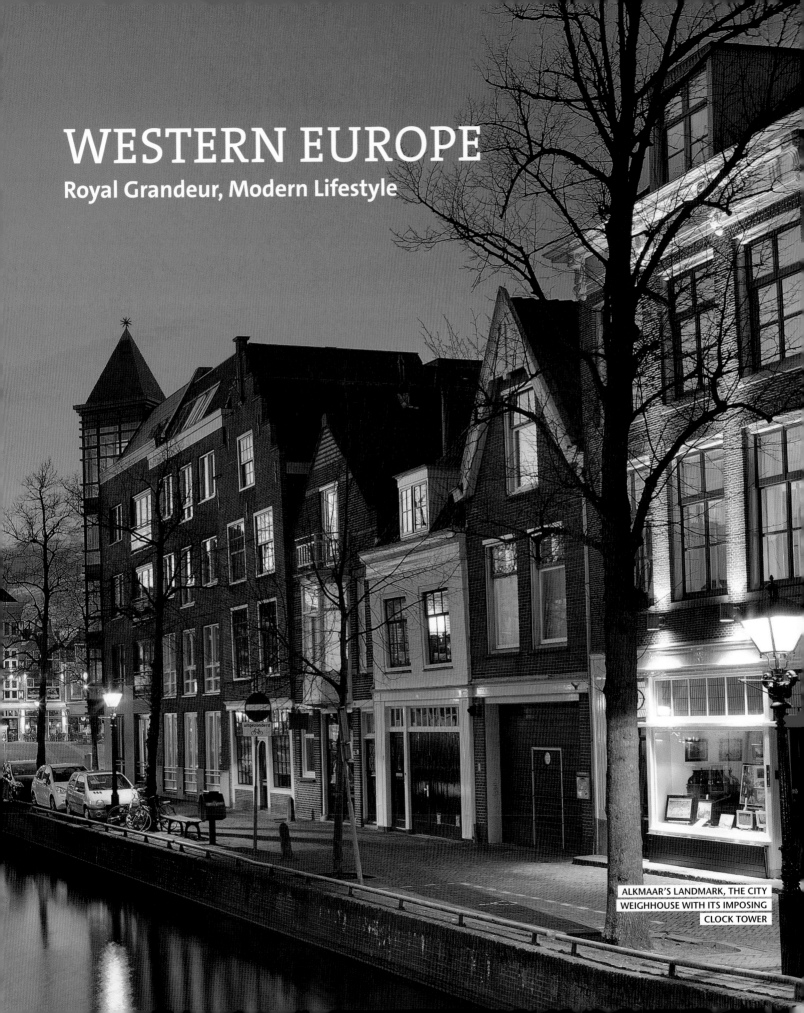

WESTERN EUROPE

Royal Grandeur, Modern Lifestyle

ALKMAAR'S LANDMARK, THE CITY
WEIGHHOUSE WITH ITS IMPOSING
CLOCK TOWER

IRELAND

TRADE, ART, AND GOOD FOOD

This city in southwestern Ireland is somewhat overshadowed by its famous sisters Dublin and Galway, but a visit to Ireland's economic metropolis is well worth it. Its location on the Irish Riviera alone speaks for itself. There are also historical buildings and its reputation as a mecca for gourmets.

Cork has always been busy, and today the city is surrounded by a growing industrial zone with its subsidiaries of international corporations. The Old Town center is on an island and is surrounded by the north and south channels of the River Lee. The shopping area stretches between Grand Parade, St. Patrick's Street, and South Mall, while tourists and locals can enjoy themselves in pubs and cafés in the northern district. Art galleries show modern works, and medieval art can be found in the city's churches.

LYING CLOCKS AND WOMEN'S PRISON

To get a good overview, head for Elizabeth Fort. This 17th-century fortification, on Keyser Hill before the Old Town island, had to face off violent attacks time and time again. Parts of the fortress burned down during the Irish Civil War in the 1920s. Walking along the ring around the fort is very peaceful today and can end with a visit to the nearby St. Finn Barre's Cathedral. The city's primary church, located west of the fort, with its statues, glass windows, and mosaic floors in neo-Gothic style, presents itself as a self-confident 19th-century building. St. Peter and Paul's Church in the Old Town center dates from the same period. It replaced an older building from the 18th century. The Georgian St. Anne's Church, located north of the Old Town island, is not only older than these other two churches, it also has two special features: one is that visitors can ring the carillon by hand, and at the same time, no one should rely on the four clocks on the tower: The "four-faced liar" is what the locals mockingly call their church tower

clock, which stubbornly refuses to display the exact time. St. Anne's Church is located in the multicultural Shandon district, with its bistros, cafés, and craft shops. Anyone who assumes that they are looking at a palace when they see this building's elegant walls is wrong: during the 19th and 20th centuries, the Cork City Gaol served as a prison. It was mainly used to imprison women, including Countess Markiewicz, an Irish nationalist and the first woman to be elected to the British House of Commons in 1918. As a museum, the gaol offers a very special history lesson. Cork is also known for its collection of the works of Irish painters such as Sean Keating and Jack Butler Yeats, which are to be found in the Crawford Municipal Art Gallery. The Lewis Glucksman Gallery, on the university campus, is the right place for anyone who wants to take in the impact of contemporary art. Temporary exhibitions are held regularly in the award-winning building, while the Café Glucksman is waiting for you to take a break from the art.

CORK, WITH ST. ANNE'S CHURCH (*LEFT*)
THINGS WERE NOT ALWAYS SO PEACEFUL: IN THE CORK CITY GAOL, TODAY A MUSEUM, VISITORS CAN VIEW TWO GUARDS PLAYING CARDS (*BELOW*).

THE ENGLISH MARKET

The way to someone's heart is through their stomach—this saying is particularly true in Cork. Since the 18th century, the city has been known as the gourmets' meeting point in Ireland. The reason for this is the English Market at the middle of the Old Town island. The imposing Victorian building is home to over fifty market stalls selling everything your heart might desire: fish and seafood, pigs' trotters, Milleens cheese, traditional Irish dishes, bread, chocolates, fruits, and vegetables. Not even fire and war were able to destroy the market. During the 1980s, city residents saved the magnificent hall from demolition, and they began to reflect on their culinary heritage. Even the Queen paid a visit to the English Market in 2011. Among so many delicacies, drinking shouldn't be forgotten: The Franciscan Well Brewery builds on the city's old brewing tradition and offers freshly tapped ales, stouts, and wheat beers in its beer garden. The time-honored Beamish Brewery and the famous Murphy's are now in Dutch hands.

EVERYTHING'S JUST FINE (GERMAN EXPRESSION: ALLES IN BUTTER)

Irish butter is an export hit for the Emerald Isle. In Cork, which has been the center of the European butter trade for a long time, they have dedicated a whole museum to this dairy product. In the Butter Museum in the Shandon district, visitors can learn all about its history, production, and trade. Ireland's famous lush pastures have always given the milk of Irish cows its distinctive taste. Butter and cheese have long been important commodities. From its humble beginnings in the Middle Ages, to an international business in the 19th century, to the present-day Kerrygold brand, the museum tells its very own, typically Irish history. A video shows how the Irish government created the now-famous brand with the help of an American advertising agency in the 1960s.

MORE INFORMATION
The English Market
www.englishmarket.ie
Butter Museum
thebuttermuseum.com—including the butter wrapper collection, a collection of packaging from past decades

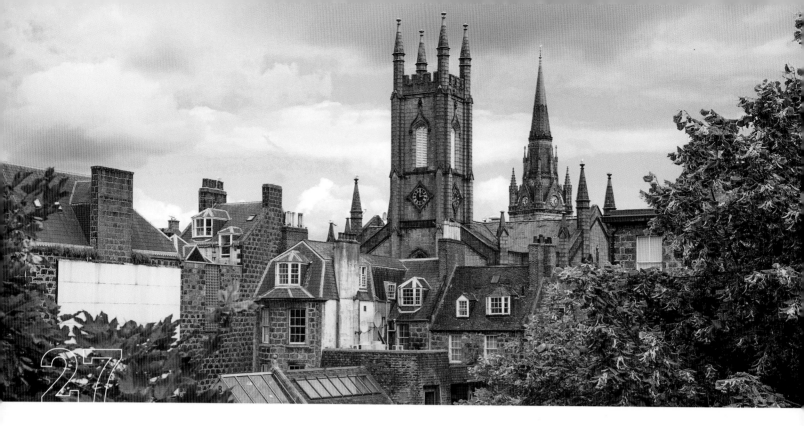

SCOTLAND

OLD UNIVERSITY CITY AND OIL METROPOLIS

After every downpour, the houses, built of gray granite, glisten in light silver. The time-honored and lively university town of Aberdeen lies between the Rivers Dee and Don and is not only a metropolis of North Sea oil, but also a multiple winner of the "Britain in Bloom" flower competition.

The prefix of the city name comes from the Gaelic *aber*, meaning "mouth." Here, where the Dee and Don Rivers flow into the North Sea and people had been living for 8,000 years, a settlement was established in the sixth century. By the 12th century, the town had a cathedral, a castle, and a Hanseatic League city charter. It traded predominantly in wool, furs, and silver "darlings." These silver darlings were salted and exported, because the romantic nickname referred to North Sea herring.

OLD, BUT LIVELY

The oldest part of the city, Old Aberdeen, was built near the Brig o' Balgownie Bridge, which has spanned the Don since 1320. Where the river curves around like a bishop's crosier, St. Machar Cathedral was built on top of earlier buildings in the 14th century. Its walls are said to contain the left arm of the Scottish freedom fighter William Wallace, who was executed in London. The idyllic Seaton Park nearby, one of the city's numerous green spaces, is less eerie.

The quiet clerical life in this district changed when Bishop William Elphinstone established the university with the founding of King's College in 1495. Old Aberdeen has become a student campus and remains charming and lively with its historical buildings and cobblestone streets. The symbol of the university rests as a stone crown on the chapel of King's College. In 1593 Aberdeen's second university was founded as a Protestant

THE GRANITE HOUSES TOWARD KING'S COLLEGE ARE A SOLID COLOR (*OPPOSITE*); THE UNIVERSITY IS COLORFUL (*LEFT*). ST. MACHAR CATHEDRAL LOOKS LIKE A DEFIANT CASTLE (*BELOW*).

counterweight to the Catholic King's College in the city center. The planning for today's building was completed in 1906. Since then, a superlative facility has been standing in the heart of the city. The four-winged building, towered over by the 236-foot-high Mitchell Tower, is the world's second-largest granite building, after the Escorial near Madrid. The Tolbooth Museum is just a few steps away. This former town hall and prison is open to visitors who are not afraid of ghosts. The Georgian and Victorian buildings along Union Street, such as the Provost Skene House, the oldest residential building in the city, show faces made of granite. Many buildings were built of the hard stone from the surrounding region. This building material gave the city its nickname, the "granite city" or "silver city."

NORTH SEA BEACH AND NORTH SEA OIL

North Sea petroleum made Aberdeen the oil metropolis of Europe in the 1970s. The highlight of the exhibit in the Maritime Museum is a full-size oil rig. The museum combines the medieval Provost Ross House with a modern building with glass facade overlooking the oil port. If you are lucky, you will see a dolphin go swimming by. The North Sea promenade leads to the city beach and the Beach Ballroom. The most beautiful ballroom in Scotland is famous for its sprung dance floor and art deco style. Footdee, pronounced "Fittie," is a charming little quarter, a settlement for poor fishermen dating from the 19th century and today a colorful mixture of eccentricity and shabby chic. On rainy days, one of the largest winter gardens in Europe attracts visitors to Duthie Park.

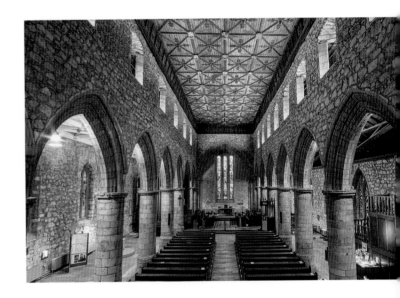

DUNNOTTAR CASTLE

The ruins of Dunnottar Castle cling like a bird's nest to a red rock above the often-stormy sea. Only a narrow land bridge leads to the remains of the fortress, which has been on guard here since the early Middle Ages. It has been under attack from Picts, Vikings, Englishmen, and Scottish clans. William Wallace came here with deadly intent. Other kings lingered peacefully in this difficult-to-conquer place, and even Mary Stuart spent a few days on the windy castle rock. During the Scottish Civil War in the 17th century, the Scottish crown jewels were hidden here and finally secured under difficult conditions. Dunnottar Castle is a mystical place regardless of the weather, where the ghost of the "Green Lady" likes to make unpredictable visits.

MORE INFORMATION
Aberdeen
https://www.visitscotland.com/destinations-maps/aberdeen
Maritime Museum Aberdeen
https://www.aberdeencity.gov.uk/AAGM/plan-your-visit
Dunnattor Castle
www.dunnottarcastle.co.uk

THE BEATLES Story

EXHIBITION

THE BEATLES Story EXHIBITION

A MAGICAL EXPERIENCE

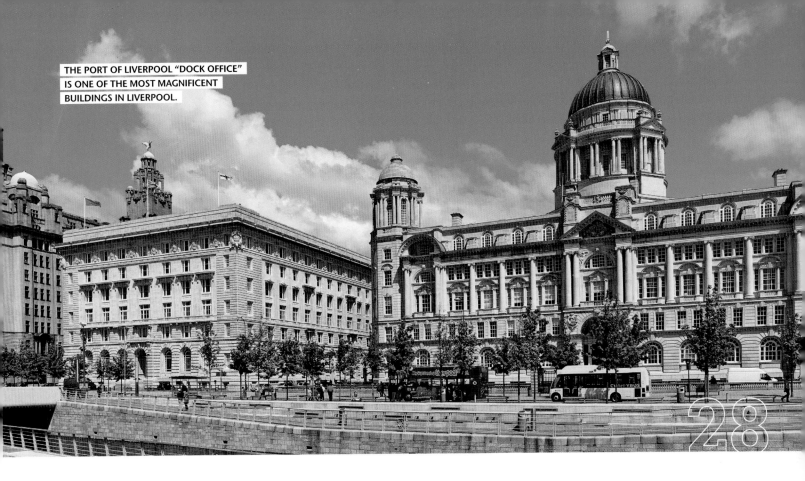

28

LIVERPOOL—MULTICULTURAL RHYTHM

THE HIPPEST CITY IN ENGLAND

The airport is named "John Lennon," and its motto is "Above us only sky." It isn't just in bad weather that Liverpudlians sing their hymn: "Walk on through the rain . . . you'll never walk alone." They play football in Anfield and Goodison Park, and the Beatles are playing almost everywhere.

ENGLAND

The hard years began after World War I. This was followed by destruction by bombings during World War II, and the city's industry was shut down during the 1970s. Tristesse lay over the 800-year-old city. Big port cities are not for wimps. "You may say I'm a dreamer, but I'm not the only one" (John Lennon). Today, Liverpool is a modern metropolis and was European Capital of Culture in 2008. The film industry has found a home there, and "Liverpool2" is a new container port providing 5,000 jobs.

Liverpool became a port due to its location where the River Mersey flows into the Irish Sea. Its period as a great port began after the discovery of the New World, and by the early 19th century the port was handling 40 percent of world trade. Magnificent houses, which meanwhile have been sandblasted and restored, were built. Trade was in steel, textiles, brandy, sugar—and people. Until it was abolished in 1807, Liverpool was Britain's most important port for the slave trade. The International Slavery Museum attempts to work through this bitter chapter in history. In addition, transporting emigrants earned the shipping companies a lot of money. More than nine million people left Europe for America, Australia, and New Zealand from Liverpool. Others came to replace them. Chinese traders in tea, silk, and cotton founded the oldest Chinese settlement in Europe in 1834, Liverpool's Chinatown. Most of the immigrants, however, came

from Ireland; three-quarters of Liverpudlians are said to have at least one Irish ancestor.

THE THREE GRACES AND A STRANGE BIRD

From Pier Head, the "Three Graces" look out over the water. Two mythical copper "liver birds" watch over the city from the towers of the Royal Liver Building, home to the insurance company of the same name, and one of the world's first reinforced-concrete buildings. The birds have been the symbol of the city from time immemorial. Once they were eagles, but meanwhile they have come to look like a mixture of an eagle, cormorant, and plucked chicken—a mix that suits Liverpool. The second "grace" is the Greek Revival–style Cunard Building, formerly the seat of the famous shipping company that sailed its luxury liners across the ocean from this location. The third of the beauties, the Port of Liverpool Building, formerly the Mersey Docks and Harbour Board Offices, is neobaroque. The ferry across the River Mersey leaves from the quay in front of the building. A ferry ride offers the perfect view of the cityscape and of the second-longest cathedral in the world, the Cathedral Church of Christ. For musical entertainment on board, the song by Gerry and the Pacemakers resounds from the speakers on every trip: "So ferry 'cross the Mersey / 'Cause this land's the place I love / And here I'll stay."

NEW LIFE ON THE DOCK

The Albert Docks, named after Queen Victoria's German husband, were once the most modern in the world. In 1846, the warehouses built there were for the first time made of cast iron and red brick instead of wood. Hydraulic cranes loaded and unloaded the ships; this dispensed with reloading cargo onto barges. After the docks were shut down in the 1980s, redevelopment of the site began. A mix of historical sites, stylish bars, restaurants, and cultural institutions emerged. The Tate Liverpool art collection, the Beatles Story Museum, the Merseyside Maritime Museum with the International Slavery Museum, the World Museum,

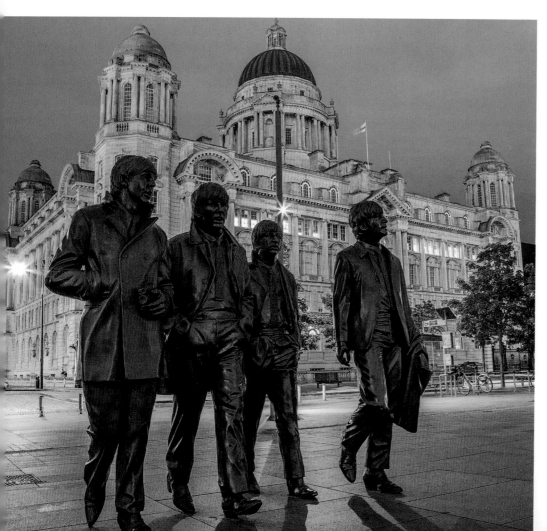

THE "FAB FOUR" ARE FOUND EVERYWHERE IN LIVERPOOL (*LEFT*).
BOMBED OUT SINCE WORLD WAR II, THE RUINS OF ST. LUKE'S CHURCH ARE NOW A PEACE MEMORIAL (*ABOVE*).

and the Piermaster's House offer a variety of installations and information. While having a drink on one of the terraces, your view ranges over the warehouse buildings glowing in the evening light.

ART AND SCOUSE

Restored Victorian-era buildings stand in the city center. And it attracts art: the Liverpool Biennial is the British Biennial for Contemporary Art, which is held every two years in the city's numerous galleries and in public places. In 1873, Andrew Barclay Walker, who had made his money from brewing beer, donated the Walker Art Gallery to the city. Today the museum houses one of Europe's most important art collections, including works of art from the Middle Ages to the present day.

The George Hall, a concert hall, is one of the most beautiful neoclassical buildings in the world. The ceiling, supported by red-granite columns, is breathtaking. If you want to take a break, there is scouse. Liverpool is the only British city where lobscouse, the northern European sailor's dish made of corned beef (or lamb), potatoes, herring, and beetroot, is part of traditional cuisine. Here the dish, traditionally called Labskaus in Germany, is called "lobscouse," or "scouse" for short. But scouse is more than just food: it also encompasses the difficult-to-understand dialect of the Liverpudlians, their relentlessly sarcastic humor, their port city mentality, and their rejection of London. Scouse can still be heard in the ordinary pubs of the nongentrified working-class neighborhoods. This is where the debates revolve around "the Blues"—Everton FC (Football Club)—or "the Reds," Liverpool FC.

A PINK MARBLE URINAL

The heart of Liverpool is its music. "The kind of town where people go out on Monday without thinking about Tuesday." The cradle of beat music includes the Cavern Club on Matthew Street. This is where the bands that later became legendary played: the Rolling Stones, Kinks, the Who, and, of course, the Beatles. A Magical Mystery Tour takes you along Penny Lane and to Strawberry Field. Classical music is played by a traditional symphony orchestra in the Liverpool Philharmonic Hall on Hope Street. When Simon Rattle heard Gustav Mahler's music played there when he was 11 years old, he knew that he would become a conductor. Diagonally opposite, the Philharmonic Dining

Rooms public house offers a very special sight: the urinal in the most famous gents' toilet in England is made of ornate pink marble. In the Hard Days Night Hotel, you can have a wonderful dream: "Imagine all the people living life in peace."

CROSBY BEACH

One hundred life-size, cast-iron figures stand on the sand by the sea; some appear to be sinking into the sand; others are looking for shells and seaweed. Some of them have their "skin" peeling off. At times they are almost completely covered by the high tide. This installation by British artist Anthony Gormley is called *Another Place*.

The sculptures are 17 different versions of casts of his own body. The artwork was first seen in Cuxhaven, Germany, and was moved to Crosby Beach in 2005 and was to remain there for two years. But the population decided to have it installed permanently. The mood with and among the 100 statues changes with the time of day and the weather—an original encounter on the beach north of Liverpool.

MORE INFORMATION
Municipal museums
www.liverpoolmuseums.org.uk
Biennial
www.biennial.com
Crosby Beach
www.visitliverpool.com

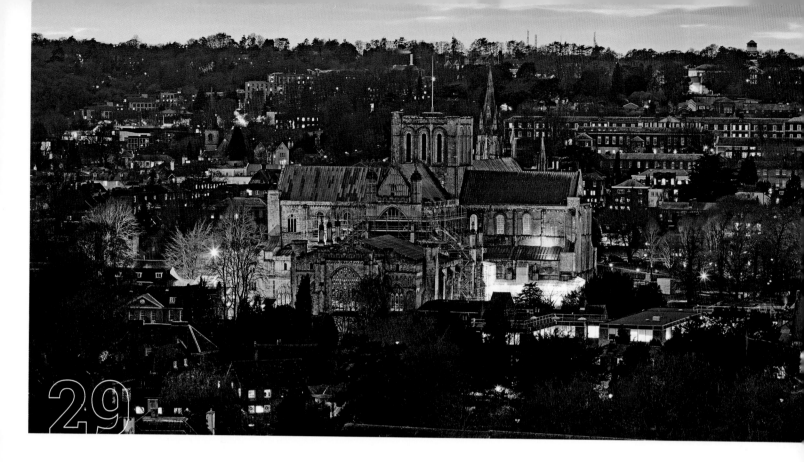

ENGLAND

CITY OF GREAT KINGS AND A ROMANTIC POET

Merry Olde England at its finest. The old Anglo-Saxon capital is idyllic and effervescent. Here stands the longest Gothic cathedral in the world, the streets are filled with colorful bustling markets, beer is on tap in cozy pubs, and the River Itchen Way takes you to quiet riverside meadows. A place not only for Romantic poets.

At the western upper end of High Street stands the Great Hall, built of flint, the knight's hall in the former castle complex. The Norman conquerors of England built it on top of Roman foundations after 1066. The quiet hall houses the most famous round table in the country.

ARTHUR THE IMMORTAL AND ALFRED THE GREAT

The legendary King Arthur supposedly sat here with his Knights of the Round Table. But dendrological studies have confirmed the presumption that Merlin, the magician, did not carve a single name into it—the board dates from the 13th century.

Even if the legendary sixth-century king never took his place at it, the tabletop remains remarkable and is hung up high out of reach on the wall of the Great Hall.

At the other end of the city stands the cast statue of Alfred the Great. During the ninth century, the Saxon king became the first ruler of all the Anglo-Saxons. Only two English monarchs are called "the Great," and both are buried in Winchester. Only one pelvic bone of Alfred has been found, in a museum case. Through the fortified Westgate city gate, which houses a small medieval museum, the High Street leads directly to the market High Cross, called the Buttercross.

WINCHESTER CATHEDRAL IS ATMO-
SPHERICALLY ILLUMINATED IN THE
EVENING (*OPPOSITE*); IN ITS INTERIOR,
THE CENTRAL NAVE'S GOTHIC VAULT
LEAVES A DEEP IMPRESSION (*LEFT*).

Looking like a spire that's been knocked off a church, it has watched over market activity since the 15th century. The stands are set up in the shade of the half-timbered buildings. On Wednesdays and Saturdays there is regional food, on Thursdays shabby chic, and the Sundays alternate between antiques and the most famous farmers' market in England.

RECORD-BREAKING CATHEDRAL

A few steps away, past the street poles painted with scenes from English history, the green cathedral close opens up with a view of the medieval cathedral. Construction began in 1079, and it looks like a fortress from the outside. Inside, the longest Gothic nave in the world (550 feet) surprises the viewer as a light-filled space from the High Gothic period, spanned by a filigree vault. The voices of the choirboys and choirgirls float angelically through the space every day at Evensong. They also touch the grave of author Jane Austen, who was buried in the side nave on April 24, 1817. In the crypt stands the sculpture *Sound II* by Antony Gormley, looking at the reflections of the water that seeps in when it rains.

WEDDING OF THE CENTURY AND ROMANTIC WALKS

Romantic poetry enthusiasts follow in the footsteps of the poet John Keats, who got to know the city and wandered through it during 1819. Behind the cathedral, the path goes to the cathedral close; then on to the quiet Dean Garnier Garden, with a good view over the whole length of the cathedral; then past the yellow-painted house where Jane Austen died and the oldest elite school in England, Winchester College, founded in 1382. The path passes by the ruins of Wolvesey Castle. One of the most important weddings of the century took place there in 1554: Queen Mary I of England ("Bloody Mary") married Philip of Spain, later Philip II. Mary's father, Henry VIII, had already died, but Charles V of Spain would lend glamour to this occasion. The Norman St. Cross hospital and almshouse, often used as a film set, rises on the banks of the quietly rippling little River Itchen.

MOTTISFONT ABBEY

A footbridge over the River Test leads into the world of the English country gentry. When this gentry family ran out of money, the National Trust foundation moved in and hired the rose breeder Stuart Graham Thomas. Now the world's largest collection of old roses is blooming at Mottisfont. And when the roses aren't in bloom, perennials venture out in the walled garden. Magnificent trees surround the house. In the 1930s, art patron Maud Russell moved into the old manor house and made it her "court of the muses."

MORE INFORMATION
Winchester Cathedral
www.winchester-cathedral.org.uk
Great Hall
www.visitwinchester.co.uk/listing/the-great-hall
Mottisfont Abbey
www.nationaltrust.org.uk/mottisfont

BATH—SOPHISTICATION ON SEVEN HILLS

WHERE "LIFESTYLE" CAME FROM

For thousands of years, the water from England's only mineral spring has been bubbling to the surface at a very warm 115°F. Pigs belonging to the Celtic king Bladud, who suffered from leprosy, had discovered its healing properties. The Romans expanded the spa bathing facilities, and in the 18th century, Britain's Hanoverian kings made them glamorous.

ENGLAND

Bath is synonymous with stony elegance and expensive plaster. Like Rome, it is built on seven hills, and the River Avon flows its leisurely way through the valley. When a legendary Celtic king named Bladud fell ill with leprosy, he was cast out and lived alone as a swineherd. One of the animals happened to wallow in the mud of a warm spring and discovered its healing powers, which helped the king. Since then, people have come to Bath to find healing.

A BATH FOR LONDON SOCIETY

A magnificent bathing complex was built in Roman times; it was located next to the temple of the goddess Sulis Minerva in the center of the city, then called Aquae Sulis. Nowadays, this complex is the only Roman bath in Europe still holding water, but bathing in the water is prohibited. Today the modern Thermae Bath Spa offers a wellness program, including a swimming pool on the roof, which is a part of the English Millennium Project.

Spa treatments had no role to play during the Middle Ages. It was the kings from Hanover, Germany, who first brought along with them to England their regional tradition of bringing health and society together in a sophisticated way. The city's golden age began. In winter, London high society traveled to Bath, and the houses and piazzas were designed accordingly. The Roman bath was built over and enlarged in classicist style. Terraced houses were built around circular streets or along crescents in a design henceforth named a "circus" or a "crescent." This grand 18th-century, Georgian-style architecture now comprises a UNESCO World Heritage Site. A museum at the exclusive Royal

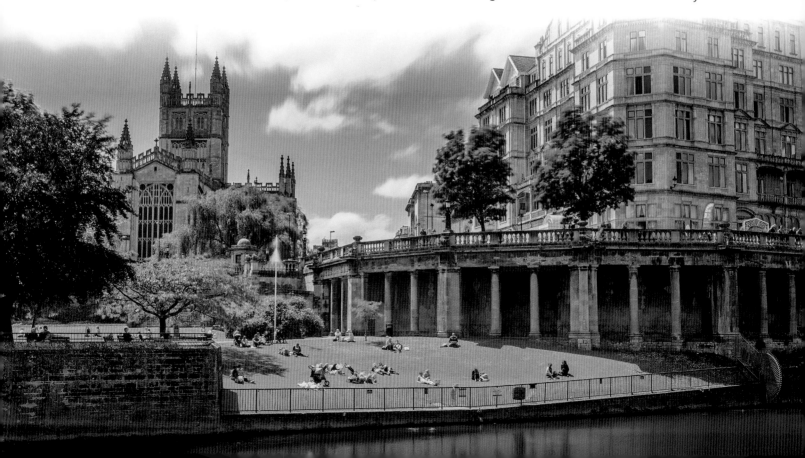

Crescent No. 1 address shows how people lived in proper style shortly before 1800.

The "winning team" of that time was the quarry owner Allen, the big landowner Gay, and the architects Wood, father and son. Their project was to design "Georgian Bath." The design principle of the modern row house attracted buyers and tenants. The uniform facades were clad with wafer-thin slabs of Bath stone, and the windows were fitted with the large, clear window panes that had just been invented in France at the time.

BALLROOM FOR BEAUTIES

During Bath's heyday, a master of ceremonies ensured the proper conduct of social life. The master of this discipline was named Beau Nash. With his mistress, named Popjoy, he entertained the ladies as they promenaded along the River Avon and on the classicist Pultney Bridge, which is lined with shops. Society gathered to chat and dance in the ballroom of the elegant assembly rooms. The local fashion museum displays the grandeur of the time in its collection of historical cloakrooms. Anyone who could afford to do so came to Bath. The German musician Wilhelm Herschel, together with his sister Caroline, moved from Hanover to the city and became the leader of one of the best English orchestras. However, his greatest interest was astronomy. He and his sister spotted the planet Uranus for the first time through a homemade giant telescope. A small museum commemorates this discovery. The Abbey, Bath's main church, stands on the city square by the Avon. At the entrance, stone angels climb up and down an oversized ladder to heaven, and a neo-Gothic vault gleams inside. The Abbey remained undamaged during the "Baedeker

VIEW OVER THE RIVER AVON TO BATH ABBEY (*LEFT*) IN THE CITY CENTER, STYLISH SHOPS INVITE YOU TO LINGER FOR A WHILE (*BELOW*).

attacks" by the German air force during World War II. Countless cafés, restaurants, and shops lining the main streets offer opportunities for shopping and taking a break. In a peaceful contrast to this, an excursion boat sails to Bathhampton along the narrow Kennet and Avon Canal. Arthur Philipp, the first governor and founder of Sydney, Australia, is buried in the village church there. A walk along the canal takes you back to the busy city.

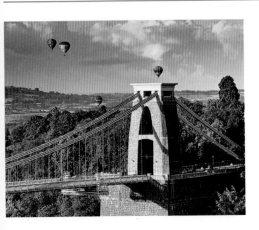

BRISTOL

After a short trip, the train arrives at one of the oldest train stations in the world, the Victorian Temple Mead Station, dating from 1840. Bristol lies, like Bath, on the River Avon and was one of the most important ports in Great Britain. From here John Cabot was the first known European to sail to the North American coast in 1497. In 1843 the *Great Britain*, the first oceangoing ship with an iron hull and propeller drive, was built in Bristol. The spectacular Floating Harbour has become the nightlife hub of this lively university city. One of the first trip-hop bands named itself after the old fishing port of Portishead and are pioneers of the diverse music scene. The street artist Banksy is one of Bristol's famous graffiti artists. The city's landmark is the Suspension Bridge, a chain bridge dating from 1864 that spans the Avon Gorge.

MORE INFORMATION
Bath
www.visitbath.co.uk
Fashion Museum in the Assembly Rooms
www.fashionmuseum.co.uk
Bristol
www.visitbristol.co.uk

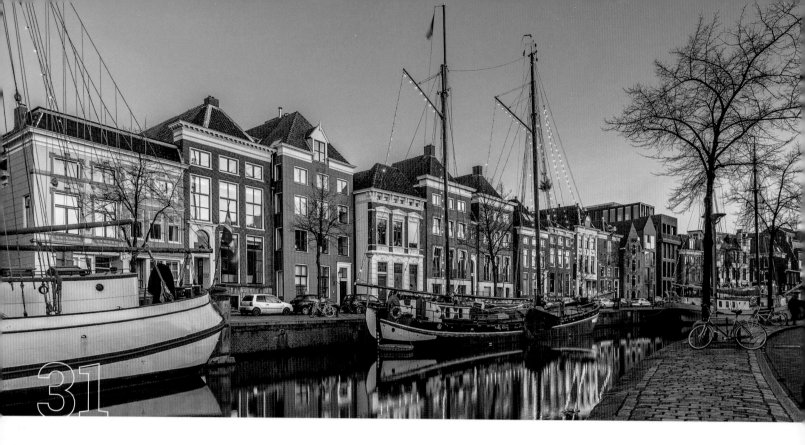

GRACHTS AND CANALS

Hanseatic city, university town, city on the water—Groningen, center of the eponymous Dutch province, lives up to its many names. With its time-honored buildings and avant-garde architecture, pedestrian-friendly streets, and lively student life, this city offers a successful mixture of old and new.

THE NETHERLANDS

Bikes everywhere. Groningen is among the most bicycle-friendly cities in Europe. The city center around the Great Market and the Fish Market is completely car-free, which makes a stroll through the historical center a pleasantly relaxing experience. The city's landmark, which is visible from afar and has already been so for over 500 years, is the 318-foot-high Martinitoren (St. Martin's Tower). It is possible to ascend the tower up to its third landing. The adjacent Martinikerk (St. Martin's Church), which was built in the first half of the 13th century and is the oldest and largest church in Groningen, houses one of the largest baroque organs in northwestern Europe. The striking academy building reflects Groningen's long tradition as a university city. As early as 1614, the first inquiring minds were already indulging themselves in science;

today, around 50,000 students are enrolled at the Reichs University of Groningen. This large throng of young people significantly lowers the average age of the city population of around 230,000 and lends a lot of color and drive to everyday life. Like a spaceship from a distant galaxy, a spectacular modernist building presides over an island in the gracht (Dutch term for an urban canal) lying between the Old Town and the main railway station: The Groninger Museum, opened in 1994, is worth seeing both inside and out. In its pavilions, this temple of art offers masterpieces from different eras but also exhibits on the early history of Groningen Province.

TRADE AND TRANSITION ON THE WATER

Groningen is crisscrossed and surrounded by a dense network of waterways. Several canals run into

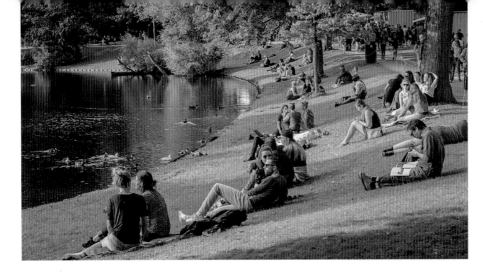

THE GRACHTS, OR "DIEPEN" (*OPPOSITE*), AS THEY ARE CALLED IN GRONINGEN, RUN IN A RING AROUND THE ENTIRE CITY CENTER. THE GREEN BANKS OF THE WATERWAYS MAKE A WONDERFUL PLACE TO RELAX (*LEFT*).

each other in the urban area: from the west, the Van Starkenborghkanaal; from the east, the Eeemskanaal; from the south, the Noord-Willemskanaal; and from the southeast, the Winschoterdiep. This favorable inland location with quick access to the North Sea made the city an important trading center for goods of all kinds by the Middle Ages. In 1422, Groningen joined the Hanseatic League and by the 17th century had developed into a flourishing trade center. Even today, water still plays an important role for merchant shipping but is also important for tourism. Sailboats and motorboats, canoes, pedal boats, and the electrically operated flat fluister-boote all sail on the grachts and other waterways. If you want to get to know Groningen from the perspective of the water, you can book these boats by the hour or make yourself comfortable on a tour boat. Once you're aboard, it will take you past interesting buildings and the remarkable warehouses that recall the great commercial history of this Hanseatic city.

LANDSCAPES FOR EXPLORERS

The area surrounding the city also has a lot to offer. Groningen is nestled in a polder landscape of broad fields, former sea dikes, large farms, old terpen (artificial hillock) villages, and borken, the magnificent country houses typical of the region. The Reitdiep River (formerly the Hunze) meanders from Groningen along the coast to Zoutkamp on the Lauwersmeer. Its valley has long been a cultural landscape, and today it invites you to explore along a network of hiking trails and cycle routes. The Lauwersmeer National Park, with its rich fauna and flora, is also a worthwhile destination for all nature lovers who are inspired by silence and space. From the coastal town of Lauwersoog, take the ferry to the Wadden Sea island of Schiermonnikoog.

ART UNDER THE OPEN SKY

Anyone who is paying attention as they walk through the city will encounter high art at many corners. On the Emmasingel and in front of the Cascade complex is Silvia B's 26-foot-high sculpture of a woman, *Ultra*. A public toilet as a work of art? Nothing out of the ordinary in Groningen, with its urinal designed by Rem Koolhaas with a wall of milk glass on the "Kleine der A" canal. And if you are traveling by boat on the connecting canal, you should also keep your eyes open. When the bridges open up, works that are part of the "Art under Bridges" project appear on the walls or on the underside of the bridge. This is how the Museumsbrug at the Groninger Museum presents a tile tableau by Wim Delvoye, based on the classic Delft blue, and the Oosterbrug presents a poem by Dutch avant-garde artist H. N. Werman.

MORE INFORMATION
Groninger Museum
www.groningermuseum.nl/en

32

ALONG HISTORICAL WAYS

Between the North Sea coast and the IJsselmeer bay, the historical trading town of Alkmaar is nestled in a beautiful polder landscape. Agricultural goods were traded prior to the Middle Ages, and starting somewhat later on, large wheels of cheese were offered for sale here. The Cheese Market commemorates this glorious past.

THE NETHERLANDS

A walk through the historical city center brings aspects of the past back to life. The city, founded more than 750 years ago and located 31 miles northwest of Amsterdam, has preserved many impressive architectural monuments in its core. Anyone strolling through the alleyways will experience one beautiful panorama after the other. You wander past narrow canals; inviting cafés, pubs, and restaurants; and the small shops, which often offer homemade items. These include the legendary Wilhelmina peppermint candies dedicated to Holland's former queen. A tour leads past Alkmaar's landmark, the Waagtoren tower, an imposing building with a clock tower that you cannot overlook. It was first used as a chapel and then as the city's cheese scale. The Sint-Laurenskerk (St. Lawrence's Church), built between 1440 and 1512 in the Brabant Gothic style, with its world-famous organs, has also shaped the cityscape for centuries. The old town hall, the Accijnstoren customs tower, the old Mohlen van Piet mill, and some historical residential complexes are also protected historical landmarks. A tour of the canals offers a different and no less impressive view of the city. On the canals, the word is "Be careful; keep your head down!," because the wide, open boats can pass under the lowest bridges.

CHEESE FOR THE WHOLE WORLD

With around 100,000 inhabitants, Alkmaar is a manageable city with many quiet corners.

However, all that changes when the world-famous Cheese Market takes place. This spectacle has been held on the Waagplein since 1622. Thousands of visitors then come to the city square in front of the city scales to attend the traditional cheese auction, held on Friday mornings from April to October. While in the past, during the city's heyday of trade, up to 300,000 kilograms of cheese wheels were displayed on the Waagplein in all kinds of sizes, shapes, and colors, today a tenth of that quantity is still offered for sale. If you come early enough, you can watch the cheese carriers or "setters," dressed in white and wearing colorful hats, some of whom are transporting huge loaves of cheese on shaky wooden frames. When everything is in good order, the lively bargaining begins.

You can find out more about the well-loved Dutch cheeses such as Gouda and Edam and the old sales traditions, which are now celebrated only for touristic reasons, in the Cheese Museum. This is located directly on the square, on the second and third floors of the former city scales. The museum shows the history of cheese making, from artisan production on the farm to industrial production, through its historical objects, paintings, drawings, films, and other exhibits.

BY THE NORTH SEA IN NO TIME
Anyone who has sniffed enough city air can set off to explore the beautiful surroundings of Alkmaar with its polders, lush green meadows, and historical windmills. The best way to do this is by bicycle, because the northern Holland region is also a cyclist's paradise. Guided by a cleverly devised "hub cycle-path network," which makes orientation child's play, you can ride safely and in a relaxed way

THESE MODERN WOODEN HOUSES ON THE WATERFRONT (*LEFT*) MAKE A NEW STYLE OF NEIGHBORLY RELATIONS POSSIBLE. TASTE AND ENJOY—THE RANGE OF CHEESES AVAILABLE IN ALKMAAR IS OVERWHELMING (*BELOW*).

on paths separate from car traffic. The sea is not far away: it takes about a quarter of an hour to drive to the North Sea beach. The nearby coastal towns of Bergen aan Zee, with its marine aquarium, and Egmond aan Zee, with its lighthouse, are particularly worth visiting.

BACK TO THE "GOLDEN AGE"
The Alkmaar museums offer a variety of exciting ideas. They pay homage not only to cheese, but also to the well-loved beverage brewed from hops in the National Beer Museum, housed in an old brewery. In the privately run Beatles Museum, there are all kinds of curiosities to be discovered about the world-famous mop-tops from Liverpool. The Stedelijk Museum at Canadaplein 1, right in the middle of the city center, is dedicated to Alkmaar itself and its past. It is one of the oldest museums in the Netherlands. As "the city's memory," this building, opened in 1875, lets visitors immerse themselves interactively into

Holland's golden age. In addition to exhibits relating to the city's history, the museum also displays masterpieces of fine art, including paintings of the Bergen school such as landscapes, still lifes, and portraits that are attributed to expressionism.

MORE INFORMATION
Alkmaar Cheese Market
www.kaasmarkt.nl/en
Stedelijk Museum Alkmaar
https://stedelijkmuseumalkmaar.nl/en

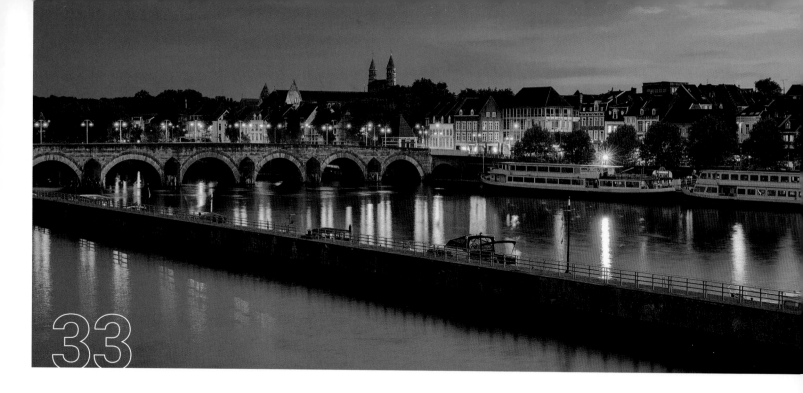

THE NETHERLANDS

ABOVEGROUND AND BELOWGROUND

The capital of the province of Limburg is one of the oldest cities in the Netherlands. Its origins go back to a Celtic settlement on the banks of the Meuse River, which is dated back to around 500 BCE, and a Roman fortress. Maastricht has developed into a modern metropolis without losing its historical charm.

A red banner with a silver star and, behind it, the figure of an angel in a bright-blue robe—the Maastricht coat of arms makes a colorful presentation. It is just as colorful as the life of the city itself. The city attracts many people with its cultural scene, its internationally renowned university, its well-stocked fashion and designer shops, and its rich culinary offerings, from star-rated cuisine to rustic regional dishes. Its geographical location in the far southeast of the Netherlands, between Germany and Belgium, gives it its international flair. Not least thanks to the Maastricht Treaty, which established the European Union in 1992, the city is a permanent anchor point for Europe.

ON THE TRAIL OF HISTORY

The historical city center is at Vrijthof Square, a popular meeting place for students, locals, and tourists alike, where you can saunter over old cobblestones or enjoy the atmosphere from one of the many street cafés. During the summer, well-attended outdoor concerts are held against the backdrop of the medieval architecture, which gives an idea of Maastricht's past as a religious center and as a fortress city. The square is dominated by two churches: the Gothic Sint-Janskerk (St. John's Church), with its bright-red church tower, and the Romanesque Sint Servaas (St. Servatius) Basilica, which is the oldest surviving church in the country. The three-nave cruciform church houses a magnificent treasury containing masterpieces of the goldsmith's art and the bones of St. Servatius.

WALKING ALONG THE RIVER

The city, with its approximately 120,000 inhabitants, is shaped by the river that gives it its name. On its way from its source region in France to its mouth in the North Sea, the Meuse also flows right

EVEN IN THE EVENING, IN THE GLOW OF ITS LANTERNS, THE MEUSE RIVER, WITH THE HISTORICAL SINT SERVAASBRUG (ST. SERVATIUS BRIDGE), OFFERS A PHOTOGENIC VIEW (*OPPOSITE*). DURING THE DAY, COZY CAFÉS IN THE CITY CENTER INVITE YOU TO TAKE A SHORT BREAK (*LEFT*).

through the middle of Maastricht, forming an attractive promenade landscape that invites you to go for a walk, a bike ride, or even a leisurely picnic. The stone Sint Servaasbrug (St. Servatius Bridge), built by the Romans, connects the Old Town to the exclusive residential area of Wyck. The Bonnefanten Museum, built from 1992 to 1995, with its extensive collection of old Flemish and Dutch paintings and contemporary art, is also located on the banks of the Meuse. This extraordinary building with its famous staircase was designed by the Italian architect Aldo Rosse.

DEEP SECRETS

Anyone who feels like having a little adventure can descend into and tour the extensive branches of the underground grottoes, which can tell many an exciting story. The labyrinthine system of corridors in the northern grottoes is located under the Sint Pietersberg plateau and the 18th-century fort of the same name. Over the course of 800 years, countless shovels and hoes dug up valuable limestone here, creating a huge network of pits and caves. This hidden world also served the population as a refuge, hospital, and hiding place. Thus, it was here that Rembrandt's masterpiece *The Night Watch*, for example, found protection during the German occupation in World War II. On the other hand, the tunnels in the casemates (fortified gun emplacements) on the western side of the city, built between 1575 and 1875, were used for military defense. Up to 5,000 soldiers were able to move through the underground passages, unnoticed by the enemy.

AN AFTERNOON IN THE PARK

Touring the city takes energy. Anyone who is looking for some relaxation after getting so many impressions will find it in the more-than-175-year-old municipal park along the Meuse River. There are actually three green spaces that run directly into one another: the Stadspark (city park), the Monseigneur Notenspark, and the Aldenhofpark. If you enter the city park from the Prins Bisschopssingel, you quickly come across the bear pit. But don't worry—instead of real bears, today there is art in the form of sculptures. A little farther on, the statue of D'Artagnan refers to the great musketeer who died nearby in 1673. The park also houses a mini zoo with local wild animals. It is also a pleasure to climb the historical city walls or simply enjoy the sunny silence from a bench.

MORE INFORMATION
Maastricht
www.visitmaastricht.com
Bonnefanten Museum
www.bonnefanten.nl/en
Grottoes and casemates
www.exploremaastricht.nl/en/maastricht-underground

BELGIUM

GLORIOUS PAST AND LIVELY PRESENT

As a European trade metropolis, Antwerp was once one of the biggest cities in the world. Even today, impressive evidence of this heyday can be found everywhere in the cityscape. But its modern life, with its diversity of cultures, languages, colors, and smells, also makes a visit an unforgettable experience.

A stroll through this Belgian provincial capital, which is located in the Dutch-speaking part of the country, is like walking through the history of architecture: anyone who walks through the largely preserved city center will encounter the late Middle Ages, Renaissance and baroque, but also traces of art nouveau and art deco. So it is not difficult to think back to the heyday of the Flemish metropolis in the 15th and 16th centuries. First documented in 726, Antwerp was granted its city charter in 1291. Thanks to its favorable geographical location on the Scheldt River, a wide estuary that allows even large ships to sail to the North Sea,

55 miles away, trade flourished early on, especially in cloth, but also in diamonds. Antwerp, today the second-largest seaport in Europe after Rotterdam, not only attracted merchants but also gathered within its walls masters of the arts such as the famous baroque painter Peter Paul Rubens (1577–1640).

THE GROTE MARKT

Anyone who reaches Antwerp by train has already gotten to know one famous sight: the majestic train station building, also known as the "railroad cathedral," is one of the most beautiful train

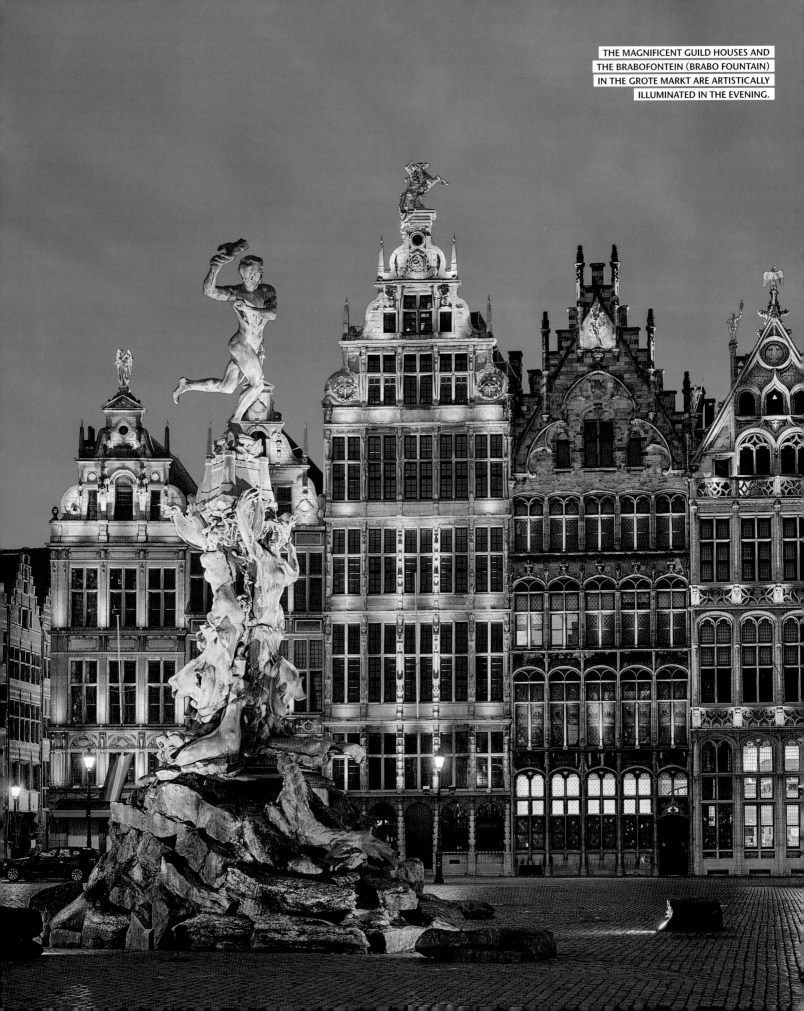

stations in the world. The Grote Markt, the central square in the middle of the historical Old Town, is the best place to start when taking in the city for the first time. By foot over time-honored cobblestones, in your mind amid a grand panorama of magnificent guild houses dating from the 16th and 17th centuries—here, you can sense history up close. On the west side of the Grote Markt rises the town hall, built in the Renaissance style, with its magnificently decorated facade. In front of it, the Brabofontein fountain, built in 1887, tells the story of the city's origins: the heroic Silvius Brabo is shown about to throw the severed hand of a cruel giant into the river. This great tyrant, at least as the story goes, had demanded all the ships sailing past pay customs duties. Those who did not toe the line lost their hands.

STONE FEAST FOR THE EYES

The Old Town is dominated by five large churches, including the seven-nave Cathedral of Our Lady. Already started in 1352, it took another 169 years for the building to be completed in all its glory. The Gothic church, whose 403-foot-high, filigree tower has been a UNESCO World Heritage Site since 1999, is a feast for the eyes both inside and out. In addition to the altars of the guilds and craft guilds and the large stained-glass windows, the cathedral is also home to a large number of famous works of art, including two triptychs by Rubens: *The Raising of the Cross* and *The Descent from the Cross*.

From the Old Town, continue to the nearby bank of the Scheldt River. This where is the oldest building in the city stands, Het Steen (The Stone) fortress. Built in the early 13th century, the colossus was part of the city fortifications; later it served as a prison, for storing fish, and as a museum. Today, a youth education center has moved in. If you continue south along the river, you will encounter another special feature of Antwerp: the Sint Anna (St. Anna) pedestrian tunnel, which leads under the Scheldt to the opposite bank. So as not to disrupt shipping, there are no bridges in the entire city area, but instead there are several tunnels.

DIAMOND TRADE

Antwerp has also been living on trading and processing diamonds for centuries. Still today, precious stones worth an estimated 220 million euros are passed from hand to hand in the city. The main center of this lucrative business is the diamond district near the main train station, which is well protected by surveillance cameras and security personnel. Tourists can discover little on their own here; guided tours are available for this. In 2018, the DIVA Diamond Museum was opened right behind the historical town hall, and it sheds more light on the silent trade in precious stones from the past to the present and also presents many fine pieces of jewelry.

MORE INFORMATION
Famous city sights
www.visitantwerpen.be/en/home
Diamond district tours
www.degoudenstraatjes.be
DIVA Diamond Museum
www.divaantwerp.be/en

ART AND COMMERCE

Antwerp is also a city of museums—with something available for everyone. Anyone who wants to walk in the footsteps of Rubens will visit the Rubens House, modeled on an Italian Renaissance palazzo. The great painter's home and workshop is now a museum that also displays a large number of his masterpieces. The Plantin-Moretus Museum, recognized as a World Heritage Site by UNESCO, is also a former residence. The Plantin-Moretus family, who heralded a new age with their printing house, lived and worked here for about 300 years.

The historical premises give a vivid insight into the family history and into the Flemish culture of art and living. A newcomer among the museums is the Museum aan de Stroom (Museum on the River), which opened in 2011 in the harbor district and is impossible to overlook due to its striking architecture alone. The history of Antwerp and its port—each of the five floors fills out the picture of an important city with countless exhibits. The panorama roof (open as late as midnight in summer) offers a superb view of the harbor and the entire city. The fashion museum, MoMU for short, demonstrates in a masterly way that the city has long been a mecca for lovers of fashion and design. It presents fashion history, geniuses of design, and new trends. Once you have acquired a taste for it, you can continue your shopping trip through the Antwerp fashion district, where you can find exclusive Parisian and international fashion houses as well as products by talented young Belgian designers.

CULINARY DELIGHTS FROM ALL OVER THE WORLD

If you need a brief rest break in between, you can immerse yourself in the city's great culinary offerings. In the streets of the Old Town, but also in the modern districts, there is a large selection of cozy cafés, chic bars, quaint pubs, and inviting restaurants. Small shops offer handmade chocolates. Nice restaurants with kosher dishes are a reference to the largest Jewish community in Europe. Delicious street food from all parts of the world is to be found on every street corner. It also becomes clear while you eat: today there are people from more than 170 nations living in the city on the Scheldt—and you can taste that too. Incidentally, the Antwerpse handjes, small pastries or chocolates in the shape of a hand, are prepared as a reminder of the feat of the city's legendary founder, Silvius Brabo, and as a trademark of the city.

THE MIGHTY HET STEEN CASTLE COMPLEX (*RIGHT*), ONCE PART OF THE CITY'S FORTIFICATIONS, IS AN ANTWERP LANDMARK. AFTER YOUR VISIT, FRESH BELGIAN WAFFLES WILL ENTICE YOU (*ABOVE*).

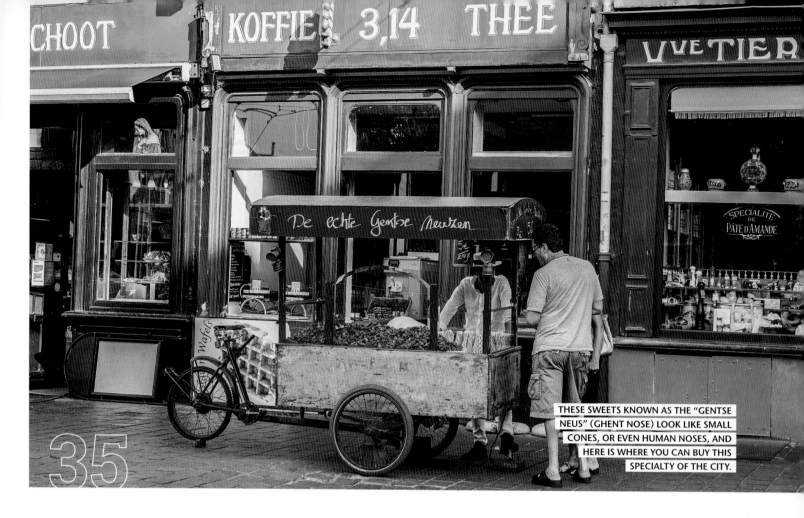

THESE SWEETS KNOWN AS THE "GENTSE NEUS" (GHENT NOSE) LOOK LIKE SMALL CONES, OR EVEN HUMAN NOSES, AND HERE IS WHERE YOU CAN BUY THIS SPECIALTY OF THE CITY.

BELGIUM

THE GLORY OF FLANDERS

The city offers an abundance of sights but is still pleasantly manageable, at least from the surface. Flemish Ghent, a modern and trendy city in historical guise, is best explored on foot or by bicycle. The historical city center invites you to travel back in time to a glorious past.

Ghent, the second-largest city in Flanders and the third-largest city in Belgium after Antwerp and Brussels, is considered the historical heart of the Flanders region and is also known as "the Manhattan of the Middle Ages." In fact, the port city at the confluence of the Leie and Schelde Rivers was a powerful city-state thanks to its blossoming cloth trade and the flourishing flax and linen industry. Its inhabitants could afford to build imposing churches and demonstrate their social position by means of stately buildings. Fortunately for all the visitors to the city, many of these medieval and early modern buildings in the

city center have been preserved and are today under special protection as impressive witnesses of their times.

TOWER LANDMARKS

Ghent was already known as the city of three towers during the Middle Ages, because its urban silhouette is characterized by the spires on three buildings. The tower of the Sint-Niklaaskerk (St. Nicholas Church) on the Korenmarkt (Wheat Market) is one of the "giants" that stand in a row in the heart of the Old Town—which can best be admired from the St. Michael's Bridge. Erected in

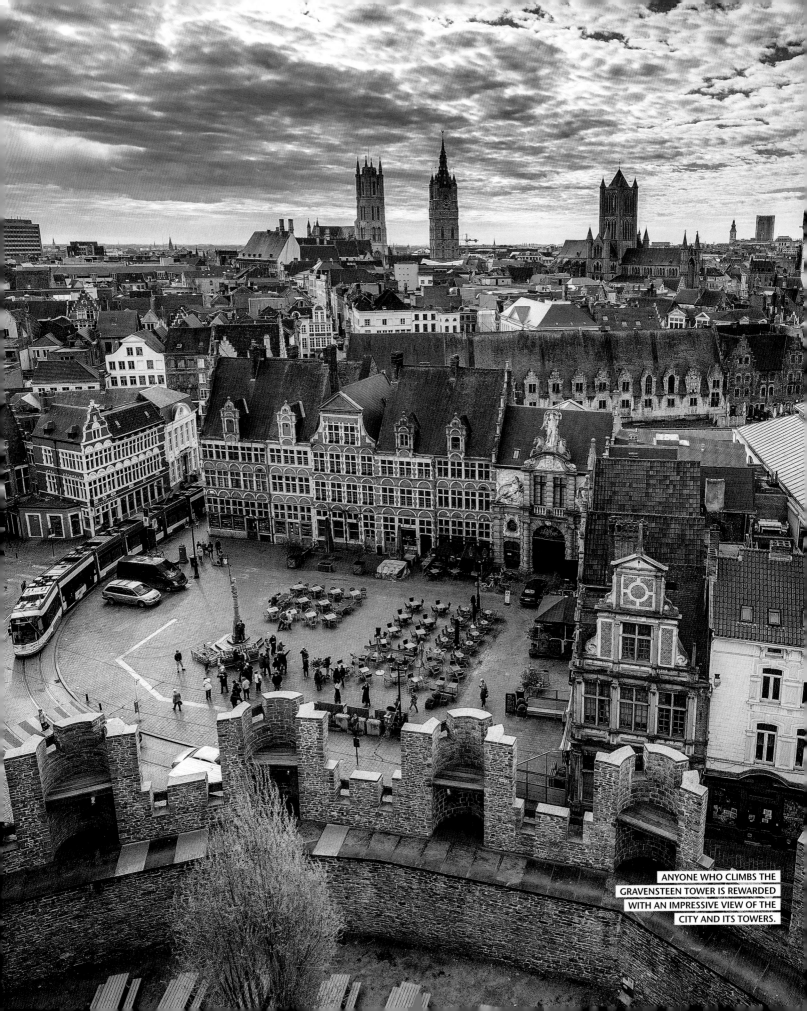

ANYONE WHO CLIMBS THE GRAVENSTEEN TOWER IS REWARDED WITH AN IMPRESSIVE VIEW OF THE CITY AND ITS TOWERS.

the 13th century in "Schelde Gothic" style (named for the Schelde River) as a parish church for the city's wealthy citizens, it is particularly ornate. Next is the Ghent Belfry, which, together with other secular bell towers of this kind distributed throughout Belgium, is a UNESCO World Heritage Site. The 311-foot-high tower, built in the 14th century as a symbol for the city's independence, supports the famous "Dragon of Ghent" at its top and stone guards on its four corner towers. For a long time, the colossus served as a refuge from enemy attacks and from devastating fires. It also housed the secret city archive, with the privileges of the city. Its large bell, the Roland bell, was rung when danger was approaching, and gave the signal to open or close the city gates. Today the belfry above all offers its visitors a magnificent view of the city. The ascent is less strenuous than you might initially expect, because there is an elevator from the first floor. The last in the row of towers is the tower of the Sint-Baafskathedraal (St. Bavo's Cathedral), the oldest

parish church on Ghent's soil, which has been made more and more magnificent over the centuries. The cathedral was given its current Gothic form in the middle of the 16th century.

THE GHENT ALTARPIECE

Anyone who has extensively admired the cathedral of patron saint Bavo from the outside should definitely enter it. Because inside, the building awaits you with its great treasures and an abundance of marble and gilded wood: there is the rococo pulpit made of oak, the baroque high altar, the Eternal Light in the form of a Gothic chandelier, the Rubens painting *Saint Bavo Enters the Convent at Ghent*, and Justus van Gent's Crucifixion triptych. In addition, of course, there is the Ghent Altarpiece by the Van Eyck brothers, which is probably the most famous Early Netherlandish Old Master painting. This masterpiece by Hubert and Jan van Eyck, completed in 1432 and bearing the full title *Adoration of the Mystic Lamb of God*, comprises 12 oak panels that show biblical scenes.

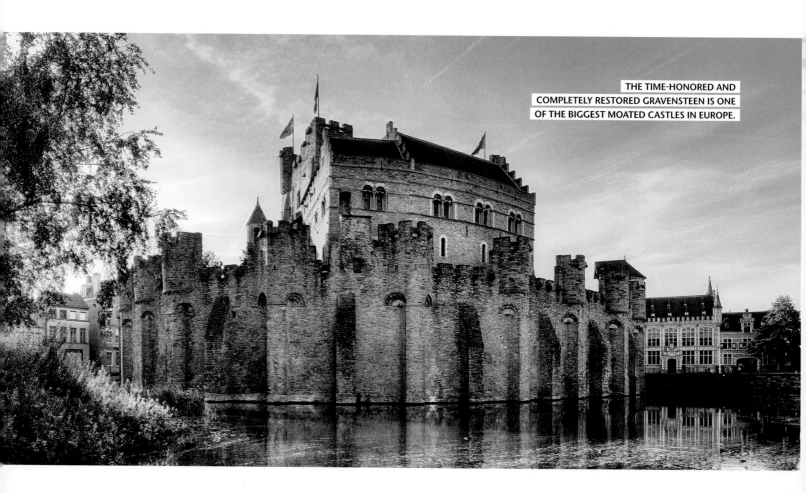

THE TIME-HONORED AND COMPLETELY RESTORED GRAVENSTEEN IS ONE OF THE BIGGEST MOATED CASTLES IN EUROPE.

The winged altarpiece has always aroused covetousness. Hardly any other work of art has been stolen, abducted, and carried off so frequently, most recently in 1934, when a double panel disappeared. One panel of it appeared again, but the scene of the "Righteous Judges" has disappeared and to this day it is possible only to admire a copy of it.

GRAVENSTEEN CASTLE

In addition to imposing places of worship, Ghent also offers impressive secular buildings from past times: by the old harbor, on the Graslei (Street of Herbs and Vegetables) and the Korenlei (Street of Wheat), there are magnificent guild houses, and near the Gravensteen castle is the fish market, with its baroque facade, and the Gothic Butcher's Hall. The Gravensteen dates from the 12th century. Built in Romanesque style, the moated castle with its almost intact defenses conveys an authentic medieval image. To protect their power, the counts of Flanders had the original wooden buildings converted into a donjon—a residential and defense tower also called a keep—completely enclosed by a wall with 24 towers. It is possible to visit this wall, as well as the donjon, the gate building, the count's residence, and the stables. If you would like to have something to chuckle about at the same time, the best thing to do is choose the audio guide narrated by the well-known city comedian Wouter Deprez, who brings its eventful history back to life in all kinds of anecdotes.

CELEBRATE AND FEAST

Every year in July, the Ghent city center is in a state of emergency for 10 days. The Gense Fieste (Ghent Festival), a free street, music, and culture festival, is one of the largest of its kind in Europe and transforms streets and squares into a state of colorful, lively hustle and bustle. In addition to the heritage gourmet snacks, the festival also offers a wide range of culinary delights. After all, the restaurant and pub scene is one of the city's highlights all year-round. There are countless pubs and bars, and not just around Sint-Veerleplein square or on Overpoortstraat. Many innovative restaurants have settled in Patershol, which was the quarter for traders and artisans during the Middle Ages and today is a warren of small, beautiful alleys. Ghent is rich in young chefs who are revolutionizing the gourmet scene. And for anyone who prefers to avoid meat: with its wide range of fresh, meatless dishes, the city is considered a European vegetarian metropolis. By 2009, Thursday was designated "veggie day," an exemplary campaign that many other cities have now followed.

ENLIGHTENMENT

When the sun goes down, a day of sightseeing in Ghent is far from over. Because in the dark, the city shows itself as a magical landscape of lights. Evening after evening, the historical city center with its monuments, churches, entrance gates, and outstanding secular buildings and squares is artistically illuminated according to a specially created and award-winning lighting plan. If you set off on an evening stroll through the medieval center, you will immerse yourself in a fascinating world of light and shadow and reexperience from an unusual perspective the historical walls that you previously visited in daylight. But night owls should take note: at the stroke of midnight, the light spectacle is all over, so it is better not to start your illuminated walk too late!

MORE INFORMATION
Ghent
https://visit.gent.be/en
St. Bavo Cathedral
www.sintbaafskathedraal.be/en
Gravensteen
https://visit.gent.be/en/see-do/castle-counts

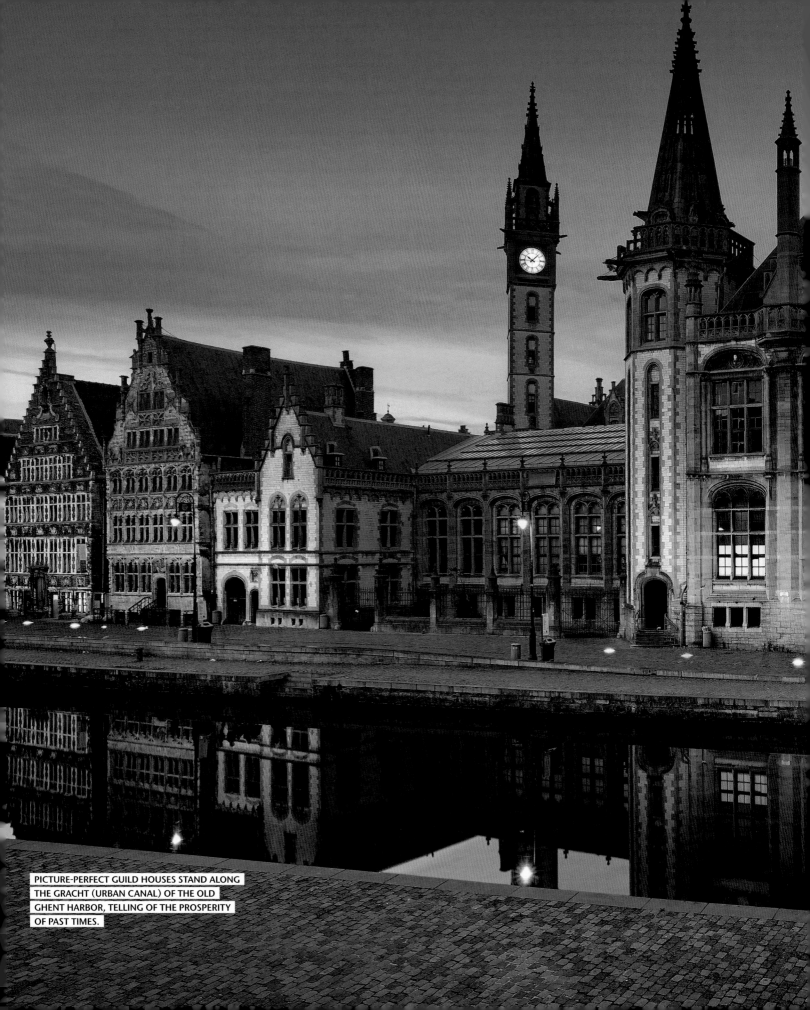

PICTURE-PERFECT GUILD HOUSES STAND ALONG THE GRACHT (URBAN CANAL) OF THE OLD GHENT HARBOR, TELLING OF THE PROSPERITY OF PAST TIMES.

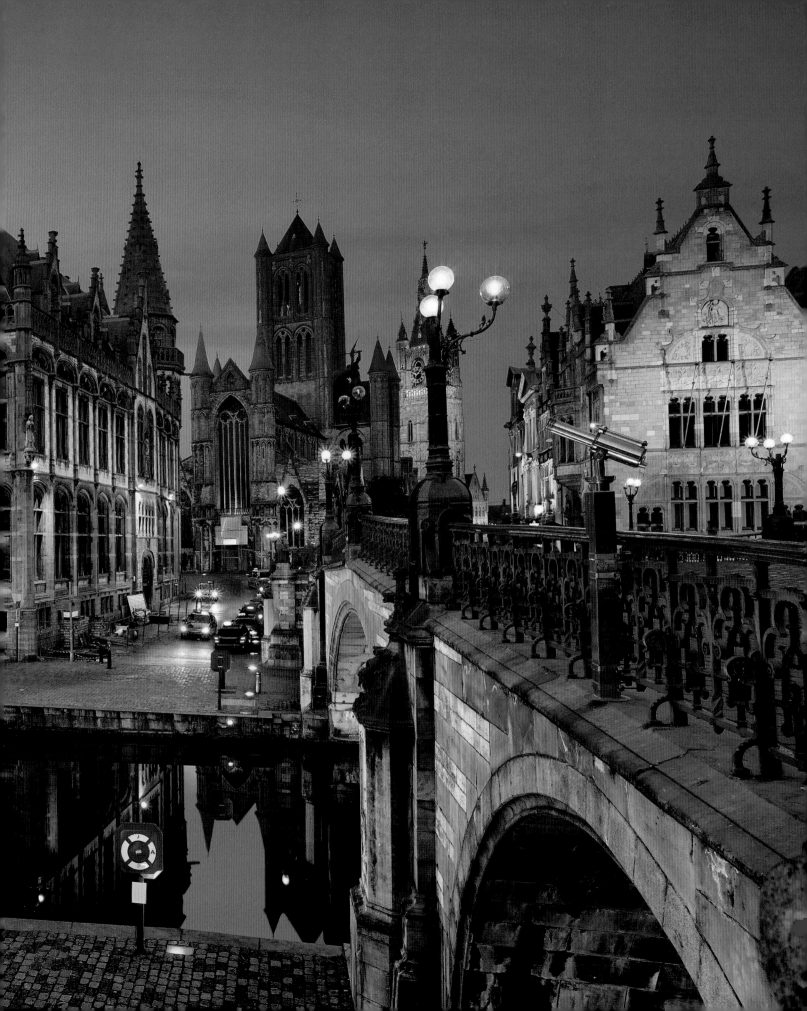

BELGIUM

FINDING HAPPINESS IN SMALL THINGS

In Belgium, tourists are mostly drawn to Bruges or Ghent. As if it has hidden itself away just for those seeking peace and quiet, Malmedy nestles between the Eifel and Ardennes mountain ranges, in a valley surrounded by gentle hills, forests, and green spaces. In a charming and unspectacular way, this city keeps many of the things that make Belgium so special in store for visitors.

At the same time, Malmedy, today only a couple of miles from the German border to the east, has had to put up with a lot. It once belonged to the principality of Stavelot-Malmedy, later to France, then to Prussia, and was allotted to Belgium after World War I. During World War II, Malmedy was under German occupation.

OF WORK AND PROSPERITY OF DAYS GONE BY

Not only those in German jackboots, but also—starting much earlier on—Norman, Hungarian, French, and American soldiers have left clear traces of devastation behind them. This and much more can be experienced in the around

32,000-square-foot Malmundarium. The building housing the museum dates from the early 18th century. A monastery once stood in this place—prior to the seventh century, monks had settled the location, with the abbot St. Remaklus among them. The Malmundarium displays a great deal of the city's history. In the leather studio, the once locally important craft of tanning leather is brought back to life, as is the technique of papermaking in the paper studio—paper from Malmedy was known for its high quality.

For most people, these crafts meant a lot of work and a modest existence; for a few, the cloth, leather, and paper industries brought prosperity. This is still evident in the alleyways and city districts,

such as in the Rue La Vaulx, the Rue Haute Vaulx, or the Quartier Outrelepont in the oldest parts in the city. In the rather crooked-looking Vinette House at Route des Chôdes 1, at the end of the 18th century the occupying French revolutionary forces wanted to deny the last rites to a poor carpenter's daughter—but the good citizens of Malmedy rose up and brought a priest in to her. The scene has been re-created in one of the rooms.

The pretty town hall and villas, such as Villa Lang (Rue Jules Steinbach 2) or Villa Steisel (Place de Châtelet 4), ornamented with wrought iron, gables, and turrets, represent the city's former prosperity. In the Viller House (Chemin Rue 11), you can even still admire the original furnishings from the early 18th century. The rich stucco and wooden decorations and the bright-blue Delft tiles give a hint that the tannery owner family did not have to pinch pennies.

STRENGTHENING MIND AND BODY

The Cathedral of Sts. Peter, Paul, and Quirin, with its imposing towers and carillon, is the landmark of Malmedy. A previous building on the site dated back to the 10th century; today's cathedral is kept simple. Its white, stucco-decorated interior; the wooden pulpit; and the marble altar from the 18th century make an elegant impression on those who want to enjoy a moment of silence. At the Place de Rome, Place de St-Géréon, and Place du Pont-Neuf, they immediately catch your eye—the photogenic music pavilions with their columns, fences, and decorative ornaments. When the city's music clubs play, people flock together to be entertained. Pretty small squares, such as Place Albert 1er or the Place de Rome, can also do something for your

TRANQUIL MALMEDY COULD PROVIDE AN AUTHENTIC BACKDROP FOR A FRENCH FILM (*OPPOSITE*). SOME OF THE GORGEOUS VILLAS RECALL THE CITY'S FORMER PROSPERITY EVEN TODAY (*BELOW*).

physical well-being. In summer, people sit outside and enjoy a whiff of French flair. Modest-appearing Malmedy has many a pleasure in store for visitors—Belgium is known to offer a range of sophisticated French-style cuisine dishes, from classic meat terrines, Ardennes ham, and Belgian moules frites to waffles and apple tart.

THE HOHES VENN–EIFEL (HIGH FENS–EIFEL) NATURE PARK

Malmedy lies at the foot of the Hohes Venn–Eifel Nature Park. The Belgian High Fens can be explored very well, starting from the Botrange visitor center, on wooden footbridges over the marshy ground. Your view wanders far and wide over plateaus with blooming cotton grass, small watercourses gurgle, and you can take a good rest under a small clump of trees. A wilderness trail is ideal for hiking in the German Eifel National Park. But you can also take a circuit trail directly from Malmedy, such as via Hédomont, Ligneuville, and Pont, up and down the hill. The steep path up Livremont hill to the north of Malmedy runs by 14 stations of the cross. The path and sta-

tions have been constantly redesigned, but nature has remained the same, with its dense foliage of beech, maple, linden, and larch, as well as the martagon lilies. The view from the belvedere over Malmedy and the surrounding area is the hiker's reward for all the effort.

MORE INFORMATION
Municipal administration Malmedy
www.malmedy.be and www.ostbelgien.eu/en
For hikes
www.naturpark-eifel.de

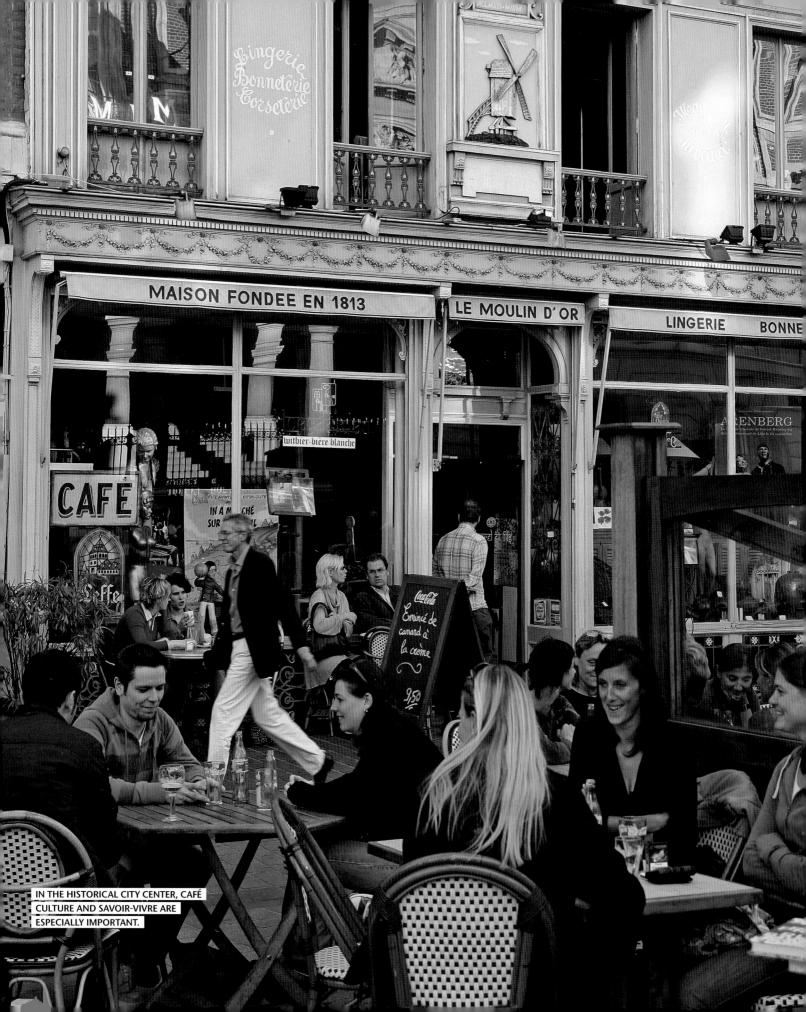

IN THE HISTORICAL CITY CENTER, CAFÉ CULTURE AND SAVOIR-VIVRE ARE ESPECIALLY IMPORTANT.

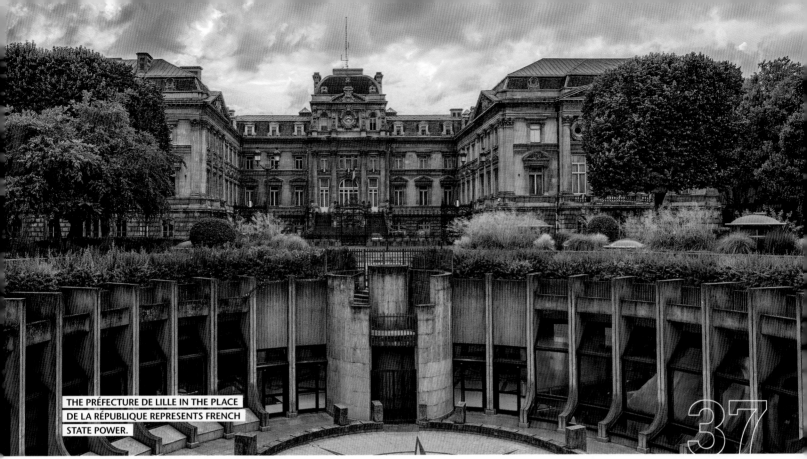

THE PRÉFECTURE DE LILLE IN THE PLACE DE LA RÉPUBLIQUE REPRESENTS FRENCH STATE POWER.

37

FRANCE

LILLE—GEM OF A CITY IN NORTHERN FRANCE

FLEMISH TRADITION AND FRENCH LIFESTYLE

As an architectural treasure trove, Lille, the "capital of Flanders," attracts visitors to the far north of France, where the country meets Belgium. This former garrison town is rich in history but also celebrates the present—not least thanks to the many students who give the city a cosmopolitan flair.

The capital of the Hauts-de-France region, founded in the 11th century on a swampy island in the valley of the Deûle River, is considered the most besieged city in France. In its eventful history from the Middle Ages to the French Revolution, it has been part of the county of Flanders, was then under the direct administration of France, belonged to the House of Burgundy, and was part of the Spanish Netherlands, before finally becoming French in 1667. All these "dominions" left their mark on the cityscape and gave Lille its unmistakable mix of a Flemish past and French lifestyle, which can be sensed everywhere. Lille once again made a successful transition to modern times during the 1990s, when many districts of this declining industrial city were extensively renovated and its population put their trust in its historical heritage, its art, and its culture, with great success. Lille today, with its approximately 230,000 inhabitants, is far more than an insider tip for city lovers.

ON LA GRAND PLACE

The best starting point for a first reconnaissance of the city is the Place du Général de Gaulle, a.k.a. La Grand Place, the Lille's historical "living room." The fountain in the middle of this beautiful square

is a preferred meeting place for young and old. Those looking for a little refreshment will find a wide range of options in the sunny street cafés that line the central square. Here is also the Vieille Bourse, the magnificent baroque former stock exchange dating from 1652. Whether street booksellers, chess players, or even tango dancers—everyone loves the historical city center with its magnificent buildings such as the Opéra, the Chamber of Industry and Commerce (with its belfry), or the Théâtre du Nord. Just a few steps farther, and you dive into the historical cobblestone streets with their colorful town houses, the lovely squares and passages, the chic boutiques, and the small wooden bridges. The Rue Esquermoise also has a magnificent heritage, even if it is more appealing to the palate: the Pâtisserie Méert has been offering luscious chocolate and delicious cakes since 1761, including *la Gaufre,* a traditional waffle that was said to have aroused the enthusiasm of President Charles de Gaulle, a famous son of the city.

CITY HISTORY, ART, AND NATURE

If you walk along the Boulevard de la Liberté toward the southwest, you will come to the Porte de Paris, the city gate that was built in 1692 and was once part of the city wall. The building is seen a monumental symbol of the incorporation of Lille into France. Not far away is the Hôtel de Ville, the town hall, with is widely visible belfry that is a UNESCO World Heritage Site. From its 345-foot-high top, which can be reached by elevator, there is a wonderful panoramic view of the city.

On the Place de la République, the Palais des Beaux Arts awaits visitors interested in art. On around 236,000 square feet of exhibition space, this 19th-century building, one of the largest art

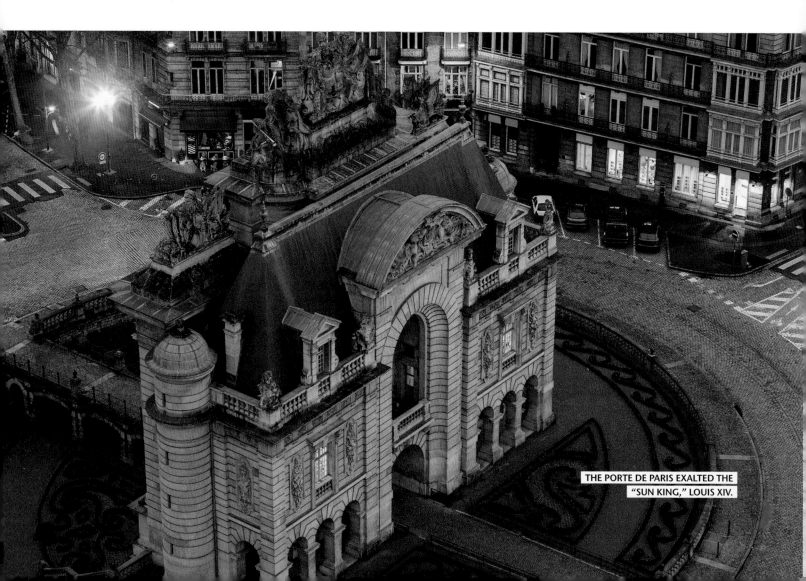

THE PORTE DE PARIS EXALTED THE "SUN KING," LOUIS XIV.

museums in Europe, offers a rich collection from antiquity to modern times. In addition to masterpieces by Rubens and Van Dyck, an exhibit in the museum basement surprises visitors with detailed relief maps of the neighboring cities that Louis XIV, the Sun King, had drawn up. If you want to get out in the countryside a bit, at the other end of the Boulevard de la Liberté is the Citadel of Lille, a fortified monument in the shape of a regular pentagon. As part of a defensive belt along the French northeastern border, the complex, also touted as the "queen of citadels," was erected in the 17th century, shortly after the city was taken. Military protection and public use have always stood side by side at the citadel. Even today, people meet here for walking, jogging, picnicking, boating, and other outdoor activities.

EURAVILLE—A LOOK INTO THE FUTURE

The new Euraville business district in the eastern city center shows that Lille can also be very modern. Steel and glass are the predominant materials in the buildings, which were designed by renowned architects from all over the world during the late 1980s. As the tallest building in the city, the spectacular L-shaped Tour de Lille (Lille Tower) office colossus rises 394 feet into the sky. The ultramodern Lille Europe train station, with Eurostar and TGV connections, and the Gare Lille Flandres train station, with its facade from the late 19th century, both unusually illuminated in the evening, are worth a closer look. Living, working, and shopping in the 21st century—that is what Euraville stands for. Anyone who has previously visited old Lille, with its splendid historical buildings, will experience an exciting alternative architectural program here.

FLEA MARKET CAPITAL

Since the 12th century, Lille has been issuing invitations to Europe's largest flea market every year on the first weekend in September. It is then that the "Braderie de Lille" attracts some three million people from Saturday at noon to Sunday at midnight, including flea market professionals, antique lovers, or simply visitors who want to experience the hustle and bustle up close. Those who would rather appreciate the offerings of professional exhibitors should take a look around in the Boulevard Jean-Baptiste Lebas. If you love junk, head for the Champ de Mars, and if you want to buy English tableware, look along the banks of the Deûle River and near the Opéra. The festival, which dominates the entire town, also features the local specialty moules frites (mussels and fries), which are available in restaurants everywhere. Oddly enough, on this weekend the empty mussel shells pile up meters high in the streets, because the restaurants compete with each other for who has the biggest pile.

DISCOVERY TOUR THROUGH WAZEMMES

With its mix of down-to-earthness, creative zest, new chic, and international diversity, the former working-class neighborhood of Wazemmes is very trendy. The focus is on the brick-built Halles de Wazemmes, the historical market halls, which every Sunday provide space for a busy and exotic market, held both inside and outside. Anyone who strolls through the alleyways will also embark on a gourmet journey through all the continents. There are Asian snacks, Arabic baked goods, and middle-eastern couscous, but also delicious cheeses, fresh beer from craft breweries, delicious waffles, and Potjevlesch, a terrine of meats typical of the region. Wazemmes is also the location of a maison folie, a "crazy house": the former Leclercq textile factory was developed into a new cultural meeting place, together with other projects, in the context of Lille as the European Capital of Culture 2004.

MORE INFORMATION
City of Lille
www.lilletourism.com

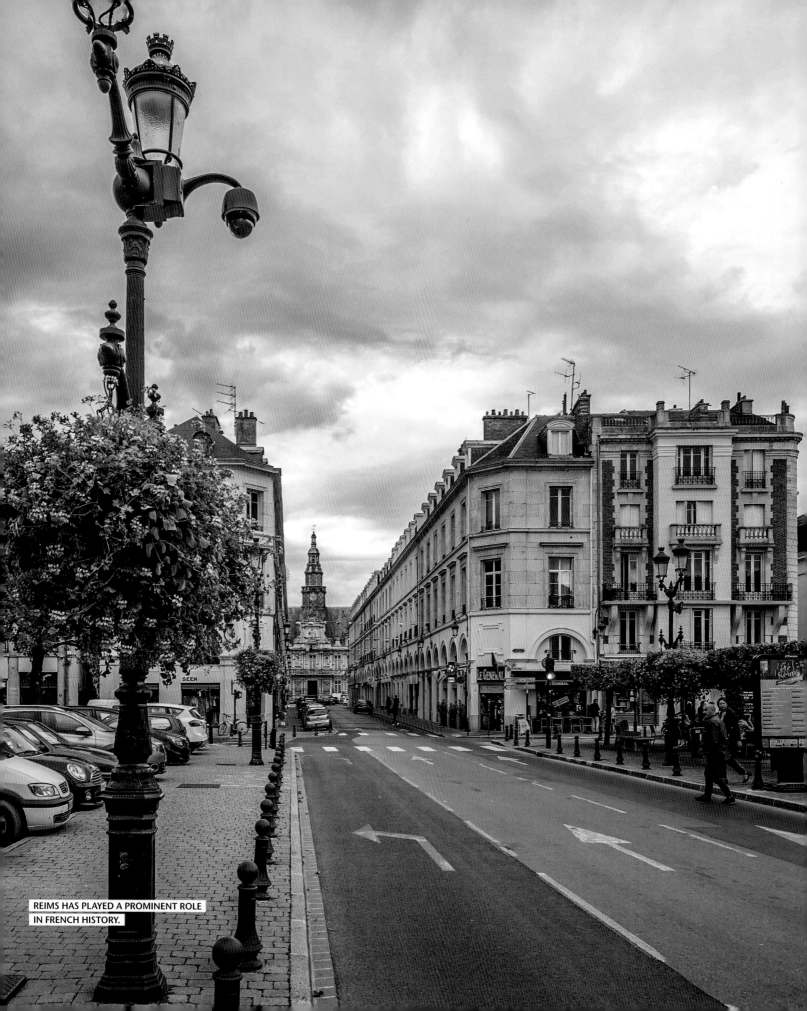

REIMS HAS PLAYED A PROMINENT ROLE IN FRENCH HISTORY.

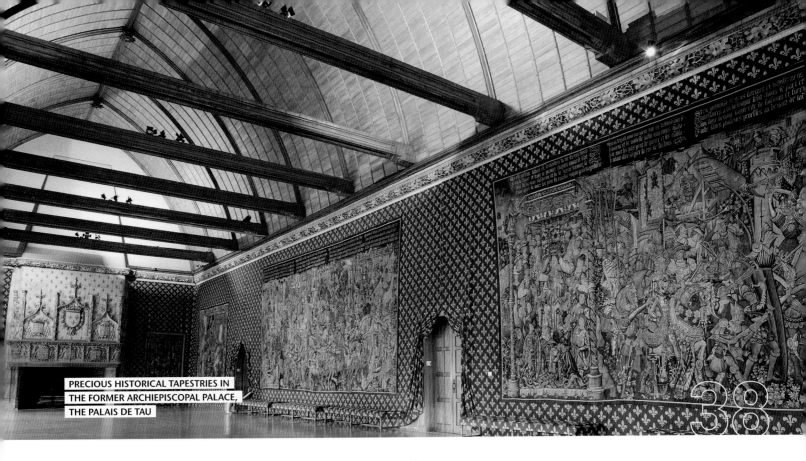

REIMS—A SPARKLING EXPERIENCE

CHAMPAGNE, CROWNED HEADS, AND PINK COOKIES

The luxury beverage sparkles everywhere in the capital of Champagne. But this city in northeastern France also stands for many of the great moments and impressive buildings of French history, for unique architecture in art deco style, and for a very special pastry: the pink ladyfinger cookie.

FRANCE

Reims lies in the valley of the Vesne River, an hour's drive from Paris. To the west and south, the city is surrounded by the elevations of the Montagne de Reims. The vines of the Champagne wine region are the foundation of its rise as the center for producing Champagne. Louis the Pious (778–840), son of Charlemagne, was the first who received his mandate to rule as a joint emperor by the grace of God in Reims in 816.

CORONATION—ONLY IN REIMS

According to legend, the cornerstone for Reims was laid by Remus, the brother of Romulus, the founder of Rome. In fact, it was the Celts who founded the city. It was named after the Remi, a tribe of the Gallic Belgians who lived in the location and were loyal to Rome: Durocortorum Remorum. The Porte de Mars (third century), the largest triumphal arch in the Roman world, which is 43 feet high and 75 feet wide, dates from the beginnings of what later became the capital of the province (Gallia) Belgica. Reims had already prospered under Roman rule, and by the early Middle Ages it became the intellectual center of Franconia with its cathedral school. From the 12th to the 19th centuries, the kings of France were crowned in Reims. So it had a special symbolic power when the French, under Joan of Arc (1412–1431), recaptured Reims from

the English during the Hundred Years' War and were able to crown Charles VII there in 1429. A statue on the Place de Luçon commemorates the "Virgin of Orléans."

The Cathedral of Notre-Dame de Reims (13th century), in the city center, was always the coronation site. It is one of the most important Gothic buildings in Europe. The two mighty west towers are 265 feet high, and inside, the "heavenly vaults" arch over the faithful at 125 feet high. The entire

structure is 492 feet long, and it is moreover decorated with thousands of sculptural elements. The cathedral's remarkable unity of style is due to the fact that it was constructed over a short period of "only" 65 years. A number of windows and rosette windows, astonishingly large for the times, provided brightness and gave the building a surprising quality of light. Those who take part in a guided tower tour not only will learn a great deal about the Gothic sculptural art of the upper "stories" but can also enjoy a broad view of the city and countryside. The terrace of the "Il Duomo" restaurant is the best place to enjoy a stunning view of the cathedral. It is especially beautiful when the building glows during a sound-and-light show from June to September. The cathedral, the archbishop's palace—the Palais du Tau (1498–1509), where the kings resided for the coronation ceremony, and the Romanesque Saint-Remi basilica (from the 11th century) are UNESCO World Heritage Sites.

TREASURE CHEST ILLUMINATED BY BOTTLES

An exceptional address for Champagne in Reims is the Boutique Trésors de Champagne (Treasures of Champagne shop). It is the showroom of a club of 28 Champagne vintners who are among the best in their profession. In the boutique you can taste—depending on your drinking capacity—the products of all 28 vintners or a selection of them, an undertaking for which you would otherwise have to visit each winery in turn. Cheese snacks are served on request with the sparkling luxury drinks. The treasury, in a very modern design, is illuminated by glass bottles, which are not just lights but also contain information about the 28 vintners. Santé!

MORE INFORMATION
Boutique Trésors de Champagne
www.boutique-tresors-champagne.com
Information on Reims
www.champagne-ardenne-tourism.co.uk/discover/weekend-town/reims

ARCHITECTURAL PLAYGROUND AND HISTORICAL SETTINGS

During World War I, the cathedral and Reims were largely destroyed. The city organized its reconstruction during the 1920s, carried out by more than 100 architects supported by sponsors, especially from the United States and the local champagne houses. Enchanting streets such as the Boulevard Foch and the Cours Jean-Baptiste Langlet were created, primarily in the art deco style. None of the houses are the same as any other. Here and there, baroque forms or the Parisian Haussmann architecture were drawn upon. The Bibliothèque Carnegie (1928), in art deco style, is outstanding. On the outside it resembles a Greek temple; on the inside, the mosaics and unusually shaped glass elements are fascinating. The 328-foot-long Boulingrin market hall (1927), with its spectacular roof construction, is likewise an art deco gem. It offers many a culinary sensation, but there are also restaurants and pubs in the streets around the market hall where you can dine exquisitely.

Reims once again played an important role during World War II. The visible evidence of this is exhibited in the Musée de la Reddition (Museum of the Surrender). It shows, among other things, the hall in the former headquarters of US general Dwight D. Eisenhower, where the declaration of surrender by Hitler's Germany was signed on May 7, 1945.

THE UNDERGROUND WORLD OF CHAMPAGNE

Rich treasures are stored below the asphalt of Reims. A system of cellars with a total length of 75 miles has been dug in the soft chalk cliffs, some of them by Roman times. At 10°C, the fine wines from the surrounding vineyards find ideal conditions and mature into champagne. Only the sparkling wine from this region, produced according to strict specifications, may be called "champagne." Thus, the grapes still have to be harvested by hand and the sparkling wine fermented in the bottle. Most of the big champagne houses have their headquarters in Reims. One of the most beautiful is the Maison de Champagne Pommery, designed by Madame Louise Pommery (1819–1890) and built in the Elizabethan style. From the palace-like building with its parklike gardens, a 116-step staircase leads down into the world of champagne. Some 21 million bottles of the sparkling beverage are stored in 12 chalk quarries with vaults 195 feet high. By the way, Madame Pommery was one of the first to recognize that the chalk pits could be used to store the champagne. In 1874, she was the first to develop a dry champagne; until then, it foamed as a rather sweet drink. Even as they were being constructed, Pommery had reliefs carved into the walls of the wine cellars. In 2003, the idea of displaying art in the cellars was taken up again. Since then, art from all over the world is to be seen among the champagne bottles. At one time, champagne probably accompanied every coronation ceremony. In the meantime, it has become more middle class—in Reims you can drink champagne on practically any occasion. However, it is also available for 12 euros per bottle. And anyone who wishes to enjoy it, in keeping with their own standards, can do as the French kings did: at their receptions, they were served champagne with a biscuit rose de Reims, the pink cookies that people used to dip into their champagne. The Maison Fossier in Reims has been making these pastries since 1756.

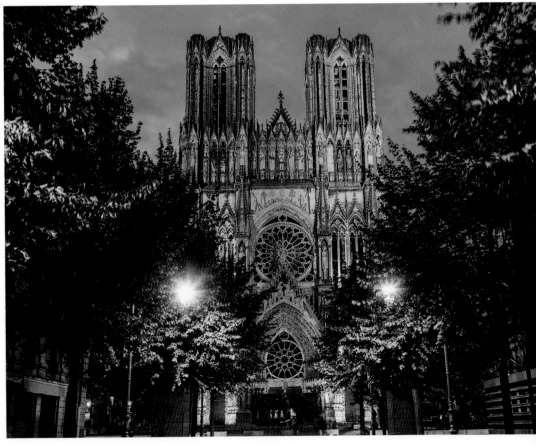

WITH ITS RICH SCULPTURAL DECORATION (*ABOVE*), THE GOTHIC CATHEDRAL OF NOTRE-DAME (*RIGHT*) FORMS A REMARKABLE ARCHITECTURAL UNIT.

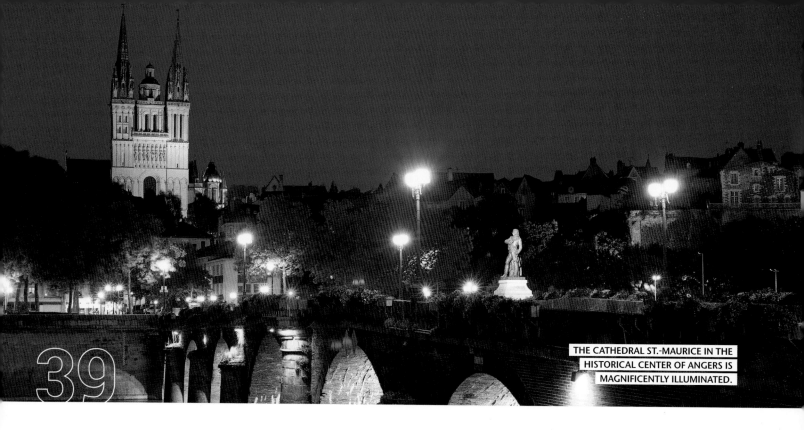

39

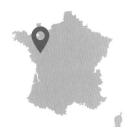

FRANCE

ANGERS—CULTURE AND ENJOYMENT IN HISTORICAL GUISE

HALF-TIMBERING AND TAPESTRIES; COINTREAU AND RASPBERRY CAKE

Angers regularly ranks among the most livable cities in France. Possibly because of its romantic alleys lined with half-timbered houses? Or its many art treasures? Because of its fine gastronomy? Or rather because the city is so green? In any case, it is worthwhile to find out what makes Angers so attractive.

In western France, on the Maine River shortly before it flows into the Loire, lies Angers, once the central location for the Celtic Andes tribe (also Andicavi)—hence the city's name. The Romans conquered the region in 50 BCE and made it their town of Juliomagus (Marketplace of Julius Caesar). The thermal baths and other Roman buildings have meanwhile been excavated. Starting from the ninth century, Angers became the seat of the Counts of Anjou. They made the city into a regional metropolis.

TUFF AND SLATE, WOOD AND MARBLE

The Château d'Angers stands on a ledge slightly above the city and the Maine River. The imposing structure, with its 17 towers built of dark slate and light tuff rock, is one of the best-preserved historical buildings in France. The entire area, the castle and the gardens, extends over more than 215,000 square feet. In the historical city center stands the Cathedral St.-Maurice, dating from the 12th and 13th centuries, with Romanesque and Gothic elements. The building, which is more than 295 feet long, represents the "Angevin style," a term coined in Angers. The vaults span the widest nave of the time, at 53.5 feet. The mighty organ rests on figures of Atlas. The high altar is vaulted by a gilded wooden baldachin (canopy) supported by marble columns. The choir stalls are elaborately carved.

WORKS BY THE CITY'S MOST FAMOUS
SCULPTOR, DAVID D'ANGERS, IN THE
TOUSSAINT ABBEY CHURCH

The walls are adorned with fine tapestries, and the windows with stained glass.

LIGHT AND HEAVY ART

On the Place Sainte-Croix behind the cathedral stands the oldest house in Angers, the Maison d'Adam, from 1491, with rich figural decoration and carving on its magnificent half-timbered facade. The Musée des Beaux Arts is today housed in a beautiful Renaissance building, which displays paintings and sculptures from the 14th century to the present. In front of it, the modern sculpture *Snake Trees* by the French Swiss artist Niki de Saint-Phalle (1930–2002) gleams in bright colors. Works by the city's most famous sculptor, David d'Angers (1788–1856), are on display in the museum in the former Toussaint Abbey church, located in the immediate vicinity.

On the other side of the Maine, to which some really beautiful bridges—including the 344-foot-long Pont de Verdun (19th century)—lead, the Quartier La Doutre spreads out. Romantic streets, lined with half-timbered buildings and magnificent town houses with facades made of limestone tuff, characterize this district. People like to drift around here. The small port of La Savette invites you to take a rest in its cafés and pubs. In the former Saint-Jean hospital (12th century), in the Musée Jean Lurçat museum, an exquisite collection of tapestries from the 20th century awaits visitors. These include works by Lurçat (1892–1966) such as the *Song of the World* (1957–1966). The 10-part work (3,735 square feet) illustrates the fate of humanity and shows, among other things, the explosion of the atomic bomb over Hiroshima and the conquest of space. The tapestry makes it clear that happiness is possible only in harmony with natural elements.

DRINK IN PROPER STYLE . . .

An important part of the Angers cultural scene is Le Quai in La Doutre, a cultural center and theater where many events are held all year-round. From

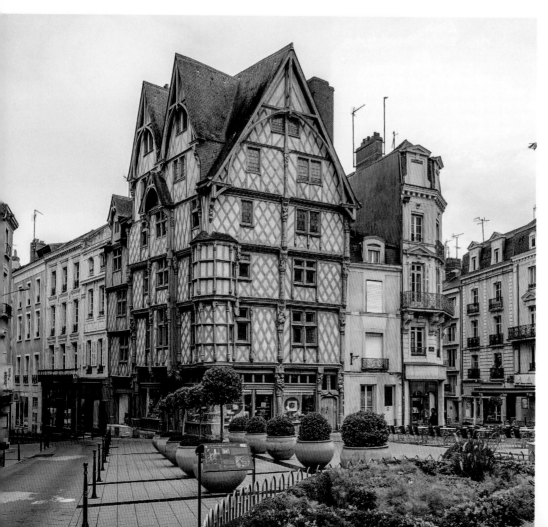

DURING THE MIDDLE AGES, IMPORTANT TRADE ROUTES LED TO THE MAISON D'ADAM (1491), THE OLDEST HOUSE IN ANGERS (*LEFT*). TAKING A BREAK AT THE MONUMENT—THE CAFÉ IN THE CASTLE COURTYARD (*ABOVE*)

the restaurant on the roof terrace you can enjoy a magnificent view of the Old Town, the cathedral, and the castle. And have a glass of regional wine in your hand: a dry white such as Savennière or a red such as Anjou Villages Brissac. A Cointreau would also be in proper style, because this orange liqueur was first distilled in Angers in 1849. The Carée Cointreau (a distillery) provides information about the history of the famous drink. Also worth seeing are the first commercials for the liqueur, which the inventors of motion pictures, the Lumière brothers, produced in the 1890s.

...AND HAVE A NOSH

Back on the other side of the Maine River, a good thing to do is to explore the streets and alleys around the heart of the city, the Place du Ralliement. Life pulsates here, surrounded by stately buildings such as the theater building and the famous Galeries Lafayette department store. Small cafés, restaurants, fashion boutiques, and shops for all kinds of beautiful things invite you to browse and enjoy. Speaking of enjoyment: The le sully raspberry cake, a regional specialty, is worth committing a sin. The delicious tuff'line, small chocolates made with raspberry jelly covered with marshmallows and white chocolate, are also typical of the Loire Valley. They symbolize the typical white tuff rock of the region. You can meet up with the best chefs in the region, like many other Angevins, at Marché Lafayette marketplace on Wednesday or Saturday mornings. The colorful products on offer, the cheerful gossiping and haggling, and the freshness and the variety of products are legendary. No wonder that Angers has a wide range of restaurants offering fine cuisine.

IN A GREEN GUISE

Many Angevins spend their lunch break in one of the city's many parks, such as the Jardin du Mail opposite the town hall. The name is derived from a game played by court society. Among flowers, bushes, and trees, a large waterspout fountain, a music pavilion, statues, and sculptures create artistic accents—the right place to relax and stroll. The Sarthe and Mayenne Rivers flow around the island of Saint-Aubin, 1.8 miles from the city center; here the rivers unite to form the Maine. The area is best explored by bike or on foot. If you are longing for more water, the amusement park at Lac de Maine, a 220-hectare green and water space, is just

right—here you can surf, sail, canoe, or swim. A more leisurely trip is to travel by vessel or rental boat along the Maine, Loire, Sarthe, and Mayenne Rivers—from Angers you can access 186 miles of navigable waters in a lovely landscape—if you want to leave the city at all.

ELEGANT FORTRESS

The Château d'Angers, constructed from the 11th to the 13th centuries, appears impenetrable from the outside: the gates are equipped with portcullises and *meurtrière* (murder holes), and there are arrow slits in the 17 towers. At the end of the 15th century, 16 of the towers were made 33 feet shorter to create platforms for artillery. Only the Tour de Moulin still stands 131 feet high. Inside the stronghold, you get another picture: in the elegant Châtelet of the Dukes of Anjou (15th century), court society once enjoyed itself. Medicinal plants and herbs grew alongside grapevines in the extensive gardens. An L-shaped gallery houses the 344-by-15-foot Angers "Apocalypse" tapestry cycle, which was woven in the 14th century. It shows motifs and scenes from the book of Revelation of St. John.

MORE INFORMATION
Tourist information about Angers
www.france-voyage.com

40

SPLENDOR AND ROMANCE ON THE BANKS OF THE MOSELLE

Taking a stroll through Metz in the heart of the Lorraine region is like traveling through time. The architectural and cultural heritage extends from antiquity to the present. It quickly becomes clear: Metz has always played an outstanding role. It's hard to believe that the city on the Moselle River is an insider tip today.

FRANCE

Traces of the first settlement are a remarkable 5,000 years old. From the fifth to the third centuries BCE, the Celtic mediomatricians settled down here. Did they appreciate the godlike location where the Seille River flows into the Moselle? In any case, they called the city the "place of the gods of the Mediomatrici"; in Latin, Divodurum Mediomatricorum. In the High Middle Ages, it became Metis and finally took on its current name. Starting in 52 BCE, the Romans led Metz during its first flourishing, following their conquest of Gaul. In the early Middle Ages, Merovingians and Carolingians built Metz up to become one of the most important cities in the Frankish Empire. Then the Franco-German back-and-forth began: from the

16th century until 1944, Metz changed hands three times to France and two times to Germany—and not without consequences.

"THE LANTERN OF GOD"

It is possible to still admire relics of the Romans only in the museums of Metz—Attila, king of the Huns, destroyed the city in 451. The narrow streets from the Middle Ages formed the picturesque Old Town. The many churches are particular architectural witnesses of this period, but there are also other buildings such as the granary of Chèvremont (1457) and the squares of Saint-Louis, Sainte-Croix, and Saint-Jacques. What remains of the Franconian period is the Porte des Allemands (Gate of the Germans;

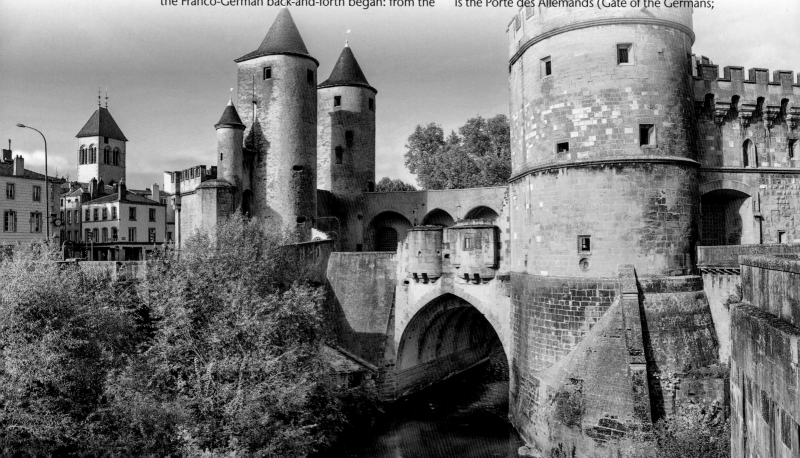

construction phases in 1230, 1445, and 1529, when it was completed), the last surviving city gate in Metz. Outstanding among the churches is the Cathédrale Saint Étienne, St. Stephen's Cathedral. Its peculiar floor plan was created by consolidating the structure with a collegiate church in 1250. The vault measures 138 feet; its bell tower with the famous "Dame Mute" bell is 295 feet. The Gothic architectural style allowed large spaces for windows, which take up nearly 70,000 square feet in the cathedral and were designed by stained-glass artists from different eras, including Marc Chagall (1887–1985). The gigantic glass panels have given the church the name Lanterne du Bon Dieu (Lantern of God).

BAROQUE DELIGHTS

By the 18th century—when Metz was part of France—the streets had become too narrow: the late baroque era arrived, along with new city districts, more-magnificent buildings, wider streets, and more-spacious squares. This is evidenced by the Opéra-Théâtre (1752) and the town hall (1771), as well as the Place d'Armes (by the cathedral), the Place de la Comédie, the Place Saint-Thiébault, and the Place de la France. The countless sidewalk terraces of the cozy Old Town cafés invite you to enjoy all kinds of culinary delights. These include, besides the excellent regional wines, Mirabelle plums in every way they can be prepared and in all its varieties—Metz produces 70 percent of the world harvest. And again and again you find yourself on one of the branches of the Moselle River and on romantic bridges.

THE GERMAN IMPERIAL QUARTER

Between 1870 and 1918—under German rule—Metz was enlarged to become the strongest fortress town

THE PORTE DES ALLEMANDS IS THE LAST PRESERVED CITY GATE IN METZ DATING FROM THE MIDDLE AGES (*LEFT*). ENJOYING LIFE IN FRONT OF A VENERABLE BACKDROP—A CAFÉ IN FRONT OF THE CATHÉDRALE SAINT ÉTIENNE (*BELOW*)

in the German Reich; the New Town was constructed, including the train station. Architectural and colorful diversity found their way onto the extensive boulevards: Romanesque, Gothic, Renaissance, and baroque, art deco, and art nouveau. A fine example is the charming Avenue Foch. Modernity starts behind the train station, including with the airy Centre Pompidou Metz (2010), which brings together under its curved roof—a wooden structure covered with a translucent membrane—all the artistic forms of the 20th century.

CULINARY SEDUCTION

The bishop's palace was built in the Old Town in 1785, near the Cathédrale Saint Étienne. The French Revolution of 1789 changed the plans, and from 1831 onward this spacious building with its square courtyard served as the Marché Couvert market hall. This is where the culinary heart of Metz beats: in the world-famous quiche Lorraine, a round, baked, short-crust pastry with a layer of savory filling enriched with eggs and milk; other French specialties, from snails and seafood to goose liver; and a tempting range of pâtisserie. The range of delicacies available also includes

jams, fresh organic products, cider, and wine. And the best thing: you can taste many of the items on-site. But you can also fill a basket with goodies and enjoy them in a cozy spot on the banks of the Moselle.

MORE INFORMATION
Metz Tourist Information
www.tourism-lorraine.com/destinations/metz

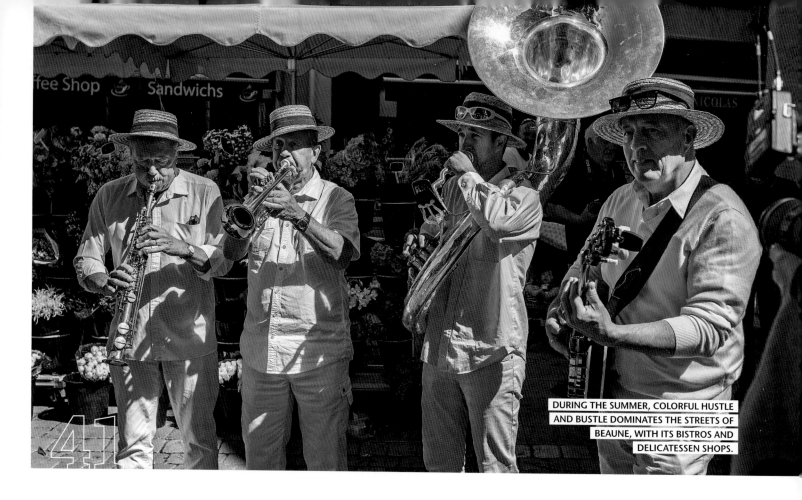

DURING THE SUMMER, COLORFUL HUSTLE AND BUSTLE DOMINATES THE STREETS OF BEAUNE, WITH ITS BISTROS AND DELICATESSEN SHOPS.

FRANCE

FRANCE IN MINIATURE

The tranquil city of Beaune embodies Burgundy, and, yes, France itself, in miniature as hardly any other city does. Surrounded by gently rolling vineyards and fertile fields, Beaune upholds the banner of exquisite wines and offers many a feast for the eyes and palate. A destination for pleasure-bent vacation travelers with the highest expectations!

Not only is Burgundy enchanting, due to its scenic beauty, where hills, fields, vineyards, and picturesque villages alternate harmoniously; the region is also richly blessed with impressive churches, monasteries, and castles. In many places, magnificent examples of often Romanesque but always masterly architecture cast a spell.

REFUGE FOR THE POOR AND THE SICK

In Beaune it is the Hôtel-Dieu, a charity hospital from the Middle Ages, that attracts visitors interested in history and art. In the quiet inner courtyard of the complex in the middle of the town—which, by the way, is still surrounded by a fortress wall

today—with the buildings covered with gleaming, colorful shingles and with all their decorative wooden cladding, gables, loggias, and columns, you feel as if you have been transported to a different time. The hospital became famous for its ward, which was way ahead of its time in terms of its design: in a huge, airy room, long rows of beds with modern equipment—for their time of origin—stand opposite each other. A kind of alcove made it possible for every patient to be treated discreetly, and the sick could even attend a liturgy from their beds. A separate pharmacy, very well equipped and open to view, decorated with pretty tiles, provided natural medications for all kinds of diseases,

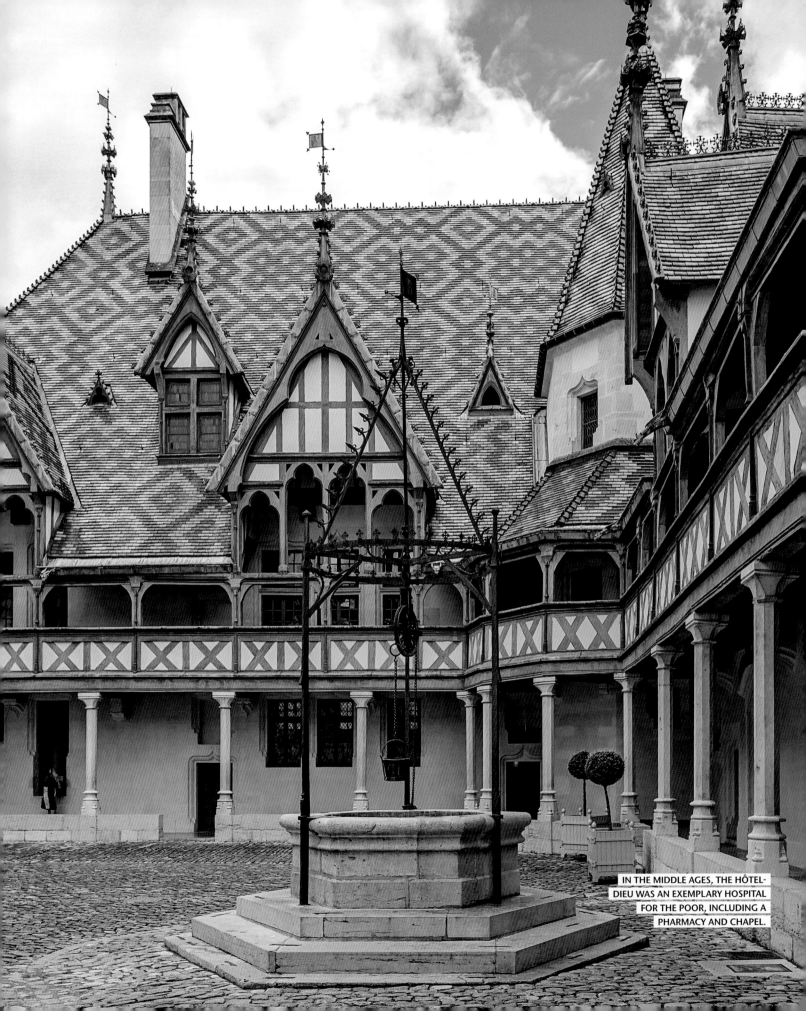

IN THE MIDDLE AGES, THE HÔTEL-DIEU WAS AN EXEMPLARY HOSPITAL FOR THE POOR, INCLUDING A PHARMACY AND CHAPEL.

prepared by expert hands using plants from the medicinal herb garden. Meals were prepared over an open fire in an archaic-looking kitchen with lots of copper cookware and a huge fireplace. In another part of the building, a masterpiece of Early Netherlandish painting is displayed in a darkened room. You will never get tired of gazing at Rogier van der Weyden's monumental winged altar, with scenes from the Last Judgment, from the middle of the 15th century; the depictions on the individual panels are so lifelike. The walls of the Salle Saint-Louis in the north wing are covered with valuable tapestries from Tournai and Brussels.

CAPITAL CITY OF WINE

The most famous wine-growing region in the world, the Côte d'Or, borders on Beaune, and it is also not far from the other wine towns that have made a name for themselves with specialties in red or white: Nuits-St.-Georges, Meursault, Mercurey, Beaujolais, Chablis, Pommard, Buxy, and Givry, to name just a few. All these delicacies can of course

also be enjoyed in Beaune, since many wineries have cellars and wine shops in the city. It is no wonder, then, that the Hôtel-Dieu is also associated with wine! The charity hospital also owns vineyards, whose products have always been auctioned in November for the benefit of the hospital. During the "Trois Glorieuses" (Three Glorious Days), the traditional festival days during November in wine towns such as Beaune, Nuits-Saint-Georges, and Dijon, with their processions, wine auctions, tastings, and sales stands, you can get to know the wines of the region, including in the wine cellars of Beaune, which you encounter everywhere. The wine museum at the Hôtel des Ducs provides the historical background of fine wines, and interesting facts about how they are made and the equipment used to do it. Again and again, flat silver bowls catch the eye. These tastevins are the tasting bowls typical of the region. At the Clos de Vougeot castle, a former Cistercian monastery halfway between Dijon and Beaune, the Chevaliers des Tastevins have their

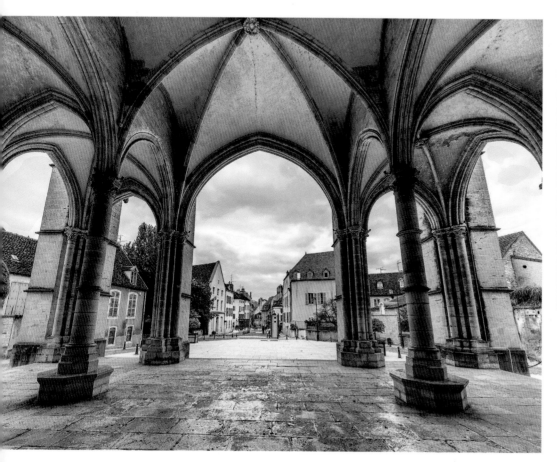

THERE ARE MANY LOVINGLY RESTORED OLD STRUCTURES WITH ATTRACTIVE DETAILS TO BE DISCOVERED WHEN STROLLING THROUGH THE SMALL BURGUNDIAN CITY OF BEAUNE.

headquarters. This is a brotherhood of wine lovers dedicated to maintaining high quality and promoting Burgundian wines. Members are proven wine connoisseurs, including some prominent ones.

IN THE LAND OF COCKAIGNE

Beaune invites you to stroll through its tranquil alleys and to discover how to slow down—however, in the meantime, many people from big French cities have now discovered this and flock to the city on family vacations and holidays. If all the hustle and bustle in the city center becomes just too much local color for you, you will be able to find a table at a bistro on a side street or at the edge of a typical tree-lined small French square, where you will get the most-friendly service possible, no matter how full it is. The city is so full of restaurants and bistros of every kind that it is hard to choose. The best thing is to do as the French do: before eating at a bistro, drink an aperitif such as a freshly tapped beer or a sparkling Crémant wine and then set out to eat. The many small delicatessen shops, confectioners, and butchers have many an enticing temptation in store. Finally, Burgundy is home to Charolais beef, Bresse chicken, Dijon mustard, Époisses cheese, and other delicacies. They also find their way into the pot or pan at the local restaurants. If the weather permits, you can enjoy these specialties while sitting at a small table with a red-checkered tablecloth on the street in front of the bistros. Bœuf bourguignon (braised beef stew in red wine sauce), escargots (snails), civet de lièvre (stew with onions or chives), jambon persillé (cooked ham under parsley jelly), or spice cakes are of course homemade with regional ingredients. And a creamy eclair, filled and glazed choux pastry, still fits "in your hand" as you stroll along, and tastes very good.

TRÈS FRANÇAIS

The bright town houses with their stucco and wrought-iron fences or the old, colorful children's carousel in the middle of an enchanted little square look *très Français* (very French). Anyone who settles down in one of the romantic cafés and bistros in the late afternoon already feels like a native. You can enjoy the sunny little town, without any big fuss. At Christmastime, colored lights bring the buildings to life—Beaune knows how to unfold its magic even during the winter.

THE RUBY-RED SEDUCTION

If you are in Beaune, you should not miss the opportunity to enjoy the regional specialty where it is proffered à point: in the bistros, they mix a kir cocktail of dry Aligoté white wine and creamy-sweet crème de cassis, the dark-red to almost purple currant liqueur. The highlight is the sparkling kir royale, made with crémant (bottle-fermented sparkling wine) and crème de cassis. Enjoyed under a large, shady tree—and everyone becomes French. There have been black currants in Burgundy since the late 16th century, where they are cultivated mainly near Dijon. The fruit is used not only to make cocktails, but also in hearty and sweet cuisine for refining sauces or desserts.

MORE INFORMATION
Beaune Tourist Office
www.beaune-tourism.com
L'Hôtel-Dieu
hospices-de-beaune.com (French)

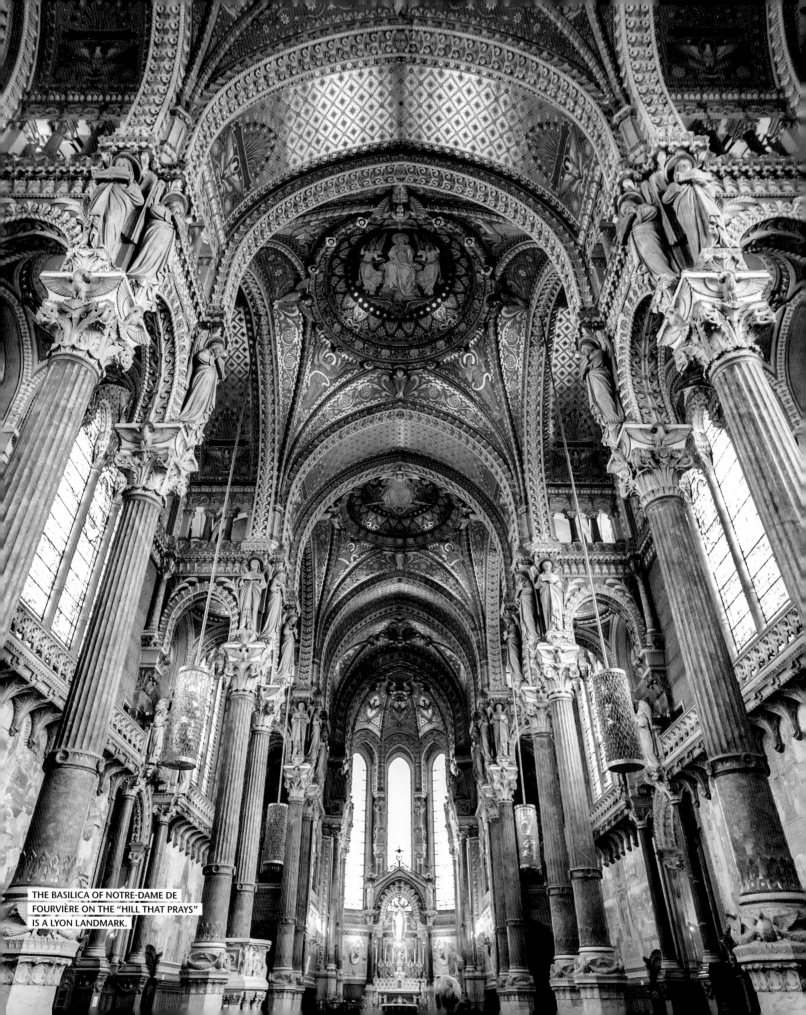

THE BASILICA OF NOTRE-DAME DE FOURVIÈRE ON THE "HILL THAT PRAYS" IS A LYON LANDMARK.

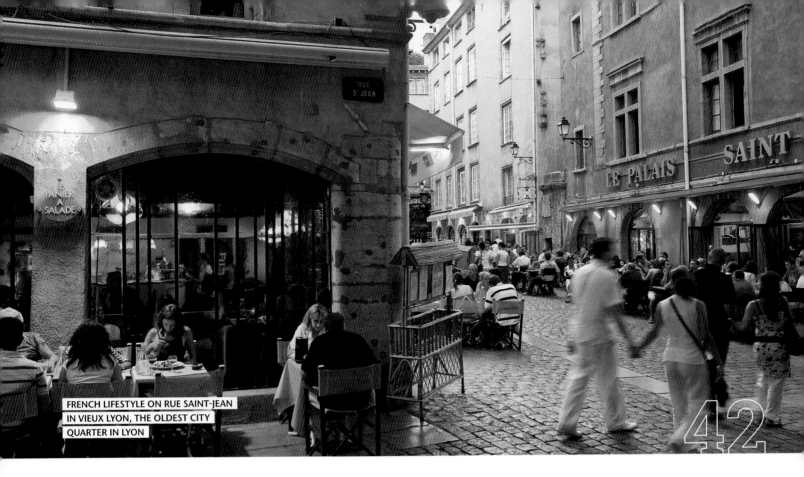

FRENCH LIFESTYLE ON RUE SAINT-JEAN IN VIEUX LYON, THE OLDEST CITY QUARTER IN LYON

42

MAGIC AND ENJOYMENT ON THE RIVER

Medieval alleys and Renaissance houses, upper-class palaces and squares, ultramodern architecture, and a restaurant scene that has gourmets raving. No, this isn't Paris, but rather Lyon. Anyone who, like so many, knows France's third-largest city only from driving through it should definitely stop by.

FRANCE

Lyon lies in southeastern France at the confluence of the Rhone and Saône Rivers and is surrounded by a fertile landscape and famous wine-growing regions. The Romans, who founded Lyon as Lugdunum in 43 BCE, presumably already valued its mild climate—Lyon has 300 days of sunshine a year and offers the best of Paris in pocket format.

SILENT PATHWAYS AND A HILL THAT PRAYS

In the oldest district of Lyon, Vieux Lyon, the Middle Ages meet the Renaissance. During the 15th–16th centuries, the city was able to achieve prosperity by producing silk, which allowed merchants and bankers to build imposing houses.

Along the picturesque alleys rise the fronts of typical Renaissance buildings, with inner courtyards and stair turrets. In the car-free Old Town, you can happily drift along past the countless shops, restaurants, and designer boutiques, and as you do so, at some point you come across an open door, a passage into a hidden inner courtyard. These mysterious passages, the traboules, cut across the entire city quarter and connect the main streets, passing under rear-courtyard houses and through inner courtyards and stairwells. While they originally served as dry transport routes for the precious silk fabrics, they later became escape routes and hiding places, such as during the uprisings at the beginning of industrialization or for the French

Resistance during World War II. On special guided tours, you get caught in this web of hidden pathways and histories.

The center point of Vieux Lyon is the 12th-century Gothic Cathédrale St-Jean (Cathedral of St. John). The funiculaire, the city cable car, takes you to the "hill that prays," Fourvière. Up there gleams the white four-towered basilica of Notre Dame de Fourvière (1872–96), Lyon's landmark, finished inside and out in loving attention to decorative detail. The paintings and mosaics in gleaming gold, the imposing stained-glass windows (13th century), and the astronomical clock (14th century) are striking. From the basilica's panoramic terrace, Lyon lies at your feet. Atop the hill are to be found a theater (first century BCE) and an odeon (first century CE), today a place for readings, besides the remains of a Roman settlement. The Lugdunum Museum—that was the city's Roman name—exhibits archeological finds.

BISTANCLAQUE IN THE BELLY OF FRANCE

Diagonally opposite, on the other side of the Rhone, lies the "hill that works," the Croix-Rousse quarter, where in the 19th century there were thousands of "bistanclaque" for weaving silk. The onomatopoeic designation imitates the sounds of a loom. The houses where the looms stood were up to 13 feet high and had huge windows—there was no electric light. Today, silk is woven only in the museum, but there are still chic silk boutiques. Young creatives have settled in Croix-Rousse quarter and give the streets a certain bohemian flair, with their galleries, cafés, and stages. Croix-Rousse also features an endless selection of restaurants. No wonder, since Lyon is the "belly of France," home of top chef Paul Bocuse (1926–2018) and known for first-class regional products such as Charolais beef and fruits and vegetables from the Rhone River valley. The city's more than 4,000 restaurants, including more than 15 star-winning restaurants as well as many bouchons—small, rustic restaurants—conjure up dishes for the discerning palate as well as the down-to-earth hunger.

The best view of the regular evening spectacle is from the banks of the Rhone in Croix-Rousse. This is when the bridges and churches are magnificently illuminated; the lighting arrangements are

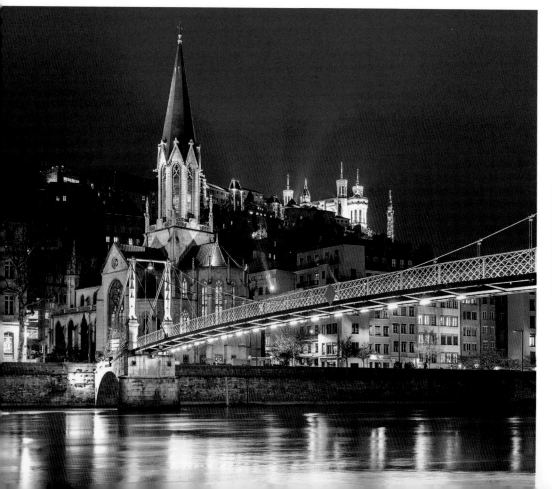

EVERY EVENING, LYON SETS THE SCENE FOR ITS BRIDGES AND CHURCHES WITH LIGHTING, TO GREAT EFFECT (*LEFT*).
APÉRITIF ANYONE? IN THE GRAND CAFÉ DES NÉGOCIANTS (*ABOVE*).

decoratively reflected in the river. This spectacle is surpassed only by the Fête des Lumières (Festival of Lights), held in early December. Yet, the banks of the Rhone and Saône Rivers are also an experience without illumination, with miles of cycle paths and promenades, outdoor pools, parks, and ship restaurants.

ART OR REALITY?

On the peninsula between the Rhone and Saône beats the heart of Lyon, the Presqu'île, which is a World Heritage Site, just as Vieux Lyon is. The opulent palaces and expansive squares can easily take on those of Paris. The Place des Terraux is the location of the magnificent town hall (17th–18th centuries), the Musée des Beaux Arts (art museum, 1801), and l'Opéra de Lyon, a building dating from 1826. It was renovated in 1989 except for the neoclassical facade and was given a striking steel-and-glass-dome roof. By the way, the bar terrace is a good place for an aperitif. The center of the square, where salsa dancers and break-dancers frequently show their skills, is adorned by the fountain by Frédéric-Auguste Bartholdi (1834–1904), who also created the Statue of Liberty in New York. The Presqu'île is also a perfect place for shopping. The shops of international fashion labels are lined up along the Rue de la République in the pedestrian zone. Things have become very exclusive in the 1065-foot-long former Grand Hôtel-Dieu hospital, with its luxury boutiques and exquisite gastronomy. The Passage de l'Argue, from the 19th century, is also very stylish with its historical ambience. One of the largest open-air frescoes—over 100 of the ones that Lyon offers—is La Fresque des Lyonnais (8,600 square feet), on a wall by the Saône River. This modern trompe l'oeil painting is so deceptively real that it is difficult to distinguish between what is illusion and what is reality. The masterpiece by the CitéCréation artists' association shows the history of the city and its inhabitants. Some 30 historical and current personalities of the city are shown embedded in true-to-life situations.

But the Presqu'île has another face. At the very front, where the Rhone and Saône meet, an ultramodern district, Confluence, has emerged with its residential buildings and shopping centers and an entertainment complex. The architecture is almost experimental: facades printed with over-sized photos, a dark-blue house that looks as if it was created while playing the game of Tetris,

colorful cubes with holes in the facade that look like Swiss cheese—there seem to be no limits to the imagination. The highlight of this district is the "spaceship" on the tip of the peninsula, the Musée des Confluences: a silvery, shiny UFO made of steel and glass.

WHERE DO WE COME FROM?

The Musée des Confluences—the name not only is derived from its location at the confluence of the Rhone and Saône Rivers but is also intended to express the "confluence of knowledge"—is devoted to fundamental questions about humanity: Where do we come from? Who are we? What are we doing? From the bright foyer you can reach the dark, windowless exhibition rooms via escalators and bridges. Two million exhibits, including archeology, natural history, technology, and art history, each illuminated with spotlights, provide exciting and entertaining answers. Thus, the "Where do we come from?" room is designed in a helical shape and takes the visitor from *Homo sapiens* all the way back to the big bang. Touching is allowed and encouraged. This way makes the development of the world and of humanity "comprehensible."

MORE INFORMATION
Lyon experience
www.france-voyage.com
Musée des Confluences
www.museedesconfluences.fr/fr/visit-museum

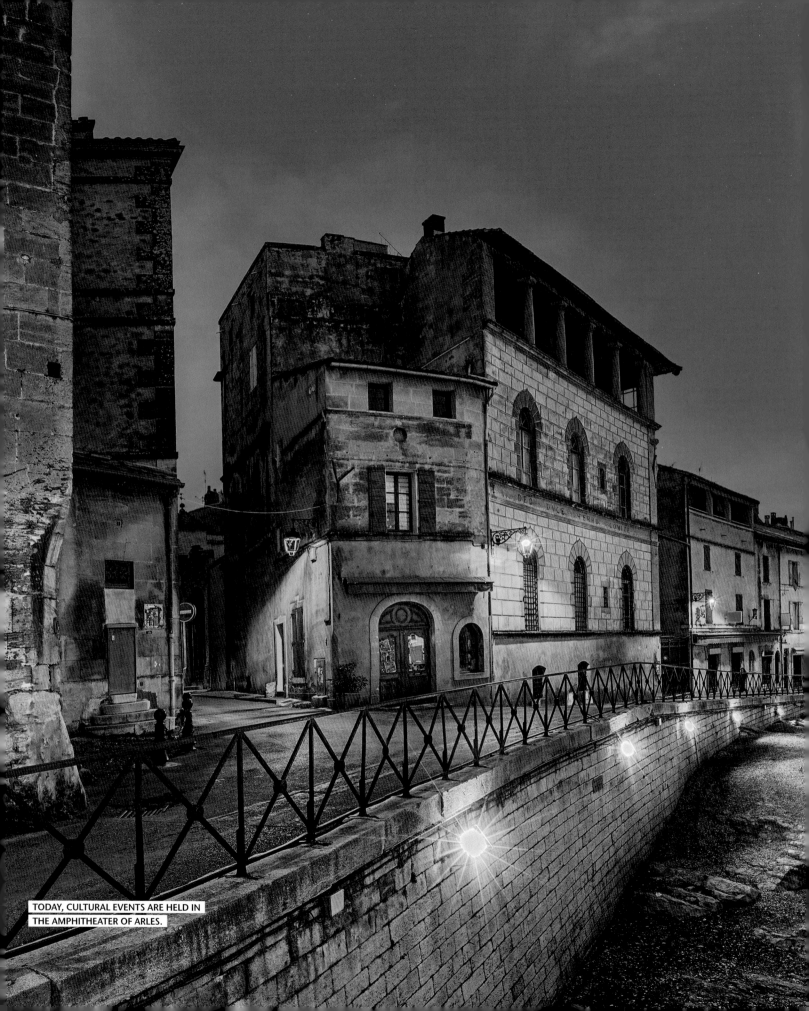

TODAY, CULTURAL EVENTS ARE HELD IN
THE AMPHITHEATER OF ARLES.

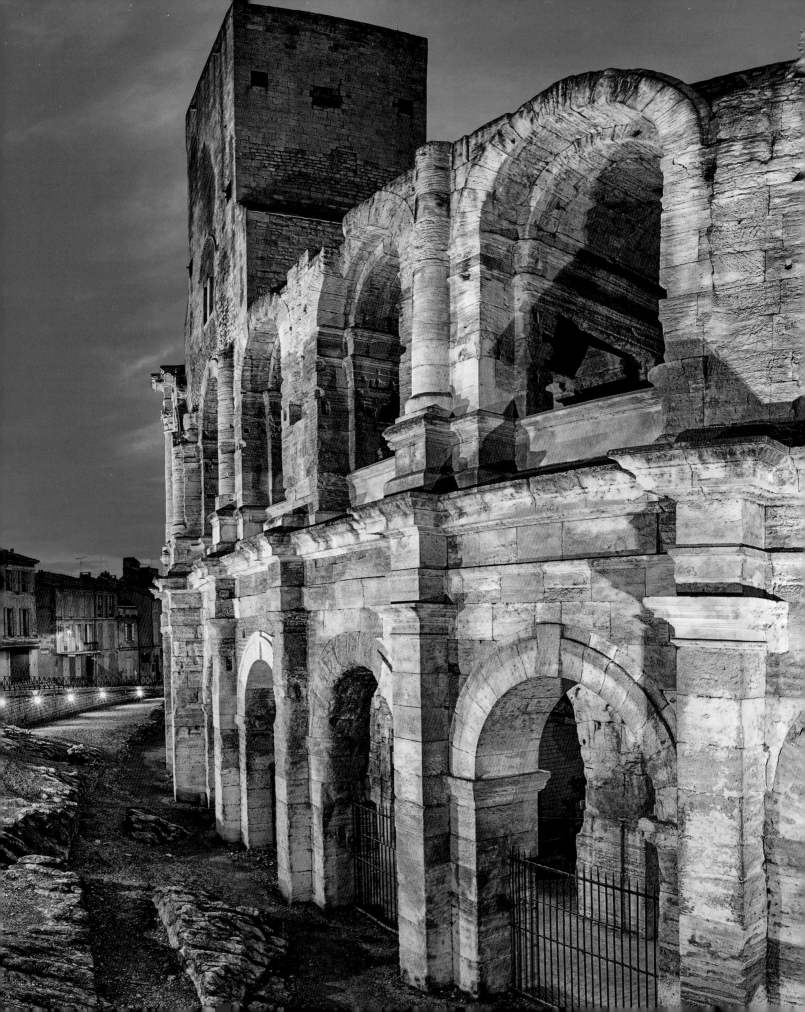

FRANCE

UNDER THE SUN OF HISTORY

Arles offers its visitors impressive relics from the Roman era, evidence of a turbulent Middle Ages and the traces of the great painter Vincent van Gogh (1853–1890). Add to that fresh fish dishes with a nice wine and Mediterranean lifestyle under a blue sky almost all year-round.

Arles lies in southern France, 15 miles from the Mediterranean. The city on the Rhone River is the gateway to the unique natural landscape of Camargue and borders on the Massif des Alpilles National Park to the west. In addition to its natural beauties, Arles also has a rich historical heritage. In 46 BCE, Julius Caesar made the city a Roman military colony. Under Emperor Constantine (272–337), it blossomed into a prosperous trading town, and eventually the highest authority of the Roman Empire in the west was moved there from Trier in 402. Starting in 536, Arles was part of the Franconian Empire; in 879 it became the capital of the kingdom of Burgundy, which from 1033 onward was part of the Roman-German Empire.

Here the emperor of the Holy Roman Empire, Friedrich Barbarossa, was crowned king of Burgundy in 1178.

ROMAN RELICS

In the amphitheater of Arles, you can immerse yourself in antiquity, starting from the first century CE. There was room for 25,000 spectators seated behind the 60 arcade arches on two levels. Restored starting in 1846, the arena is still a showplace for cultural events and bullfighting today—but they allow the bull to live: the Courses Camarguaises "bullfights" are all about skillfully taking the trophies that are attached to the animal's horns. The Roman theater (25 BCE) rises next to the arena.

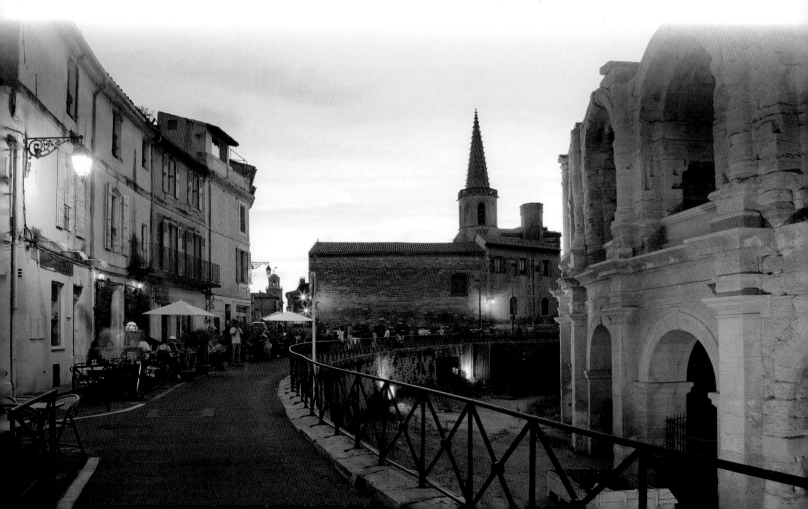

Two of its Corinthian columns, the orchestra, and the lowest row of what were once 33 rows of seats have been preserved. The rest of the forum dates from the year 20 BCE. It includes a cryptoporticus, an underground archway. There are likewise relics from the thermal baths, which date from the fourth century. The Alyscamps, an early Christian burial site with ancient stone sarcophagi, stretches from an avenue lined with plane trees from the southeastern edge of the Old Town to the unfinished St. Honorat church (12th–19th centuries). This quiet place has always attracted painters.

SOUTHERN FLAIR

The Saint-Trophime Church (1100–1150, enlarged 1454–1464) on the Place de la République is dedicated to the first bishop of Arles. The basilica, with its 65-foot-high nave, is characterized by Romanesque and Gothic elements. The portal (1150–1200) on the west facade, which resembles a Roman triumphal arch and has richly adorned figures, is outstanding. In the church cloister you can find all kinds of round and pointed arches, pillars, columns, and capitals. Also located on the Place de la République is the town hall (1675), with a Roman stone ceiling in the entrance area. Some 50 city palaces from the 17th century are likewise to be found in the Old Town. They contribute to the special flair of the city, where there is still enough room for enjoyment and joie de vivre among all the stone witnesses of history. Excellently prepared fresh fish and a cool local wine in one of the many street restaurants on a mild evening—you will really feel that you have arrived in France.

IT WAS THE LIGHT

Vincent van Gogh came to Arles in 1888 in search of the special light of the south. During the 15 months he stayed there, he painted more than 300 works, an extremely productive phase. There are markers at the places in Arles where Van Gogh set up his easel and painted. The commemorative tablets show the corresponding picture, and the visitor sees the "original" subject as it is today, such as the café on the Place du Forum, a model for Van Gogh's *The Night Café*.

WHITE HORSES AND PINK FLAMINGOS

The Camargue at the gates of Arles is a 100,000-hectare wetland, crossed by swamps, lakes, lagoons, and salt steppes, where a rough wind often blows. Located in the Rhone delta and by the Mediterranean Sea, fresh and salt water mix together there, creating a unique flora and fauna. The northern part of the Camargue is used for agriculture; fruits, vegetables, and the typical red rice are the main crops. The southern part is used for harvesting Fleur de Sel sea salt. In addition to countless bird species, bulls, the famous white horses, and flamingos live in the Camargue. The sturdy, agile, and sure-footed horses have always been used by cattle herders as a means of transport. There are many tours that can let you experience this unique cultural and natural landscape.

MORE INFORMATION
Arles
www.arlestourisme.com/en
The Camargue
www.avignon-et-provence.com/tourisme-provence/arles

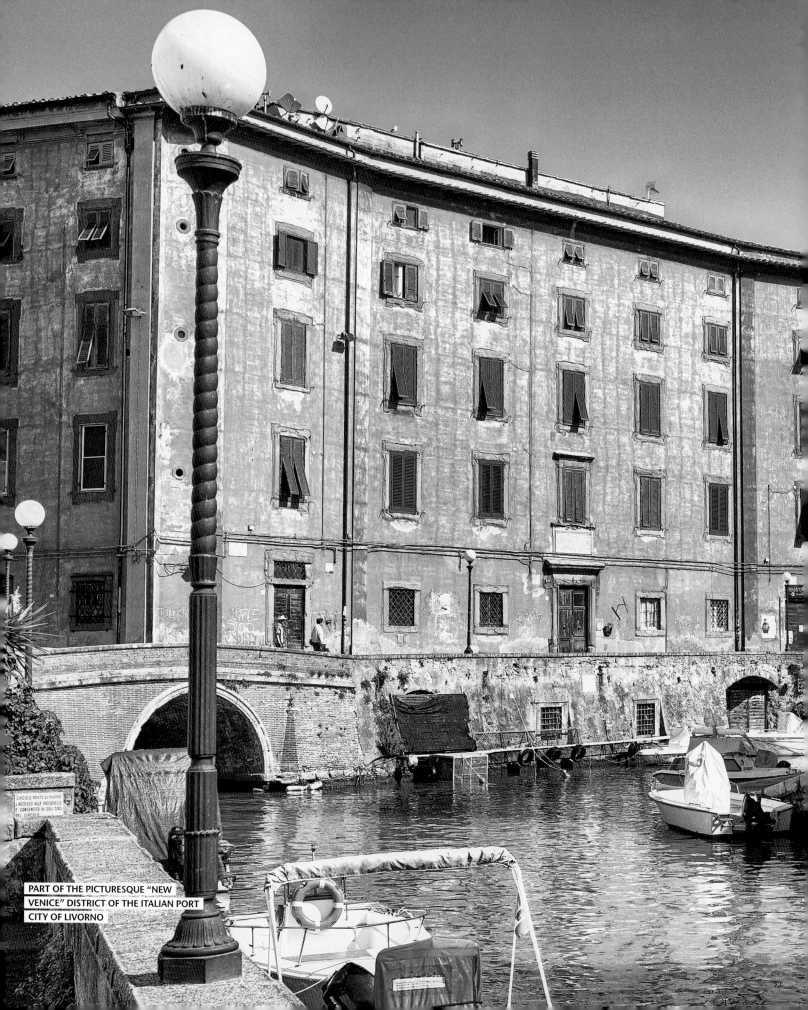

PART OF THE PICTURESQUE "NEW
VENICE" DISTRICT OF THE ITALIAN PORT
CITY OF LIVORNO

SOUTHERN AND SOUTHEASTERN EUROPE

Glory of the Ancient World, Melting Pot of Cultures

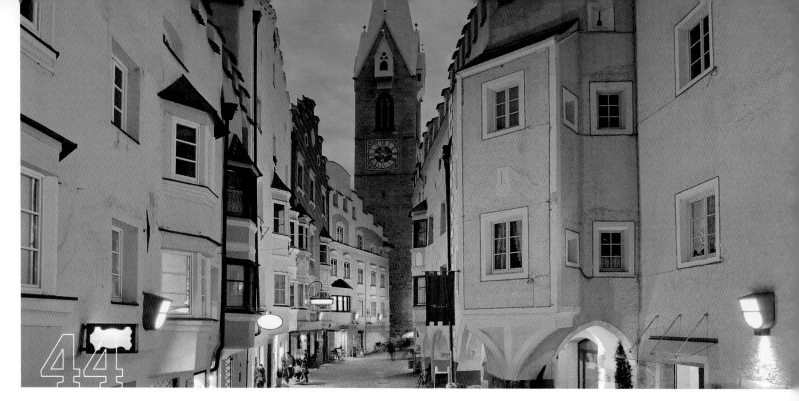

ITALY

CHURCH ART WITH A VIEW OF THE ALPS

Brixen—Bressanone in Italian; much of the population speaks German as their first language—with its picturesque Old Town lies between the eastern edge of the Sarntal Alps and the 8,202-foot--high, sometimes snow-covered local Plose massif. Once an important station in the history of the Church, the city is famous for its sacred art—but also for its Austrian Italian flair, fine cuisine, and the good regional wines.

During the 11th century, Holy Roman Emperor Conrad II donated several counties to the bishops of Brixen and Trento, but not without ulterior motives—this was to secure his route to his coronation in Rome. From then on, Brixen has written church history: a native of Brixen became pope, another the antipope, the Brixen bishops were involved in the distribution of power between the emperor and the pope, and Brixen prospered. Secularization at the beginning of the 19th century put an end to Brixen's ecclesiastical power and outstanding position, but its beautiful churches, the Hofburg palace, and town houses were preserved. Despite the baroque renovations, the medieval townscape is still recognizable.

AN INN AND CHURCH WITH FRESCOES

Art lovers should plan enough time for the buildings on the Domplatz (cathedral square). The cathedral, originally dating from the 12th century and frequently renovated, is a prime example of Tyrolean baroque, with its architecture, frescoes, and statues, and makes an impression with its mighty dome towers, extensive gilding, and dark marble. Many of the 20 arcades in its cloister are decorated with colorful frescoes that bring biblical stories to life. Since the middle of the 15th century, representatives of the Brixen school have been creating these images. You can view frescoes of Saint John on Patmos and scenes from the life of other saints and the Blessed Mother, as well as Samson fighting the lion and David beheading Goliath, among others.

A strange representation in the third arcade deserves special attention: a kind of horse with large ears and a narrow trunk. The local artist, Master Leonhard, had apparently already heard of elephants but could not imagine much about them. If he had

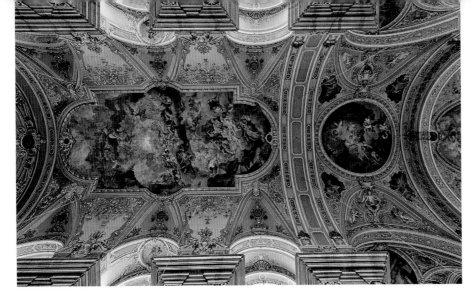

UNDER BRIXEN'S ARCADES IS A
WONDERFUL PLACE TO STROLL ALONG
AND STOP FOR A BITE TO EAT (*OPPOSITE*).
THE BRIXEN CATHEDRAL, WITH FRESCOES
BY ARTIST PAUL TROGER, IS A CITY
LANDMARK (*LEFT*).

lived some 80 years longer, he would have been able to see an example. This is because Archduke Maximilian of Austria, on his way over the Alps, stopped off at the *Am Hohen Feld* (high field) inn, with a wedding present in the form of a real Indian elephant among his luggage. It made a perfect sensation; the elephant moved on, but the landlord renamed his house and had the eponym painted quite faithfully on the wall of the building. Not far from the Domplatz is the Hofburg, the former residence of the prince-bishop. During the 16th and 17th centuries, an old fortified castle was transformed into a magnificent three-story palace with loggias. The first floor is decorated with terra-cotta statues, and on the ground floor is a museum with almost 100 Christmas mangers dating from the 18th century. The Diocesan Museum impresses visitors with sacred art from many centuries.

SAUNTERING ALONG UNDER THE ARCADES
Brixen welcomes the traveler with great hospitality, and its mountain scenery already creates a visual entry into the Tyrolean mountain landscape. The oldest city in Tyrol, built within protective walls, today surprises visitors with one of the best-preserved and most-beautiful Old Towns in the region. If you walk along the Eisack River or through the Sun Gate and into the alleys, you will feel as if you are on vacation. This also is something to do with the cozy arcades, where shops and workshops were previously located. The narrow fronts are deceptive; the space behind them is quite extensive. Today there are fine shops, traditional inns offering South Tyrolean specialties, and chic café bars in the arcades. Sitting here is a fine part of the South Tyrolean way of life—it is dry when it rains, and nice and cool in hot summers.

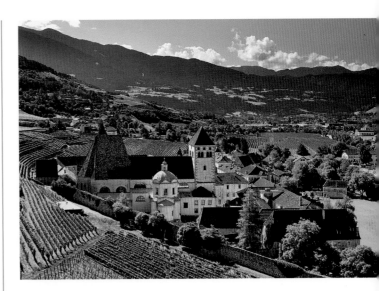

NEUSTIFT ABBEY
About 1.5 miles north of Brixen, a mighty monastery stands amid the vineyards: Neustift Abbey (12th century), with its splendid baroque abbey church, frescoed cloister, and rococo library hall, is the destination not only of art lovers, but also of wine lovers. After a walk through the extensive vineyards, the wines made from grape varieties ranging from Sylvaner and Kerner to Gewürztraminer and Lagrein to Riesling can be tasted in the abbey wine cellar and purchased in the abbey shop.

Not far from the abbey, the Brückenwirt (bridge innkeeper) awaits guests along the Eisack River. It was a guard and customs station during the 16th century, and today it is a restaurant and hotel. During the summer you can enjoy South Tyrolean delicacies under ancient trees in the garden; in winter, indoors by the tiled stove.

MORE INFORMATION
Brixen Tourist Association
www.brixen.org
Augustinian monastery Neustift
www.kloster-neustift.it/en

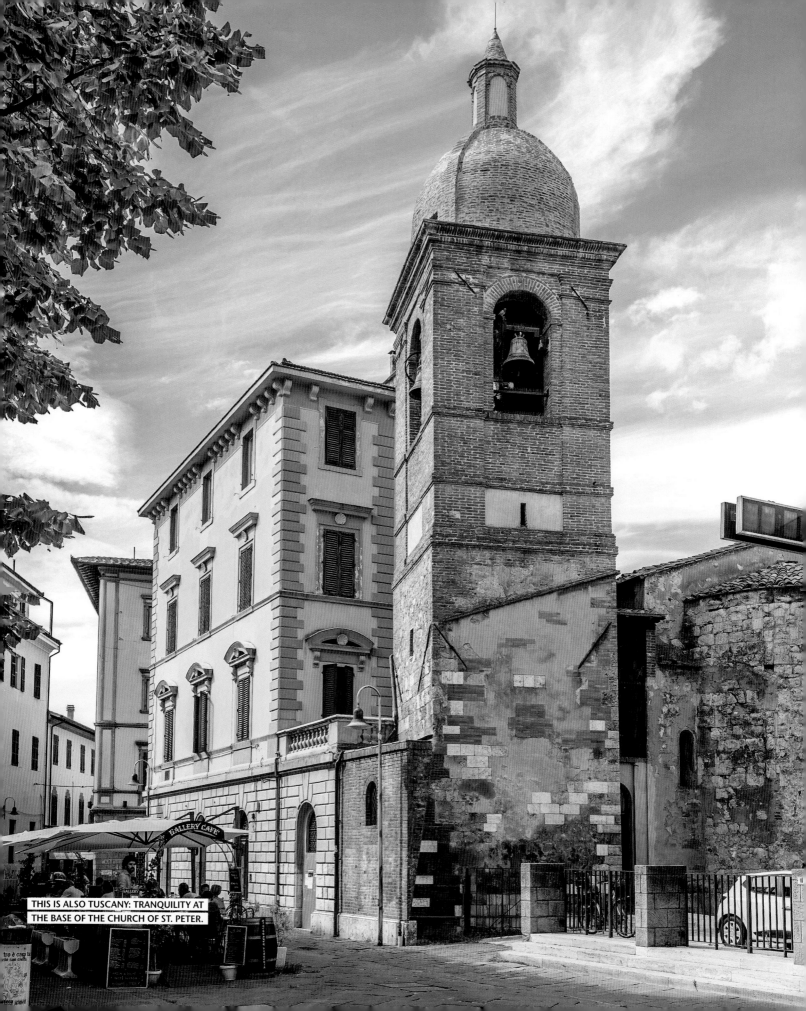

THIS IS ALSO TUSCANY: TRANQUILITY AT THE BASE OF THE CHURCH OF ST. PETER.

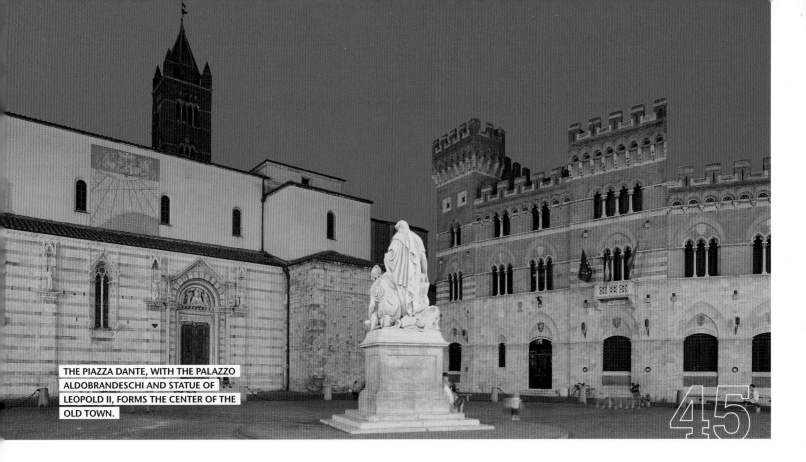

THE PIAZZA DANTE, WITH THE PALAZZO ALDOBRANDESCHI AND STATUE OF LEOPOLD II, FORMS THE CENTER OF THE OLD TOWN.

45

IN THE QUIET CORNER OF TUSCANY

Tuscany, with its cultural centers of Florence, Siena, Lucca, and Pisa, has long been one of the best-loved and liveliest holiday regions. If you are looking for a little more peace and quiet and Italian originality, the medieval town of Grosseto and its picturesque landscape is the perfect place for you.

ITALY

From a bird's-eye view, the city's hexagonal walls, with their arrow-shaped bastions protruding outward, are particularly easy to spot. They surround the historical city center with its alleyways and medieval buildings and invite visitors to take a panoramic and pleasantly shady walk high above the houses of Grosseto, with its 82,000 inhabitants. Founded in the Middle Ages and raised to the status of a bishop's see, Grosseto, also called the "Lucca of the Maremma" because of its intact walls, belonged first to Siena and then to Florence. During the 16th century, the Medici had the stony ring erected around the city in its present form for protection against sieges. On the eastern wall, they also integrated the Cassero

Senese, a castle complex from the time the city was under Siena's control, which is used mainly for art exhibitions today.

DWINDLE AND GROWTH

If you have managed to get a first impression from above, the charming Old Town lies open before you. Somehow time seems to have stood still there. Small cafés, bars, and restaurants with Tuscan specialties await visitors, as does the Romanesque-Gothic cathedral of San Lorenzo, with works of art from different eras, the Franciscan church dating from the 13th century, and the Palazzo Aldobrandeschi and the Palazzo Communale. The center of the Old Town is the Piazza Dante. The

monument to the Habsburg Grand Duke Leopold II also stands there. During the 19th century, he rendered great service to Grosseto. He initiated the drainage system for the city and its surrounding area, so that the region became habitable again. The Maremma was originally a swampy landscape with a climate hard for people to tolerate. Since the 16th century, the ruling Medici had shown little interest in the Grosseto region and neglected drainage, and malaria became so widespread that the population of Grosseto by the mid-18th century had dwindled to just 648 people. A colossal decline, because according to historical sources, the city is said to have had more than 3,000 men under arms at the beginning of the 13th century alone. Thanks to Leopold's efforts to drain and reforest the area with countless pine trees, Grosseto recovered quickly. By 1836, more than 2,300 people were again living in the city, and since 1945 the population has grown fourfold.

AGRITURISMO—CLOSE TO NATURE

Grosseto is an excellent starting point for flying visits to the surrounding area. Grains, citrus fruits, other fruits, and vegetables are grown on the level areas, while the hills are covered with olive trees and vines. High-quality wines that can be tasted on-site thrive in the sunny climate. The Maremma region is committed to agritourism, vacations on the farm. Those who prefer taking a vacation in the countryside have a wide choice of accommodation: all kinds are available, from a simple podere, once a farmhouse, to a spacious fattoria, or manor house.

TO THE SEA

Good destinations for a day trip are the pretty regional villages such as Campagnatico or Gavorrano, but also the coast, which is just a couple miles away. The fine-sandy beaches of the Maremma, with their clear, deep-blue water and the rock-framed swimming bays, are among the most beautiful in Tuscany and regularly achieve top marks for water quality and cleanliness. About 7.5 miles from Grosseto is the former fishing village of Marina di Grosseto, which certainly has meanwhile grown considerably but has not lost its original charm. Surrounded by gently rolling hills and Mediterranean macchia shrubland, the place offers both free public beaches with fine sand and calm waves suitable for children as well as sections of beach that charge visitors a fee and provide them with sun loungers.

IN THE FOOTSTEPS OF THE ETRUSCANS

Between 800 BCE and the second half of the first century BCE, the Maremma was part of the area settled by the Etruscans, the ancient people who lived in Etruria, in north-central Italy. With the Roman conquest, the Etruscan culture largely merged with that of Rome. The finds displayed in Museo Archeologico e d'Arte on Piazza Baccarini in Grosseto invite visitors on a journey through time into the world of the Etruscans. Anyone who wants to learn more about this advanced culture should make their way to the Roselle archeological park, about 3 miles from Grosseto. The excavations show remnants of Etruscan houses as well as traces of a Roman settlement such as thermal baths, an amphitheater, and a forum.

MORE INFORMATION
Maremma
www.enjoymaremma.it/en
Roselle excavation site
www.visittuscany.com/en/attractions/archeological-area-in-roselle

PARCO REGIONALE DELLA MAREMMA

The Parco Regionale della Maremma, about 10 miles south of Grosseto, often called the Parco dell'Uccellina, should also definitely be on your travel plan. This nature park, which was established in 1975, runs along the coast of the Tyrrhenian Sea and presents the landscapes typical of the Maremma as a natural ecosystem: cultivated pastures, where the Maremma horses and the

Maremmana, the region's characteristic gray-speckled cattle with large horns, graze; extensive pine forests; fragrant rosemary and myrtle bushes; growths of holm oaks on the rocky slopes and shallow lakes; and marshes and small dunes in the estuary at the mouth of the Ombrone River. Automobiles can access the park, which is open all year-round, only at certain points. Cars are allowed in the Alberese and Talamone Visitor Centers, where tickets are also available, and there is a paid parking lot on the pine-lined beach of Marina di Alberese.

The landscape is crisscrossed by well-marked hiking trails that offer different levels of routes— from easy to challenging. These lead to sights such as the ruins of the monastery of San Rabano, prehistoric caves such as the Grotta dello Scoglietto and the Grotta della Fabbrica, and to the watchtowers built in the Middle Ages, such as the Torre di Castel Marino and the Torre Cala di Forno. These once served to warn the population about pirate attacks. Bird lovers will also get their money's worth, because the park is designated as a protected area. Common buzzards and kestrels, eagle owls and barn owls, gray herons, great egrets, and endangered species such as European rollers and great spotted cuckoos live there all year-round. Some species such as the Eurasian golden plover and lapwing come to spend the winter, and others such as the nightingale and Eurasian jay come to breed in summer. So it's best to take your binoculars along with you.

AFTER A STROLL THROUGH THE ALLEYS (*LEFT*) AND SIGHTSEEING IN THE HISTORICAL BUILDINGS (*ABOVE*; SIDE PORTAL OF ST. LORENZO), A TRIP TO THE NATURE PARK IS INVITING. HERE, THE MAREMMA HORSES FEEL RIGHT AT HOME (*RIGHT*).

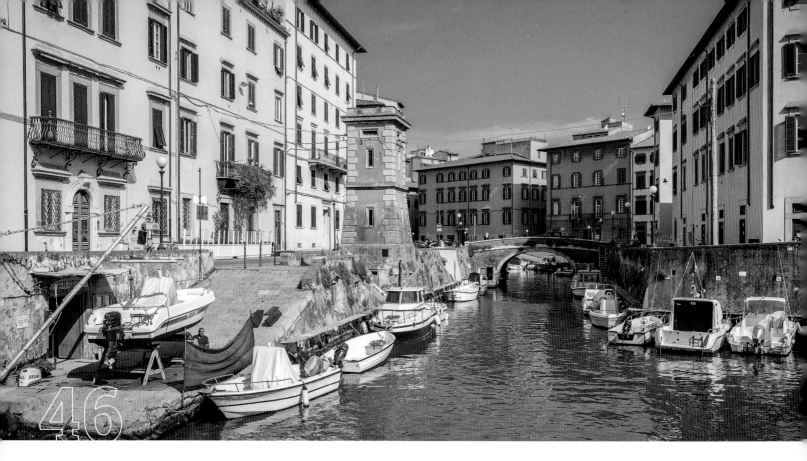

46

HARBOR CITY WITH ADDED VALUE

Even declared lovers of Tuscany consider Livorno to be "just" a port city where you take the ferry to Elba, Corsica, and Sardinia. But anyone who is content with this will miss out on historical architecture and Venetian moments, Italian lifestyle, and Tuscan delicacies.

ITALY

The province of Livorno stretches about 62 miles along the Etruscan Riviera. Pisa is not far away from the definitely quieter provincial capital. Livorno is indisputably a port and industrial city, but that's not all: by the 10th–11th centuries, inhabitants had settled the swampy terrain. As the port for Pisa, Livorno was expanded farther and farther, especially during the 16th century under the rule of the Medici. The swamps were drained and more and more people arrived there. Architects laid out an "ideal" city with ramparts, canals, and right-angled streets, which is still recognizable today. However, Italian fascism also left its mark on the architecture, as did the bombings in World War II. In the reconstruction in the 1950s, there was no sense in building anything

imposing. Industry was spreading. Some corners have an inhospitably cool effect. On the other hand, Livorno has also produced important artists. The painter and later professor at the Florence Art Academy Giovanni Fattori (1825–1908) was born there, as was the painter and graphic artist Gianfranco Ferroni (1927–2001). The most famous son of the city caused a sensation above all with his intensively colored, long-limbed, and ethereal female figures: Amedeo Modigliani (1884–1920).

CATHEDRAL AND FORTS BEHIND PALM TREES

The Viale Arsenal, which runs from the port across the wide Via Grande, is full of countless shops, coffee bars, and ice cream parlors, some of them

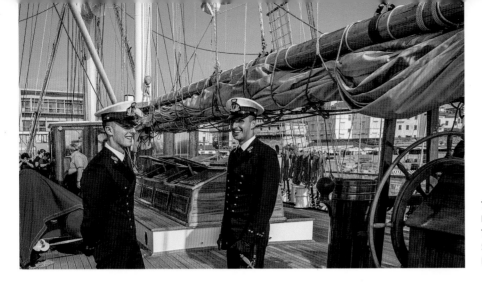

THE BEST WAY TO GET A FIRST IMPRESSION OF LIVORNO IS TO TAKE A BOAT TRIP THROUGH THE CANALS OF "NEW VENICE" (*OPPOSITE*). SEAFARING AND FISHERIES ARE CHARACTERISTIC OF THIS PORT CITY (*LEFT*).

under arcades. The Viale Italia promenade leads to the southern suburbs. From the port, you can stroll past green spaces and palm trees, palazzi and art nouveau villas, bars, and simple bagni for swimming. From the spacious, elegant Terrazza Mascagni you can enjoy a view of the sea or stop off at the Acquario di Livorno. In the middle of the Livorno Old Town, which is surrounded by water, the Cathedral of San Francesco di Assisi stands on the Piazza Grande. Outwardly quite simple, in the interior it is adorned with frescoes. The two forts make beautiful images for photos: the Fortezza Vecchia, a fortress with a watchtower dating from the 11th century, stands by the old port, and west of it, almost opposite, the Fortezza Nuova is built on an island. A green space now stretches within its crenelated reddish brick walls. The best way to conquer Venezia Nuova is by boat on the canals: again and again, you sail under bridges while "New Venice," with its pastel-colored buildings, is passing by to your left and right. In the evening, the day comes to an end with a glass of wine and a beautiful view of the water from the terrace of a trattoria in the lively pub district.

LIVORNO FOR CONNOISSEURS

In the Mercato Centrale, once one of the largest market halls in Europe and still one of the most beautiful, you can get all kinds of Tuscan specialties. You will find mainly fresh vegetables and fish under the roof of this art nouveau iron construction on the Scali sassi. There you can also get the ingredients for the rich Livorno fish stew, cacciucco: tomatoes, peppers, garlic, white wine, and freshly caught fish, as well as squid, crayfish, and mussels.

SUN, BEACH, AND PINE TREES

Enough of all the turmoil? Better to leave the city behind? Just 655 feet above Livorno lies the hamlet of Montenero, with the sanctuary of Santa Maria delle Grazie and its many villas. The funicular takes you up the hill, which offers a view of the entire city and the sea—not far south of Livorno you come to rocky coast, sandy beaches, and pine forests. In the mid-19th century, medicinal and thermal springs were discovered here, and Livorno later developed into the first seaside resort in Italy according to the fashion of the times. Tourism became an economic factor. Many exuberantly decorated villas were built around the turn of the 20th century.

MORE INFORMATION
Azienda di Promozione Turistica Livorno
Piazza Cavour 6, tel. 0039/586898111
www.discovertuscany.com/livorno

47

ITALY

DUKE FEDERICO WILL SEE YOU NOW

The buildings of a town nestle against the lovely green hills of the Marche. Only a bell tower, a church dome, and two towers rise high above the other roofs. This is almost exactly the way that the great scholars paying their respects to its art-loving ruler must have seen Urbino in the 15th century.

Gauls, Romans, Goths, and Longobards (Lombards) played lords of the city before the Papal States repeatedly stretched their hands out toward Urbino. The homogeneous architectural appearance of Urbino is due, on the one hand, to its clever ruler, Duke Federico da Montefeltro (1422–1482), and, on the other hand, to his less gifted successors, to its lack of "progress," and to its remote location in a rather barren area in the hinterland of the Adriatic coast, at the foothills of the Appenine Mountain range.

During the 12th century, the Montefeltro family had been appointed by Holy Roman Emperor Friedrich Barbarossa as the imperial vicars of Urbino. During the second half of the 15th century, Duke Federico designed the city along with well-known architects on the basis of Renaissance principles. He promoted art and

culture and made his court one of the most glamorous in Europe by inviting important artists and scholars. The duke helped Urbino to blossom—UNESCO has thanked him and declared the city a World Heritage Site in 1998.

SHOWPIECES

The Palazzo Ducale, once a duke's residence, dominates the cityscape. The building was started in the middle of the 15th century and is considered the most important secular Renaissance building in all of Italy. Its two towers are the symbol of the city. The simplicity of the building, with the courtyard, the Cortile dell'Onore (Court of Honor) arcades, may perhaps be disappointing from the outside. But the interiors hold many a treasure: the vaulted cellar served to hold the household supplies for the ducal court, and there was even a precursor of the

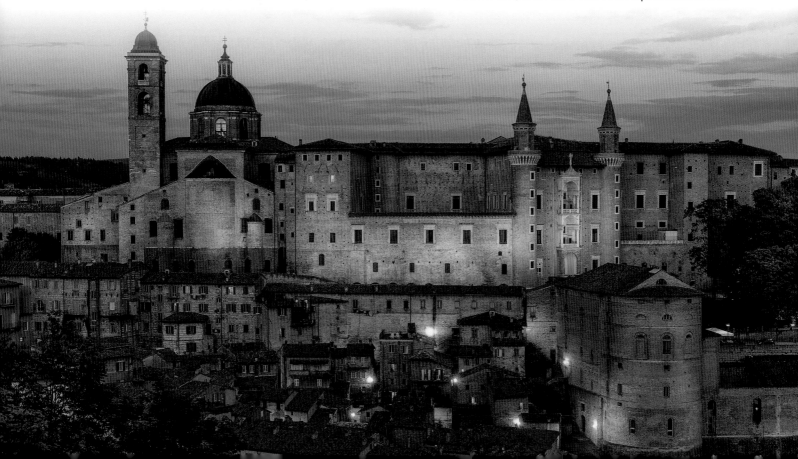

refrigerator, which used snow to preserve food. But above all, the palace now houses the Galleria Nazionale delle Marche, one of the most important Italian Renaissance collections. In the palace and museum you can go on a journey of discovery through the halls and towers. As you do so, you encounter the representation of the "Ideal City" in the Angel's Hall, created at the end of the 15th century and attributed to Luciano Laurana. Next to all the splendor, the duke's study in the palace seems almost humble, despite the trompe l'oeil inlay. Countless palaces, churches, and the cathedral in the Piazza Duca de Federico form a harmonious overall image. You get a wonderful view over it all on a hill, from the Albornoz Fortress (14th century) —and can put together your own route of discovery. There are many singular features along the way: for example, the Oratorio de San Giovanni Church in Via Barocci, once a meeting point for a charitable lay brotherhood, is completely painted with biblical scenes in bright colors.

ORIGINALS AND COPIES

Under Federico da Montelfeltro, the city also flourished in the performing arts, which today draw art lovers here. In the guest rooms of the princely palace and the Galleria Nazionale, such works as *The Flagellation of Christ* and the *Madonna of Senigallia* by Piero della Francesca (1417–1492) or *The Resurrection* and the *Last Supper* by Titian (ca. 1488–1576) can be found. Giovanni Sanzio (1435–1495) painted portraits and religious motifs in Urbino. His son Raffaelo (1483–1520), trained in his father's workshop, became a master of Renaissance painting. His birthplace at Via Raffaelo

YOU FEEL AS IF YOU HAVE BEEN TRANSPORTED BACK TO THE RENAISSANCE WHEN VIEWING URBINO'S CITY SILHOUETTE (*OPPOSITE*). TYPICAL OF ITALY, LIFE TAKES PLACE OUTSIDE IN THE SUMMER (*BELOW*).

Sanzio 57 is now a museum, with original works by the father and copies of those by the son, who left Urbino behind and made his career in Rome. However, Raphael's original portrait of an unknown noble lady, *La Muta* (*The Mute*) hangs in the Galleria Nazionale.

MAJOLICA

People enjoy taking colorful ceramics home with them as a souvenir of the Mediterranean region. The Romans already knew how to manufacture it, but in such a modest way that it was forgotten. In Mesopotamia, on the other hand, people know how to give clay objects a shimmering white or colored tin glaze—double-fired to be particularly hard-wearing. The Muslim conquerors brought the technique to Spain. From there it spread to Italy, where tiles and bricks were also made in this way. In addition to the cities of Faenza (hence "faience") and Orvieto, Urbino was also among the centers for making it, because the regional clay available there could be used to manufacture it. Yellow, blue, and green are the predominant colors used for the majolica typical of Urbino, while fine tiles, plates, and vases are decorated with floral designs.

MORE INFORMATION
Urbino and the Marche
www.turismo.marche.it/en-us
https://whc.unesco.org/en/list/828

CAGLIARI—VIBRANT PORT CITY

CHARMING WALLS, PROMENADES IN NATURE

Like Rome, the capital of Sardinia was also built on seven hills. One of them is the Castello (castle) hill, which overlooks the Old Town and the harbor on the Gulf of Angels, as the Gulf of Cagliari is also called. The city exudes warm originality and also has a kilometer-long sandy beach on an offshore spit of land.

In the seventh century BCE, this city was founded by the Phoenicians at the egress from the fertile plain of Campidano as the city of Karaly. Then Romans, Vandals, Arabs, Byzantines, Pisans, Aragonese, and Piedmontese all took their turns until the kingdom of Sardinia became part of the new Italian nation-state in 1861. The nucleus of Cagliari is the Old Town around the castle hill, which comprises the Castello district, Casteddu in Sardinian, the Villanova medieval merchant quarter, the older Stampace district, and the Marina harbor district.

IN THE SHADOW OF THE BASTION

The easiest way to reach the Castello district, with its thick walls and two defense towers, is by elevator. If, as is often the case, it isn't working, you will have to take the outside staircase. You enter the old aristocratic quarter through the Torre dell'Elefante, with its small marble elephant on a corbel, passing under the frightening portcullis. Some of its patrician houses exude a morbid charm. The Terrazza Umberto I on the former Bastione de Saint Remy is an evening meeting point for locals and tourists. People can enjoy the view of the city and the lagoons off the coast from the beautiful panorama terrace. The view from the Torre di San Pancrazio, the highest point in the city, reaches even farther. Both defense towers are open on the city side to make it easy to bring in supplies. On the Piazza Palazzo stand the Santa Maria di Castello Cathedral, originally built in Romanesque-Pisan style, with its rosette-decorated crypt; the former royal palace, now the seat of the prefecture; and the old town hall.

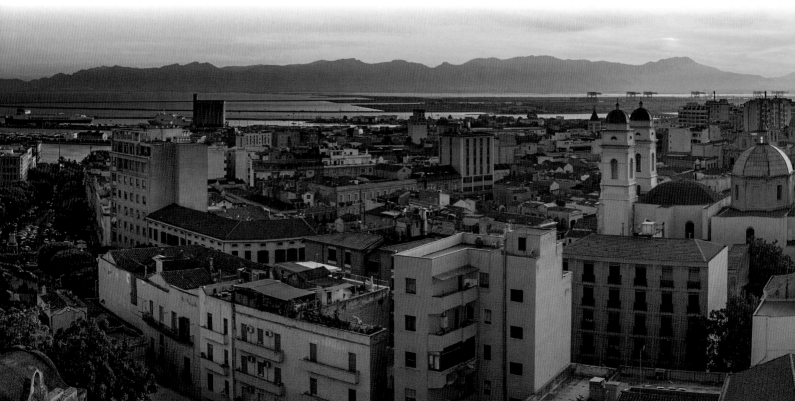

The Cittadella dei Musei museum complex, with important finds from Nuragic culture, is housed in the former city arsenal. Not far from the museums, the botanical garden spreads out within sight of the Roman amphitheater, an oasis of calm in the Stampace district. Another archeological highlight is the Roman-Punic necropolis Tuvixeddu, with the Grotta della Vipera. The Castello and Stampace neighborhoods meet at Piazza Yenne, lined with cafés and bistros. In busy Villanova, farther to the east, is the oldest church in Sardinia, the Roman-Byzantine Basilica of San Saturno. However, the Santuario di Bonaria monastery complex, which also includes the most important pilgrimage church in Sardinia, attracts far more visitors. Those who are more committed to worldly enjoyment can visit the Mercato di San Benedetto, which houses some 250 bright and shiny market stalls on two floors. Sardinia's culinary treasures are on offer here, from Pecorino Sardo to Mirto liqueur.

BEACH AND LAGOON

To see and be seen—the Via Roma harbor promenade in the Marina district is the right place for this even in the hot summer, because the many shops, cafés, and restaurants are located in shady arcades. It is also a pleasure to go shopping in the small side streets, next to Via Giuseppe Manno and Largo Carlo Fenice. Magnificent palaces from the 19th century line the Via Roma, including the new town hall with its white marble facade. The former fishing district, with its picturesque alleys, is located directly behind the strolling promenade. It is difficult to choose among the countless trattorias in the Via Sardegna.

After all the sightseeing and a delicious meal, the day ends with a walk along the Poetto city beach. At the south end, the rocky Sella del Diavolo headland ensures a beautiful view of the beach and the lagoons. This 5-mile spit of land separates the Molentargius lagoon from the sea. The salt pans were closed in 1985. Today, the salt lakes are home to many water birds. Several flamingo colonies have even been breeding there since 1993. You can get to truly beautiful beaches with clear water just a couple of miles away, at Chia to the west or at Villasimius to the east.

NURAGIC AND NORA

What would a vacation on Sardinia be without the Nuragic civilization? The prehistoric tower buildings and tower settlements, built between 2200 and 400 BCE, are distributed over the whole island. At the small town of Sarroch, southwest of Cagliari, the Nuragic complexes of Antigori and Sa Domu 'e s'Orku are to be found near the sea, and very close by is the even-older "giant's tomb" of San Cosimo. The Tombe dei Giganti are large passage tombs, which have a small entrance delimited by a semicircle with a portal stele. If you are interested in the Romans and Phoenicians, you should pay them a visit in the ruined city of Nora, which lies directly by the sea south of the tourist stronghold of Pula. Most of the well-preserved relics date from Roman times. The Stele of Nora (Nora Stone), with its enigmatic Phoenician inscriptions, can be seen in the archeological museum of Cagliari, along with important finds of Nuragic culture.

MORE INFORMATION
Cagliari and surroundings
www.sardegnaturismo.it/en/places/sud/cagliari

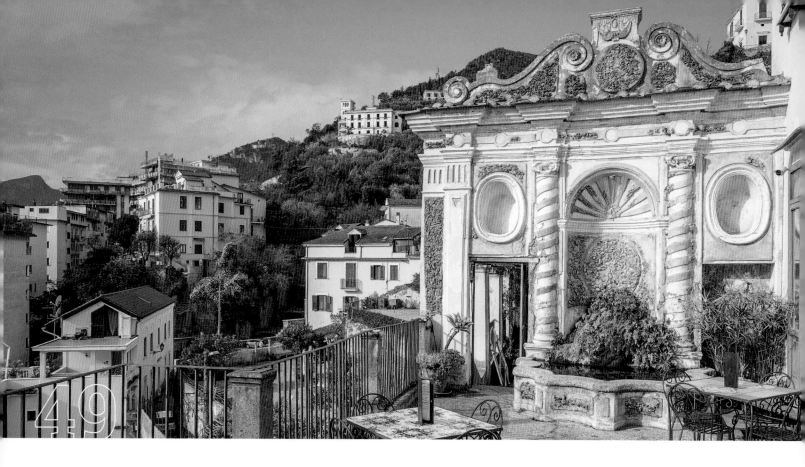

49

ITALY

BETWEEN AMALFI AND PAESTUM

For anyone who wants to avoid the hustle and bustle on the Amalfi coast, Salerno is ideal. The Lunomare Trieste, one of the longest waterfront promenades in Italy, leads from the medieval Old Town to the port at the Piazza Concordia. The Castello di Arechi rewards you for the steep climb with a fantastic view of the Gulf of Salerno.

Salerno is successfully fighting its reputation of being a dangerous place for tourists. After the severe earthquake in 1980, the city began to spruce itself up extensively in the 1990s, thanks to the support of renowned architects. In 2016 the "Oyster," a ferry terminal designed by Zaha Hadid, was inaugurated. A citizens' initiative to create green areas made Salerno into a *citta giardino* (garden city). The city has a lively nightlife, thanks to the many students and language students there.

MINERVA CATHEDRAL, FORTRESS, AND GARDEN

The enchanting Via dei Mercanti, the street of the merchants, with its many small shops and restaurants, runs through the Old Town near the cathedral.

Three monuments are of particular interest. The Romanesque Cathedral of San Matteo, with its round bell tower, is rather inconspicuous from the outside except for the magnificent bronze gate and is entered through a Moorish-style atrium courtyard with antique columns from the ancient Greek city of Paestum. Inside there is a mosaic floor from the Norman period and two pulpits richly decorated with mosaics. The crypt is a surprise with its lavish baroque style. The Castello di Arechi, founded by the Longobards (or Lombards) and later enlarged, can also be easily reached from the city by bus. There is a small museum and a nice café in the fortress. The hidden garden of Minerva deserves being called a gem. The medieval educational garden, laid out on a series of terraces, is a

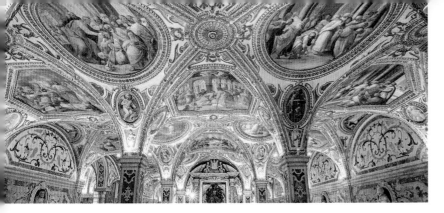

reference to the famous medical school of Salerno dating from the 10th century, where women also taught. Likely the oldest preserved botanical garden in the world, it is laid out according to the rules of the teaching of the four elements.

MOZZARELLA AND BLUE FISH

Only 31 milesalong the almost dead-straight coastal road separate Salerno from Paestum. The alluvial plain at the mouth of the Sele River is the home of one of the most famous Italian cheeses. Mozzarella di Bufala Campana is made from the milk of water buffalo. These gentle giants were likely brought to southern Italy by the Saracens, who had had an outpost in Agropoli since the end of the ninth century. The water buffalo coped well with the swampy meadows, which often lay underwater, and were more resistant to malaria than other cattle. The best way to taste fresh mozzarella is at one of the showplace farms. The tender, juicy meat of male water buffalo calves is now being marketed with increasing success. Other regional specialties of the province include scarzetta, sponge cakes filled with a wild strawberry cream, parmigiana di melanzane, baked eggplant parmigiana with mozzarella, and "blue fish"—sardines, anchovies, or mackerel prepared in a special way.

ANCIENT HERITAGE

The impressive, probably best-preserved Doric temples in honor of Hera ("Basilica"), Poseidon and Athena are to be found in the ruins of ancient Paestum. Other buildings in the city, which originated from the Greek colony of Poseidonia, are the Roman amphitheater, the forum, and the brick-covered Heroon, surrounded by a 15,500-foot-long perimeter wall with gates dating back to Roman times. The museum boasts painted tombs from Greek and Lucanian necropolises.

The "diver's tomb" frescoes are particularly touching. Near Paestum, on a hill near Capaccio, is

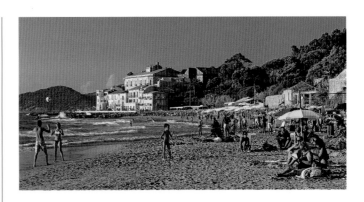

IN NORTHERN CILENTO

Nearby Cilento has long sandy beaches, rugged cliffs, a crystal-clear sea, and an unspoiled, densely forested mountainous hinterland. Picturesque towns line up one after the other from Agropoli to Cape Palinuro. The historical core of the seaside resort of Santa Maria di Castellabate is a semicircular sandy bay, lined with picturesque houses. One of the most beautiful villages in Italy, Castellabate presides over the town along with its castle. Both villages are filming locations for *Benvenuto al Sud* (Welcome to the South), the counterpart to the French box office hit *Bienvenue chez les Ch'tis* (Welcome to the sticks).

MORE INFORMATION
Salerno
www.summerinitaly.com/guide/salerno
Paestum
www.livesalerno.com/archaeological-site-of-paestum
Cilento
https://whc.unesco.org/en/list/842

the medieval sanctuary of the Madonna with the Pomegranate, a much-visited sanctuary. The veneration ties in with the ancient goddess Hera cult associated with a river shrine. The square in front of the church offers a wonderful view of the ruins of Paestum and of the Gulf of Salerno. A footpath leads to the still-higher-situated ruins of the village of Capaccio Vecchio.

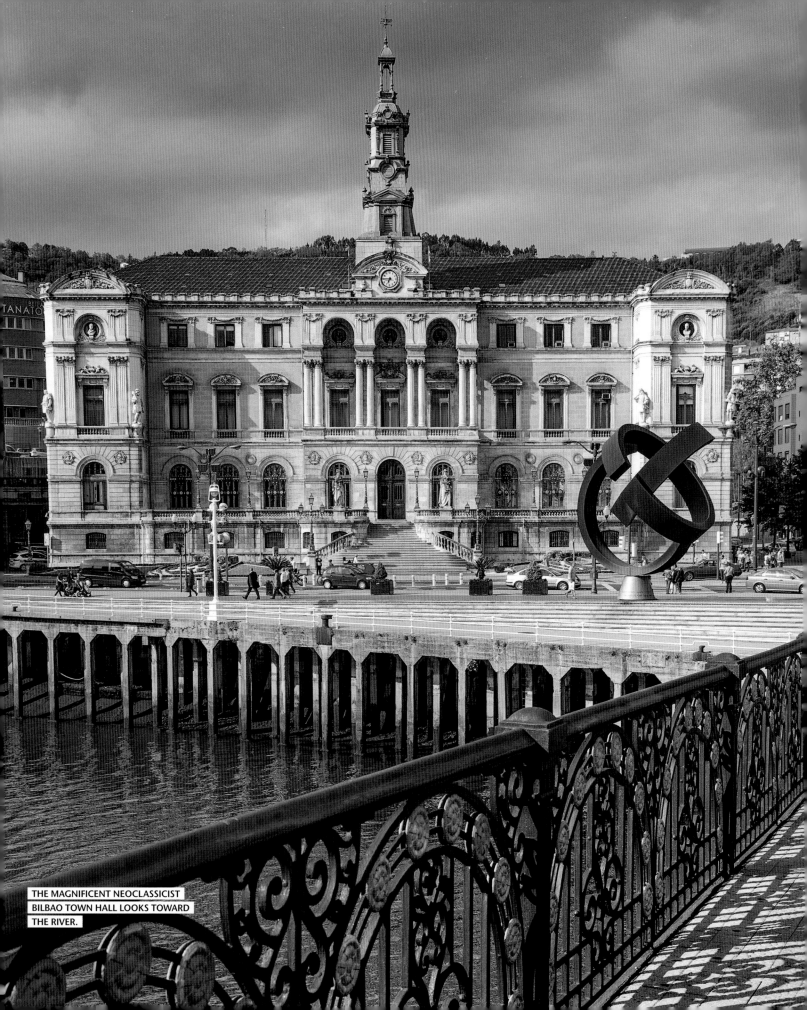

THE MAGNIFICENT NEOCLASSICIST
BILBAO TOWN HALL LOOKS TOWARD
THE RIVER.

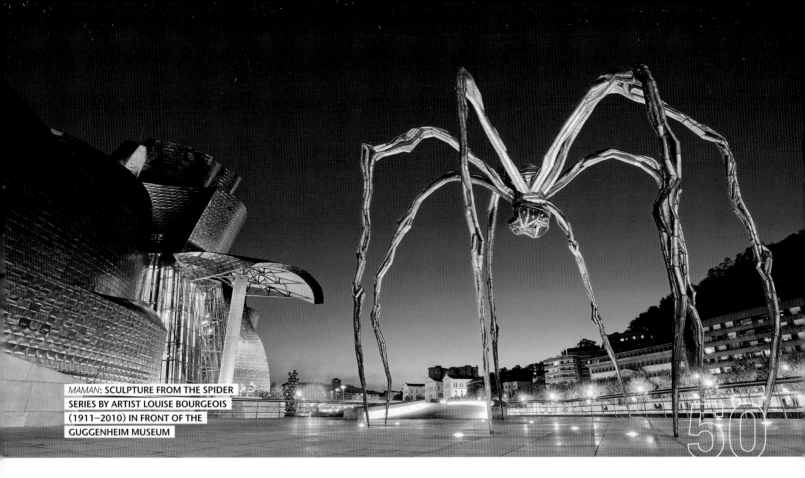

MAMAN: SCULPTURE FROM THE SPIDER SERIES BY ARTIST LOUISE BOURGEOIS (1911–2010) IN FRONT OF THE GUGGENHEIM MUSEUM

ARCHITECTURE AND ART SPICED WITH PINTXOS

SPAIN

Bilbao, which lies in northern Spain's Basque Country, has succeeded in making the transition from a gray industrial city to a modern architectural, art, and cultural metropolis in a way never thought possible. People have even started speaking of the Bilbao effect! The city offers an exciting image, characterized by stark contrasts.

Bilbao lies among seven hills in the Spanish Basque Country. The city, founded in 1300, is located on the site of a Roman settlement established because the Romans already knew how to make use of the iron ore deposits in the surrounding area. The city is also located on the Nervión River, which flows into the Atlantic Ocean and is navigable a good distance inland. Bilbao thus rose to become an industrial metropolis and achieved some prosperity. Its decline started in the 1970s. The city fathers reacted by changing its image—away from gray industry to art and culture.

The Guggenheim Museum Bilbao fired the starting shot in 1997. You can get a stunning view of the museum and Bilbao from the local Mount Artxanda (820 feet tall). A charming cog railway runs to the top.

GREAT ARCHITECTURE

In a broad arc, the Nervión River divides Bilbao into two halves. East of the river rise the futuristic buildings of the modern city center in the Ensanche district; the Old Town, Casco Viejo, spreads out in the southwest. The Guggenheim

Museum in the New Town became the symbol of Bilbao. The building, according to the assertion of its designer, the Canadian American architect Frank O. Gehry, lies like a "stranded ship in the Nervión," and indeed the oval building with its long, protruding roof sections is reminiscent of a ship. The sun's rays are often refracted in the shiny facade of glass, titanium, and limestone. The center point of this gigantic museum is the glass atrium, with its flower-shaped skylight. Modern art is displayed in 20 galleries on 118,400 square feet. The Guggenheim is known for its installations, media artworks, and sculptures. It did not remain alone. World-famous architects designed an entire area along the Nervión: the Argentinian César Pelli designed the Torre Iberdrola office tower, the Iraqi architect Zaha Hadid built a new district on the Zorrotzaurre Peninsula, the Japanese Arata Isozaki created another symbol of Bilbao with the Torres Isozaki twin towers (272 feet), and the Spaniard

Santiago Calatrava (b. 1951) planned the Zubizuri footbridge over the Nervión River. Visitors should definitely cross over the elegantly curved "white bridge"—which is what Zubizuri means—at least once, in any event. The main shopping street, Gran Via de Don Lopez, is also located in the New Town.

THE SEVEN ALLEYWAYS OF THE CASCO VIEJO

The oldest part of Bilbao is Siete Calles, the "seven alleyways," popular as a pub district with countless restaurants and bars. At the heart of the Casco Viejo lies the Plaza Nueva, a square created in 1821, framed by classicist buildings with cafés, pubs, and small shops under arcades. The square is busy at all times of the day and night. The locals meet here for a txakoli, the fresh white wine of the Basque Country, along with pintxos. These appetizing little nibbles are not tapas, something important to the Txikiteros (Bilbao residents).

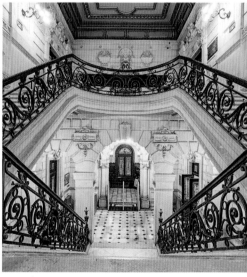

FAMOUS FOR ITS DELICIOUS PINTXOS: CAFÉ BILBAO ON PLAZA NUEVA IN CASCO VIEJO (*LEFT*) STEP OUT AS BEFITS YOUR SOCIAL STATUS—THE OPULENT STAIRCASE OF THE FORAL PALACE, WHICH DATES FROM 1900 (*ABOVE*).

Rather, the word comes from "pinchar," to skewer, because pintxos are made of ingredients that are skewered to slices of white bread with a wooden skewer: meat, fish, cheese, vegetables—there are no limits to creativity. Some of Bilbao's best pintxos bars are to be found in the Plaza Nueva neighborhood.

At some point you will come across the Mercado la Ribera, the largest covered market hall in Europe. If the abundant Spanish and Basque fresh produce whets your appetite, you can enjoy it in one of the trendy bars on the ground floor. To the south of the Plaza Nueva is the Catedral de Santiago Apostól (14th–16th centuries), dedicated to the apostle James, the oldest building in the city. Today's facade and tower date from the 19th century. The choir and cloister are particularly worth seeing. Only feet away is the Church of San Antón (14th century), a Gothic building with traces of the Renaissance.

PALACES FOR ART AND WELL-BEING

The prosperity of the industrial age also manifested itself in stone palaces. One of the most beautiful is the Foral Palace (1900), with its murals, antique furniture, and works of art in the interior. The town hall, a neoclassical building, is all dressed up with a magnificent facade and beautifully decorated rooms. One is the Arabic-inspired Moorish hall with golden tiles and arches, which seems to come from the *One Thousand and One Nights*. No less impressive is the Arriaga Theater (1890; rebuilt after a fire in 1914), which is intentionally reminiscent of the Paris Opéra. Balconies break through the facade, while the interior houses historical furniture and carpets from the king's own makers.

The former Azkuna Zentroa wine store (1909, also the Alhóndiga) presents a successful symbiosis between old splendor and modernity. It was redesigned by the French designer Philippe Starck. Today it is a cultural and leisure center where knowledge, culture, sports, and fun can unfold in equal measure. The rich and beautiful of Bilbao meet in the rooftop bar for a "sundowner" with a view over the roofs.

Bilbao is also a green city with many parks and gardens. These have included the central Parque Doña Casilda for more than 100 years. With its flower beds, shady trees, walking paths, arbors, fountains, and large pond, it resembles an English garden. The park adjoins the Museo de Bellas Artes (Fine Arts Museum), one of the most important in Spain. It displays works from the 12th century to the present and focuses intensively on Basque artists.

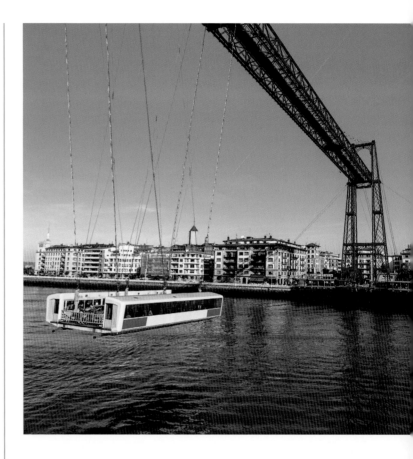

HOVERING ACROSS THE RIVER

At the place where the Nervión widens as it flows into the sea, the Puente de Vizcaya suspension bridge (also known as the Puente Colgante or Biscay Bridge) connects the municipalities of Portugalete and Getxo, which belong to Bilbao. The world's first ferry bridge (1893)—one of the very few that are still in operation today—is a transport gondola hanging from a supporting structure between the steel lattice towers. It makes it possible for you to switch banks in an elegant way. The bridge design is reminiscent of the Eiffel Tower; no wonder—its architect Alberto de Palacio was a student of Gustave Eiffel. A visitor has the choice: he either hovers over the river or crosses the 525 feet by foot at a height of 164 feet. Both are special experiences.

MORE INFORMATION
Bilbao
www.spain.info/en/destination/bilbao
Basque Country, Bilbao, and the Biscay Bridge
https://tourism.euskadi.eus/en

SPAIN

RAMBLA, TAPAS, AND DALÍ

The provincial capital Figueres is only 12 miles beyond the French border. It bids welcome to all those who take a little more time, instead of just making a stop on their way to the sunny southern coasts, and it gives you the feeling of being right in the middle of Spain. The Catalonian town has long been considered a mecca for art lovers; after all, Salvador Dalí lived and worked here.

The capital city of Girona Province has a homey feel. Coming from the north, you are just 12 miles west of the Costa Brava and the Bay of Roses and are already in touch with everyday Spanish life, with the Pyrenees peaks greeting you in the distance. If you want to stretch your legs after a long drive, stroll to the Castell de Sant Ferra, which lies just outside. It is one of the largest fortifications in Europe dating from the 18th century. A walk through the city, where some buildings are decorated with baroque, classicist, or art nouveau elements, is more entertaining. A side trip takes you through the former Jewish quarter of Carrer Magre. The main goals of your walk should

be La Rambla or the Plaza del Ayuntamiento, the square in front of the old town hall. Here you are in the midst of Spanish life, where there is always something happening.

DRINKING A CAVA

You stroll past many shops on La Rambla—the main boulevard lined with old plane trees, where festivals such as the Semana Santa during Holy Week, the wine festival in September, and a small Christmas market are held—and the Plaza del Ayuntamiento, the square in front of the old town hall. Would you like some pretty handmade espadrilles, light summer shoes made of fabric and

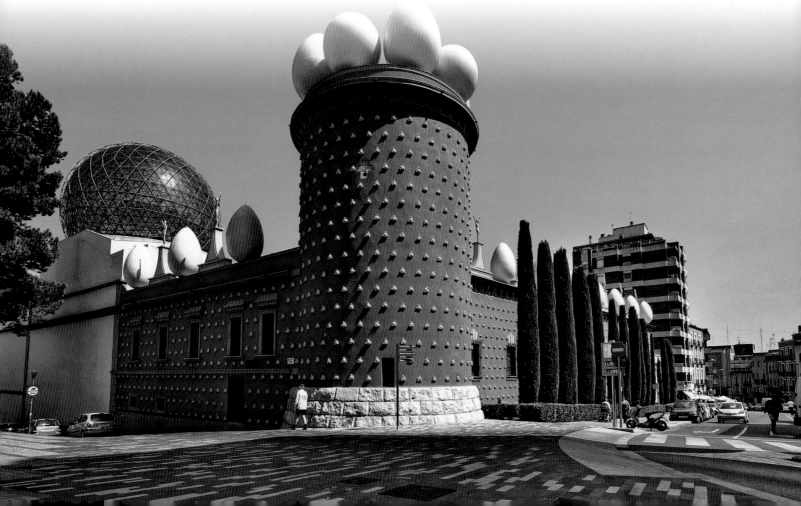

straw? The typical tapas bars are inviting; this is where the Spaniards make the time pass more quickly before their late dinnertimes, with an aperitif and appetizers. Some people stay right with a fresh sparkling wine, white wine, or rosé, as they are grown in the Empordà, the hinterland of the Costa Brava, especially around the Castell de Peralada. These go well with ensaladilla rusa (potato salad with tuna, egg, and vegetables), albondigas (meatballs in spicy tomato sauce), or canejo al ajillo (rabbit in garlic sauce). With a sparkling cava on the town hall square, your vacation can begin!

SURREAL AND ECCENTRIC

It catches your eye directly: the blood-red outer walls of the Teatre Museo are decorated with artificial bread and topped with huge white eggs, while slender gold figures in between welcome visitors from all over the world to the universe of the artist Salvador Dalí (1904–1989). The Catalan grand master of surrealism created a place for living and working, as well as his own crypt, in the former city theater with an attached tower—the Torre Galatea.

As the son of a local wealthy lawyer family, he was able to indulge in his passion for art early on—and later lead a provocative lifestyle. After studying in Madrid and Paris, where he maintained intensive contact with the painter Pablo Picasso and the director Luis Buñuel, he returned to his birthplace—to the horror of some long-established residents, who were somewhat at a loss about the grand master's bizarre performances and scandalous lifestyle. Dalí's art was also sensational at the time of its creation: he transformed his hallucinations with photographic accuracy into color-intensive painting, which also liked to cite Old Masters.

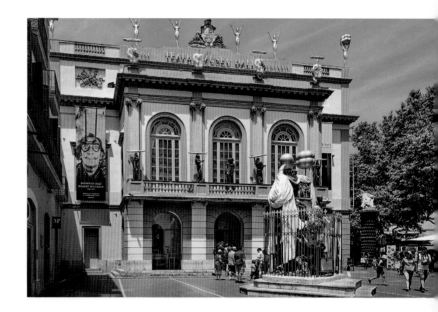

GIANT EGGS ON THE ROOF, AND BREAD ON THE FACADE (*OPPOSITE*) **SALVADOR DALÍ ALSO KNEW HOW TO ASTOUND PEOPLE AT HIS OWN MUSEUM, ONCE THE CITY THEATER** (*BELOW*).

The museum itself is considered to be the greatest surrealist work of art and is part of the "Dalí triangle." It brings the art a little bit closer to everyone who is willing to accept the waiting time at the entrance. Patience is rewarded, because in addition to famous paintings, including those featuring typical Dalí motifs such as melting watches or his wife, Gala, sculptures and surprising installations also await you. The artist is buried in the crypt.

THE DALÍ TRIANGLE

Dalí devotees make pilgrimages to three locations in Catalonia: besides the museum in Figueres, they include the Casa museo Salvador Dalí (Dalí House Museum) by the bay of Port Lligat on the rocky Cap de Creus peninsula near the town of Cadaqués, about 25 miles east of Figueres. There Dalí has combined several fishermen's houses into a total work of art, domicile, and studio with a retractable easel. In addition, Dalí acquired a dilapidated small castle complex northeast of Girona in the medieval town of Púbol for his idolized wife, Gala, restored it, and turned it into an aesthetically designed refuge with a small pool and music room. Long-legged elephants (sculptures) walk through the romantic garden, and other artistic surprises await the visitor. Púbol became Gala's place of residence in her last years, and her final resting place.

MORE INFORMATION
Figueres
www.cbrava.com/de/tourismus/figueres
Spanish Tourist Office
www.spain.info

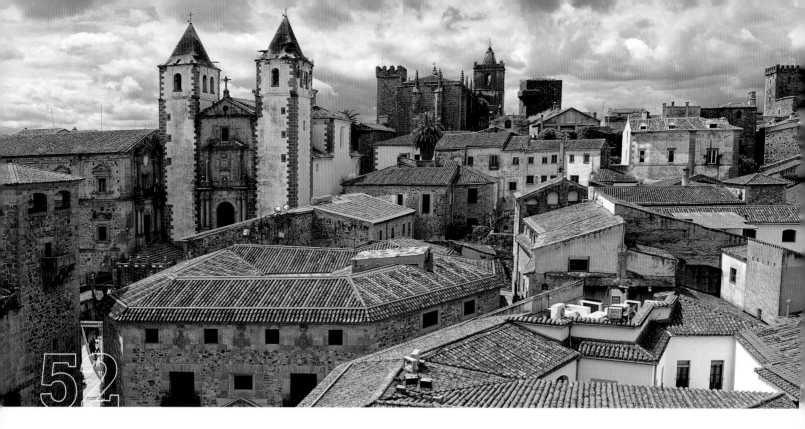

CÁCERES—STONY LEGACY

THE SPANISH MIDDLE AGES

SPAIN

Many people came; some of them left again: Celts, Romans, Visigoths, Arabs, and Christians. They all left their mark behind them. Under Muslim and Castilian rule during the 15th and 16th centuries, this historical townscape was created and was then recognized by UNESCO in 1986 as one of the most homogeneous on the Iberian Peninsula.

The provinces of Cáceres and Badajoz form the Extremadura region. It is roughly the size of Switzerland, but very sparsely populated outside the cities. During the 1960s, it was not the thirst for discovery like that of conquistadors Hernán Cortéz and Francisco Pizarro, who came from the region, that caused people to move away from it. Rather, they did it out of necessity. Agricultural Extremadura was one of the poorest regions in Spain, which could barely offer small-scale farmers or traders any prospects. At that time, tourism was not yet an economic factor. Today, many hikers and pilgrims know how to appreciate the tranquility of the inland.

ON THE VÍA DE LA PLATA—
THE SILVER ROUTE

A Celtiberian settlement from pre-Christian times was refounded by the Romans. The Muslim conquerors fortified the city, which had meanwhile been destroyed by the Visigoths, now under the name of Quazris. Starting from the 12th century onward, Cáceres came—with interruptions—under the rule of the House of León; later the city became host to the Catholic ruling couple Ferdinand of Aragon and Isabella of Castile—who had the battlements of most of the towers cut down to demonstrate who was now in charge. Unfortunately, in 1936 the Spanish dictator Francisco Franco chose Cáceres as the headquarters of his movement.

The Middle Ages were the time of economic ascent. The Silver Route, already built by the Romans, passed through Cáceres and was used by travelers on the way from Seville via Mérida to Astorga in the north and was also part of the Camino de Santiago (the Way of St. James) to

CITY WALLS, CHURCHES, AND PALACES SHAPE THE MEDIEVAL CITYSCAPE OF CÁCERES IN EXTREMADURA. IT SEEMS AS IF NOTHING HAS CHANGED AT ALL SINCE THEN.

Santiago de Compostela. Patrician families gained wealth through agriculture and cattle breeding and built palaces and churches. This is how one of the most beautiful—and today best-preserved—medieval towns in Spain came into being.

BEHIND THE WALLS OF THE ALMOHADS

The overwhelming majority of architectural master-pieces date from the 15th and 16th centuries, and the greatest number of the historical building structures lie within the tower-reinforced, 12th-century city wall, which was built by the Berber Almohads. From the Plaza Mayor, with its many small restaurants and shops in white buildings, a staircase at the Torre Bujaco leads through the Arco de la Estrella to the historical Old Town. A leap in time: there is nothing there besides the compact, reddish-brown palaces; the manor houses decorated with coats of arms; small squares; and bumpy alleyways to disturb the uniform image. Almost every house, every church, has its own history. The Santa María de Cáceres co-cathedral stands on the small Plaza de Santa María; this Coria-Cáceres diocese co-cathedral dates from the 13th century. The altar and choir stalls are artistically carved cedar wood. The tourist office is located in the Carvajal family's former town palace, with its mighty tower and arcade-lined courtyard. The Casa de los Golfnes de Abajo appears sublime, with its style mix of Gothic, Moorish, and Renaissance elements. The rather modest Casa de las Veletas, built during the 15th century on the remains of the Moorish Alcázar palace, owes its name of "weather vane house" to the shape of its gable decoration. Today the provincial archeological museum is located here.

EXTREMADURA CUISINE AND WINES

The area surrounding Cáceres, in the midst of the hilly foothills of the Meseta, the central Iberian plateau, is a paradise for nature lovers. The region is still rural, and this is reflected in the rustic cuisine as it is also served in Cáceres: lamb stew, braised kid, tender Iberian ham, and spicy sheep's cheese. Spain's largest wine-growing areas lie south and southeast of Madrid, and Extremadura is a kind of appendage to it. More than 80 vintners supply the grapes for the Bodega Marqués de Cáceres, which is well known beyond the borders of Spain. The red wines mature first in oak barrels, then in the bottle; in the full-bodied varieties, the woody notes harmonize with the fruity notes without masking them. The white wines are fruity, fresh, and low in acid.

MORE INFORMATION
Extremadura Region including Cáceres
www.turismoextremadura.com/en/index.html
Overnight stay in the Parador de Cáceres
Manor house (14th century): Calle Ancha 6, www.parador.es/en

SPAIN

LIGHTHOUSE SINCE ANTIQUITY

The Carthaginians founded Cartagena; the Romans conquered it before the Vandals, Visigoths, and Moors came; and all of them left behind many fascinating testimonials of their presence. An "invasion" of tourists has so far not happened. And thus, Cartagena is a charming insider tip with a great past and a lot of original Spanish flair.

Cartagena, located on Spain's southeastern coast, the Costa Calida, looks back on 3,000 years of history as a settlement. In 227 BCE, the Carthaginians made it their capital on the Iberian Peninsula—its strategically favorable location and natural harbor were cogent arguments for this. When the Romans conquered the city in 200 BCE, during the Punic Wars, they called it Carthago nova, from which the current name is derived. From the eighth to the 15th centuries, the Muslim Moors were masters of this port city before the Christians conquered it. Cartagena, a base for long-distance trade, has always been very wealthy and at the same time an attractive place to live. The port is still used for civil and military purposes today.

Cartagena is also a university town and the seat of the Asembla Regional, the parliament of the autonomous region of Murcia.

CORTADO IN MODERN TIMES
A stone's throw from the harbor is the Plaza Ayuntamiento with the Palacio Consistorial (1907), one of Cartagena's most beautiful modernist Spanish art nouveau buildings. It has a triangular floor plan with rounded-off corners, and the facade is lavishly decorated with figures. The entire traffic-calmed central city and Old Town feature art nouveau style. Many four-to-six-story buildings with playful oriels, turrets, artistically forged railings enclosing the small balconies, and rich facade decorations line the main

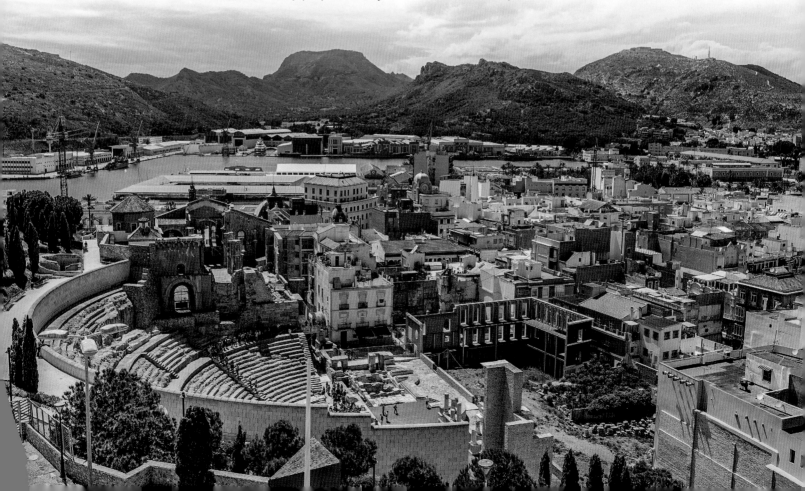

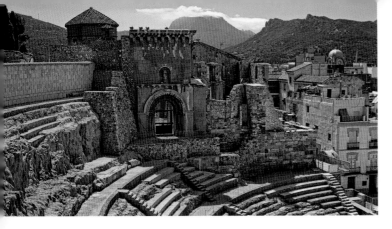

IN CARTAGENA THERE ARE MANY TESTIMONIALS TO ITS
ROMAN PAST (*OPPOSITE AND LEFT*).
STROLLING BY GORGEOUS ART NOUVEAU FACADES: THE
SHOPPING STREET IN THE HISTORICAL OLD TOWN (*BELOW*)

shopping streets—the result of the economic upswing due to mining at the end of the 19th century. The casino (18th century), the Palais Aguirre (1901) with the Museum of Modern Art, the Gran Hotel (1916), and the Casa Maestre (1905) on the Plaza de San Francisco, with their huge, ancient trees, are particularly imposing. Countless shops are housed on the ground floor of the art nouveau houses and at least as many cafés, bistros, and restaurants. Cartageners meet there at almost any time of the day for a snack, a cortado (an espresso with milk), or a "43," accompanied by lively and gestural discussions. The liqueur made with 43 ingredients and a pleasant hint of vanilla has been made in Cartagena since 1924.

UNDERGROUND SECRETS

An entire Roman settlement could likely be found under today's Cartagena. An amphitheater (44 BCE) was discovered more or less by chance in 1988 during the construction of a shopping center. With its 7,000 seats, it is one of the largest Roman structures in Spain. In 2008, at the foot of the extensive El Molinete Archaeological Park, the remains of entire blocks of houses with a forum and thermal baths came to light, as well as another Roman amphitheater beneath the former bullring. This is all easy to see from the Cerro de la Concepción (230 feet), which can be reached on foot or by elevator. Not much has been preserved of the former fortress (11th–13th centuries) on the hill, but there is a multimedia presentation of the city's history. And the panoramic view is always worth it. Parts of the historical city wall (18th century) can still be seen, and you can walk along it by the harbor. The Paseo Marítimo promenade leads along the harbor basin, where small and large yachts bob and sometimes a cruise ship docks. There are also beaches with enough space for sunbathing, swimming, surfing, or sailing.

EVERYDAY ROMAN LIFE IN THE CELLAR

In the Casa de la Fortuna, somewhat hidden under a residential and commercial building, you can immerse yourself in the world of 2,000 years ago. A rich Roman once built a 2,195-square-foot house there. The living and reception areas, the bedrooms, the triclinium for celebrations, the bathroom, and the kitchen all were accessible from a central courtyard (atrium). There was an attached room that was rented out to artisans. All kinds of everyday objects, floor mosaics, and murals give a vivid impression of the prosperity of the time. From the front and the back there was access to a street, under which the sewage system of time can still be seen. The street, with its houses that you can see, is continued in a picture—as it appears, people lived well in the Roman province of the time.

MORE INFORMATION
Cartagena tourist information
www.cartagenaturismo.es
Information about staying in Cartagena
www.cartagenapuertodeculturas.com

SPAIN

RICH SPECTACLE IN A FERTILE VALLEY

The composer Augustín Lara Murcia described it as Spain's rose, as a city full of light and flowers. Artichokes, citrus fruits, and figs grow as if they are in the Land of Cockaigne. Orange trees bend under the weight of their fruit even in the city center, where architectural gems and traditional festivals vie for the attention of visitors.

Much in the city appears to be Moorish. In fact, Murcia owes its foundation to the Muslim Moors, as early as the ninth century, and they ruled until well into the 13th century. As a bishopric and university town, Murcia is the lively market town of the autonomous region of the same name. In some Old Town alleyways, however, time seems to have stopped. Benches set in many of the city squares, such as the Plaza de las Flores, invite you to linger, and tapas bars seduce you with their offerings—a montadito, a small but very well-laden half roll or piece of baguette with a copa de vino rosado, a glass of sparkling rosé, tastes good at any time of day. Murcia can look

back on a truly rich history, as can be seen in buildings such as the Almudí Palace, with its relief-adorned front—the original 15th-century building served as a granary—or the bishop's palace on the Plaza Cardenal Belluga, to the right-hand side of the cathedral.

TAMING AND USING WATER

Murcia is located in a valley that is particularly fertile thanks to the Río Segura; in spring and summer the river would run dry early on, but in winter it overflowed its banks. Its floods left fertile mud, but also a lot of destruction, in their wake. The Moors knew how to tame the winter floods of

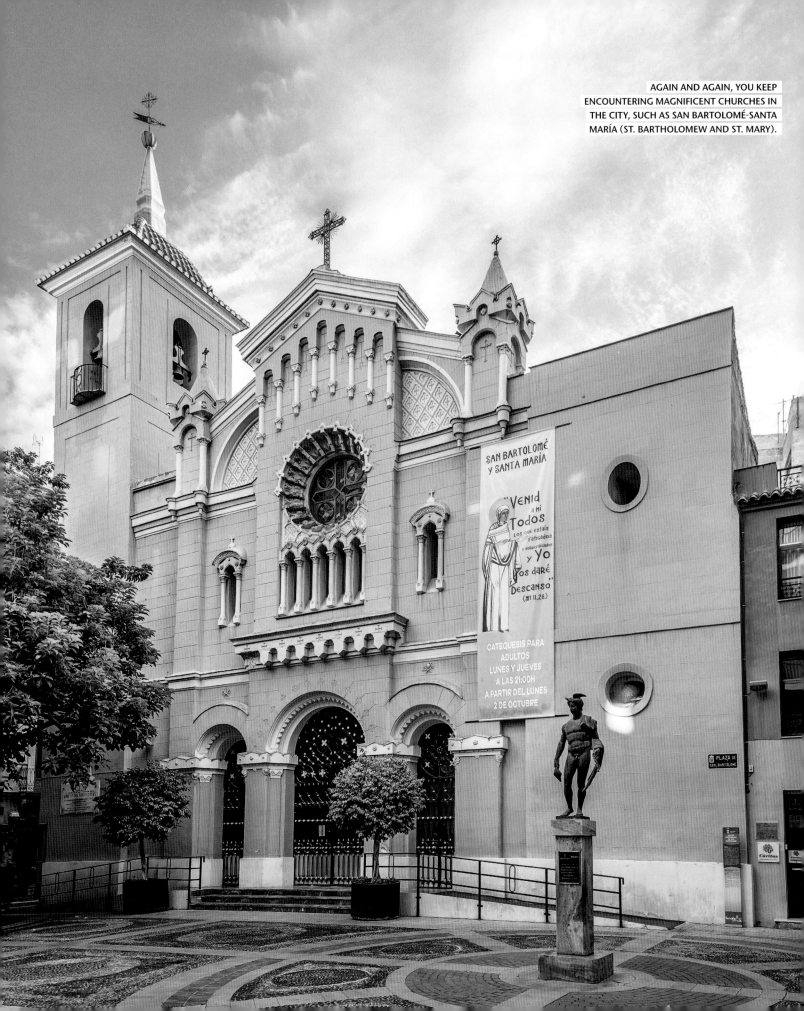

AGAIN AND AGAIN, YOU KEEP ENCOUNTERING MAGNIFICENT CHURCHES IN THE CITY, SUCH AS SAN BARTOLOMÉ-SANTA MARÍA (ST. BARTHOLOMEW AND ST. MARY).

the Río Segura and regulate them through a cleverly designed irrigation system that could be used for growing crops. Prior to the 15th century, the city also constructed the Paséo to protect it against flooding; these mighty walls in the Arrixaca district have likewise been converted into a promenade and today lead out of the city to the Capuchin monastery and the botanical garden—a beautiful walk.

A FEAST FOR THE EYES AND TASTE BUDS

The environs of Murcia are called "La Huerta," the vegetable garden, for good reason. In addition to vegetables and fruits, palm trees and even mulberry trees for making silk flourished and are still flourishing. If you ever have the opportunity, you should visit one of the numerous weekly markets in the region, outdoors or in one of the market halls. You won't find anything fresher, or of better quality, anywhere else. Perfectly ripe tomatoes, peppers, strawberries, and the like are much more aromatic immediately after harvesting than when they arrive in German supermarkets. Just the splendid color of many otherwise little-known varieties alone awakens the appetite. Speaking of markets: A spectacular medieval market is held every year in early February in the town of Orihuela, less than 12 miles northeast of Murcia. The exhibitors all wear costumes. Showmen parade through the streets to amuse the visitors. Camels rest under palm trees, Arabic delicacies from savory to sweet find many buyers, and friendly sutlers make freshly baked crispy-sweet flores, the typical local lard pastry.

BAROQUE SPLENDOR

Where the magnificent Murcia Cathedral was built during the 14th and 15th centuries, a mosque had previously stood. Today the sheer exuberance of the 18th-century baroque cathedral facade dominates the Plaza Cardenal Belluga. At almost 330 feet high, its bell tower is not only the symbol of the city, but also the second tallest of its kind in Spain. Inside, among the 23 chapels, the Capilla de los Vélez with its 10-cornered star dome and lavish Moorish-style decoration is particularly impressive. A museum with archeological finds and valuable sacral objects is housed in the former cathedral cloister. The cathedral frequently provides the backdrop for the musical events and festivals held in the square in front of it. A festive concert on such a stage, such as during the Christmas season, remains unforgettable.

SPANISH NATIVITY SCENES

Francisco Salzillo created a Nativity scene including some 500 figures, which is now in the Salzillo Museum in Murcia. The figures are carried through the streets during Holy Week, as part of the procession by the brotherhood Nuestro Padre Jesús Nazareno. Nativity scenes themselves have been a tradition in Spain for centuries: During the Christmas season, from the beginning of December to the Epiphany—the Three Wise Men (in Spain, the "Día de reyes" is more important than Christmas Eve is in Germany or Christmas Day in the United States)—opulent Nativity scenes including scenes from the Bible are often set up on large walk-in stages on the Plaza Mayor (main square) in many cities. The announcement to the shepherds or the birth of Jesus, elaborately re-created in faithful detail, catch the attention of families in their Sunday best.

MORE INFORMATION
Murcia Tourism
www.turismodemurcia.es/en

SEMANA SANTA—HOLY WEEK

One museum is dedicated to the Murcian sculptor and wood carver Francisco Salzillo (1707–1783). Pasos, larger-than-life religious figures he once carved, are also used in the processions during the Semana Santa, Holy Week, which are held in many places in Spain. Christian brotherhoods parade the pasos in festive procession through the streets. The participants carry heavy frames bearing church treasures, which would otherwise remain hidden from the public eye, on their shoulders. These include entire scenes such as the Last Supper, in almost life size. The participants are

dressed in special robes, and each brotherhood has its own color. Some of the "cowl wearers" look a bit eerie in their pointed hoods with narrow slits. Spectators come in time to find the best places along the route of the procession and bring folding chairs or rent them on-site. According to old custom, the procession participants are given sweets by children.

INDULGE YOURSELF AT THE CASINO

In the Trapería, one of the major shopping streets in the city center, there is a typical Spanish establishment: the casino. In many places still today, the original idea was that such a visit would be reserved for urban dignitaries or members of the glitterati club. However, you can visit the Murcia casino, which dates from the mid-19th century, for a fee at certain times (realcasinomurcia.com). It is worth it: gold, marble, stucco, fine woods, cut glass, and works of art in excess. A richly decorated portal between large, inviting windows leads to the Arabic-style inner courtyard under a glazed iron structure. Abundant ceiling paintings are arched above a neobaroque dance hall and women's changing rooms. There is also a restaurant. Hungry after the Tour of Discovery? No problem in Murcia—there are countless bars all around the cathedral and in the shopping streets. If you want to take it easy, take a break in the San Antón, San Andrés, San Antolín, or San Basilio districts, which are farther away from the hustle and bustle and where you can relax.

MANY EVENTS AND TRADITIONAL FESTIVALS ARE HELD IN THE SQUARE IN FRONT OF THE CATHEDRAL (*RIGHT*). MURCIANERS OFTEN WEAR TRADITIONAL DRESS AT EVENTS (*ABOVE*) SUCH AS THOSE DURING SEMANA SANTA (HOLY WEEK) BEFORE EASTER.

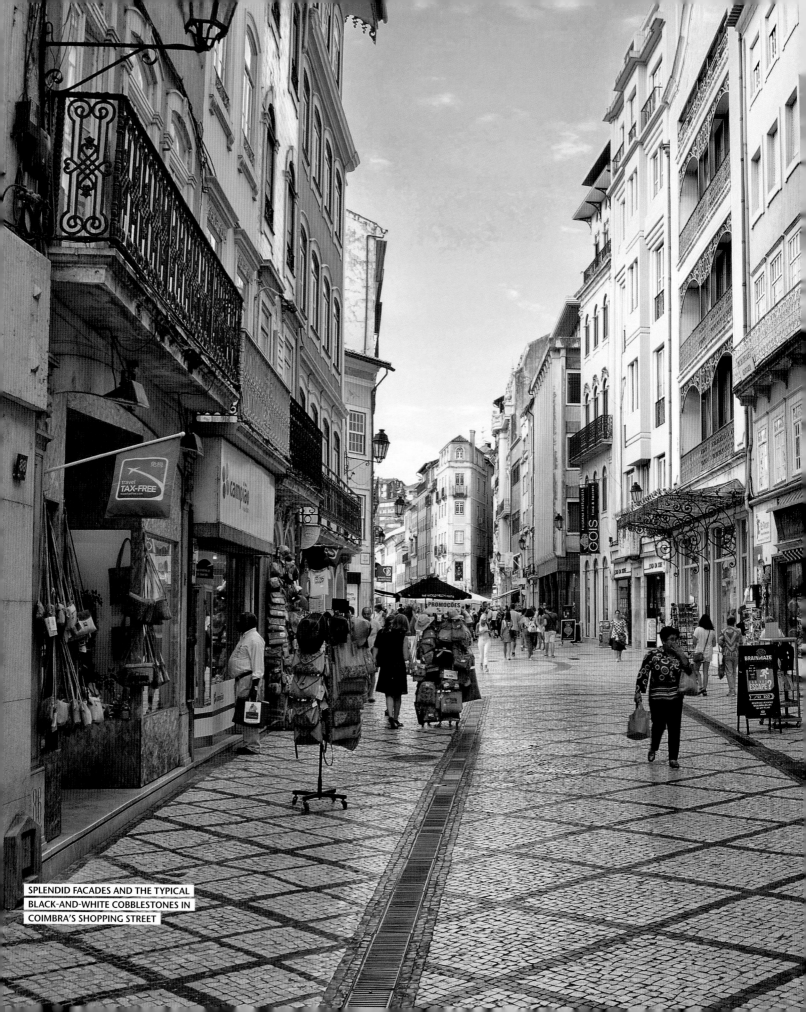

SPLENDID FACADES AND THE TYPICAL
BLACK-AND-WHITE COBBLESTONES IN
COIMBRA'S SHOPPING STREET

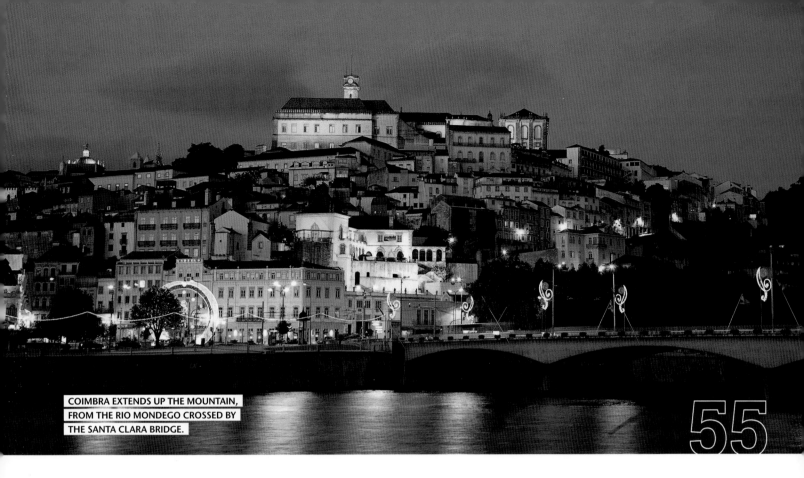

COIMBRA EXTENDS UP THE MOUNTAIN, FROM THE RIO MONDEGO CROSSED BY THE SANTA CLARA BRIDGE.

PORTUGAL'S RICH HERITAGE

At the highest point in the city stands the oldest university in Portugal. But it shapes the city not only geographically: with its students' joie de vivre, and with its many pubs, festivals, and music, it also shapes the atmosphere of Portugal's first capital amid a historical setting.

Coimbra is located in central Portugal on the banks of the Mondego River, which flows 25 miles farther west into the Atlantic. The place was probably already settled in Celtic times; the Romans then named it Aeminium. When their headquarters at Conímbriga was destroyed by Germanic tribes in 468 CE, they moved it to Aeminium and also transferred the name to that city, which was easier to defend. Portugal's most important Roman archeological site is located in Conímbriga, 10 miles away. There you can marvel at the high standard of their urban culture, with its magnificent mosaic floors, bathing facilities with pools, underfloor heating, and gardens with water features. In the eighth century, the Muslim Moors conquered Coimbra, which was subsequently contested between them and the Christians. During the 12th century it finally came into Christian hands and became the capital of the new kingdom of Portugal. When this was later relocated to Lisbon, Coimbra was compensated in the late 13th and early 14th centuries with a university—until 1910, the only one in the country. It has determined the spiritual life in Portugal for a long time.

PORTUGAL

GATEWAY TO THE OLD TOWN
The modern Rua Ferreira Borges commercial street and its extension, Rua Visconde da Luz, separate the upper town from the lower town. The Arco de

Almedina archway is the most beautiful way to enter the atmospheric maze of alleyways in the Old Town and upper part of the city, with its countless small shops. The arch dates from the Moorish period and was part of the city wall. The Gothic tower (15th century) above it now houses the city archive.

A steep staircase, which is called the Quebra Costas—the backbreaker—for good reason, leads up to the Old Town. On the left you come to the Palacio de Sub Ripas with its beautiful Manueline decor. Farther up, through narrow streets and up stairs, you finally reach the old cathedral, Sé Velha (12th century).

With its crenelation, it is more reminiscent of a fortress and was intended to serve as such if necessary.

The Cathedral is one of the most beautiful Romanesque churches in Portugal. The richly decorated portal on the north side was added in the early Renaissance period. The three-nave interior makes an impression with its late Gothic high altar, a baptismal font, and a Renaissance chapel and the Gothic cloister. Northeast of the old one stands the new cathedral, Sé Nova (16th–17th centuries). Behind its early baroque facade, the interior displays a coffered barrel vault, a baroque altar, and an organ from the 17th century.

SUMMIT OF SCIENCE

Not far away, the Museo Nacional Machado de Castro, in the former bishop's palace, presents one of the richest art collections in Portugal, with exhibits from the first century to the 18th century. The most important museum in the city is named after the Portuguese sculptor Joachim Machado de Castro (1731–1822). The forum from the Roman period was discovered under the bishop's palace, and its remains can also be seen. The university is located at the highest point in the city. It was established in the former royal palace and was partially restored during the 17th and 18th centuries. The Porta Férrea (1634), its main entrance, leads to an inner courtyard that has been rebuilt on three sides. The fourth side is occupied by the terrace, which offers a beautiful view of Coimbra and the river. Via an open staircase you reach the Via Latina, a colonnade where students were

PORTUGAL'S MONUMENTS IN THE PORTUGAL DOS PEQUENITOS MINIATURE PARK (*LEFT*)
GOLDEN FIGURINE IN SÉ VELHA (12TH CENTURY), THE OLD CATHEDRAL (*ABOVE*)

allowed to speak only Latin. From there, it runs to the magnificent Sala dos Capelos, where graduation ceremonies are held. The baroque clock tower, erected between 728 and 1733, sets the pace for student life; it is jokingly called the "cabra," or goat. The university's baroque Capela de São Miguel (1517–1552) church is decorated with frescoed ceilings, tile decor, Manueline elements, and a gilded organ. Next to it is the Biblioteca Joanina, the old university library (1717–1728), which is considered the most magnificent and most beautiful in the country.

MOSTEIRO DE SANTA CRUZ MONASTERY

In the lower town, north of Praça Comercio, stands the Mosteiro de Santa Cruz monastery (1131, rebuilt in the 15th–16th centuries). Today the town hall is housed in the north wing, while the monastery church (1132) occupies the south wing. You enter through a Renaissance portal and a portal arch from the 18th century. Inside the church, you can see the ornate pulpit (1522) and the sacristy (1622), with a coffered barrel vault and Azulejo cladding, as well as the late Gothic tombs of the first Portuguese kings. The two-story Manueline cloister is decorated with reliefs. The Jardim da Manga, with its remarkable fountain (1533), lies adjacent behind the monastery: it features four towers connected by bridge arches, with a pavilion in the water basin. Next to the church, there is a café in the monastery premises, where a galão (espresso with milk) tastes particularly good under the beautiful vault.

STUDENT FLAIR, OASES OF CALM

The students meet on the Praça da República, with its Romanesque Church of São Tiago, in cafés and pubs in front of the art nouveau facades on the surrounding town houses. There are 30,000 students in Coimbra, and they give the city a young, casual, and international flair. Many of them live in the so-called repúblicas, shared apartments. These are comparable to German student associations and have been providing for a fresh cultural life since the 16th century. Graffiti painted around the repúblicas address current political issues. In the evening and at night, Portuguese fado music—along with modern music—can always be heard coming from the student pubs, which are everywhere in the upper and lower towns, as well as on the streets and squares.

One of the highlights of the year is the Queima das Fitas (ribbon burning) student festival in May. The students wear their black gowns with colored ribbons. They tear off these ribbons and burn them during a happy, daylong festival. The Parque Santa Cruz, which belonged to the monastery of the same name, and the Jardim Botânico (1772), the oldest botanical garden in Portugal, create quiet green oases. Beyond the Mondego are the ruins of the Gothic cloister of Santa Clara-a-Velha (1330), where Isabel of Portugal (1271–1336) was buried. Due to frequent floods, the monastery and tomb were moved up the mountain to the newly founded Santa Clara-a-Nova during the 17th century.

PALACE OF BOOKS

With its columns, friezes, and decorations, the library of the University of Coimbra, donated by King João (John) V, is a prime example of baroque architecture in Portugal. It occupies three halls on two floors. Elaborate illusionist ceiling frescoes; shelves made of rosewood and ebony; lacquer painting on pointed pillars and balustrades; tables made of rosewood, ebony, and jacaranda wood; and opulent gold decorations lend the rooms an exuberant splendor. The shelves hold 300,000 valuable volumes, including 3,000 medieval manuscripts. The Biblioteca Joanina was in use until 1910; today its contents can be viewed only with a special permit. When it is closed to visitors, a colony of bats are given a go at the insects in the library—an original way of protecting books.

MORE INFORMATION
Coimbra
www.visitportugal.com/en/destinos/centro-de-portugal
Biblioteca Joanina
https://visit.uc.pt/en/space-list/joanina

PORTUGAL

SLEEPING BEAUTY OF THE ALGARVE

Dreamy Tavira in the sandy Algarve region is enchanting with its pastel-colored, beautifully decorated facades; cobblestone alleys; and squares where you can immerse yourself in the casual Portuguese way of life. The offshore Ilha de Tavira lagoon island has miles of sandy beaches for sun worshipers.

Tavira is located in the eastern Algarve, just 12 miles from the Spanish border, on the Rio Gilão where it flows into the Atlantic Ocean. The city, nestled among orchards of almond and carob trees, is separated from the Atlantic by the Ria Formosa lagoon area. Tavira was inhabited prior to the time of the Romans; during the eighth to 13th centuries the Moors were doing well there; during the Age of Discovery it was an important starting point for expeditions to North Africa. Rebuilt in a uniform style after the 1755 earthquake, Tavira rose to become a center for tuna fishing. Due to the silting up of the port and the

decline in the fishing industry, the town fell under a "sleeping beauty" spell, from which it is now being gently awakened by tourism.

SET THE CLOCKS BACK

Tavira's center is the Praça da República, with its town hall and some impressive buildings directly on the banks of the Gilão. For centuries, enslaved people were traded on the square; later, fish and fruit were the main offering. Today it is lined with cafés that invite you to drink a galão, espresso with hot milk. Restaurants on all sides offer local specialties, including tuna, of course. Tavira has

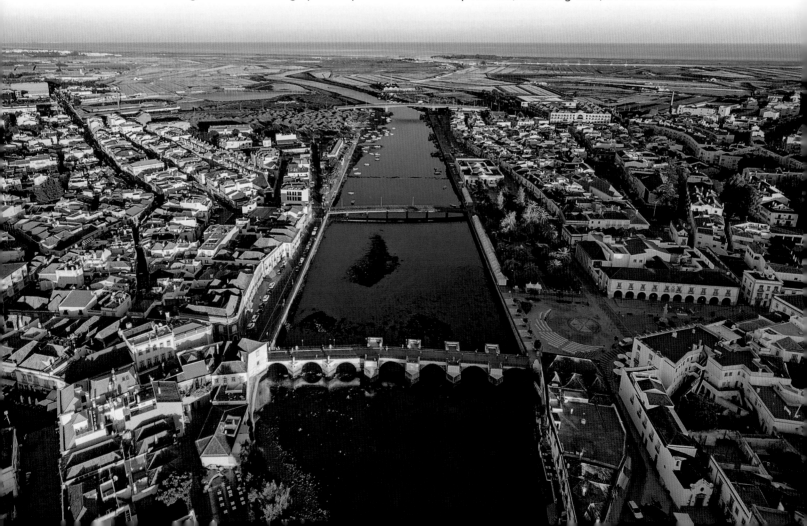

retained the flair of a former fishing town where the clocks are still kept ticking a little bit more slowly. There is an adjacent park, and behind it the former market hall dating from the 19th century. It now houses small shops and cafés; in some of them you can sit right on the riverbanks. The hipped roofs are picturesquely reflected in the water. From the Praça da República you can see the Ponte Romana, which, as the name suggests, references a Roman bridge on the site; this seven-arch stone bridge dates from the 17th century. Strolling through the dreamy alleyways, you reach the Igreja da Misericórdia Church (built around 1540), one of the most important Renaissance buildings in the Algarve and one of the 37 churches in Tavira. The magnificent entrance door is richly carved. The altar is garbed in opulent baroque, while the 18th-century Azulejo tiles show motifs of mercy.

CASTLE WITH GARDEN

The ruins of Castro dos Mouros castle rise above the city. The foundation walls probably date back to the Neolithic Age; the Phoenicians and Moors also had a fortress there. Today's ruins date back to the 17th century. An exotic garden has now been laid out within the castle walls. The octagonal tower offers a picturesque view of Tavira. In the former water tower next door, the Torre de Tavira, a camera obscura provides a 360-degree view of the city.

Below the castle stands the Gothic Igreja de Santa Maria do Castelo, which was built atop a mosque in the Gothic style. It was rebuilt after the earthquake.

THE SEVEN-ARCHED PONTE ROMANA, FROM THE 17TH CENTURY, LEADS ACROSS THE RIO GILÃO (*OPPOSITE*).
INTERIOR OF THE IGREJA DA MISERICÓRDIA (CHURCH OF MERCY), WITH ITS BLUE-AND-WHITE AZULEJO CERAMIC TILE WORK WALL DECORATIONS (*BELOW*)

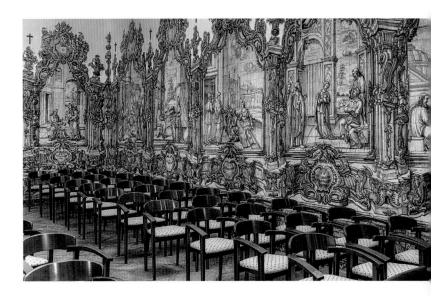

RIA FORMOSA

Immediately before the city, glistening white salt pans line the street. The best salt in Portugal is said to be harvested in Tavira. Beyond is the Ria Formosa lagoon, a wetland with channels and sandbars, a nature preserve that offers protection to thousands of water and migratory birds and marine life. The offshore Ilha de Tavira has miles of fine, golden, sandy beaches where you are never crowded together.

PRAIA DO BARRIL—BEACH AND CEMETERY

The really beautiful Praia do Barril beach is located west of Tavira on the offshore Ilha de Tavira. It can be reached from Pedras D'el Rei by a magical open-air train that runs across the Ria Formosa wetlands. The leisurely, half-mile trip gives you the opportunity to admire the landscape in the nature park and its inhabitants, the birds and crabs. Praia do Barril is not just a beach—it was once the home of a tuna-fishing community. Many ship anchors are grouped together to form a decorative "anchor cemetery" (Cemitério das Âncoras), which recalls the former fishing fleet.

The fishermen's cottages have been converted into bars, restaurants, and shops. But of course, you can also simply sunbathe here and plunge into the crystal clear waters . . .

MORE INFORMATION
Tavira
https://algarve-south-portugal.com

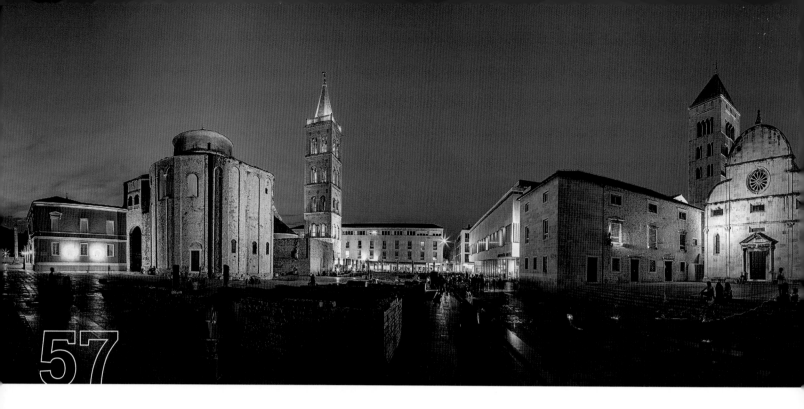

CROATIA

TREASURES ON ROMAN WALLS

A walk through Zadar's Old Town is like traveling through time in a beautiful and exciting open-air museum. There have been many rulers in Zadar over the course of 3,000 years—Roman, Frankish, Byzantine, Venetian, Austrian, French, Croatian—and all of them left their traces there. You can walk through these traces today in a relaxed Mediterranean atmosphere.

Zadar, on the Adriatic Sea in southern Croatia, is the gateway to Dalmatia. The city is made up of four parts. One of them is the Old Town on a narrow promontory, separated from the mainland by a moat. Zadar was settled by the seafaring Liburnians in ancient times, and then the Romans came. Starting in the ninth century, Franconians, Venetians, Croats, Hungarians, the French, and the Austrians moved into the town on the peninsula. Many buildings—churches, monasteries, and palaces—bear witness to its prosperity and rulership. For centuries, Zadar was the political and cultural center of Dalmatia.

HISTORY, COMMEMORATION, COMMERCE

The Old Town is surrounded by an impressive wall from the 16th century. There are four city gates; the Land Gate (1543), formerly the main entrance from the mainland, is the most beautiful. It is reminiscent of a triumphal arch, decorated with the coat of arms at the top and guarded by the Venetian lion. Behind the gate, you plunge into the alleyways, made of slabs of white granite and marble and lined with walls, gates, towers, and houses steeped in history, where today many shops, restaurants, and cafés vie for customers. Locals and tourists alike sit on the terraces, in the squares, and in the parks and enjoy the atmosphere of Mediterranean joie de vivre. Five long streets, with eight cross-streets—the Old Town layout dates back to Roman times. The forum (100 BCE–300 CE) was located at the central intersection. Today, in the summer, open-air events are held amid the remains of Roman temples scattered all the way down to the sea. The rotunda of the Church of St. Donatus (Sveti Donat, ninth century) also rises from the forum. It is a symbol of Zadar. It is often used for concerts because of its excellent acoustics. Right next to it is the bell tower

IN THE EVENINGS, ZADAR'S ALLEYWAYS, LINED WITH HISTORICAL BUILDINGS, ARE STYLISHLY ILLUMINATED (*OPPOSITE*). UNUSUAL VIEW INTO THE CHURCH OF ST. DONATUS, WHICH DATES FROM THE 9TH CENTURY (*LEFT*)

(15th century) of the Romanesque Cathedral of St. Anastasia (Sveti Stošija), which goes back to an old Christian basilica. This is the largest church in Dalmatia; its marble altars, rich in figurines, reliefs, and paintings, as well as a font from the sixth century, are worth far more than just a look. The crypt holds the relics of St. Anastasia. Opposite, in the monastery and Church of St. Mary (Crkva i samostan svete Marije; 11th century), the permanent exhibit of the "Gold and Silver of Zadar" displays church art from the eighth century to the 18th century. The city's eventful history comes to life again in its many other museums and galleries. The People's Square (Narodni trg) has been the center of life in Zadar since the Renaissance. Lined with imposing buildings such as the city guardhouse (1562), the Church of St. Laurentius (11th century), with a bell tower, and the city loggia (1565), there is a lively bustle at all times of the day, which you can observe delightfully from one of the many cafés.

MODERN PLEASURES

On the peninsula headland, easily accessible via the spacious promenade, stand two modern works of art, the *Sea Organ* and the *Greeting to the Sun* installation (2005), which have become tourist attractions. Zadar is located on the Adriatic Sea—so it makes sense to enjoy the sun and sea on the beach. Borik, which lies east of the Old Town, is one of the few sandy and pebble beaches in Croatia; Kolovare offers only pebbles, but plenty of space. Sandy Zaton beach is a little farther away.

THE SOUND OF THE SEA AND *GREETING TO THE SUN*

Rows of stone stairs extending over 195 feet lead down to the sea from the top of the Old Town. Tubes of different sizes with pipes at the ends are installed under the steps. The waves now push air into these tubes. A stony underwater passage serves as a resonance chamber, and openings in the stairs let the sound resonate above. The strangely meditative sound of the sea penetrates the ear in seven chords and five notes. The Croatian architect Nikola Bašić (b. 1946) conceived of the *Sea Organ* and also placed a monument to the sun next to it: beneath 300 glass plates, which are arranged in a 72-foot-diameter circle, lie solar cells that light up colorful LEDs to the rhythm of the sea organ after sunset. Bašić named his work *Greeting to the Sun*.

MORE INFORMATION
Zadar
www.zadar.hr/en/destinations/zadar

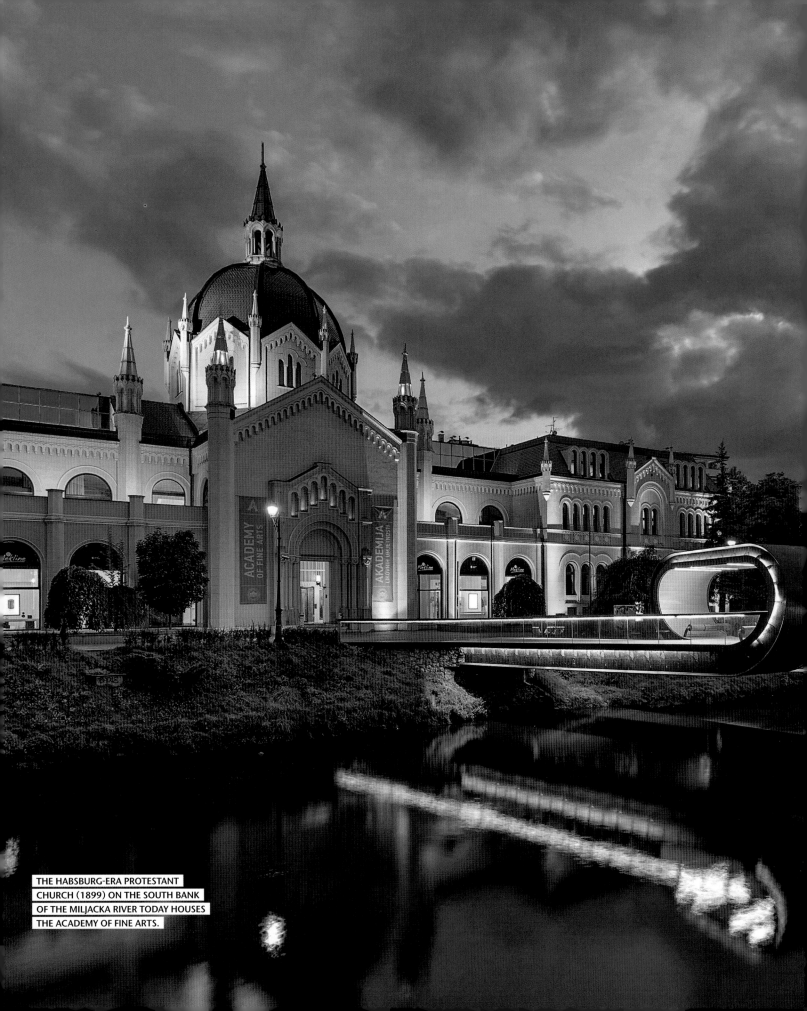

THE HABSBURG-ERA PROTESTANT
CHURCH (1899) ON THE SOUTH BANK
OF THE MILJACKA RIVER TODAY HOUSES
THE ACADEMY OF FINE ARTS.

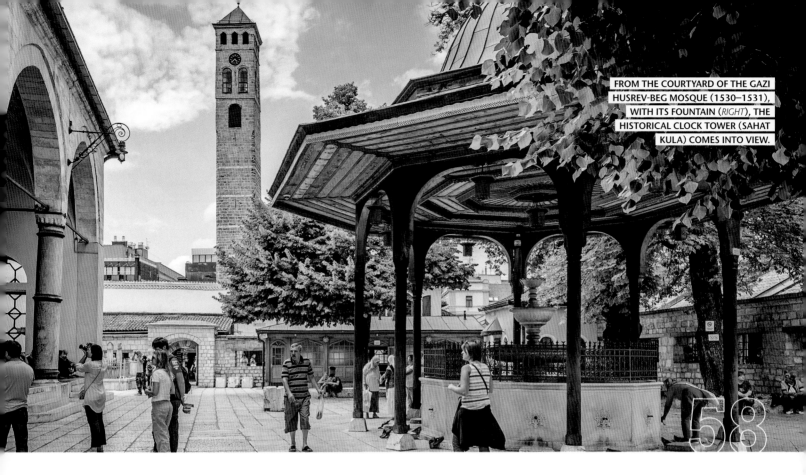

58

REMEMBRANCE OF WAR; KEEPING PEACE IN MIND

The capital of Bosnia and Herzegovina will likely be forever associated with war. Yet, in the narrow valley of the Miljacka River, in this metropolis surrounded by high mountains, you can see and feel how different cultures can peacefully coexist.

BOSNIA AND HERZEGOVINA

The wounds of the Bosnian War (1992–1995), when Sarajevo was besieged by Bosnian Serb troops for 1,425 days, have not healed; the destruction is still visible, and the victims remain in the collective memory. Visitors are confronted with this as soon as they arrive at the airport: there was a tunnel running under the airport runway, through which residents of Sarajevo tried to escape the brutalities of the blockade: no electricity, no fuel, no drinking water, and snipers shooting at anything that moved along the central arterial road ("Sniper Alley"). Supplies came into the city only via an airlift. Part of the "Sarajevo tunnel" has been preserved as a museum. With its collection of very

personal documents such as diaries, drawings, photos, toys, and songs, the "War Childhood Museum," which opened in 2017, captures in a very touching way the memories of those who were the youngest at the time. More than this, the name Sarajevo stands for the event that started World War I. On June 28, 1914, Franz Ferdinand, the heir to the Austro-Hungarian throne, and his wife, Sophie, died in an attack by a Bosnian terrorist. Gavrilo Princip fired the fatal shots from the Latin Bridge. It was due to a series of coincidences that he "got his turn" at all. Anyone who wants to know more about this event and the political background to the bumblingly organized crime can

do so at the Museum of Sarajevo 1878–1918, directly at the former crime scene.

SEPARATING, CONNECTING

Sarajevo is no longer a multiethnic city—more than 80 percent of its inhabitants are Muslim Bosnians—and Bosnia and Herzegovina is no longer "Yugoslavia in miniature," but a state with dividing lines among entities, nationalities, cantons, and three state languages. The eastern part of Sarajevo, which is now inhabited exclusively by Serbs, belongs to the Serbian Republic, as does the ski area of Jahorina, where the women's alpine skiing competitions were held during the 1984 Winter Olympics. It is the opposite to the Federation of Bosnia and Herzegovina, where most of Sarajevo is located. Yes, at that time the youth of the world came together on the snow-covered heights of the Dinaric Mountains to compete in sports in a peaceful way. Some sports facilities have been rebuilt, while other areas have become dilapidated. Those who want to practice winter sports

somewhere else than on interconnected ski facilities and at the ski lift circuit are heartily welcomed on these slopes, surrounded by extensive forest and barely 18.5 miles from Sarajevo.

Plenty of greenery and water, an Islamic influence, and good value for money—these factors have been attracting Arabs from the Persian Gulf to the Sarajevo area, where there is no visa requirement (does not apply for citizens of Saudi Arabia). Not always welcome, but financially strong, this clientele prefers the atmosphere of the closed resorts near the summer resort of Ilidša, by the lovely Spring of the Bosna River at the foot of Mount Igman. The "Roman Bridge" across the still-young river with its genuine antique stone arches dates from the 16th century. Speaking of bridges: there are a large number of them linking the banks of the Miljacka, which flows through Sarajevo and then empties into the Bosna River. In the evening, the lanterns strung along the riverside streets between the upper and lower towns create a magical atmosphere. One of the most original

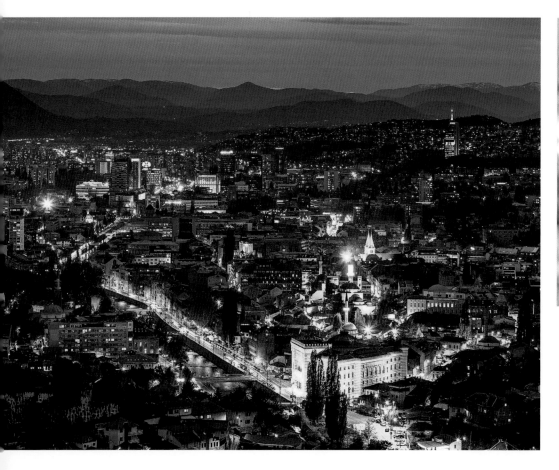

THE CAPITAL OF BOSNIA AND HERZEGOVINA (*LEFT; OLD TOWN IN THE FOREGROUND*) **CELEBRATES ITS TURKISH HERITAGE IN ITS COFFEE AND TEA CULTURE** (*ABOVE*).
IN THE KOVAČI CEMETERY, THE COUNTRY'S FIRST PRESIDENT, ALIJA IZETBEGOVIĆ, LIES BURIED (*OPPOSITE*).

bridges is the "looping" Festina Lente bridge by the former Protestant church, now an art academy. The magnificent white building (1899) dates from the time when the Austrians were spreading their influence in Bosnia.

EAST AND WEST

At that time, the gentlemen from Vienna were going to great lengths to turn this old Turkish center of arms and trade (Bosna Saraj), founded in the middle of the 15th century, into a presentable "European" city. The Catholic Cathedral of the Sacred Heart of Jesus (1889), with the neighboring National Museum (1913), also comes from this era. Architects were allowed to realize their ideas, in particular west of an imaginary line that today is painted on the pavement as a "meeting point of east and west." There, in the extension of Ferhadija Street, the Orient merges into the Occident, so to speak. The Hotel Europa also stands on this border, where once the Nobel Prize for Literature laureate Ivo Andrić (*The Bridge over the Drina*) drank his mocha. From there, both "worlds" can be reached equally easily by foot. Probably the most striking testimonial of the Habsburg period is the Vjećnica building, which was built in Moorish style, destroyed in the war, and rebuilt. It is the site of the city administration and the National Library.

THE OLD TOWN—THE REAL SARAJEVO

The heart of Sarajevo, formerly home to dozens of markets, is the area around Baščaršija trg, where long-distance trade and connecting streets converged. Around the elongated square, the Sebilj, with its fountain in the form of a kiosk, are grouped one-story buildings housing many shops, which today sell handicrafts and all sorts of trinkets. For a meal, there are typical Balkan dishes, covered in batter or not—their classification as buregdžinica or ćevabdžinica gives the first hint of their culinary nature. They go well with a local beer or rakija. Near Baščaršija square, the mosque of the same name (džamija), a gem, points to the long-term Turkish presence. The Gazi Husrev-beg Mosque complex (1530–31) is more famous: a domed building with a minaret, a secluded courtyard, two mausoleums, an Islamic college (madrassah), and a library. Immediately next to it is the 98-foot-high clock tower (sahat kula), probably from the 16th century. The time display, which is traditionally based on sunset as the beginning of the day

(twelve o'clock), had to be harmonized with the lunar calendar so that the five daily prayer times could be set correctly. Accuracy in detail corresponded to a certain level of religious tolerance during Ottoman times. Church towers stood their ground next to the minarets. In addition to extensive mosques such as the Imperial Mosque (from 1560), number two among the Sarajevo mosques, there was also room for houses of worship of other faiths. The main Ashkenazi synagogue on the left bank of Miljacka, an imposing building from 1902, still does not require any police protection. Where else is that the case in Europe?

ON THE TREBEVIĆ

In the past, meaning before the Bosnian War, an excursion to Trebević Mountain, with its television tower by the cable car that went into service in 1959, was part of a well-spent Sunday afternoon. Since 2018, a gondola lift has been back on Sarajevo's local 5,345-foot mountain, which has thus restored a bit of peace and normalcy. A rich American deserves thanks for this investment. On the way up, a wide view of the valley basin opens up, with the Old Town in the foreground and the prefabricated apartment buildings of Novi Sarajevo and Novi Grad in the background. Mount Trebević adjoins the ski area of Jahorina. A chic bobsleigh track was added on the northern slope for the 1984 Winter Olympics; its concrete has been crumbling for a long time.

MORE INFORMATION
Sarajevo
https://sarajevo.travel
http://visitsarajevo.ba
Sarajevo Tunnel
https://tunelspasa.ba

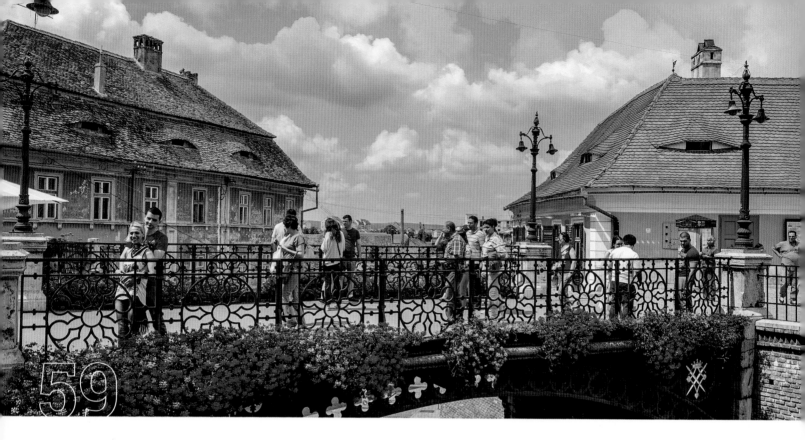

ROMANIA

SHOWCASE OF TRANSYLVANIA

Sibiu, located on the northern edge of the southern Carpathian Mountains, was and still is the cultural center of the Transylvanian region of Romania. Sibiu, which was founded by German settlers in the 12th century under the name of Hermannstadt, boasted of its Old Town, protected by five defense rings. Today, modern Sibiu is building on its former innovative spirit and presenting itself as a big city with a high level of cultural and leisure value.

Suffering decay during the Nicolae Ceauşescu era and affected by the exodus of the German population, the "dusty provincial town" of Sibiu (which has been its official name since 1919) has slowly recovered and has benefited from an economic upswing for almost two decades. Investments from Germany and Austria, extensive urban renewal, the hard work of its residents, and the prudence of its then mayor, Klaus Johannis (2000–2014), today president of Romania, gave Sibiu its soul and purpose back. This metropolis of the Transylvanian Saxons, whom the king of Hungary had brought into the country starting in the 12th century and to whom he granted privileges on his "royal soil," reflected on its multicultural heritage when it was the European Capital of Culture in 2007.

Although Romanian Germans make up less than 2 percent of the population today, a total of 147,000 people, the "German" element is (again) present in the educational sector, including at the German-language Brukenthal Gymnasium (dating from 1380) on Huetplatz and the state university (dating from 1990), as well as in municipal and economic policy as a flagship for the benefit of all. If you don't believe this, you only have to cross the cast-iron Lügenbrücke (Bridge of Lies; 1859)—and then see what happens . . .

FORTIFIED AND ARTISTIC
The fact that Sibiu was once much sought after by foreigners as a trading metropolis and city of craftsmen—the Turks tried to take it several

times—is something to which the preserved towers and bastions on the former fortification rings bear witness; the guilds also kept their valuables in the towers. The oldest gate in the Old Town, consisting of the upper and lower town, is the Saga Tower (1542), at the junction to one of the typical staircases that connect the two city quarters. The Ratturm Tower (13th century) is Sibiu's landmark. It is connected to the former town hall (Rathaus, meaning city council house; now the historical museum), which once marked the entrance to the second defensive belt. Its most powerful representative is the Dicke Turm (fat tower), where the first municipal theater was set up in 1788. Up to 500 visitors can listen to the concerts by the State Philharmonic Orchestra in the Thalia Hall today. The Grand Square (Piața Mare) and the Small Square (Piața Mică) form the Old Town's "parlor" space—these "rings" are not walls, but squares surrounded by colorful town houses, imposing palaces, and stately churches. They provide a wonderful backdrop for cultural events, the most important of which are the International Theater Festival and the Sibiu Jazz Festival in early summer. The "Gong" children's and youth theater has a permanent performance venue, which provides space especially for the art of puppetry.

FACES OF THE OLD TOWN

Several museums in Sibiu bear the name of the Baron von Brukenthal, who was governor of the Habsburg Grand Duchy of Transylvania between 1777 and 1787, an art lover, and sponsor of science. The paintings he owned, the core of today's collection, are housed together with his large library in the baroque Brukenthal Palace (1788), the former official residence, on the Piața Mare. Together with the former Jesuit church, the palace creates a beautiful baroque ensemble. The mighty Gothic parish church (14th century), with its bell tower (240 feet), still characterizes the face of the former Hermannstadt, now Sibiu.

PĂLTINIŞ (HOHE RINNE)

More than 100 years ago, people did not so much appreciate the brown bears (today reportedly almost 6,000 in number) as they did the good, clean air in the southern Carpathians in the "land behind the forests"—and this is where they built a health resort only 22 miles from Sibiu in the Zibin Mountains, at around 4,900 feet in altitude. Păltiniş still today has everything that makes up a vacation in the mountains: hiking trails, wooden huts, a wooden church, and a bit of the ski lift circuit, Romanian style. In addition to the dense forest, containing blueberries, flowery meadows, and cool heights with good views, nature lovers are particularly enthusiastic about the glacial lakes in the Iezărele Cindrelului nature preserve.

MORE INFORMATION
Sibiu Tourism
https://turism.sibiu.ro
National Museum Brukenthal
www.brukenthalmuseum.ro/index_en.html
State Philharmonic Orchestra
www.filarmonicasibiu.ro/en
Păltiniş (Hohe Rinne)
www.hoherinne.com

It has been only since the beginning of the 20th century that it has faced serious competition from the Orthodox cathedral. The magic of the Old Town, whose medieval and early modern character has been carefully restored, is revealed only when you stroll through the cobbled streets, enchanting back alleys, narrow archways, and hidden battlements.

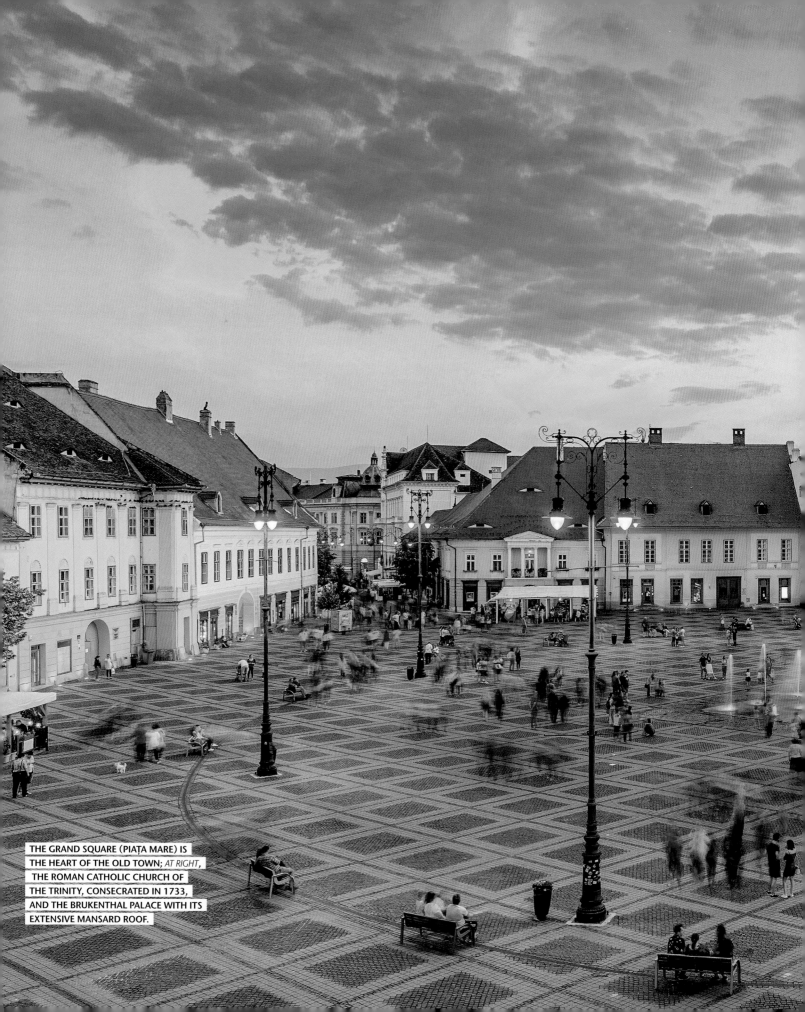

THE GRAND SQUARE (PIAŢA MARE) IS THE HEART OF THE OLD TOWN; *AT RIGHT*, THE ROMAN CATHOLIC CHURCH OF THE TRINITY, CONSECRATED IN 1733, AND THE BRUKENTHAL PALACE WITH ITS EXTENSIVE MANSARD ROOF.

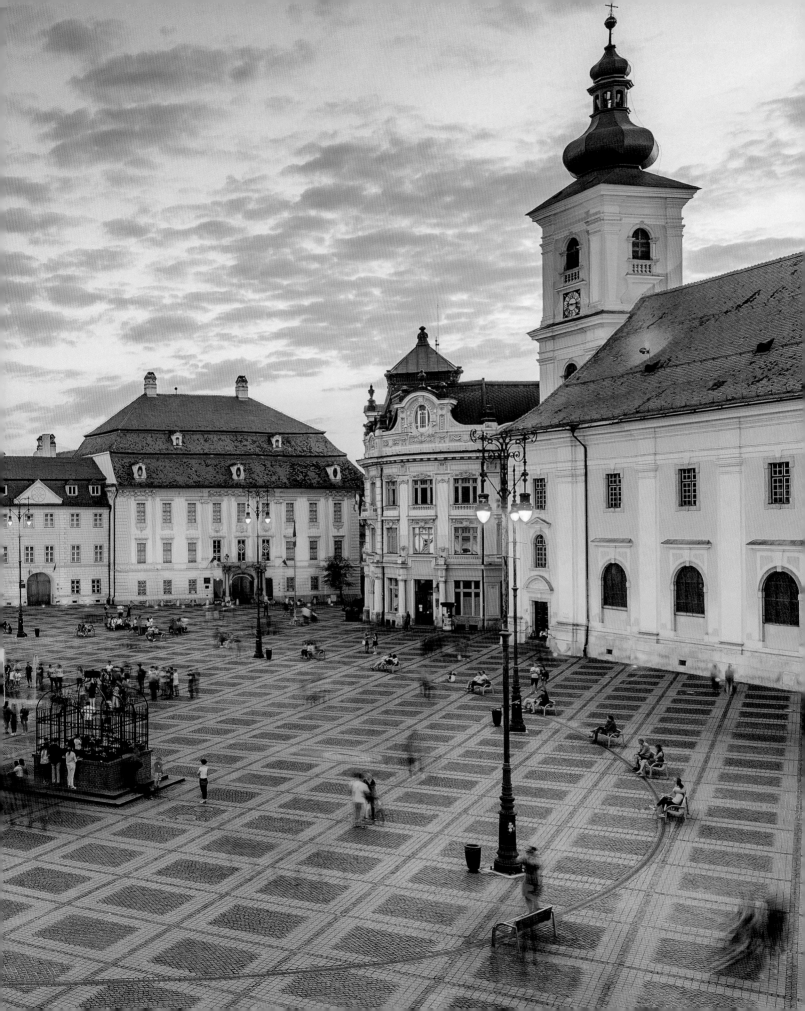

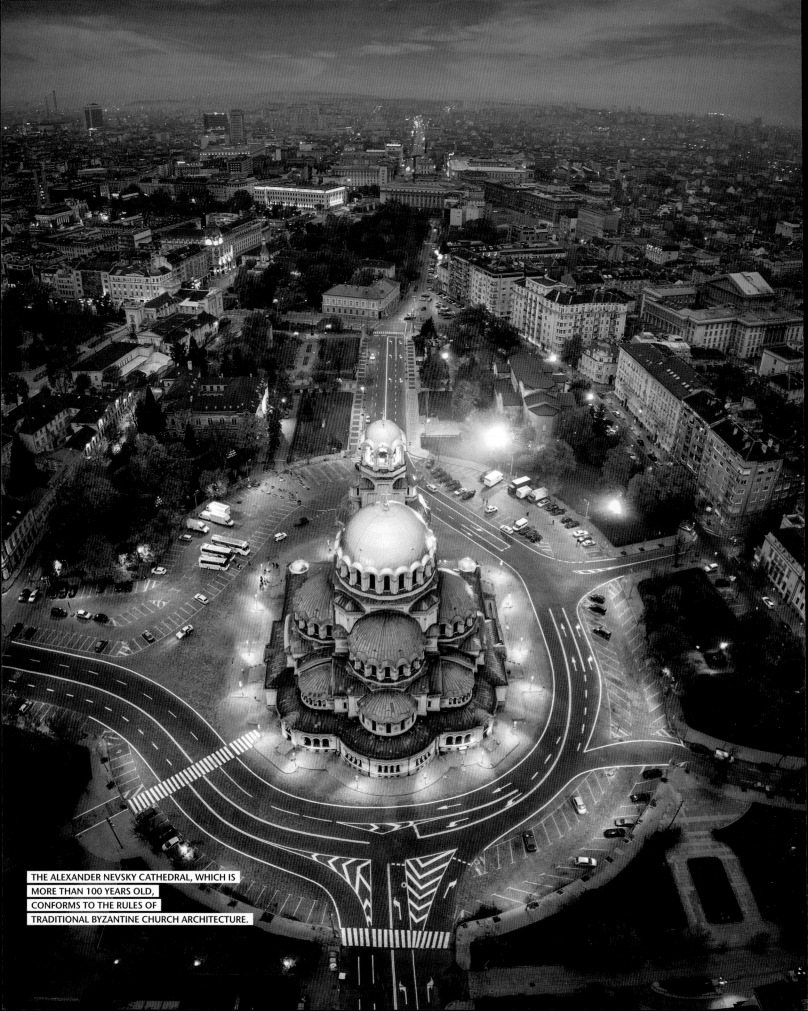

THE ALEXANDER NEVSKY CATHEDRAL, WHICH IS
MORE THAN 100 YEARS OLD,
CONFORMS TO THE RULES OF
TRADITIONAL BYZANTINE CHURCH ARCHITECTURE.

ON ROMAN FOUNDATIONS

Sofia is located on an ancient trade route dominated by the Vitosha Mountains, which soar to 7,500 feet high. The city is one of the oldest continuously populated places in Europe, and a melting pot of cultures. Thracians, Greeks, Romans, Slavs, Turks, and Sephardic Jews have shaped the ancient city of Serdica, the medieval Sredez, and the modern Sofia.

BULGARIA

Emperor Constantine the Great declared that "Serdica is my second Rome," before he in fact chose the city of Byzantium as his Constantinople. Renamed as Sofia—the wisdom (of God)—during the Middle Ages, the city's great hour came in 1897, when it became the capital of Bulgaria as it became independent from the Ottoman Empire. Since 2000, the figure of wisdom has stood symbolically on a 40-foot-high marble column that looks toward the Parliament. Before 1990, Lenin stood on that pedestal and kept an eye on what was then the headquarters of the Bulgarian Communist Party.

Adventure calls from central Europe, where it begins with deciphering the Cyrillic letters and continues among the Socialist monuments, the more-than-1,000-year-old churches, dilapidated prefabricated apartment buildings, chic fashion boutiques, street art, glass office temples, and great museums.

GROWING BUT NOT GROWING OLD

A statement on the city coat of arms sets standards. The secret of growing without growing old likely lies in the city's 15 mineral springs. In 1913 the central bathhouse was built over the Roman thermal baths in the post-Byzantine-style mixture of the Vienna Secession art movement. For a long time, the bathhouse was the center of social life until it fell into disrepair and was closed under

socialism. In the meantime it has been converted into the Museum of the City of Sofia. The springs continue to bubble, and new tapping points have been set up in front of the bathhouse. The water from the thermal springs is free to all, including for bottling. Near the central springs there is an area that is still wistfully called the "triangle of religious

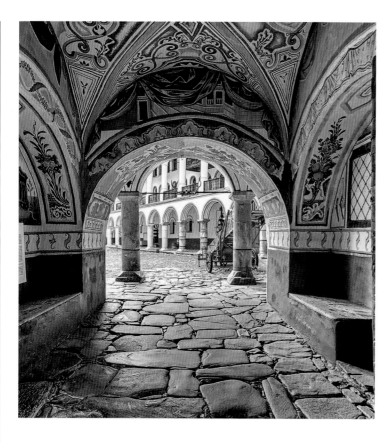

RILA MONASTERY

In the middle of the mountains of the Rila National Park, about 75 miles from Sofia, the largest and most important monastery in Bulgaria stands in a 3,770-foot-high valley. It goes back to Saint Ivan Rilski, who lived by the Struma River as a hermit. His followers built the first monastery in the 10th century. After a major fire in the early 19th century, the Rila Monastery was rebuilt starting in 1834 and painted inside and outside with frescoes in Bulgarian Revival folk style. The preserved fortified Chreljo tower, dating from the 13th century and part of the stable wall, protected the complex from attacks by the Turks.

MORE INFORMATION
Sofia
www.sofia.bg/en/web/sofia-municipality/sofia
National Historical Museum
https://historymuseum.org/en
Rila Monastery
https://rilskimanastir.org/en

tolerance." This includes the Christian Orthodox cathedral Sveta Nedelja, which was built in the 10th century directly atop the Roman baths. It is completely painted inside. A few steps away is the Banja Baschi Mosque, the mosque of the "many baths." Designed in red brick in 1566–67, the dome-vaulted building is one of the oldest Muslim houses of prayer in Europe. At the "third corner," the Sephardic synagogue dating from 1909 conveys an Eastern flair in a mixture of Viennese Secession and Moorish styles. In the past, 20 percent of Sofia's residents belonged to the Jewish community. After they were expelled and after the Holocaust, there are fewer than 2,000 Jewish people in the approximately 1.2-million-population metropolis today. The Central Market Hall is another example of the diversity of Sofia's art nouveau style. It is worth seeing for architecture fans and always good for a quick, stylish breakfast of a filled puff pastry. Every weekday, the women's market is held nearby in the open air. Its irritating name comes from the Ottoman period, because women were allowed to take part in public life only at this market. Fruit, vegetables, cheese, sausage, filled mason jars, and baked goodies are just as much a part of what is on offer as the synthetic textiles and junk of all kinds.

A BALKAN TWIST AMONG CHURCHES AND A CULTURAL PALACE

The opposites are fascinating. In the concrete gray "Serdika" metro station, archeological windows open directly into the Roman era. Squeezed between main roads and its level dug lower by Socialist urban planning, the small church of Sveta Petka Samardschijska (Church of St Petka of the Saddlers), with its medieval frescoes, likewise stands on Roman foundations. While enjoying a typical, slightly bitter Bulgarian coffee in the Arena di Serdica Hotel, you think you can still hear the sounds of the gladiators fighting. The foundations of the amphitheater, almost as large as the Roman Colosseum, are part of the design of the hotel foyer.

Surrounded by tall buildings, behind which the Communists wanted the little church to disappear into the remains of the fourth century, stands the oldest building in Sofia: the Sveti Georgi (St. George) Rotunda was built under Emperor Constantine the Great and contains early frescoes. A finely carved, ninth-century angel face looks down with unusual intensity from the vault. Likewise built on Roman ruins is the Great Mosque,

dating from the 15th century, into which the National Archaeological Museum moved almost 150 years ago. The huge Palace of Culture, in socialist modernism style, is a 12,900-square-foot colossus for music and other major events; a theater is housed in the basement. Skaters practice in front of its doors, and graffiti artists spray-paint to the Balkan beat in the Graffiti Park. The city's landmarks are the golden domes of the Alexander Nevsky Cathedral, which was erected in the early 20th century. Mosaics, ornate wood carvings, flamboyant frescoes, alabaster and onyx columns, gold decorations, and Italian marble let the world of orthodoxy shine by candlelight.

TREASURES IN SATELLITE TOWNS

On the outskirts of Sofia, dilapidated prefabricated apartment buildings stretch out in seemingly endless satellite cities.

This is where the Communists "planted" people from the countryside. The Museum of Socialist Art is as real as the women waiting at the bus stop with their chickens in a basket. The National Historical Museum, in the former presidential residence on the large ring road in Bojana, has been offering a comprehensive insight into the history of Bulgaria since 2000. The gold of the Thracians still gleams there. This ancient people, described as wild and hard-drinking, processed the precious raw material into uniquely beautiful pieces of jewelry; the most magnificent are on display. Small medieval churches with precious furnishings and painted throughout are laid out like a wreath around the city. The frescoes in the Boyana Church have been enchanting people since 1259. From the outside, it is impossible to guess at the magnificence inside, under an inconspicuous barn roof. The martenitsa, small textile adornments, are more ephemeral: in the spring, narrow red-and-white ribbons or yarn, talismans of health and long life, waft on bushes and branches in many parks in Sofia.

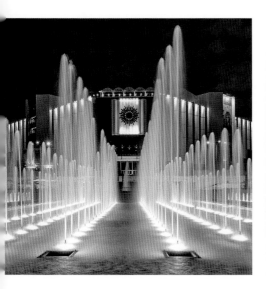

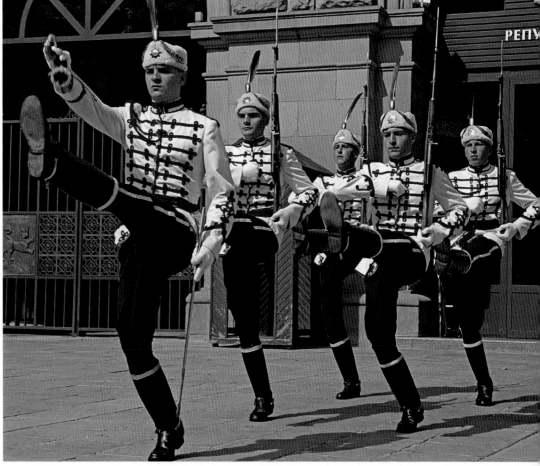

THE CAPITAL CITY INCLUDES THE PALACE OF CULTURE, WITH ITS PLAYING WATER FOUNTAINS (*ABOVE*) **AND, NATURALLY, THE PARADE OF THE PRESIDENTIAL GUARD** (*RIGHT*).

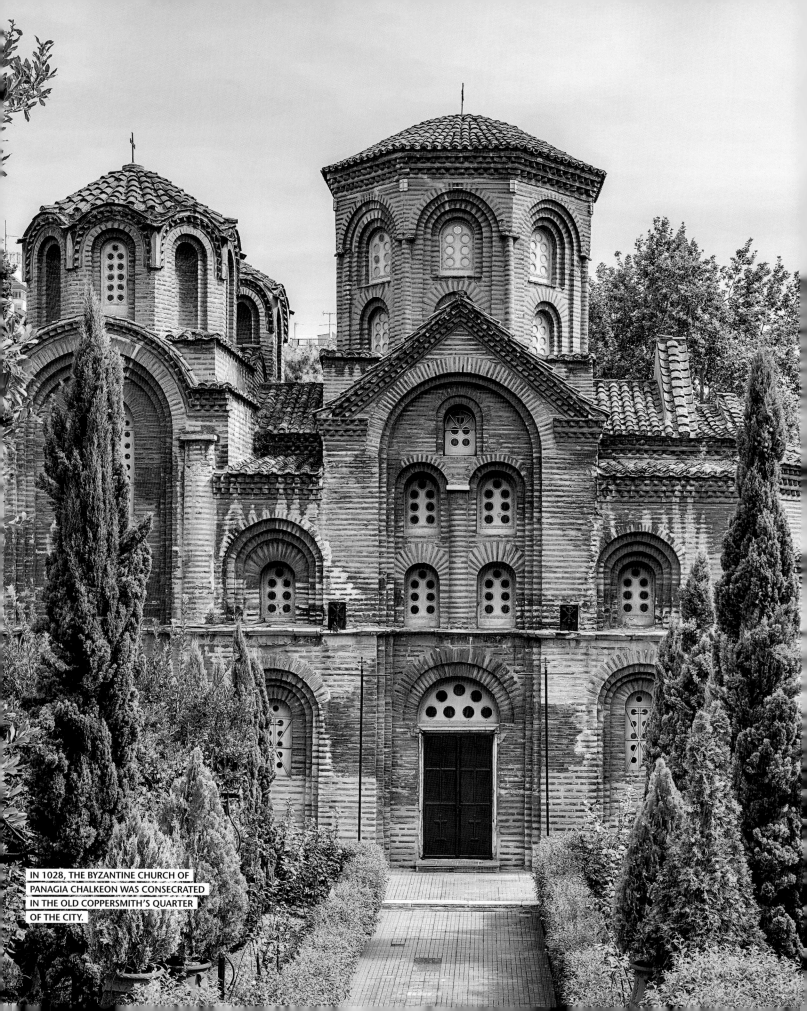

IN 1028, THE BYZANTINE CHURCH OF PANAGIA CHALKEON WAS CONSECRATED IN THE OLD COPPERSMITH'S QUARTER OF THE CITY.

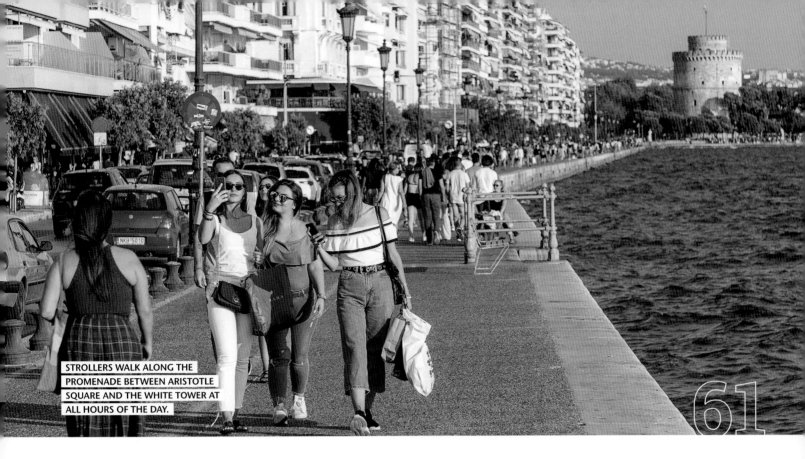

STROLLERS WALK ALONG THE PROMENADE BETWEEN ARISTOTLE SQUARE AND THE WHITE TOWER AT ALL HOURS OF THE DAY.

61

BETWEEN ANO POLI AND THE WHITE TOWER

Most vacationers see the city, which is also briefly and casually called Saloniki, only as a transit station on the way to the sandy beaches of the Halkidiki Peninsula or to the northern Aegean islands. Yet, a visit of several days to this lively port, university, and trade city is worth its while.

GREECE

This bustling city in northern Greece is the center of Greek Macedonia and, with more than 325,000 inhabitants, the second-largest city in Greece. Protected in the north by the foothills of Mount Chortiatis, which ranges up to 3,940 feet high, the port city lies on a bay of the Thermaic Gulf in the northern Aegean. Many students live here, and an evening stroll along the harbor promenade leads past chic bars and cafés full of young Greeks. Buildings from all eras are to be found in the hilly upper town and the lower town, laid out like a chessboard, starting with the remains of the city wall from ancient times. The Greeks and especially the inhabitants of

Thessaloniki would have gladly liked to see their city as the capital of the entire Macedonia region, including the Republic of North Macedonia, as Greece's neighboring country to the north—capital: Skopje—is now called. Today Thessaloniki is a thoroughly Greek city. You would hardly notice anymore that it had been a sanctuary for refugees for centuries—Sephardic Jews, Armenians, and displaced Greeks from Asia Minor.

METROPOLIS OF ANTIQUITY

Today's Diktiriou Square in the middle of the lower town is considered the nucleus of the city. In the still-ongoing excavations, remains from the

Hellenistic era in addition to Roman and Byzantine remains have been discovered during the construction of an underground garage. Nothing else in Thessaloniki recalls the glorious times of the Macedonians under Philip II and Alexander the Great, although the city was named by King Cassandros after his wife, Thessalonica, a half sister of Alexander. At that time there was probably a city wall, on the remains of which the Romans, rulers of Macedonia starting in 168 BCE, and later the Byzantines built massive fortifications, with the citadel set on the highest point of the upper town. Remarkable buildings remain from Roman times: the Galerius Arch, with artistic reliefs, the remains of the Galerius Palace, and the Agora (forum), with the Odeon. Large parts of the formerly 5-mile-long and up to 39-foot-high wall are still preserved, and it is possible to walk along some of it. It and the early Christian and Byzantine buildings scattered all over the city have been UNESCO World Heritage Sites since 1988.

JEWISH AND TURKISH HERITAGE

If you are interested in the later history of the city, you should follow the traces of Jewish and Turkish life. Before World War II, there were still more than 50,000 Jewish residents, and now there are only around 1,500; only 1,783 Jews survived the German occupation, which started in 1941. When the apostle Paul arrived here in 50 CE, he spoke before a large Jewish community. For a long time, the city was considered the "Jerusalem of the Balkans." The Ottoman Empire protected Jews from all parts of Europe from persecution in Thessaloniki. In 1614, they represented 68 percent of the city's residents, which had a positive impact on trade and the port. The Jewish cemetery, which lay outside the city walls, including an estimated 300,000–500,000 graves, was the largest in Europe even before the one in Prague. Today it is the location of the university campus. Only a few of the often-magnificent Jewish apartment buildings survived the great city fire of 1917. The city is still full of references to this heritage. It is only since the turn of the millennium that plaques, memorial monuments, or "stumbling stones" (small brass plaques set in the sidewalk listing local Holocaust victims' names) have been installed. The Jewish Museum was opened in 2001. Only the Monastiriotis Synagogue survived the German destructive frenzy. Many more points of interest have been preserved from the Turkish period. Almost all Christian churches were

converted into mosques during the almost 500 years of Ottoman rule. After it ended, all the minarets were removed, except for the one on the rotunda, now a museum. There are only a few mosques left, but a few restored Turkish baths, part of the Ottoman cemetery, and the Bezesteni, a market covered with six round domes and its jewelry and clothing stalls, still stand. The Bey Hamam, dating from 1444, the largest surviving Turkish bath in Greece, is worth visiting. It continued to operate until 1968. The former Yeni Cami mosque is now used for exhibitions. Few visitors from Western countries know that Mustafa Kemal, later called Ataturk, was born in Thessaloniki in 1882. His birthplace, which has been restored several times, is now a museum.

ANO POLI, THE UPPER TOWN

Distinctive style has been preserved in the winding alleys, with their fountains and tombs from Ottoman times, and the lively markets in the Old Town. Some of the many Turkish-style houses were lovingly restored after Thessaloniki was named the European Capital of Culture in 1997. They now house small shops, taverns, and *kafenions* (cafés). On Dimitris Poliorkitou Street you can admire houses with jettying upper floors, roofed-over bay windows, and gallery passageways. None of the larger hotels are to be found here; Ano Poli belongs to tourists only during the day. There is a phenomenal view of the city from the trapezoidal city wall, which nestles like an amphitheater on the slopes of Mount Chortiatis and along the Thermaic Gulf. You can take the bus to the Anna Palaiologina Gate, near the Trigonium Tower, with its wide observation deck, to save yourself a tedious walk along the city wall.

The best-known and best-preserved city wall tower is the White Tower in the lower town. From there, the defensive fortification led north up the hill to the citadel, then west to today's Vardari Square, and from there down to the sea. There are well-preserved sections of the wall still standing on

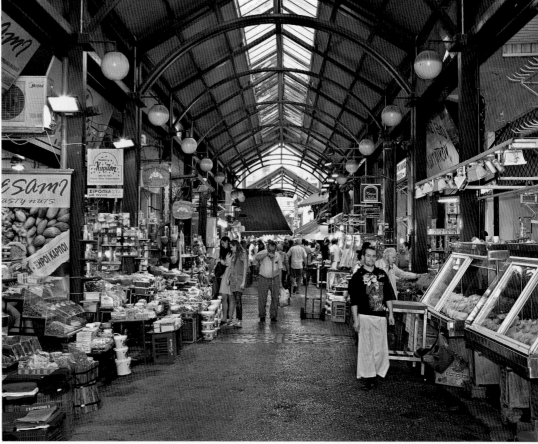

HALFWAY BETWEEN THE UPPER AND LOWER TOWNS, THE VLATADON MONASTERY IS SITUATED IN A CHARMING GARDEN (*OPPOSITE*). IN A CASUAL POSE, ARISTOTLE LOOKS OVER THE SQUARE NAMED AFTER HIM (*ABOVE*). THE KAPANI MARKET HAS TEMPTING DELICACIES ON OFFER (*RIGHT*).

the Acropolis hill and on the university campus. The citadel, built in Byzantine times, is also called the Eptapyrgio, or the "seven towers," after the seven remaining angular or round towers, and was used as a prison until 1989. Even though renovation work is still ongoing, a visit is worthwhile simply because of the wonderful view. The picturesque Vlatadon Monastery, with its cross-in-square church dating from the 14th century, also offers a beautiful panorama. It is one of the few sacred buildings from this period in the upper town. It is interesting to observe the still-active monastic life. The church is surrounded by several research institutes of the Ecumenical Patriarchate. Old cisterns on the extensive grounds are fed with water from Mount Chortiatis.

ALL AROUND THE WHITE TOWER

Directly on the waterfront promenade, where strollers flock especially during the evening hours, stands the landmark of Thessaloniki, the 42-foot-high White Tower—despite its color, which has meanwhile become gray, the name sticks. It formed the end of the eastern walls surrounding the city and the connecting sea walls. Built in Ottoman times in place of a Byzantine predecessor, it served as a watchtower, garrison, and prison. Since 2001 it has housed the multimedia city museum with an observation deck. Over six floors, which are connected by a stone spiral staircase, the visitor moves from the first settlements of Thessaloniki to the harrowing events of the 20th century. When Sultan Mohammed had numerous Janissaries, the Ottoman's elite household troops, executed there after a revolt in 1826, the White Tower became the "Tower of Blood."

From the White Tower it is only a stone's throw to Alexander the Great, who rides toward the east on a massive pedestal. On the landside there is a pretty park, one of many thematically designed gardens set along the 3-mile-long waterfront

NEAR THE WHITE TOWER, THE STATUE OF ALEXANDER THE GREAT RECALLS MACEDONIA'S GLORIOUS PAST (*LEFT*).
GILDED CANDLESTICKS DECORATE THE INTERIOR OF THE THREE-NAVE BASILICA OF HAGIA SOPHIA (HOLY WISDOM) (*ABOVE*).

promenade between the concert hall and the harbor. Elegant Aristotle Square, near the harbor, is the central square in the lower town. Hotels and white, six-story commercial buildings are grouped around the elongated, spacious square that opens up to the sea; cafés, restaurants, and chic shops are hidden away along its arcades. Pier 1 of the old port is now a "cultural mile," with a film museum, photo museum, and the State Museum of Contemporary Art.

EASILY OVERLOOKED TREASURES

The most-important sights from the ancient, early Christian and Byzantine periods and the most-important museums, including the Museum of Byzantine Art and the Archaeological Museum, are scattered throughout the lower town, sometimes wedged between unadorned office buildings from the 1970s. Probably the most important building from the early Christian period is the Rotunda of Galerius, a Roman domed structure that was built in 306 CE. The wall mosaics from the fourth century are exceptional; even more magnificent are the mosaics in the five-nave Demetrios Basilica, which was built almost 300 years later—St. Demetrios is the patron saint of Thessaloniki. The wood-covered basilica Panagia Acheiropoietos has remained almost unchanged since the fifth century. Dating from the 11th century, the Panagia Chalkeon is built of striking red bricks. The tiny Chapel of the Transfiguration is easily overlooked, also because it is set below street level. The wall paintings were created in the 13th century.

STRONG, SWEET, LOUD

Anyone who still wants to do something after an extensive sightseeing tour will dive in the evening into the Ladadika quarter, near the ferry harbor. The area is especially popular among students—Thessaloniki has the biggest university of Greece—and young tourists. Bars, pubs, and quaint taverns line the streets of what was formerly the olive oil traders' quarter. Instead of ouzo, tsipouro, a high-proof pomace brandy, is the preferred tipple. The best cocktails are said to be found on Iktinous Street. Live Greek music is offered by the always highly frequented bouzoukia nightclubs. You should fortify yourself with some solid food beforehand, perhaps with hearty tripe soup with pasta or vlita, a green leafy vegetable prepared with lots of olive oil and lemon. Exiles from Asia Minor brought sesame bread rings with them. The sweets are famous, such as trigona panoramatos, puff pastry cones filled with vanilla cream. The most beautiful, largest—and loudest—market is the Kapani or Vlali Market, with its many barkers and tempting food stalls. Right next door is the covered Besesteni Market from Ottoman times.

THE STAR OF VERGINA

One of the most important excavation sites in Greece lies around 50 miles from Thessaloniki, a day trip. The palace complex and the necropolis of Vergina, with its numerous burial mounds, have been a UNESCO World Heritage Site since 1996. In the accessible Great Tumulus there are four graves of nobles, furnished with precious gifts. The largest could be the tomb of Philip II, father of Alexander the Great. There is a golden burial box decorated with the star of Vergina. The return trip passes by Pella, the former capital of the kingdom of Macedonia. Only part of the former urban area has been excavated. Important excavation finds and mosaics are exhibited in the modern museum, including one of a lion hunt, which may likely show Alexander and his friend Krateros hunting.

MORE INFORMATION
City of Thessaloniki
https://thessaloniki.gr/?lang=en
Sights in and around Thessaloniki
https://thessaloniki.travel

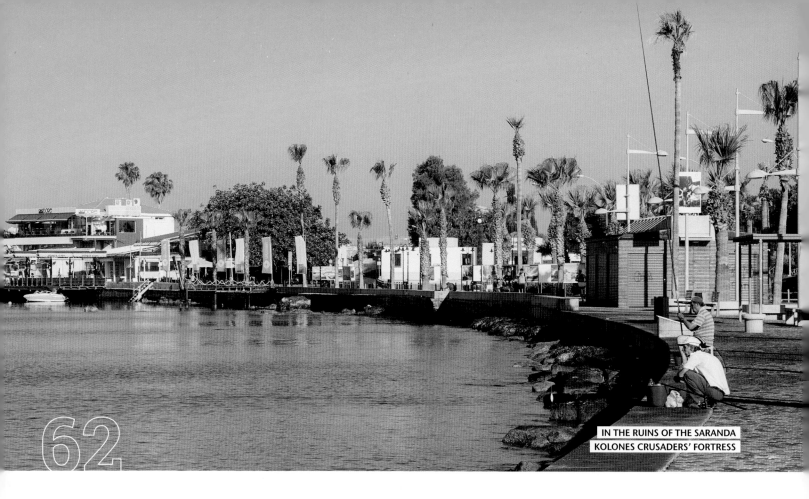

IN THE RUINS OF THE SARANDA
KOLONES CRUSADERS' FORTRESS

62

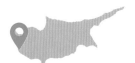

CYPRUS

THE PAST REINTERPRETED

Paphos was already a place of longing in ancient times. Today, the revitalized alleyways in the Turkish Quarter, the extensive archeological park, and the traces of the early Christians constitute much more than a good address for beach and swimming vacationers. As a bonus, it features the most-beautiful sunsets in the Mediterranean.

The city has two sides, an upper and a lower one. Pano Paphos, upper Paphos on a hill, is the city of the Paphites and the narrow streets around the mosque, church, and museums. Kato Paphos, the lower part by the sea, was the port for the Temple of Aphrodite in ancient times.

ROMAN LOVE SCENES

Paphos is a panopticon of history. Lower Paphos, with its small Ottoman fort by the harbor, was once the seat of the Roman governor and the capital of Cyprus when it was a Roman province. The city featured villas with views of the sea, theaters, and communal buildings, until slowly everything sank into the sand and was reborn only centuries later as hotels. While tourists who come to enjoy the swimming flood the promenade in the high season, good-looking ancient athletes are to be seen on the floor mosaics right next door. As a farmer was plowing his field near the harbor in 1962, the ground yielded Roman relics. Since then, the area has been systematically excavated. One sensation followed the last. Ancient Néa Páfos, which is coming to light, is now a UNESCO World Heritage Site. The main attractions are the Roman-era floor mosaics in the house of Dionysus and the houses of

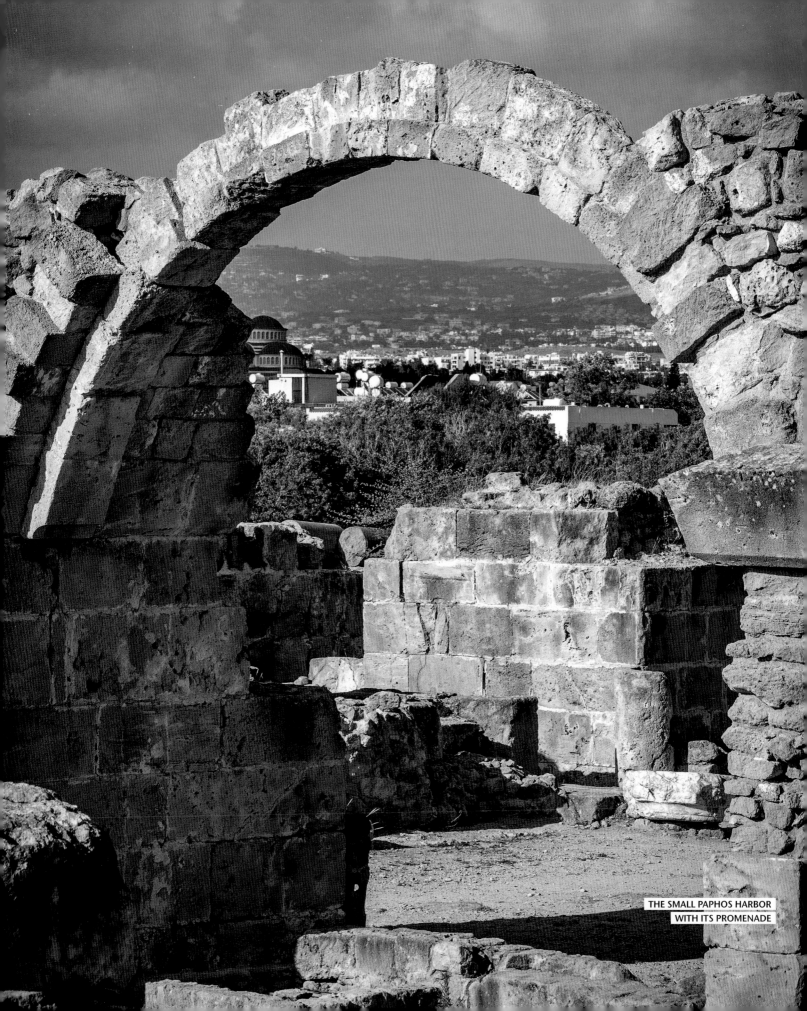

THE SMALL PAPHOS HARBOR
WITH ITS PROMENADE

Eon, Theseus, and Ulysses. Their scenes tell very vividly of futile and desperate love, of escaping from the labyrinth with the help of Ariadne's thread, and of beauty competitions and cruel executions.

STEPS INTO THE UNDERWORLD

The necropolis of the Hellenistic and Roman upper classes is not far away. The best location, right by the sea, was chosen so that the deceased could be rowed into the realm of Hades by the ferryman. The houses of the city of the dead are set into the stone, and steps lead into the underworld. The grave spaces are empty and abandoned by the dead, because grave robbers have taken everything with them. Yet, the architecture of this vast place is fascinating and unique in Europe.

Another excavation site was the largest early Christian basilica in Cyprus. Its fourth-century pillars have been set upright again. In the Middle Ages, a small Franconian church was built over the complex. It is used ecumenically today and is popular among couples getting married.

Perhaps the lovers had passed a tree by the roadside on their way to the upper town. In addition to its green leaves in summer, it bears countless handkerchiefs and other pieces of fabric. The roots of this *Pistacia terebinthus*, or turpentine tree, grow deep into a Hellenistic burial chamber complex. According to legend, the Jewish woman Solomoni sought protection from her persecutors there in Roman times. But the Romans bricked up the entrance, and Solomoni died an agonizing death. When it was opened again later, the woman arose, surprisingly alive. Since then, the custom has been to tie handkerchiefs to the tree in order to ask for healing from suffering—and help in difficult matters of love.

OLD TOWN

Old Paphos spreads out on a natural rock balcony along the coast. The quiet upper town with its alleys and small squares invites you to discover many things. It was extensively restored for the 2017 year as Capital of Culture.

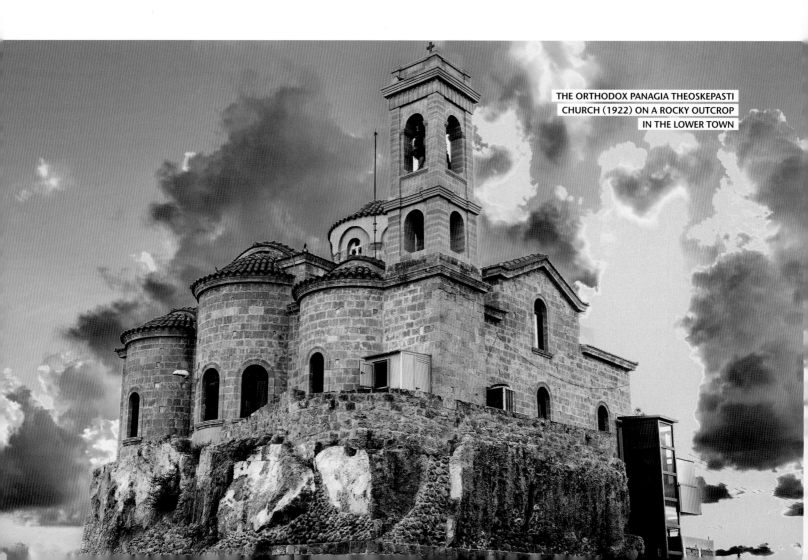

THE ORTHODOX PANAGIA THEOSKEPASTI CHURCH (1922) ON A ROCKY OUTCROP IN THE LOWER TOWN

Far away from the ancient excavations, the Cypriot Old Town shows its real face. Many buildings tell of the times before 1974; that is, before the political division of the island. Their decay points to the former Muslim residents who now live in the north. They recall a time when Paphos was more Eastern than Western. The slender spires of the mosque protrude from the maze of houses, as do the church towers. The town hall, post office, schools, and police station are in neoclassical British colonial style. The redevelopment of the Old Town around the market hall and the Kebir Mosque has brought some luster back to the former Turkish quarter of Ktima. Traffic-calmed streets, lined with shops and bars as well as the new "Ibrahim Han" cultural center in the former caravanserai, attract passersby. The old electric power plant is now a modern exhibition space with a café. House walls were planted with hanging gardens, and graffiti artists have expressed themselves exuberantly on bare firewalls. The hammam is now a bar. Where people used to sweat things out and be scrubbed, couples can now marry. The market halls offer a wide range: from the best-quality olive oil to plastic donkeys. Tablecloths from East Asia hang right next to the meticulous Lefkar embroidery typical of Cyprus. In the upper town there are places to browse and chat, small cafés, bars in historical buildings, and a souvlaki grill in the open garage. The streets become silent at midday.

ROMANTIC AND COOL PLACES

The most beautiful view is of lower Paphos as the sun sinks into the sea. On the upper Papho plateau there are scenic outlooks with benches, and restaurants where halloumi, sheftalia, and souvlaki are served, which invite you to view the coast in the evening glow.

Paphos is considered the warmest place in Europe. When it gets too hot in the sun, the cool museums are waiting. Not far from the Bishop's Church, the private folklore museum preserves the treasures of the Eliades family. The house has maintained its original architecture and traditional furnishings, ceramics, costumes, and carved wooden chests and provides a good insight into the Cypriot way of life. The Archaeological Museum displays exhibits from the Neolithic to the late Middle Ages. Still too hot? Then go to the water park or dive into the sea!

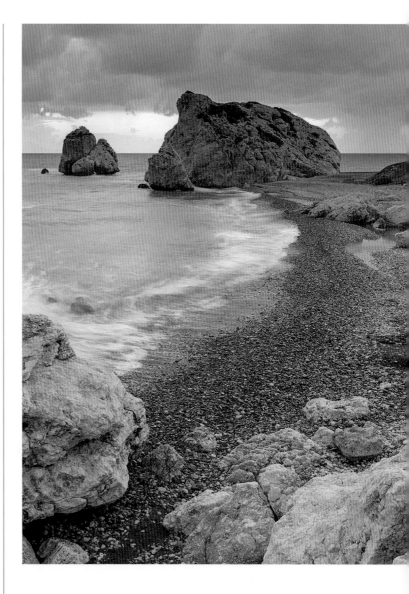

PETRA TOU ROMIOU—BIRTHPLACE OF APHRODITE

East of Paphos, where Aphrodite, the goddess of love and beauty, once rose from the sea, the Aphrodite Rock lies in the sea. The Cypriots call it Petra tou Romiou, the rock of the Romans, which was once hurled at an enemy. Bright white limestone protrudes from the azure water—a truly beautiful place. The beach is full of rough pebbles, but that didn't bother Aphrodite. According to Homer, she came ashore light of foot and walked to her large temple near Kouklia. It is said that if you swim around the Aphrodite Rock three times under a full moon, you will become thirty years younger. Anyone who might have doubts about this promise should enjoy a bottle of Cypriot wine for consolation and watch the sunset.

MORE INFORMATION
Paphos
www.visitpafos.org.cy, www.Paphos.com
Aphrodite Cultural Route
www.visitcyprus.com

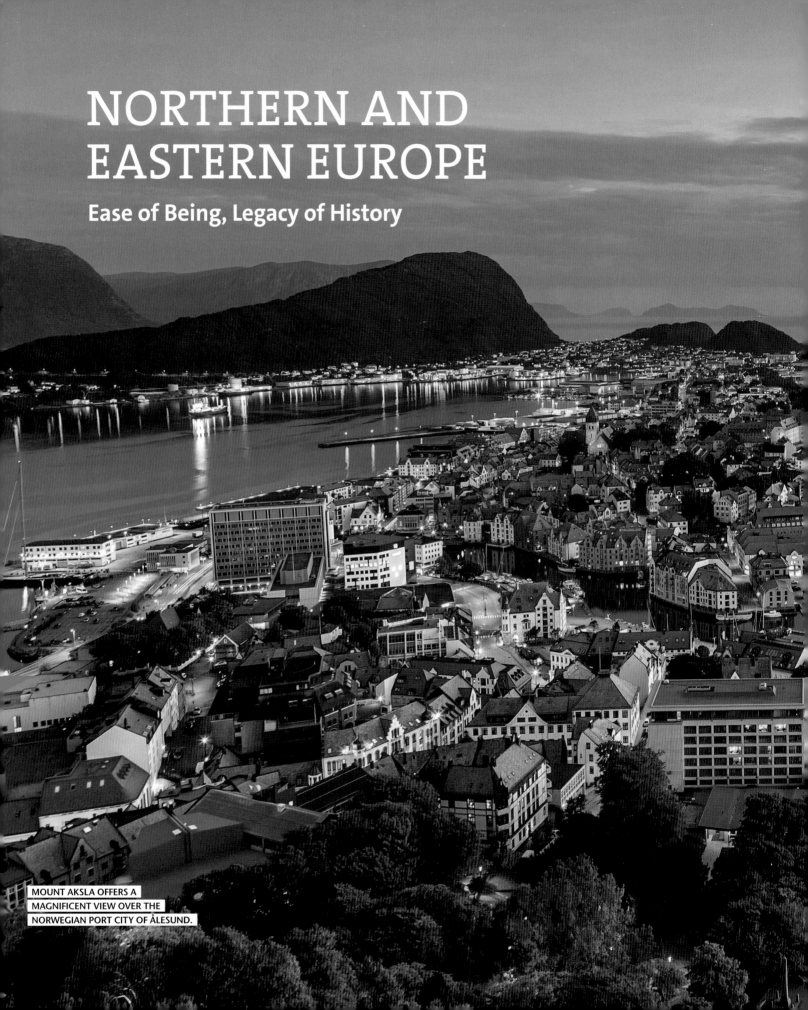

NORTHERN AND EASTERN EUROPE

Ease of Being, Legacy of History

MOUNT AKSLA OFFERS A
MAGNIFICENT VIEW OVER THE
NORWEGIAN PORT CITY OF ÅLESUND.

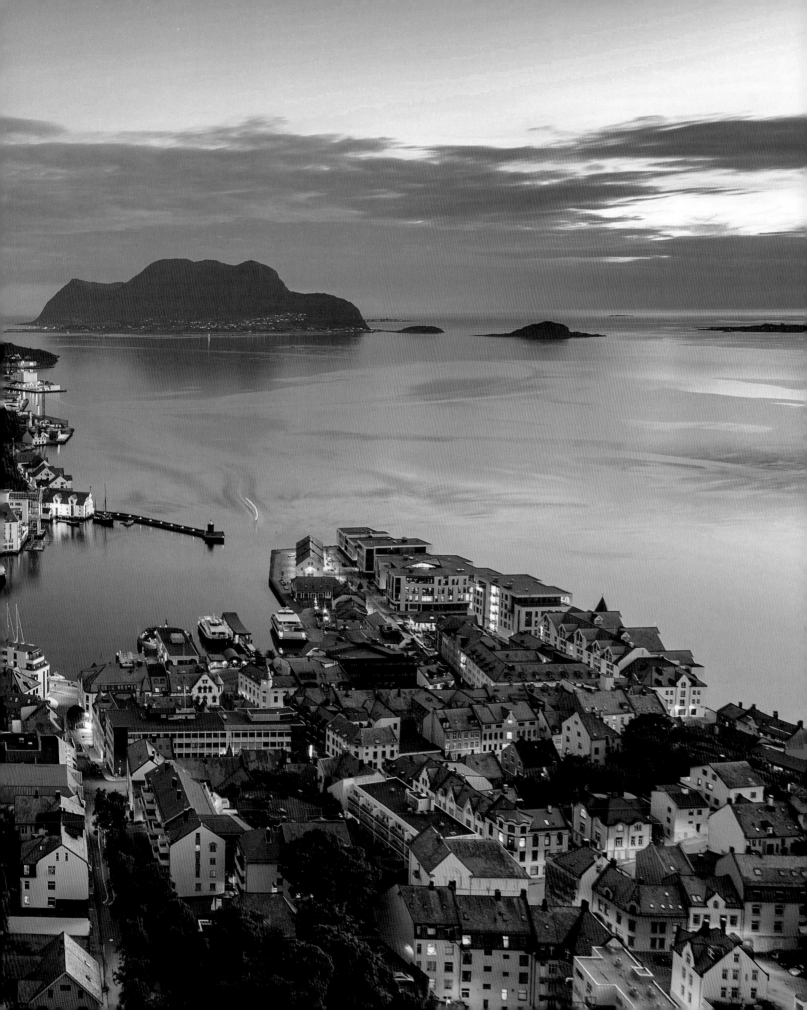

DENMARK

JUTLAND'S CHARMING CALLING CARD

Being hyggelig—this trendy word for typical Danish coziness and comfort seems to have been coined for Aarhus. The city on the east coast of the Jutland Peninsula, with its cafés, designer shops, modern museums, pretty spots, and green surroundings, is an attractive destination for a relaxing and at the same time inspiring break.

Young and old at the same time: With its many students, Aarhus is one of the Danish cities with the youngest population, and you can feel it everywhere in the lively atmosphere. On the other hand, the city's roots go back to the eighth century. The Vikings founded an early settlement there over 1,200 years ago, laying the foundations for today's city with its approximately 273,000 inhabitants.

VIKINGS UNDERGROUND

With such a history, Aarhus, together with Ribe in South Jutland, is one of the oldest existing communities in Denmark. The place offers unique exhibits with good commentary on the Viking Age.

Excavations have shown that the "Aros" of the Vikings was set exactly where today's city center stands. Those who want to delve deeply into the past should visit the underground Viking Museum, which opened in 2008 in the basement of the Nordea Bank on St. Clemens Torv, a square. Among the exhibits to be seen is an animation of a Viking attack from a dragon ship.

CYCLIST'S PARADISE

Anyone who is visiting Aarhus, Denmark's second-largest city, for the first time will quickly be able to find their way around. The city center, with its pedestrian zones and open squares, the historical Latin Quarter, the cathedral, the old

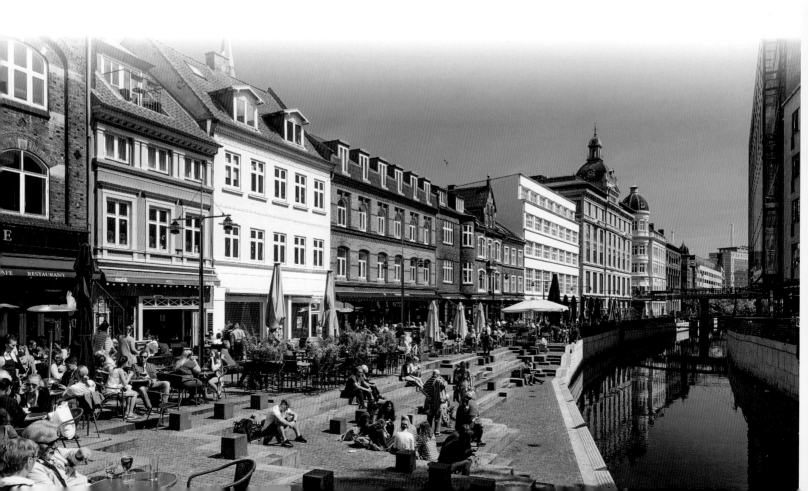

customs office, and city hall, as well as the Church of Our Lady, can be explored on foot. For a slightly larger scope, which might also include the international seaport, the best way to see it is by bicycle, the most popular form of transportation in the city. With lanes specially designed for two-wheeled traffic, tourist cycle routes, and good connections to the long-distance cycle network, Aarhus shows itself to be an exemplary cycle-friendly town. Free city bikes are available for visitors at some 50 places in the city center. To unlock one, all you need is a 20-kroner coin, which you can get back at any bike station after parking your bike—just as you get a shopping cart in a European supermarket.

TIME TRAVEL THROUGH HISTORY

The city's attractions include a wide range of museums. On the one hand there is the ARoS Art Museum; its art collections from the 19th century up to today are among the largest in northern Europe. The walkway sculpture *Your Rainbow Panorama* on the roof offers a magnificent view of the city. The Museum Moesgaard, which is located in the countryside south of the city, takes you back to the prehistoric past and is also an architectural masterpiece. Its "evolutionary staircase" illustrates the history of human origin. Den Gamle By (the Old Town) open-air museum, near the botanical garden, offers a journey back in time to the more recent past: in reconstructed city quarters, visitors can immerse themselves in various decades from the end of the 19th century up to the 1970s, and as they do so, they can watch the residents live their everyday lives in their homes, gardens, and

ÅBOULEVARDEN (*LEFT*), THE LIVELY PROMENADE ALONG THE AARHUS Å (RIVER), IS A POPULAR MEETING POINT. DEN GAMLE BY OPEN-AIR MUSEUM ALSO FEATURES AN OLD-TIME VILLAGE SHOP (*BELOW*).

shops. Marselisborg Palace is located to the southwest. When the Danish royal family resides there in summer, the changing-of-the-guard parade is conducted every day at 12 noon. The beautiful castle park can be visited for free if the family is not in residence.

STREET FOOD

Mmm, that smells good! As you approach the old bus station terminal, you can smell the full-bodied aroma of the international street cuisine dishes. Since 2016, a permanent street food market has been established in a large hall that boasts a good portion of industrial charm. It is enjoying increasing popularity with locals and visitors. The stalls distributed throughout the hall offer freshly prepared food from all over the world at fair prices, seven days a week. Whether Danish labs-kovs (which resembles corned beef hash), hot dogs, cinnamon buns, fish and chips, hamburgers, pizza, pita, or Indian curry, there is something for every

taste. When the weather is nice, you eat outside at long tables and quickly get into a conversation with your neighbors.

MORE INFORMATION
City of Aarhus
www.visitaarhusregion.com
Moesgaard Museum
www.moesgaardmuseum.dk/en
Den Gamle By Open-Air Museum
www.dengamleby.dk/en

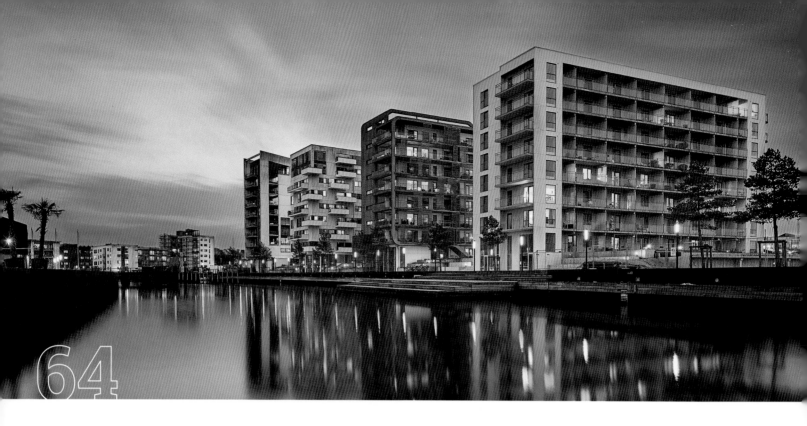

DENMARK

ODENSE—ANDERSEN'S FAIRY-TALE TOWN

IN THE GARDEN OF DENMARK

You are heartily welcome—Odense, the third-largest city in Denmark, has an inviting atmosphere with its medieval city center, its parks and tree-lined avenues, and its small shops, restaurants, and cafés. The city's most famous son is the fairy-tale writer and poet Hans Christian Andersen, whose traces can be found everywhere.

This large city with its approximately 178,000 inhabitants has a wonderful location: nestled on the island of Funen, it lies in the "Garden of Denmark." Its name probably goes back to the time of the Vikings, who in the early Middle Ages built a place of worship here for Odin, the principal deity of Nordic mythology, and Nonnebakken Castle. In the Jernalderlandsbyen open-air museum in the suburb of Næsby, Odin's Odense comes to life again in the reconstructed houses and workshops. After the city became a bishopric around 1060, they built a large number of monasteries and churches, including Vor Frue Kirke, Odense's oldest church. Named after the Danish king Knud (St. Canute), the 14th-century cathedral with its high, bright nave is one of the most beautiful Gothic religious buildings in Denmark. The magnificent altar by the Lübeck woodcarver

Claus Berg is worth a close look. You can pay an in-depth visit to the country life that was typical on Funen Island during the 18th and early 19th centuries at Den Fynske Landsby ("the Funen Village") open-air museum. Those who prefer to immerse themselves in the world of art can visit the Art Museum Brandts in the Latin quarter, which offers an art gallery with several simultaneous exhibitions, a museum for photographic art, and a media museum.

IN ANDERSEN'S FOOTSTEPS

The best travel reading for visiting Odense is unquestionably the fairy tales of Hans Christian Andersen, because his famous characters can be found all over the city. They include the Little Mermaid, the seahorse, the wild swans, the steadfast tin soldier, and other childhood heroes. If

ODENSE HARBOR PRESENTS ITSELF IN MODERN ARCHITECTURE (*OPPOSITE*). A MONUMENT IN FRONT OF THE GOTHIC SANKT KNUD'S KIRKE HONORS THE FAMOUS FAIRY-TALE AUTHOR AND POET HANS CHRISTIAN ANDERSEN (*LEFT*).

you are familiar with their adventurous stories, the striking sculptures of course have an even-better impact. Andersen was born in Odense in 1805 and spent his childhood here until he moved to Copenhagen at the age of 14. The city today honors its world-famous son with several buildings and squares that can be visited along an inventively marked route. The path starts at his birth house, a yellow corner house. Nearby is the Hans Christian Andersen Museum, which presents not only its master's literary works to its visitors, but also his paper art. In Munkemøllestræde you can inspect the premises where the impoverished family lived and worked for years. In summer there is a regular highlight for young and old: one of his fairy tales will be staged in the Funen Village as part of the Andersen Festival games.

BY AND ON THE WATER

The Odense Å, Funen's longest river, winds through the city center. Quiet banks invite you to take a break or have a picnic. But you can also experience a lot on the water. For those who like to take it easy, enjoy coffee and cake as you glide along on a pleasure boat through the beautiful river land-scape. Pedal boats and rowing boats are available for those who are more active and like things to be either romantic and calm or damp and splashy. A special experience for the whole family is the "H. C. Andersen on the river" boat tour, which also includes the emperor in his new clothes, little Claus and big Claus, and the princess and the swineherd among its passengers. In turbulent little scenes they tell monstrous stories from their fairy-tale life.

FYNS HOVED—LONELY SPIT OF LAND

Only about 25 miles from Odense, at the northern tip of the Hindsholm Peninsula, one of Denmark's most beautiful landscapes is waiting to be discovered. If you look toward the Great Belt strait from Fyns Hoved (at the tip of Funen), you feel as if you are in your own world. Rare plants thrive on the low-rainfall coastal cliffs, headlands, reefs, and old mussel beds. There is also a rich variety of animal life here. Seabirds fish, swamp birds wade, and common buzzards and honey buzzards are circling. If you are patient and keep your eyes open, you might be able to watch a ring snake or adder sunbathing on the stones. The light at the northern tip of Funen is unique and has already attracted numerous painters. Many of them have immortalized Fyns Hoved on canvas.

MORE INFORMATION
City of Odense
www.visitodense.com
Hans Christian Andersen in Odense
www.hcandersensodense.dk/en
Museums in Odense
https://odensebysmuseer.dk/?lang=en

65

CITY OF ART NOUVEAU STYLE

Bergen is considered the most beautiful city in Norway, but Ålesund is a serious competitor. This city on the west coast is located on several islands in the European North Sea, framed by the landscape of the Sunnmøre Alps. The entire panorama can be seen from its local Mount Aksla. From there you can also see the Hurtigruten mail boats in the harbor.

NORWAY

Ålesund was first mentioned in the 15th century. In the 19th century, the city developed into one of the largest fishing ports in Norway, and dried cod became a much-sought-after commodity. Ålesund owes its current appearance to a catastrophe: in January 1904, a conflagration destroyed almost all the houses in the Old Town and left 10,000 people homeless. But help came promptly—in particular, German kaiser Wilhelm II, a fervent lover of Norway, gave the order immediately after the great fire became known to ship medicine, food, and building materials to the scene of the disaster. Thus it was possible to rebuild the city within a few years, and it was done in art nouveau style, according to the current taste at the time.

IN MEMORY OF A DISASTROUS FIRE AND FISHING

Anyone walking through the Kongensgata pedestrian zone will inevitably become acquainted with early-20th-century architecture. One art nouveau house follows another, wonderfully ornamented, and almost every building displays colorful facades and picturesque gables. Visitors can find out everything about the catastrophic fire and reconstruction of the city in the art nouveau center in the old Svane pharmacy in

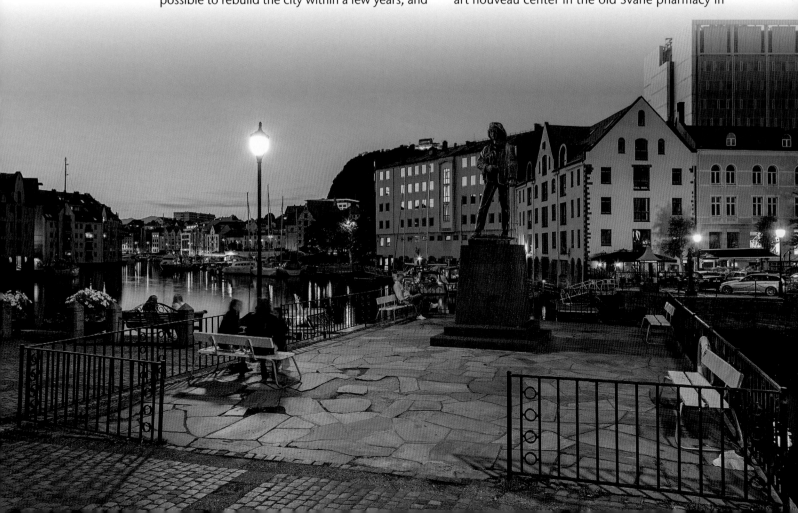

the Brosundet. The Ålesund Museum, near the St. Olavs plass (place), also features this event and furthermore provides insight into people's everyday lives. Seafaring, fishing, and old handicraft traditions are vividly demonstrated, and an original merchant's shop takes you back to the "good old days." For anyone who wants to know more, the Fisheries Museum—in the 19th-century Holmbua warehouse, which was one of the few houses to survive the city fire—is dedicated to the city's main source of income. About 2.5 miles outside Ålesund, the Sunnmøre Museum invites you to pay a visit to history. Several of its departments are located in an extensive park of around 120 hectares: an open-air museum with 55 historical houses, a boat exhibit with Viking ships, and a medieval section on the history of the Vikings. If that's too much history, you can look around one of the largest saltwater aquariums in northern Europe: the Atlantic Park on the island of Hessa is located directly by the sea and takes visitors into the fascinating underwater world off Norway's coast.

VIEW FROM ABOVE

Postcards from Ålesund usually show the city from above, and not without reason: the 620-foot-high local Aksla Mountain offers a magnificent view of the colorful sea of houses and the surrounding area. From the Fjellstua and Kniven scenic outlooks, you can also see that Ålesund lies on three islands connected by bridges: the Nørvøy, Aspøy, and Hessa. If you are in good-enough condition, you can walk the 418 steps up the mountain, but there is also a road. Before the ascent, it's a good idea to

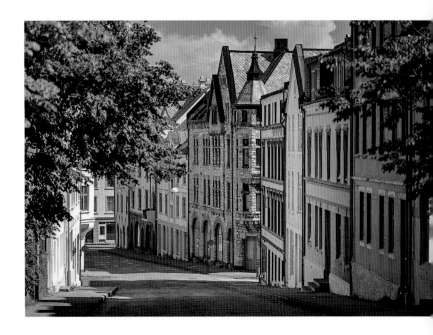

RECONSTRUCTION AFTER THE CATASTROPHIC FIRE AT THE BEGINNING OF THE 20TH CENTURY MADE ÅLESUND INTO THE JEWEL THAT IT PRESENTS TO VISITORS TODAY.

visit the city park. There, the grateful residents commemorate Kaiser Wilhelm II with a memorial. Another statue is of Viking Gange-Rolv, who occupied Normandy during the 10th century and was an ancestor of William the Conqueror—who saw better prospects in England in 1066. There is also a monument dedicated to the Norwegian writer Kristofer Randers.

GEIRANGERFJORD AND RUNDE BIRD ISLAND

The Hurtigruten mail ships make a stop in Ålesund at the entrance to the Storfjord. In summer, this is an opportunity for a trip to the majestic world of the fjords. The ship first sails into the 12.5-mile-long Sunnylvsfjord, and then turns into the 10-mile-long Geirangerfjord, since 2005 also a UNESCO World Heritage Site. You may feel very small and awestruck at the sight of the spectacular mountain scenery. At the same time, that is an experience you have to share with many other people. If this is all too hectic, Runde bird island offers an alternative; trips are available from Ålesund. Some 170,000 pairs of seabirds breed on the steep cliffs. Puffins, kittiwakes, gannets, guillemots—all of them cavort here. You can also visit the research station.

MORE INFORMATION
Historical museums in Ålesund
www.sunnmoremuseum.no/english
Hurtigruten
www.hurtigruten.com/ports/alesund

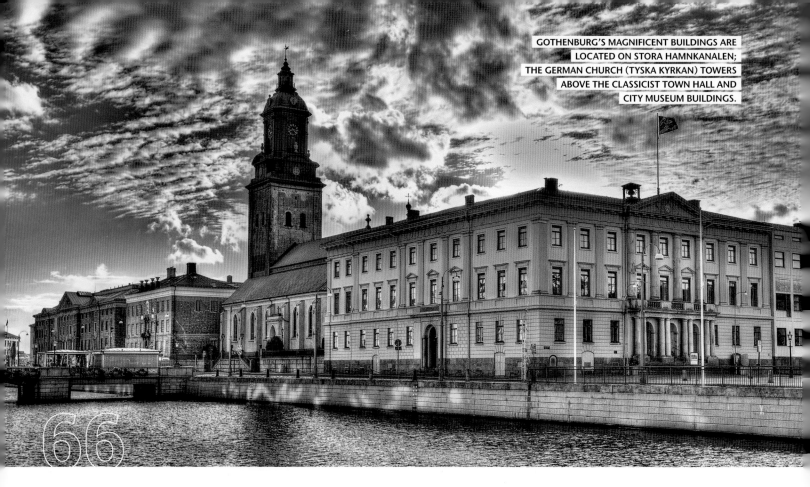

66

GOTHENBURG—HIP AND "MYSIG"

CITY FOR GOURMETS AND ANYONE THIRSTY FOR KNOWLEDGE

Stockholm's eternal rival can easily compete with other European metropolises: imposing city buildings, an exciting art and culture scene, fascinating museums, good opportunities for shopping, and a much-lauded gastronomy scene. Then there is also maritime flair, parks, and the archipelago before the city gates.

SWEDEN

Gothenburg (Göteborg in Swedish) was already intended to be a counterweight to Stockholm when it was founded in 1619. King Gustav Adolf II personally signed the city charter, which was written in German. From the beginning, the settlement along the Göta älv (river) was a city of immigrants who came mainly from Germany and Holland, many of whom were Jewish. At that time, only a third of the municipality's population were Swedish citizens. Gothenburg quickly developed into a flourishing trading city (tea, silk, porcelain) and even had an East India

fleet. During the 19th century, due to its location on the Swedish west coast, it had very close connections to England.

PORT AND TRADE WITH A BOULEVARD
Gothenburg is a port city, so the best way to start exploring it is in the Lilla Bommen district, the "small boom" on the harbor. The Utkiken building observation deck gives you an overview. Because of the red and white stripes on its outer facade, this commercial building is popularly called "the lipstick." Right next door is the *Barken Viking*, a

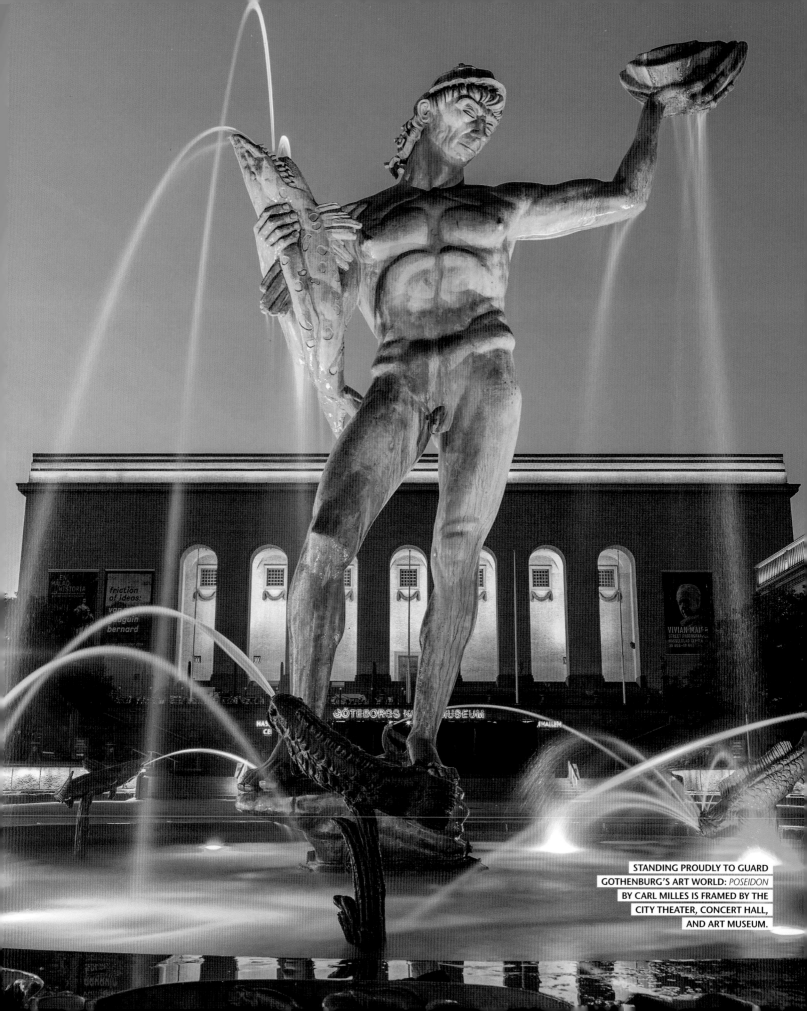

STANDING PROUDLY TO GUARD GOTHENBURG'S ART WORLD: *POSEIDON* BY CARL MILLES IS FRAMED BY THE CITY THEATER, CONCERT HALL, AND ART MUSEUM.

training ship moored in the harbor and now a hotel. In the Maritiman, the Maritime Experience Museum, you can view ships of all kinds; life jackets provided at the entrance ensure the necessary safety. The opera house next door is a complete work of art and is rightly considered one of the most beautiful musical theaters anywhere. On the way to the city center, you pass Gothenburg's oldest building, the Kronhuset. This 17th-century building has defied the frequent city fires as one of its few brick houses. A few feet farther and you are at Gustav Adolfs torg, where there is a monument of the city's founder, framed by the splendid classicist town hall and stock exchange buildings. The Christinae kyrka, also called the Tyska kyrka (German Church), is right next door. It was built by the residents immediately after the city was founded and then rebuilt during the 18th century. Sunday services are still held in German today. The city museum is located right behind the church in a brick palace that used to belong to the former East India Company. It is worth a visit just to see the magnificent interior design, with cast-iron columns and elaborate wall paintings. The exhibits span a period of 12,000 years, from the Stone Age to the Middle Ages, to the years of the East India trade and industrialization, to modern times. The remains of *Äskekärrskeppet* are a real eye-catcher; this is the only Viking ship ever salvaged in Sweden. It was found submerged in Göta älv in 1933. If you continue along Östra Hamngatan toward the mainland, you will inevitably reach the most elegant avenue in Gothenburg: Kungsportavenyn between Stora Teatern and the *Poseidon* fountain. The only "genuine" boulevard in the North is lined with countless shops, cafés, and restaurants. Shopping enthusiasts share the "Avenyn" with street artists. At the end is Konstmuseet, a museum famous for its collection of Scandinavian painters such as Carl Larsson or Edvard Munch.

If you want to get to know the city from a completely different side, you should take a Paddan boat tour. The small excursion boats ("paddan" means turtle) sail along the canals and pass under even the lowest bridges—heads up!

ON THE ARCHIPELAGO

The archipelago is right in front of Gothenburg. You can reach the first of its offshore islands in just 20 minutes by ferry. A distinction is made between the northern and southern archipelago. When sailing toward Vrångö in the southern archipelago, which, unlike the northern part, is car-free, the ship passes several islands, including Donsö or Kårholmen. The 10 islets of the northern municipality of Öckerö, with their sandy beaches or overgrown cliffs where the typical red wooden houses stand, are a popular destination. If you have more time, you can head out farther north to Tjörn and Örust for a summer break: Route RV 160 is one of the most beautiful roads in all of Sweden.

MORE INFORMATION
Gothenburg
www.goteborg.com/en
Food trucks
"Streetkäk" app for locations and meals

"FIKA"—TIME FOR A BREAK

Things can also be quieter. It is not for nothing that people in Gothenburg maintain a lifestyle that the Swedes call "mysig," cozy. And it's best celebrated in one of the pleasant coffee houses. In the Vasastan university quarter, west of Kungsportavenyn, you can enjoy the student atmosphere in the small cafés and shops and pay a visit to Rösskah museet: opened in 1916, it is entirely dedicated to Swedish handicrafts and design. The trendy district of Haga with its creative shops and cozy cafés extends a little farther along toward the Göta älv. Here you should definitely take a "fika" coffee-and-cake break and try the delicious Swedish cinnamon buns. The Café Husaren in the Haga Nygata pedestrian zone says it has the largest ones in the world. Especially at

Christmastime, the pretty little wooden houses look like the backdrop from a Scandinavian fairy tale. A bridge, Rosenlundsbron, leads to the other side of the canal. At Wallgraben you will find another city landmark: the Feskekörkan (fish church), which serves not spiritual but culinary purposes. This former auction hall for fish and seafood, with its characteristic pointed arches, is still the number one place to go for freshly caught seafood.

PALM HOUSE AND RAZZMATAZZ

There are several parks at the edge of the city center; Trädgårdsföreningen, with its palm house and rose garden, is the most popular. Its layout was inspired by the 19th-century botanical gardens in Berlin and Greifswald, Germany. The Liseberg offers more thrills: exciting rides and spectacular shows attract over three million visitors to Scandinavia's largest amusement park every year. But there are also quieter corners on the 20-hectare site, where you can relax from all the razzmatazz.

TRAVEL WITH ALL YOUR SENSES

Right nearby, the Universeum science center takes you to another world. "Science is an exciting experience"—under this motto, the center offers its visitors a tropical rainforest, one of the largest aquariums in the world, a space department, a chemical laboratory, and even an "occupational place" where children can try out what they want to do as a career later on. This temple for knowledge using all the senses is open all year-round, even on Christmas Eve. Next door, artists in Världskulturmuseet, another museum, deal with the cultures of all five continents—a fascinating journey around the world.

If this still hasn't been enough for you, head to Slottsskogen district, which features Sweden's oldest zoo, an observatory, and the Natural History Museum, with the world's only stuffed specimen of a young blue whale.

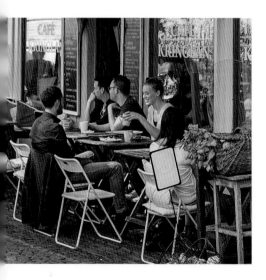

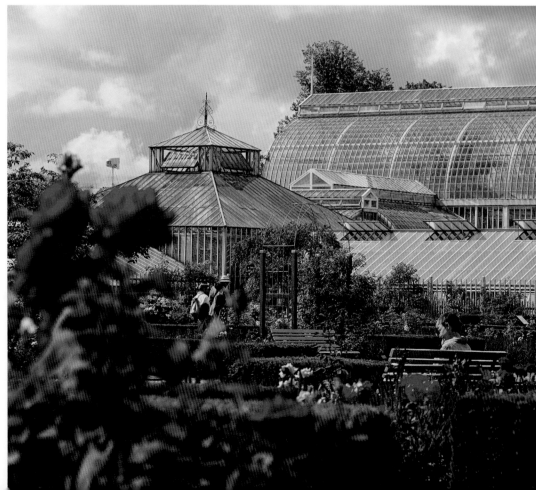

TAKING A BREAK FOR COFFEE AND DELICIOUS CINNAMON BUNS IN HAGA NYGATA (*ABOVE*) NO FEAR OF A COMPARISON WITH LONDON'S KEW GARDENS: TRÄDGÅRDSFÖRENINGEN (GARDEN SOCIETY) DELIGHTS VISITORS WITH ITS VICTORIAN PALM HOUSE AND ROSE GARDEN (*RIGHT*).

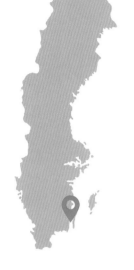

SWEDEN

ROYAL PAST

Kalmar is one of the oldest cities in Sweden and has always been an important trading center. Politically, the baroque fortress town has always been of great importance to Sweden. The name means "stony ground" in Old Swedish and refers to the stony banks in front of the city at the bottom of Kalmar Sound, which used to make it difficult for seafarers to pass through.

The term "stony ground" also applies in other respects: anyone wandering through the Old Town will discover a striking number of stone houses, not the wooden houses customary in Sweden. The reason for this was a fire during the Kalmar War during the 17th century, which almost completely destroyed the place and thus ensured that the newly rebuilt houses were of built stone to prevent another catastrophe. The limestone used as a building material came from the nearby island of Öland.

BUILT ON ISLANDS

The magnificent Kalmar Slott (Kalmar Castle) stands on a small island at the edge of the Old Town. It is one of the best preserved Renaissance castles in northern Europe. As early as 800 years ago, there was a castle in the immediate vicinity of the former border with Denmark. It was given its current appearance in the 16th century. The Swedish Vasa kings Eric XIV and Johan III had the structure converted and erected on the basis of the Continental model. The castle has always been of strategic importance for Sweden. In 1397 the Kalmar Union was concluded there, which united Denmark, Norway, and Sweden under a ruling dynasty until 1523. During a visit you learn everything about the building's long history and the way of life of the castle lords; you can also visit a women's prison. If that's too dark for you, enjoy the

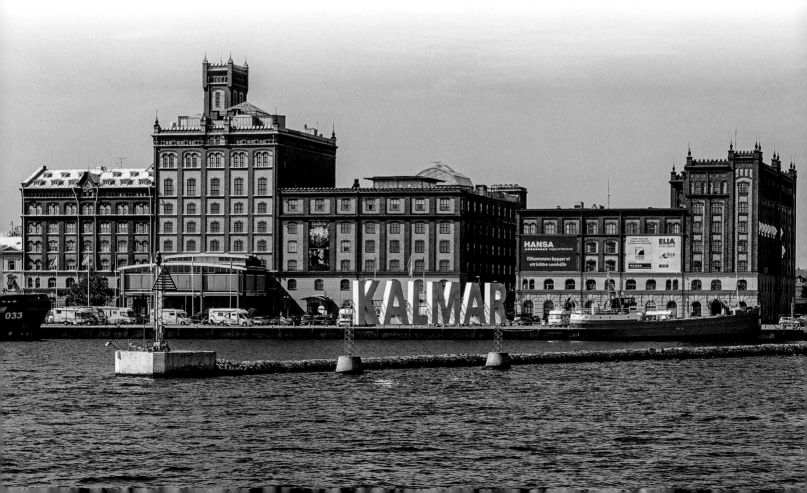

beautiful view when walking on the outer wall or try Swedish delicacies in the castle restaurant.

Not only the castle but all the rest of Kalmar is built on islands. The medieval town center extends over Kvarnholmen. This is the Gamla Stan (Old Town) quarter with its narrow streets and small houses; the three tall wooden buildings among them, "Tripp, Trapp, Trull," could come directly out of a Pippi Longstocking film. In the middle of Kvarnholmen (the German name is Mühleninsel: Mill Island) is the mighty cathedral, dating from the 17th century. The baroque building combines Jesuit and Protestant elements and has three organs. The Dutch Renaissance–style town hall stands directly opposite the church. Storgatan runs across the square and leads to Kaggensgatan, the main shopping street. If you stay on Storgatan and travel away from the city, you will eventually come to Sweden's oldest movie theater, the "Saga," in Malmen district on the mainland. It was opened in 1906 and has been continuously in operation ever since. This neat wooden villa from the 19th century doesn't look at all like a movie theater, but it has a modern theater with digital sound and 173 seats.

ART, DESIGN, AND DINOSAURS

The Kalmar Läns Museum (County Museum) displays the finds from the wreck of the royal cargo ship *Kronan*. The ship, which was sunk in a 17th-century naval battle, was salvaged in the 1980s. The works of the Swedish painter Jenny Nyström are also on display here. You can learn more about Swedish art in the Kalmar Konstmuseum: this modern black cube in the city park shows works from the romantic to the modern and also presents the design so typical of Sweden.

AN OLD FACTORY BUILDING (A STEAM MILL) HOUSES THE KALMAR LÄNS MUSEUM (*OPPOSITE*).
KALMAR SLOTT, WITH ITS FOUR CORNER TOWERS, IS A TYPICAL VASA ROYAL HOUSE CASTLE FROM THE 16TH CENTURY (*BELOW*).

Farther outside Kalmar, children and dinosaur fans will get their money's worth: "A World of Dinosaurs" is not Jurassic Park, but the more than 100 models from prehistoric times impress visitors. Not quite as old, but at least the oldest house in Scandinavia: the Tingby House is a proud 8,500 years old—this reconstruction is right next to the dinosaur park.

EXCURSION TO ÖLAND

If you want to go on vacation like the royals do, you don't have to travel to the Caribbean or the South Seas. The Swedish royal family has their summer residence at Solliden Castle on Öland. The long, narrow island east of Kalmar is connected to the mainland by the 3.5-mile-long bridge named Ölandsbron. When you arrive on the island, you immediately feel that here things are different than they are in the rest of Sweden. This is due to the heath landscape with its unique plants, some of which grow only here. Two lighthouses "guard" the island: Long Eric in the north and Long Jan in the south. In between, visitors can dis-cover primeval burial mounds and settlements, as well as some 400 post windmills. Öland has been supp-lying the limestone for Kalmar for a long time. Particu-larly impressive are the 120 raukar, or limestone stacks, near the village of Byrum.

MORE INFORMATION
Kalmar Castle
www.kalmarslott.se/English
A World of Dinosaurs
www.aworldofdinosaurs.com

FINLAND

STYLE AND FORM IN FINNISH

In the flourishing port city of Turku in southwestern Finland, student life with lots of music and bars unfolds in front of important historical treasures. Art, from old times as well as modern, is written in capital letters, and it becomes evident on every corner that Turku has a knack for original design.

The Aurajoki River flows through the oldest city in Finland and then nearly 2 miles farther into the Baltic Sea. Settled during the Stone Age, and a trading center from as early as the Iron Age, Turku was one of the most culturally and economically important cities in the country during the Middle Ages. Under Swedish rule since the 13th century and under Russian rule starting in 1808, Finland gained its independence in 1917. In 1819 the capital was moved from Turku to Helsinki. Bilingualism has remained from the Swedish period.

BARS, ART, AND DESIGN

Life pulsates along the Aurajoki River. In summer you meet in the evening to chat, eat and drink, and make music. Many boats in the river house bars and restaurants. Turku is lively, not least because of its two universities, one Finnish and one Swedish. The art scene is also dynamic. Many bars have been converted into alternative exhibition spaces. All ages are represented at the art openings, and you get to know the artist personally. The best idea is to follow the art students, who are usually dressed in very striking style . . . The route will certainly lead past shops displaying original arts and crafts or chic fabrics "designed in Finland." The Aboa Vetus and Ars Nova museums in the Rettig Palace (1928) are dedicated to already established art, including excavations from the 14th century and modernist works. The Taidemuseo building (1904) is in national Romantic style and provides a good overview of Finnish art since 1891. The Sibelius Museum honors other types of art; namely, that of the composer Jean Sibelius (1865–1957), and the

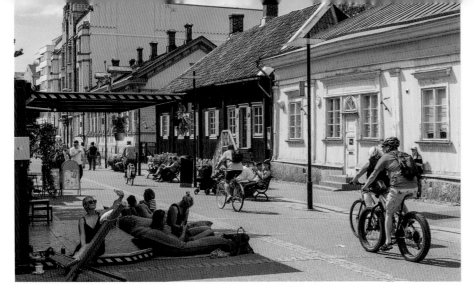

ROMANTIC EVENING ON THE
AURAJOKI RIVER (*OPPOSITE*)
SUMMER DAYS AMONG HISTORICAL
RESIDENCES (*LEFT*) AND MODERN
DESIGN: FOUNTAIN SCULPTURE IN THE
FORM OF A WHALE'S FLUKE (*BELOW*)

Forum Marinum displays its small museum fleet entirely under the banner of seafaring.

OPULENCE — SPIRITUAL, WORLDLY, CULINARY

Turku's landmark is the cathedral (consecrated in 1300), the most important medieval building in the country. Enlarged several times during the 15th century and rebuilt after the city fire in 1827, the exterior shows influences of the German Brick Gothic style, while the interior, especially the paintings on the ceilings and walls, is all under the Romantic banner. Some important personalities of Finland were laid to rest in the cathedral.

Turun Linna Castle (1280), formerly located on an island in the Aurajoki, is the largest surviving medieval building in Finland. It was given its current appearance during the 16th century, when it was enlarged in Renaissance style to become the residence of the then Swedish lords of the castle. The interior displays opulent ballrooms, and there is a city museum in the eastern part showing furniture and carpets from the 16th to 19th centuries. The 395-foot-long market hall (1896) is also worth a visit, not only because of its remarkable architecture, but also for the specialties that you can taste here.

NATURE AT THE DOOR

Turku is a green city with many parks and botanical gardens. But it is also the gateway to a romantic world of 20,000 archipelagos and islands, largely uninhabited and pristine. Some islands are connected by bridges; others can be reached only by ship. All are small natural paradises that can be explored on foot or by bike.

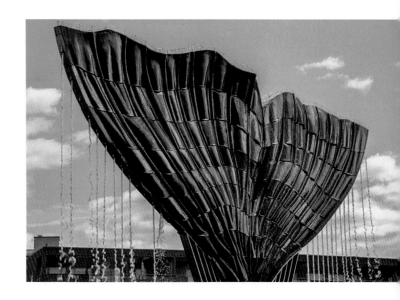

OLD-TIME CRAFTS

A district of Turku that was spared the 1827 fire was converted into the Luostarinmäki open-air museum in 1940. Time has stood still in the old wooden houses: they are lovingly furnished with traditional utensils, household items, and furniture, and even the staff greets guests in period clothing. The 14 courtyards and their buildings take you into the preindustrial era. Each house is dedicated to a special handicraft. If you have ever wanted to learn about how a watchmaker or silversmith worked and lived in the 19th century, you can attend a corresponding workshop in the museum. In summer there are also small musical performances, of course in the appropriate outfit.

MORE INFORMATION
Turku
https://visitturku.fi/en/visit-turku-en/tourists/tourist-information
www.visitfinland.com/article/turku
Luostarinmäki open-air museum
www.visitturku.fi/en/luostarinmaki-handicrafts-museum_en

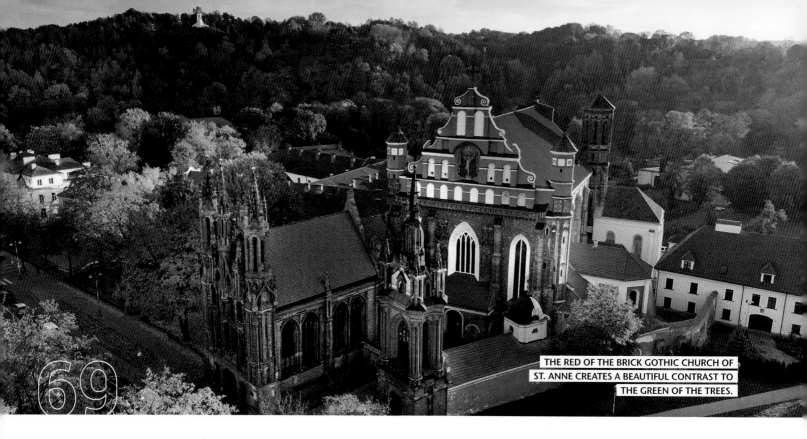

THE RED OF THE BRICK GOTHIC CHURCH OF ST. ANNE CREATES A BEAUTIFUL CONTRAST TO THE GREEN OF THE TREES.

69

LITHUANIA

MOST EXTENSIVE BAROQUE INNER CITY NORTH OF THE ALPS

The view from above is worth it. The city center spreads out below with its red roofs, narrow streets, and many church towers. In the distance, the skyline of a mini-Manhattan is growing on the banks of the Neris River. The baroque charm of one of the most extensive Old Towns in eastern Europe lies at the feet of the beholder.

The 220-foot-high tower of the Vilnius University Church of the St. Johns offers a wonderful view. Alternatives are the Cathedral Tower or Gediminas's Tower in the Upper Castle. From there, the eye wanders over a city—a UNESCO World Heritage Site—that is too far inland for cruise tourists. Anyone who still wants to have a look at the Socialist-era prefabricated apartment buildings on the city outskirts has to go to the 625-foot-high television tower observation deck.

A LONG WAY

Vilnius is not particularly typical of the Baltic states. Here, where the Vilnia River flows into the Neris, there was already an early settlement on Gediminas Mountain. In 1323, Vilnius is mentioned in documents as the capital of Lithuania. In contrast to its neighboring countries, the Teutonic Order could not gain a foothold there. Instead, Vilnius developed into the capital of the rival grand duchy of Lithuania, which later extended from the Baltic Sea to the Black Sea in conjunction with the kingdom of Poland. In the heyday of what was then Europe's largest state, baroque architecture was laid over the city like a net with the help of Italian master builders. In 1795, after the third division of Poland, Vilnius belonged to the Russian Empire until the end of World War I. Shortly afterward, the city was occupied by Poland. World War II and the German occupation brought Vilnius its darkest hours. All

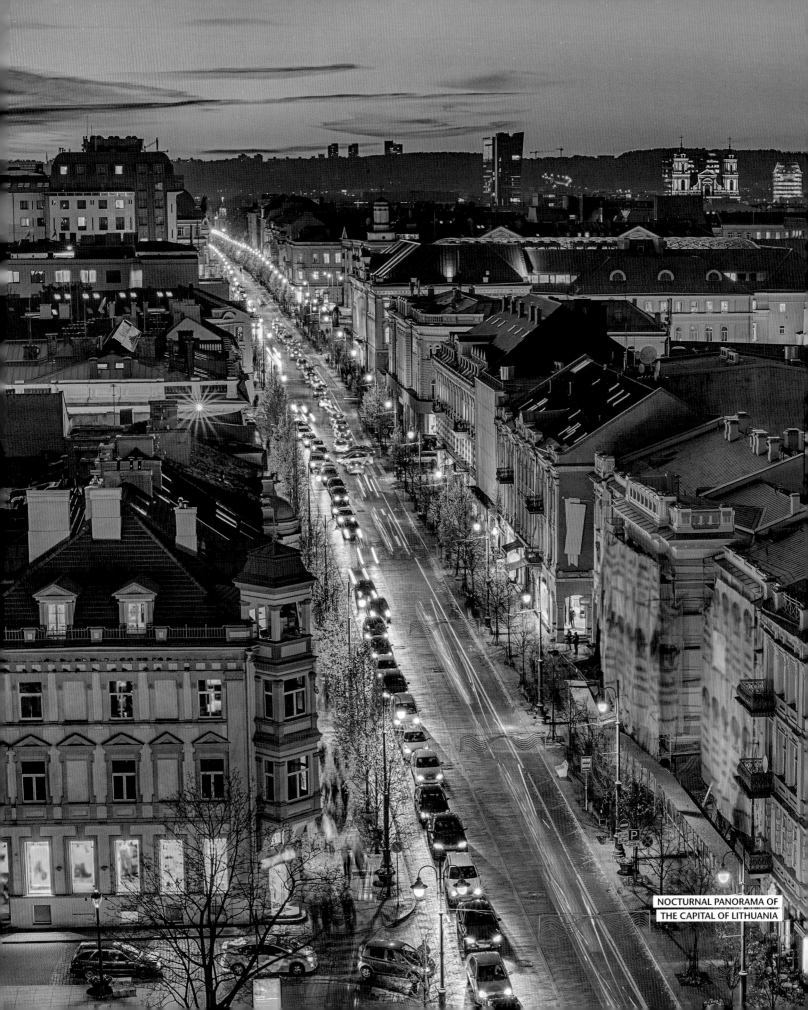

NOCTURNAL PANORAMA OF
THE CAPITAL OF LITHUANIA

that remained was an almost undestroyed backdrop—most of the city's Jews, about 30 percent of the population, had fallen victim to the Holocaust, and 130,000 Poles had been displaced, forcibly resettled, or murdered. Under Soviet rule, Vilnius was repopulated, and after the catastrophes of the 20th century, in 1990 it became the capital of the once-again-independent Lithuania.

REMEMBRANCE

Vilnius, the "Jerusalem of the North," was a center of the Jewish enlightenment, and around 1900 it had one of the largest Jewish communities in the world. Appreciation and analysis of its Jewish history have only just begun. The streets of the large and small ghettos, with signs featuring the Star of David, recall this, as does the Gaonvon Vilnius Jewish Museum (with the Holocaust Memorial), the Museum of Tolerance, and the memorial to the victims of the SS massacres at Paneriai (formerly Ponary). Only the Choral Synagogue remains of what were once over 100 synagogues in the city. The history of repression during the German occupation and the Stalinist terror is addressed in the Museum of Occupations and Freedom Fights (formerly the Museum of Genocide Victims). It is housed in the building where the Gestapo resided from 1941 to 1944, and then the Soviet NKVD, or KGB, from 1944 to 1990.

ROME IN THE EAST

The "Rome of the East" has more than 50 churches. Which one is the most beautiful? The Basilica of St. Stanislaus and St. Ladislaus is a simple classicist building that dates back to a Gothic hall church. It includes a separate bell tower, which was originally a defense tower of the Lower Castle and stands, somewhat crooked, next to the reconstructed Grand Duke's Castle. The oldest representative of baroque style is the Church of St. Casimir, the patron saint of Lithuania. It was the church of the Jesuits, who had been active in Lithuania since 1569. In the Soviet period, the interior was destroyed, used first a storage room and then as the

RESTAURANTS IN THE NARROW MEDIEVAL STREETS INVITE YOU TO LINGER COMFORTABLY (*LEFT*). DECORATIONS FOR MIDSUMMER DAY, CELEBRATED AS ST. JOHN'S DAY IN LITHUANIA (*ABOVE*)

Museum of Atheism. In the meantime it has been renovated and glows in a soft rose color. On the other hand, the Church of St. Peter and Paul, a late baroque pearl, is a dream in white and more beautiful than any wedding dress. It makes an impression with its masterly stucco work and sculptures, created by Polish and Italian craftsmen and artists in the 17th century. The Catholic Church of the Holy Spirit is resplendent in lavish baroque and rococo. The Church of St. Anne, on the other hand, glows in red brick, and its facade presents a rare example of the Gothic style in Lithuania. One of the oldest churches is the University Church of the St. Johns, which dates from the 14th century. When the Jesuits founded the university in 1579, it was integrated into a complex of Renaissance, baroque, and classicist buildings and 13 courtyards. The library in the former refectory and the White Hall are particularly magnificent. The Black Madonna is particularly important for Catholic Christians. The miraculous icon is worshiped in the chapel of the Gates of Dawn, a beautiful city gate in the fortified wall. Pope John Paul II prayed there in 1993, and Pope Francis on September 22, 2018. Beyond these, the National Gallery of Art and the National Museum also await art lovers. Families who want to create illusions go to the Vilnil Museum.

IN THE MIDDLE OF EUROPE

The plaster is flaking on many walls, and buildings in the city outskirts especially are waiting to be renovated. Lost places such as the former sports palace, which was built in 1961 atop the destroyed Jewish cemetery, display ramshackle Stalinist architecture. But appearances are deceptive. Vilnius is a very modern European city, only a couple miles away from the geographical center of Europe. Its internet is one of the fastest in the world, and "Traf" is a trendsetting app that you can use to request all the public transport and car-sharing offerings in real time. One of the capital's residents' favorite dishes, however, is almost old-fashioned: cepelinai are meat-filled potato dumplings shaped like a zeppelin. For Lithuanians, they always go with a beer. On the edge of the Old Town, on the other side of the Vilnia River, the Užupis district attracts visitors with street art, art galleries, and trendy cafés. It used to be one of the poorest parts of the city, but after 1990, artists and life artists moved into the dilapidated houses and founded the "Republic of Užupis." Although gentrification

and tourism are extending their impact, the republic is stably administered in parliamentary fashion from the "Café of Užupis," and a multilateral coexistence is being creatively and colorfully promoted. Article 1 of the 41 articles of its constitution reads: "Everyone has the right to live on the Vilnia River, and the Vilnia River has the right to flow past everyone."

TRAKAI

The picturesque moated castle of Trakai is built on an island amid three lakes. It can be reached from the mainland only via a narrow dam. Trakai was the medieval residence of the grand dukes of Lithuania. In 1655, Russian troops destroyed the castle, which comprised two separate structures. It was only in the second half of the 20th century that it was rebuilt as a national symbol. A special feature of the village of the same name is the historical evidence of the Carians. This Jewish community exclusively recognizes the Torah as the basis of its faith and writes its language, which belongs to the Turkic languages, in Hebrew letters. Some houses and a prayer house, the Kenesa, have been preserved in Trakai.

MORE INFORMATION
Vilnius
www.govilnius.lt/visit-vilnius
Vilnius on foot
https://walkablevilnius.com
Museum of Illusions
http://vilnil.lt/en
Trakai
www.trakai-visit.lt/en

UKRAINE

LVIV—GALICIAN BEAUTY

MULTICULTURAL HERITAGE

Lvov (Russian), Lwów (Polish), Lemberg (German), Lviv (Ukrainian)—the city at the edge of the Carpathian Mountains has many names. They are mirrors of its turbulent history. The charming Old Town, a UNESCO World Heritage Site, is enlivened by a colorful cultural scene. It shows Ukrainian self-confidence and the undestroyed flair of the former Austro-Hungarian imperial and royal monarchy.

All bumpy cobblestone streets lead to Rynok Square, the center of the Old Town. The square is lined with magnificent houses, which tell of the riches of this trading city during the 16th and 17th centuries. In addition to local builders, wealthy merchants employed German and Italian builders, as can be seen from the ocher, yellow, and pink facades. The classicist-style town hall is guarded by two stone lions, the city's heraldic animals. A thoroughly strenuous ascent to the town hall tower is rewarded with a panoramic view. In the distance stand the Soviet-era prefabricated apartment buildings. Each city quarter shows a different face of Lviv's multicultural heritage.

PAINFUL FATE

The journey through time starts at the airport, which was rebuilt for the FIFA World Cup in 2012. In 1256, Prince Daniel, ruler of the Rus in what was then the country of Halytsch, founded a castle on the High Castle Hill. He named it after his son Lev, which means lion. Almost 100 years later, its 400-year membership in the Polish-Lithuanian Commonwealth began in a campaign of conquest. With the first division of Poland in 1772, Lviv fell to the Habsburgs and became the capital of the kingdom of Galicia and Lodomeria. At the end of World War I and after the collapse of the Austro-Hungarian dual monarchy, the city, which was inhabited mainly by Poles, was assigned to the resurrected Poland. Soviet troops came along with the Hitler-Stalin Pact of 1939. At that time, about 160,000 Poles, 150,000 Jews, and 50,000 Ukrainians were living in Lviv. The Jewish population was murdered under the German occupation and reign of violence between 1941 and 1944. After the end

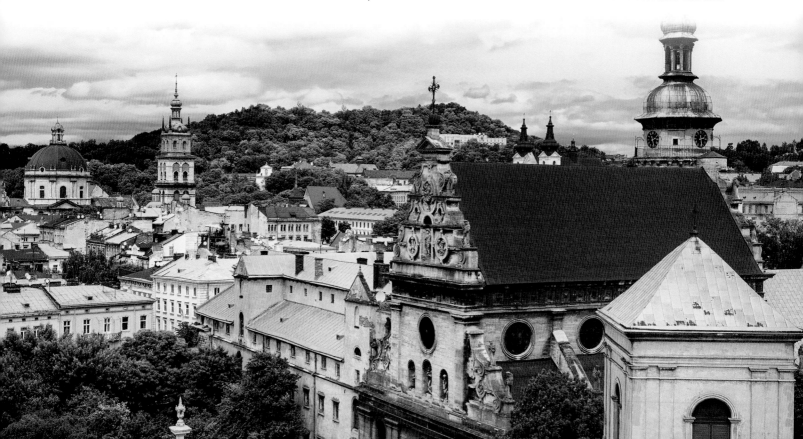

of World War II, Lviv became part of the Ukrainian Soviet Socialist Republic, and the Poles had to vacate the city. Lviv has been part of independent Ukraine since 1991 and is once again, like the whole country, seeking historical proximity to Europe.

STROLL TO THE COFFEE HOUSE

Every culture has left its mark. In the Armenian quarter, the cathedral is an exemplary mixture of the Romanesque-Gothic style of eastern Europe and the local architecture. Only two synagogues still bear witness to the almost wiped-out Jewish way of life: the Jankel Janzer School and the Tsori Gilod Synagogue, with its art deco facade. In the maze of alleyways, the more than 100 churches from different Christian faith communities provide orientation. The Greek-Catholic St. George's Cathedral, very visible on a hill, makes an impression with its rococo forms and the famous icon of the Mother of God from Terebovlja. The Boim Chapel, near the Roman Catholic Assumption Cathedral, with its stone carvings, is a pearl of the Renaissance.

MAGNIFICENT TESTIMONIALS OF AUSTRO-HUNGARIAN IMPERIAL AND ROYAL TIMES

The opera house radiates Austrian turn-of-the-20th-century charm and is one of the most beautiful European theater buildings. The pomp of the Austro-Hungarian imperial and royal monarchy is also reflected—besides in the 20 palaces —in the main building of the university, which was founded in 1661; the building was formerly built for the parliament of the kingdom of Galicia. At the Hotel George, Franz Liszt and Jean-Paul Sartre used to sink into the heavy plush armchairs to take their coffee out of the city center and into the green at the

VIEW OF THE MANY CHURCHES IN THE OLD TOWN (*OPPOSITE*)
SWEET TEMPTATIONS ARE CREATED BY CHOCOLATE MAKERS (*BELOW*)

outskirts. The open-air Museum of Folk Architecture and Life, with its houses and wooden churches from Transcarpathia, is located there. A little farther into the city, the Lychakiwer Cemetery, one of the most beautiful cemeteries in Europe, invites you to a pensive ramble.

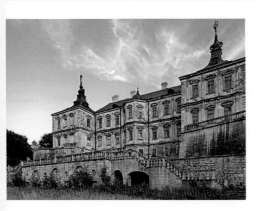

THE GOLDEN HORSESHOE

Three castles and fortresses, which were built to protect against attacking Tartars or as spacious residences in the Lviv area, form the "golden horseshoe." Olesko Castle was built as a fortress in the days of Kievan Rus. It has a strategically favorable location on a rock in the middle of flat land and therefore guarantees a good view of the landscape. It is the birthplace of King Jan III Sobieski, who defeated the Turks in front of Vienna in 1683. Pidhirzi Castle is a very photogenic palace built by Italian masters, with a colorful garden, but is in urgent need of renovation. The great love story between Jan Sobieski and the French Marie Casimire Louise de la Grange d'Arquien took place at Solochiv Palace, composed of a Renaissance building and a Chinese palace.

MORE INFORMATION
Lviv
https://lviv.travel/en
www.lemberg-lviv.com
National Opera of Lviv
www.opera.lviv.ua/en

SUMMER EVENING PANORAMA FROM
GEDIMINAS MOUNTAIN, THE LEGENDARY
FOUNDING LOCATION OF LVIV

INDEX

PHOTO CREDITS

Page 1: Ljubljana Old Town, Slovenia (meet/shutterstock)
Pages 2–3: Albert Dock in Liverpool, England (Shahid Khan / shutterstock)

Bildagentur LOOK: 14, 227a (Olaf Meinhardt), 15, 41r, 59, 64r, 79a, 95b, 113b, 137, 139, 152, 177b, 185, 203r, 208r, 227b, 235b (age fotostock), 16l, 31 (Günther Bayerl), 16r (Hauke Dressler), 17 (Heinz Wohner), 18, 20 (Ulf Böttcher), 19, 71r, 157b (Andreas Strauß), 24 (Arthur ff. Selbach), 25l, 30, 33r, 40 (H. & D. Zielske), 33l, 54 (Travel Collection), 34, 35, 36r (Jörn Sackermann), 38, 77a (Thomas Stankiewicz), 57, 232r (Hemis), 61b (Arnt Haug), 73b (Ernst Wrba), 83, 103, 109b, 170, 175b, 233 (robertharding), 102 (Travel Library), 118, 128, 131, 134 (SagaPhoto), 119l (Holger Leue), 133 (Photonon ff.stop), 141a, 224 (Brigitte Merz), 156 (Rainer Mirau), 157a, 191a, 213 (ClickAlps), 159 (Franz Marc Frei), 163b (Daniel Schoenen), 169b (Konrad Wothe), 214–215, 220, 223, 225l (Christian Bäck), 219b (TerraVista), 225r, 232 (Franz Marc Frei)
Huber Images: 26 (Andrea Armellin), 27a (Günter Gräfenhain), 147 (Massimo Borchi), 148r (Massimo Mastrorillo)
Shutterstock: 1 (Triff), 2–3 (Shahid Khan), 10 (Goskova Tatiana), 11a, 48 (Umomos), 11b (pinot noir), 12–13 (fotolupa), 21l (StockphotoVideo), 21r (mmodium), 22 (Oleg Senkov), 23l (Tobias Arhelger), 23r (Uhryn Larysa), 25r (Bildagentur Zoonar GmbH), 27b (Tsuguliev), 28–29, 117 (Mapics), 32 (D.serra1), 36l, 44, 115b (LaMiaFotografa), 37 (TravelNerd), 39 (knipsde-sign), 41l (Pustefower9024), 42 (Yevhenii Chulovskyi), 43l (Vi ff.talijus Satilovskis), 43r (Karin Jaehne), 45b (my_ photos), 45a (b.J. Alexander), 46–47, 49, 140, 150–151 (Sergey Dzyuba), 50l (tichr), 50r (inavanhateren), 51 (clearlens), 52 (Michael Thaler), 53, 209 (Cortyn), 55, 144r (Massimo Santi), 56 (Oliver Foerstner), 58, 66–67 (Boris Stroujko), 60 (Ksenija Toyechkina), 61a (euge ff.niek), 62 (Ekaterina Pokrovsky), 63 (Kiev.Victor), 64l (ArtOlym ff.pic), 65 (goga18128), 68 (ILEGRI), 69 (Oleg Lopatkin), 70 (Karl Allgaeuer), 71l (Markus Plank), 72 (Christian Vinces), 73a, 191b (xbrchx), 74–75 (Balakate), 76 (Bertl123), 77b (saiko3p), 78 (Ma ff.tej Kastelic), 79b (Bakusova), 80 (Delpixel), 81a (ELEPHOTOS), 81b (Procyk Radek), 82, 124–125 (Rudy Balasko), 84 (Renata Sed ff.makova), 85l (StockStudio), 85r, 164, 168, 169a (Stefano_Va ff.leri), 86 (Laszlo Szelenczey), 87b (Iakov Filimonov), 87a (Woj ff.ciech Tchorzewski), 88 (Wojciech Dziadosz), 89 (Patryk Michalski), 90 (Telly), 91 (Stanislav Samoylik), 92 (Adam Kraska), 93b (Elz ff.bieta Sekowska), 93a (Janusz Baczynski), 94 (Mike Mareen), 95a, 190 (Radoslaw Maciejewski), 96–97 (Sara Winter), 98 (Peter O'Toole), 99b (Anastasia Myasnikova), 99a (Andrei Nekrassov), 100 (s_karau), 101a (James Jones Jr), 101b (Moomusician), 104l (chrisdorney), 104r (Joe Dunckley), 105 (eldramart-work), 106 (AG Baxter), 107a (Kevin Standage), 107a (Mark Christopher Cooper), 108 (Valdis Skudre), 109a (1000 Words), 110 (Rudmer Zwerver), 111a (Hindrik Johannes de Groot), 111b (Ale_ Koziura), 112, 114 (Allard One), 113a (wjarek), 115a (DutchScenery), 116 (Rudy Mareel), 119r (littlewormy), 120 (J2R), 121 (canadastock), 122 (TTstudio), 123 (Michelpix), 126 (Harrie Muis), 127b (happylights), 127a (trabantos), 129 (Lena Serditova), 130, 135r (Henryk Sadura), 132, 138l, 158, 181 (mi ff.losk50), 135l (Anton_Ivanov), 136 (SergiyN), 138r (Elena Chevalier), 141b (Pack-Shot), 142 (Nigel Jarvis), 143 (Roka), 144 l. (Luciano Mortula), 145 (Goncharov_Artem), 146, 148l (Pigprox), 149 (prochasson frederic), 153b (pixelshop), 153a (Emanuele Mazzoni Photo), 154–155 (Fortgens Photography), 160 (poludzi ff.ber), 161l (Luca Ladi Bucciolini), 161r (R. Maximiliane), 162, 163a (lorenza62), 165b (Veniamin Kraskov), 165a (makalex69), 166 (Giorgio Morara), 167b (Kartouchken), 167a (GIANFRI58), 171 (Mimadeo), 172l, 207r (Heracles Kritikos), 172r (FCG/), 173 (dvoevnore), 174 (Vladimir Sazonov), 175a (Rolf G Wacken ff.berg), 176 (oserpizarro), 177a (Gabino Cisneros), 178 (Hakat), 179a (Shaun Dodds), 179a (Kurbanov Vener), 180, 183l (Poff.dolnaya Elena), 182 (Miguel Sánchez), 183r (Sergey Didenko), 184 (Petr Pohudka), 186l (Dolores Giraldez Alonso), 186r (elxe-nia), 187 (Benny Marty), 188 (Sergio Stakhnyk), 189b (Dolores Giraldez Alonso) 189a (Lux Blue), 192 (Oma Photography), 193 (Zoran Milosavljevic), 194l (amyrxa), 194r (Zoran Gajic), 195 (Klark Medya), 196 (Dziewul), 197a (dorinser), 197b (Roberto Sorin), 198–199 (Calin Stan), 200 (Kanuman), 201 (Mariia Golovi ff.anko), 202 (Dennis van de Water), 203l (Anton Donev), 204 (Ne ff.nad Nedomacki), 205 (Anton Chalakov), 206 (IURII BURIAK), 207l (Irma eyewink), 208l (YK), 210 (Irina Papoyan), 211 (Turneround-Designs), 212 (Oleksandr Savchuk), 216 (Marc Lechanteur), 217b (Prostock-studio), 217a (Salvador Aznar), 218 (framedbythomas), 219a (RPBaiao), 221b (Gertjan Hooijer), 221a (Konstantin Yols ff. hin), 222 (Leonid Andronov), 226 (Pawel Szczepanski), 228 (Tuo ff. mas Lehtinen), 229a (Jarmo Piironen), 229b (Evelyn Jackson), 230 (MNStudio), 231 (krivinis), 234 (RastoS), 235a (Sun_Shine), 236–237 (MNStudio)

Front cover:
Ghent at dusk, Belgium (Rudy Balasko)

Back cover:
Top (from left to right): Dragon Bridge in Ljubljana, Slovenia (Xseon/shutterstock), Market Square, Hildesheim, Germany (Mapics/shutterstock), Praça da República in Tavira, Portugal (S. Lubenow / Lookphotos)
Bottom: View from Aksla Mountain in Ålesund, Norway (Christian Bäck / Lookphotos)